Art: key contemporary thinkers

Art: key thinkers

Edited by
Diarmuid Costello and

contemporary

Jonathan Vickery

First published in 2007 by
Berg
Editorial offices:
1st Floor, Angel Court, 81 St Clements Street, Oxford, OX4 1AW, UK
175 Fifth Avenue, New York, NY 10010, USA

Berg is the imprint of Oxford International Publishers Ltd.

Library of Congress Cataloging-in-Publication Data

Art : key contemporary thinkers / edited by Diarmuid Costello and
Jonathan Vickery.
 p. cm.
 Includes bibliographical references and index.
 ISBN-13: 978-1-84520-319-1 (cloth)
 ISBN-10: 1-84520-319-4 (cloth)
 ISBN-13: 978-1-84520-320-7 (pbk.)
 ISBN-10: 1-84520-320-8 (pbk.)
 1. Art, Modern—20th century—Philosophy. 2. Art, Modern—21st
century—Philosophy. I. Costello, Diarmuid. II. Vickery, Jonathan.

 N66.A76 2007
 709.04—dc22

 2006031856

British Library Cataloguing-in-Publication Data

A catalogue record for this book is available from the British Library.

ISBN 978 184520 319 1 (Cloth)
ISBN 978 184520 320 7 (Paper)

Typeset by JS Typesetting, Porthcawl, Mid Glamorgan
Printed in the United Kingdom by Biddles Ltd, King's Lynn

www.bergpublishers.com

CONTENTS

ACKNOWLEDGEMENTS

We would like to thank our commissioning editor Tristan Palmer at Berg for first proposing this project, and the contributors who made it possible. Their generosity, punctuality, and good-natured responses to numerous requests for clarifications and reformulations made a potentially hazardous project almost manageable. Particular thanks are due to Michael Richardson and Riccardo Marchi for contributing at shorter notice. Our gratitude also goes to D. J. Simpson, Hannah Jamieson, Sarah Shalgosky at the Mead Gallery, Warwick Arts Centre, and Sue Dibben at the Humanities Research Centre at Warwick University. The School of Arts & Humanities at Oxford Brookes University supported work on this project prior to Diarmuid Costello joining Warwick University, as did, indirectly, a Leverhulme Trust Research Fellowship. In a deeper sense, we are both indebted to the Departments of Philosophy and the History and Theory of Art at the University of Essex, in whose intense and congenial atmosphere the intellectual commitments that animate this volume were formed.

GENERAL INTRODUCTION

What different ways of interpreting art are there, and what different concepts and theoretical frameworks are involved? What is the value of art? How does art communicate, embody or otherwise express its meaning? Why does art's form and significance change over time, and within different contexts? Do changes in art reflect changes in culture and society as a whole, and if so how? These are questions that continually need to be asked and reassessed. Art itself is a 'discourse' – a conceptual field within which and around which move various kinds of objects, activities, processes, ideas and theories, subcultures and movements, institutions and exhibitions. The central characteristic of this discourse, particularly in its most recent forms, is its unstable, internally conflicted and often bewildering character. This can make trying to master the discourse of art a frustrating, but equally an intellectually exhilarating endeavour. Contemporary art in particular has never enjoyed such widespread interest and currency, yet the theoretical frameworks it produces and draws upon frequently remain opaque.

This book is a response to this situation, and is intended to put its readers in a position to explore and question theories, ideas and claims that they might otherwise be forced to take on trust. Of course no primer, however good, can replace reading the original texts. But in the case of those thinkers on art considered here, some introduction is necessary to understanding what one encounters when one does so. If this book sends its readers back to the originals with greater confidence and curiosity, and a better sense of how a given thinker sits within a wider field of overlapping debates, it will have served its purpose. To this end the collection brings together upcoming younger scholars with scholars of international standing to write in a way that is clear and approachable yet nonetheless challenging – both for the reader and towards the thinkers and texts discussed. As such, the intention was always to lay the ground for further *critical* exploration on the part of the reader. Read in this spirit, in conjunction with the primary and secondary literature discussed, we believe that this collection will put its readers in a much better position to develop their own perspective.

The volume spans the ideas and theories of forty-five 'key contemporary thinkers' on art. What counts as 'key', in this context, is a matter of both judgment and the audience we envisage, and in part hope to forge, through this collection. All such lists are partial, and there were a number of theorists whose work we were unable to cover in the space available, much as we would have liked to. By 'contemporary thinkers', we mean theorists who are associated with a coherent *body* of thought or ideas, which their work on art embodies or reflects, and whose work *continues* to impact on thinking about artistic practice, theory and historical analysis today. As such, we use the term 'contemporary' in a fairly loose sense historically (roughly equivalent to 'since the 1960s'), and to signify impact rather than origins. To pick an obvious example: Benjamin is hardly a 'contemporary thinker' in biographical terms (he died in 1940), but his work has had an exceptional influence on art theory and criticism since the late 1960s. We take the 1960s as our point of departure because it is the locus of the most salient cultural transformation of our time – the move from modernism to postmodernism. To

the extent that we still inhabit postmodernism today or its aftermath today, this is the period of our 'contemporaneity', broadly conceived. This book is in part a cultural, philosophical and art historical roadmap of the ramifications of that transition.

The book is divided into four broad sections. These are in no sense meant to exhaust the range of discourses one can find represented in other books surveying the theory of art today. But given how widely areas not represented here (areas such as queer theory or post-colonial theory) have been covered elsewhere, we wanted to focus instead on broad 'bodies of thought' around legacies of modernism and postmodernism in the arts. The first section is unusual, in so far as artists are typically neglected in anthologies of this kind. We have sought to redress this by including a section on artists *as thinkers*, that is, artists who have made a major contribution to thought about art since the 1960s through their writings as well as their art. Though one can find many anthologies of artists' writings, one rarely finds artists treated on an equal footing with theorists, historians and philosophers when it comes to producing knowledge *about* art. Section II includes those art historians and theorists who have made, or still are making, the greatest impact on thought about art during this period, and whose work clearly embodies a broader intellectual position despite remaining close to its object. Section III includes philosophers, from both the 'analytic' and 'continental' traditions, who have not only made major contributions to recent debates in aesthetics and the philosophy of art, but whose work is also widely read beyond the confines of professional philosophy. Section IV is the most diverse, and in this sense reflects the genuine diversity of thought about art today. Thinkers in this section are drawn from a range of disciplines, such as sociology, and sub-disciplines, such as semiotics and psychoanalysis, as well as the 'philosophy of culture'.

Most of the thinkers profiled in this book will already be more or less familiar to readers in the field; though we have also included several we believe are typically overlooked (such as Wellmer and Luhmann), as well as more recent thinkers (such as Bernstein and Elkins), whose work is only now beginning to gain recognition and influence. In one case we have even included a curator (Bourriaud) given how widely his writings and exhibitions have been discussed over the last decade. If it is possible to talk about a coherent 'discourse of art', it is a hybrid discourse, which includes, in addition to academic discourse, the conventions of exhibition and display, varying traditions and anti-traditions of artistic practice, and the rhetoric of art and literary criticism, not to mention the range of cognate discourses the latter draws on. This volume hopes to engage readers who are involved with the arts in this expanded sense, as that is where serious thinking about art is today most needed.

Art Theory and Practice

INTRODUCTION

The term 'art theory' is broadly self-explanatory; it is a conceptual framework, series of principles, or set of substantive theses that explain the appearance, structure, function or significance of works of art. What is art 'practice'? In an age of ready-mades, installation art, video art, environmental art and performance art, that question is more complex, and indeed more complex now than it has been at any previous point in art history. Perhaps surprisingly, then, it is no longer regarded as a *contentious* question. Over the last three to four decades an 'institutionalization' of once-radical avant-garde art practices has taken place: what was once controversial, experimental, unconventional or simply chaotic, no longer provokes the shock, censure or marginalization it once did. As the old adage goes – heterodoxy becomes orthodoxy, and the question 'but is it art?' has for the most part simply fallen away. Contemporary orthodoxy is not doctrinaire, however, or at least is so only to the extent that it insists on the absence of any restriction on what might count as art, in principle. As such, it refuses to specify an alternative, or even 'expanded', set of art-making procedures to fill the vacuum left by the demise of previous constraints on art practice.

Since the 1960s art has thus come to be understood less in terms of an object, and more in terms of an activity, process, form of 'intervention' in a given context or discourse, or the creation of a new context in which something might happen. Where talk of art practice previously involved discussing the material construction and artistic creation of works of art (the demands of the medium, of painting or of sculpture, their techniques and so on), since the 1960s the medium or material constitution of the work has tended to become increasingly relative to the means, location and context of utterance; and the 'visual' aspect of that act and that context need not be dominant or explicit, and in some cases is not even apparent. The only procedural restrictions on practice today take the form of physical-economic restrictions (what technically can and cannot be accomplished), and institutional protocols (what forms of practice institutions are or are not prepared to support).

Many of these characteristics of art practice since the 1960s originate during the 1920s or even earlier: film, montage, text and image composition, performance, graphic design, installation, non-art materials, even the use of rubbish and various other forms of detritus. The European avant-gardes were reacting against 'classical' training, where the historical genres of drawing, painting, sculpture and architecture each had their own hierarchy of sub-genres, and these were governed by strict procedures of technical convention and stylistic protocol. The institutional power of the academies, its training mechanisms and grip on the art market were still significant. But the avant-garde were also reacting against the hermetic social world of bourgeois ateliers, galleries and salons, where even once-radical forms such as Impressionism and post-Impressionism were being turned into a form of passive consumption. In the face of a corrupt and increasingly violent world, the avant-garde came to see existing art as a mere salve for the eyes, a form of social consolation, with no further significance or ability to intervene in society for the better.

During the 1960s such avant-garde impulses were reinvigorated, and with them the demand that art find ways to address and even intervene in social and political life. Consequently, many artists felt the need to understand the relation between art and society, and to conceive, at the level of ideas and concepts, how art and life might be realigned. Intellectual debate and theorizing about the nature of art became commonplace, and often intrinsic to the process of art making itself. Articulating one's practice in written form, writing art criticism, making public statements, manifesto-like political commitments, or philosophical pronouncements on the nature of reality or human experience became an increasingly common component of artistic practice. As a result, practice itself became more and more theorized, and theory became the framework within which practice was increasingly reconceived.

Conceptual artists (such as Joseph Kosuth), who believed that claims about the meaning of art rested on a philosophical understanding of the nature of language were key to this transition; while sculptors (like Robert Morris) explored how language itself emerged from a deeper perception and cognitive and bodily engagement with the surrounding world and its horizons of intelligibility. Other artists from the same period, such as Daniel Buren, Dan Graham and Robert Smithson, investigated art's networks of production and dissemination through both their writings and their works for non-standard contexts (magazines, billboards, and various other borderline or non-art spaces). Artists such as Adrian Piper and Mary Kelly added more explicitly political issues such as race and the construction of self and gender to the equation, and the theoretical context has only got broader since. As a result, the exploration and construction of meaning has itself become a 'practice' viewers need to engage in, and one made complex by the fact that works or activities are themselves emerging out of heavily theorized contexts of artistic practice. The artists included here have substantially contributed to this context since the 1960s.

DANIEL BUREN (1938–)

Daniel Buren emerged in the late 1960s to reorient site-specific art through the theory and practice of 'institutional critique'. Buren began as a painter, when a visit to a Montmartre textile market led him to discover the commercially produced, striated awning canvas that would become his signature 'visual tool'. This tool invariably consisted of alternating white and coloured vertical bands whose width was fixed at 8.7 cm. As this device 'reprised' the monochrome and the ready-made, it also critiqued the acculturation of those earlier artistic models. Activating the intrinsic potential of artistic production for critical discourse, Buren worked *in situ* to address the institutional confinement of culture. Positioning his neutral, anonymous signs in precise relation to the architectural context and institutional support that contained them, his site-specific installations dismantled the mythic autonomy of art and its institutions. Buren's interventions, however, were deconstructive rather than destructive in impulse. Working within the institutional frame, Buren unveiled the invisible conventions that regulate the aesthetic meaning and economic value of art, as well as its interdependence with the broader network of social, economic and political elements occluded by the cultural politics of its time.

Buren's oeuvre can be roughly divided into abstract painting, *in situ* installation, and works that cannot be characterized as prompted by their sites, such as the *Photo-Souvenirs*, or photographic documentation of his projects. Between the early and mid-1960s, Buren shifted from abstract paintings on bed sheets and hessian to the vertically striped awning fabric, whose outermost white stripes he coated with white paint.

As such, the work's internal structure was deduced from its ground's woven properties. After 1967, Buren pursued the implications of this gesture by going beyond the pictorial field to create works *in situ*. Turning his attention toward the institutional frame, Buren's site-specific projects reversed the usual relationship between art and its places of presentation and reception. Parallel to the contemporaneous displacements of Michael Asher, which took as their point of departure the 'conclusion' of sculpture, Buren's strategic placement of his striped signs drew attention to their site's ostensibly neutral architectural details and exhibition conventions.

Some works were situated outside the traditional parameters of the art system, such as *Affichages sauvages* (1968), anonymously fly posted rectangular sheets of green-and-white striped paper throughout Paris. Other installations, like the artist's censored contribution to the Sixth Guggenheim International (1971), were inserted both inside and outside their host sites; for *Peinture-Sculpture*, Buren suspended two blue-and-white striped banners across Eighty-eighth Street and through the central shaft of the museum, obstructing (as some artists protested) the view of other works. From the 1980s to the present, Buren's projects have probed the dispossession of art's critical function within advanced capitalism. Increasingly enormous in scale, the artist's manipulations of architectural elements and visual effects deploy dynamic virtual movements that conjure the late twentieth-century transfiguration of museum architecture into sites for spectacular visual consumption.

Drawing on the legacy of minimalism, Buren's practice also encompasses a considerable body of writing. Cogently articulating the political imperative of institutional critique for the post-minimalist generation, these texts comprise manifestos from the period of his association with Olivier Mosset, Michel Parmentier and Niele Toroni, pronouncing the demise of painting; interviews, responses and letters that debunk objections to Buren's disclosure of the relationship of art and its site; critical texts that define site-specificity in terms of the deconstruction of cultural limits; and verbal descriptions that accompany the *Photo-Souvenirs*, intended primarily as a reference for the reactivation of past projects. Buren warns that his writings are not intended as explanations, which might exempt the reader from the direct experience of the work. At times ambivalent about the status of his criticism, Buren has insisted on its derivative character: 'the act of painting precedes them and goes beyond them' ('Why Write Texts or the Place from Where I Act' [*WTPA*], 1973 in *Les Écrits*). Yet, the artist has also alluded to the complementary relation of his visual and textual output, thus reinforcing the dissolution of the autonomous art object: 'They are not to obscure their object but rather to permit seeing what they cannot say' (*WTPA*).

Buren's most important theoretical contributions dated from 1967 to 1973. Written for the Conceptual art exhibition, *Konzeption/Conception* (Städtische Museum, Leverkusen), 'Warning' (1969) invokes theory as a revolutionary praxis, following the lead of the structuralist Marxist Louis Althusser. In 'Warning', Buren rejects the traditional conception of art and its historical development 'from the Mythical to the Historical, from the Illusion to the Real'. To establish the radicality of this break, the essay distances Buren's project from conceptual art; by substituting concept for object, Buren contends, conceptual art fails to interrogate art's location, yielding an 'ideal-object' that merely feeds the exhibition apparatus. Buren's reading reduces conceptual art to the 'Analytic Conceptualism' espoused by JOSEPH KOSUTH's proposition, 'Art as idea as idea'. However, 'Warning' also suggests affinities between Buren's work and the more broadly construed 'Synthetic Conceptualism'. In the essay, Buren points to the 'death of the subject' propounded by French anti-humanist cultural theory in the 1960s, which decisively influenced the discourse surrounding conceptual art (cf. ROLAND BARTHES, MICHEL FOUCAULT). For Buren, the anonymity of his neutral, immutable signs signified the end of authorial ownership, while inaugurating the birth of art as public property.

In 'Warning', Buren posits 'the location (outside or inside) where a work is seen is its boundary'. The texts 'The Function of the Studio' (1971) and 'The Function of the Museum' (1970) attend to the symmetry of two such locations. While the former focuses on the space of art's production, which Buren describes as the least visible of art's containers, the latter dissects the space of its presentation, which Buren likens to an 'asylum'. Moreover, he derogates the studio to 'a kind of commercial depot', which serves not only as a place for the creation and storage of art but also as a way station for the selection and dissemination of objects by the museum. Read together, the two texts amplify Buren's critical modelling of site as a relay of the distinct, yet interrelated economies of production and consumption. Buren apocalyptically heralded the death of all art enmeshed in this circuitry (the museum is also a 'cemetery') and asserted that his work proceeds from the 'extinction' of the studio.

If the museum structurally influences the production of art, it 'marks' the reception of art in kind. Delimited as aesthetic, economic and mystical, the museum's functions ensure the proper interpretation of an object's

significance, the management of its social and economic value, and the preservation of its aura (cf. BENJAMIN). Subverting the museum's self-presentation as a refuge for art, Buren stresses that 'whether the work is directly – consciously or not – produced for the Museum, any work presented in that framework, if it does not explicitly examine the influence of the framework upon itself, falls into the illusion of self-sufficiency – or idealism'. The text aligns those institutional falsifications with ideological complicities, denouncing the 'careful camouflage undertaken by the prevalent bourgeois ideology' ('The Function of the Museum', 1970).

Buren's text 'Critical Limits' (1970) systematically diagrams these camouflage operations within the advanced art of the time, including minimal art, earth art, and conceptual art. The text presents the history of art as a 'history of rectos'. That is, if the canvas conceals the stretcher, the work of art conceals its material and political underpinnings. For Buren, this deception extends from traditional through avant-garde art, so that as conventional painting and sculpture act as 'a security valve' for an alienated, bourgeois art system, the ready-made, which only replaced painting, enacts 'the radical (i.e. petit bourgeois) negation of art in favour of the object ("reality") as it is' ('Critical Limits', [CL]). His most severe criticism, however, is directed against the exotic relocation of art to the open landscape, especially, if implicitly, by ROBERT SMITHSON. In Buren's scathing assessment, Smithson's 'artistic safaris' attempt to bypass the forces that frame artistic labor rather than confronting the crisis of culture in late capitalist society: 'Art is not free, the artist does not express himself freely (he cannot). Art is not the prophecy of a free society. Freedom in art is the luxury/privilege of a repressive society' (CL). In his most trenchant formulation of art's function, Buren concludes, 'Art whatever else it may be is

exclusively political. What is called for is the analysis of *formal and cultural limits* (and not one *or* the other) within which art exists and struggles' (CL).

The explicitly politicized rhetoric of Buren's criticism distinguishes his work from the discourse of Minimal art out of which it developed. Informed by the translation of MAURICE MERLEAU-PONTY's work, minimalist artists rerouted the site of aesthetic meaning from the self-sufficient artwork to the physical context it shares with an embodied viewer. In contrast to the phenomenological basis of minimalism, the historical materialism of Buren's critique fuelled its emphasis on art's mediation by the ideological contradictions of advanced capitalism. This conception of cultural production was deeply indebted to Situationist theory, which argued that the intensified commodification of the image in the 'society of spectacle' called for the dissolution of art as a separate and specialized sphere.

Buren's revision of Minimalist contextualism was roundly condemned by minimal artists such as Dan Flavin and Donald Judd. As Alexander Alberro notes, this negative reception was rooted in the cultural and political distance between the neo-Marxist elements of French cultural theory in the late 1960s, and the more conservative implications of American Minimal art. While Flavin similarly challenged the auratic art object and Judd lamented the museum's dependency on the commercial gallery system, both artists remained indifferent to the inoculation of art, and opposed the conflation of avant-gardism with radical political critique. As Flavin caustically remarked, 'the term "avant-garde" ought to be restored to the French Army where its manic sense of futility propitiously belongs. It does not apply to any American art that I know about' ('Some Remarks... Excerpts from a Spleenish Journal', p. 27).

By the end of the 1970s, however, Buren's project of critical negation found a sympathetic audience among critics associated with *October*. BENJAMIN BUCHLOH lauded Buren's later fashioning of 'the artist as deliberate decorator of the status quo' ('The Museum and the Monument', p. 137). For Buchloh, Buren's paradigm of art as decoration gave concrete form to capitalism's swift and total reappropriation of artistic production as political ornamentation. HAL FOSTER, on the other hand, identified Buren with the second moment of a post-war neo-avant-garde, which reworked earlier avant-garde assaults on the institution of art to open new spaces for critical elaboration. Indeed, since the 1980s, artists ranging from Louise Lawler to Andrea Fraser developed Buren's institutional analysis by highlighting the multiplied functions within an art apparatus that has expanded beyond the artist–dealer–critic nexus. Other artists, including Mark Dion, Renee Green and Fred Wilson often collaborate with different groups to blur the limits between art and non-art, pushing Buren's cultural critique towards a more diversified engagement with the social discourses of racism, sexism and environmentalism. At the same time, contemporary artists like Jorge Pardo and Tobias Rehberger reanimate the decorative impulse in Buren's work to explore the fusion of art and everyday life under the regime of design. This recent turn, however, problematizes Buren's mimicry of the very kinds of alienation he opposes. Does this critical strategy remain limited by the forces it contests? If so, might this accommodation to our totalizing culture of design lead art back into the path of consumerism it seeks to divert?

MELANIE MARIÑO

BIBLIOGRAPHY

Primary literature

Buren's essays are collected in:
Buren, D., *Les Écrits (1965–1990)* (3 vols), ed. J.-M. Poinsot, Bordeaux: Centre d'art plastique contemporain, Musée d'art contemporain, 1991.

Secondary literature

Alberro, A., 'The Turn of the Screw: Daniel Buren, Dan Flavin, and the Sixth Guggenheim International Exhibition', *October* 80 (Spring 1997).

Buchloh, H. D., 'The Museum and the Monument: Daniel Buren's *Les Couleurs/Les Formes*', (1981) in *Neo-avantgarde and Culture Industry Essays on European and American Art from 1955 to 1975*, Cambridge, Mass.: MIT Press, 2000.
Buren, D., *Les couleurs: sculptures/Les formes: peintures*, ed. B. H. D. Buchloh, Halifax: NASCAD with Paris: Musée national d'art moderne, Centre Georges Pompidou, 1981.
Flavin, D., 'Some Remarks... Excerpts from a Spleenish Journal', *Artforum* vol. 5, no. 4 (December 1966).
Foster, H., 'Who's Afraid of the Neo-Avant-Garde', in *The Return of the Real*. Cambridge: MIT Press, 1996.
Lelong, G., *Daniel Buren*, Paris: Flammarion, 2001.

DAN GRAHAM (1942-)

Dan Graham is one of the most prolific artist-writers of his generation of post-minimal artists. Although generally referred to as a conceptual artist, Graham's practice evades easy categorization. Not only has he deployed a variety of media, such as photography, film, video, performance, and architecture, not to mention the magazine page, but he has also resisted the tendency towards specialization within the art world (which has recently generated such institutional identities as the 'video artist' or 'art critic'). Instead, Graham's interdisciplinary approach to writing and art making aims to expose the inner contradictions of the cultural moments he lived through, whether this concerned the gallery practice of minimalism or the subcultural domain of rock music, to name but two of the topics he started writing about in the 1960s. Furthermore, his writing frequently plays off more than one register of meaning at the same time and does not stand in a mere supplementary relation to his artistic work. To be sure, his writerly method fundamentally differs from the exhortations of the artist's manifesto or the propositional form of art theory. Graham particularly refutes the latter genre of writing as representative of a 'logical abstract' mode of thought that leads to an impoverished practice of 'philosophical actualization' or 'idea art' ('My Works for Magazine Pages: A History of Conceptual Art', in *Two-Way Mirror Power* [*TMP*], p. 12).

Graham's artistic self-fashioning follows directly on the heels of such minimalist artist-critics as Donald Judd, Dan Flavin and Sol LeWitt. Graham started out as the director of the short-lived John Daniels Gallery in December 1964, where he exhibited the minimalists before the gallery folded after one season. John Daniels became a site of animated discussion, where art theory was debated in conjunction with a host of other intellectual currents, such as serial music, the French New Novel and New Wave cinema, and new psychological and scientific theories. The protagonists of this debate shared an anti-humanist stance which opposed the two dominant, expressionist (Harold Rosenberg) and formalist (CLEMENT GREENBERG) versions of late modernist aesthetics. Minimalist practice, for instance, negated Greenberg's twin postulates of the autonomy of the medium and the transcendence of the viewer, by implicating the architectural structure of the gallery as an exterior frame of reference and thereby immersing the viewer in literal time and space. Graham realized, however, that minimalism did not acknowledge the progressive 'mediatization' of the artwork in contemporary society. He thus decided to juxtapose the gallery space of minimalism to the information space of pop art. The result of this dialectical strategy were Graham's 'works for magazine pages', which not only transfigured the minimalist object into reproducible, disposable art pieces, but also functioned as decoys, or pseudo-objects, in which the overt content of the texts masked their underlying procedure of critique.

With circumspection, we may identify three phases in Graham's work: (i) the works for magazine pages of the latter 1960s; (ii) the performance and video time-delay works of the 1970s; and (iii) the architectural models and pavilion structures of the late 1970s and after. While each phase employs different means of presentation, there is a common strategy that runs throughout – the use of what he calls 'found structures' or media

clichés that are derived from a popular discourse on science or psychology. For instance Graham has proposed the term 'topology' as the dominant 'mathematical metaphor' of the 1960s. He appropriates such 'found structures' as relational models of socio-political organization, which allows him to critique the autonomous status of art; yet these models-as-clichés always remain critical of themselves as well. Within the context of his early writing, in particular, the text constitutes a kind of ruse that maintains an ironic relation to the 'academic seriousness' of late modernism and the 'idea art' of certain conceptualist colleagues. Yet, throughout his writing career, Graham consistently maps conflicting systems of discursive knowledge onto each other, and plays the codes of the 'high' against the 'low'.

The magazine pieces transferred the minimalist grid to the 'pop' domain of publicity. *Schema* (1966) is a perfect example of this. The schema as such consists of an abstract 'data grid' of printing components (font size, number of words, paper stock, etc.), which acquires a different content with each instance of publication. *Schema*'s grid is thus in-formed by the contingencies of its external support. Graham also conceived of texts, such as *Information*, that could pass under the editorial radar as an essay, but would actually provide a vehicle for the publication of his magazine pieces. Inspired by, among other sources, Marshall McLuhan's *Gutenberg Galaxy*, *Information* exposes the manner in which the standard, narrative and spatial order of the Western text imposes a unitary viewpoint on the reader. *Information* not only presents various counter-models to the Western text (e.g. Borges's 'Library' or Mallarmé's 'Book'), but also, by means of its own modular construction, evades the very literary perspectivalism it attacks.

This tenuous distinction between the categories of 'magazine work' and 'essay' does not always hold up. Perhaps Graham's

most celebrated work of the 1960s is the photo-essay *Homes for America* (1966–67). Accompanied by snapshots of suburban housing developments in New Jersey taken by Graham, *Homes for America* reads, at first, as a sociological essay on the standardized landscape of the 'new city', albeit an essay written in an oddly non-committal, paratactic style. In effect, the textual and graphic structure of *Homes for America* mimics the serialized logic of the housing projects themselves, which Graham describes as constituting a permutational series of empty 'shells'. The text is composed, in part, of a collage of advertising pamphlets which list in tabular fashion the predetermined options of the potential homeowner. The reader-viewer is thus situated within a shifting network of information, rather than offered the illusion of an exterior vantage point onto a social totality. Yet, this decentring of the subject does not halt at the borders of a disenchanted suburbia; *Homes for America* was first published within the pages of *Arts Magazine*. To its contemporary audience, therefore, the correspondence between the systemic logic of the tract housing 'shells' and the empty 'cubes' of minimalism would have been immediately apparent.

The various characteristics of the magazine pieces – their performative status, their deliberate confusion of the pre-packaged messages and uniform publics of special-interest magazines – were intended as a 'catalyst for change'. Nevertheless, the very ephemerality of the magazine works was to reflect the temporal condition of an emergent consumer society that dwelled in an eternal present. Hence, in the 1970s, Graham's critique would follow an altered path with his video installations and performances, which used time-delay loops and multiple, mirroring surfaces. These works were intended to foreground an awareness of the viewer's own perceptual process and to show the 'impossibility of locating a pure present tense' ('Video in

relation to Architecture', p. 186). As Graham's writing at this point indicates, his videos and performances figured as ecological (or topological) models of the various new social collectivities that emerged during the 1970s, from feminist 'consciousness raising' sessions to psychological encounter groups. The 'hermetic, anonymous information quality of earlier "conceptual" work' is now abandoned in favour of a deconstruction of intersubjective experience as articulated within the technological domain of cinema, television and video ('Performance: End of the "60s"', in *TMP*, p. 143). Graham's theoretical sources are now, among others, Kurt Lewin's dynamic psychology and Jacques Lacan's writings on the mirror stage. The visual axes of projection and identification, the process of subjectivation and objectivation, the positions of self and other, all become interchangeable in what Graham calls the chiasmic 'topological' space of his perceptual 'machines' ('Cinema', 1981, in *Rock My Religion* [*RMR*], p. 169).

In the 1980s, Graham's investigations of the mediatized realm of everyday experience lead him back to his previous dialogue with the discourse of architecture and urbanism that began with *Homes for America*. At the same time, Graham became aware of WALTER BENJAMIN and MICHEL FOUCAULT's work on the status of historical memory, which provided him with an antidote to the historicism that pervades postmodernist debates of the early 1980s. In a series of important essays, Graham traces a genealogy of social power as it filters through the overlapping domains of mass media, technology, architecture and urban planning. More specifically, Graham examines the contemporary issue of the debasement of public space (referring to the various examples of suburban housing, corporate architecture, shopping malls and entertainment parks) and he studies the attempts of postmodern architects, such as Robert Venturi or Rem Koolhaas, to counter

the historical amnesia and deracinated character of modern (i.e. functionalist) and postmodern (i.e. historicist) architecture. Parallel to this research, Graham begins to design a series of mirrored pavilion structures, which overlay, in a dizzying array of architectural typologies, Marc-Antoine Laugier's fantasy of the primitive hut, baroque garden pavilions, Rococo salons, fairground mirror palaces, modernist glasshouses, corporate architecture and, of course, the minimalist cube ('The City as Museum', 1981/93, in *RMR*).

This renewed emphasis on the public space of architecture (which has never been totally absent in Graham's work) is accompanied by an intense fascination with the public media sphere of popular culture, in particular the phenomenon of rock music. He published several crucial essays and video works (e.g. *RMR* [1982–84]) on youth culture in its hydra-headed form as both a social movement of resistance and a commodified spectacle of revolt. While the video-essay *Rock My Religion* demonstrates how the anxieties of society regarding adolescent sexuality and rebellion have been negotiated within rock music since the 1950s, it is punk that represents the true revelatory moment in this history: through its self-conscious manipulation of the codes of fashion and rock music, punk makes its audience aware of its own commercial exploitation. This reading shows Graham's interest in situationist theory ('McLaren's Children', 1981/88, in *RMR*), which, by the 1980s, became understood as an important forebear of the dominant critical paradigm of 'representation theory'. It also manifests Graham's conviction that resistance to the social power of late capitalism remains possible, yet that any form of contestation must unfold upon the terrain of the spectacle itself. Not surprisingly, therefore, several of his contemporary essays explore pre-modernist forms of spectacle ('Theater, Cinema, Power', 1983, in *RMR*).

Graham was very active as organizer, exhibiter and lecturer within the art community of the late 1960s and early 1970s. Widespread recognition of his work, however, would come in the course of the 1970s. The 1978 catalogue in the Van Abbemuseum in Eindhoven that contained the first extensive historical analysis of the work by BENJAMIN BUCHLOH was particularly significant. Dan Graham's writings and interviews are scattered across a wide variety of sources, but have been assembled in the two recent volumes *Rock My Religion* and *Two-Way Mirror Power*. Within the revived debate of the 1990s on the legacy of conceptual art, *Homes for America* came to assume a central role. The primary topic of discussion was the position of the magazine pieces within a genealogy of institutional critique, but since the publication of the *catalogue raisonné* in 2001, the focus of attention has shifted towards the politics of publicity that is implicit in Graham's work. In the process of unfolding its oblique criticism of minimalism and pop, Graham's practice established a complex and ambivalent relationship to the emergent spaces of information. The feedback structure of the video performances, in particular, foreshadow certain features of a developed 'control society' (GILLES DELEUZE) and it is this anticipatory horizon of the work to which current, critical scholarship is directed.

ERIC de BRUYN

BIBLIOGRAPHY

Primary literature

Graham, D., *Video – Architecture – Television: Writings on Video and Video Works 1970–1978*, ed. B. H. D. Buchloh, Halifax: The Press of Nova Scotia College of Art & Design, 1979.
Graham, D., 'Video in Relation to Architecture', in eds D. Hall and J. Fifer, *Illuminating Video*, New York: Aperture, 1990.
Graham, D., *Rock My Religion: Writings and Art Projects*, ed. B. Wallis, Cambridge: MIT Press, 1993.
Graham, D., *Two-Way Mirror Power: Selected Writings by Dan Graham on his Art*, ed. A. Alberro, Cambridge: MIT Press, 1999.

Secondary literature

Alberro, A., *Dan Graham: Models to Projects, 1978–1995*, New York: Marian Goodman Gallery, 1996.
Brouwer, M. and Anastas, R. (eds), *Dan Graham: Works, 1965–2000*, Dusseldorf: Richter Verlag, 2001.
Graham, D., *Articles*, Eindhoven: Stedelijk Van Abbemuseum, 1978 (text by B. H. D. Buchloh).
Martin, J.-H. (ed.), *Dan Graham: Pavilions*, Bern: Kunsthalle Bern, 1983 (text by T. de Duve).
Pelzer, B., Francis, M. and Colomina, B., *Dan Graham*, London: Phaidon, 2001.
Wall, J., *Dan Graham's Kammerspiel*, Toronto: Art Metropole, 1991.

MIKE KELLEY (1954–)

Mike Kelley was born in Detroit, Michigan, took a BFA degree from the University of Michigan, Ann Arbor, in 1976, and an MFA from the California Institute of the Arts, Valencia, California, two years later. One of the most diverse artists of his generation, Kelley has made signal contributions in music and sound culture: beginning in the mid-1970s with the formation of his noise band Destroy All Monsters, continuing with groups The Poetics and Extended Organ; in performance between 1978 (*Indianana* and *My Space*) and the late 1980s (and again in collaboration with Paul McCarthy in the 1990s); in sculpture and installation, notably in his series of floor and related pieces using yarn dolls and stuffed animals (beginning around 1987); and in single channel and sculpturally sited video (from *The Banana Man*, 1983, to his recent exhibition at the Gagosian Gallery in New York, *Day is Done*, Autumn 2005). He has also acted in several videos and films and curated exhibitions, including two versions of *The Uncanny* (1993 and 2004). Further, Kelley is an important writer, critic, theorist and interviewer whose collected writings are probably the most voluminous and generically adventurous of any contemporary artist writing in English.

Unlike some of his peers associated with New York postmodernism in the 1980s, Kelley has rarely made work in which theoretical considerations are programmatic or contrived. Instead, his areas of enquiry and reflection are interleaved across the range of his visual and textual work. These include: the aftermath of modernism and its techniques; sonic cultures; psychoanalytic and psychological theory and practice; performativity; the social actions of memory; science fiction and ufology; artist-subjects

and their authorship; architecture and the perception of social space; and the structure and deployment of vernacular Americana. Kelley provides each of his exhibitions, series or projects with a philosophically rich, research-driven context, often in the form of a supporting text, whether a script, dialogue, statement or creative fiction. While an intermittent reader of the leading French post-structuralists, including **MICHEL FOUCAULT**, **JACQUES DERRIDA**, Jacques Lacan and **GILLES DELEUZE** and Félix Guattari, Kelley has made limited specific recourse to their ideas and methods. This is, in part, because one of his main areas of interest is in American popular cultures, an area in which these writers produced little of note.

The most extensive of Kelley's philosophical concerns is a cluster of issues theorized by Sigmund Freud and in later psychoanalytic and psychological writings. These include: Freudian concepts such as the 'death drive' and 'the uncanny'; repression and Repressed and False Memory Syndrome; abjection, dirt and bodily ejecta. Kelley's practice is one of the few interventions in this area by artists since the 1920s – interventions which include automatism and work of dreams by André Breton and the Surrealists; Salvador Dalí's dissident 'critical paranoia'; Jackson Pollock's Jungianism; **MARY KELLY**'s work on language acquisition and passages into the symbolic; and the various theories and practices of narcissism and trauma developed in the 1990s.

Examining the history and postmodern reinvention of polychrome figurative sculpture, and offering an extended dialogue with Freud's 1919 text 'The Uncanny', Kelley's two exhibitions on the uncanny and his essay,

'Playing With Dead Things' (1993), represent one of the most elaborate visual analyses of a complex psychological experience. He adjudicates the effects of the uncanny with reference to the viewer's experience of a number of specific aesthetic, psychological and historical parameters: scale; colour; the relation of body part to whole; the relation of the body part to lack (which he terms, in ironic homage to Deleuze and Guattari, 'The Organs Without Body'); the effects of the ready-made and 'the double'; two aspects of the statuary tradition – its correlation with death and function as a surrogate; and, finally, in a section titled 'Aping the Mirror of Nature', in relation to naturalism and realism.

The overlapping desiderata sustaining Kelley's selection of artworks and cultural objects that generate uncanny effects can be summarized as follows. First, the work or object must be apprehended physically, by a body encountering something that is body-like – at least in a first impression. This implies, second, that the object should be roughly human-scaled, or viewed through a medium such as photography in which it can be perceptually rescaled as 'life-sized'; and, third, that the object be flesh-coloured or wear normal clothing, because work in monochromatic or non-naturalistic registers tends to resist identification and some forms of transference. Fourth, the texture of the sculpture or object should also betoken the palpability of flesh, as in wax or encaustic figures.

Kelley's writings range from the notes, diagrams and scripts that underwrote his early performance pieces to 'creative' and critical essays for art and alternative journals; catalogue essays; artist 'statements'; scripts for sound sculptures; libretti; dialogues (real and imagined); quasi-manifestos; numerous interviews (as both interviewer and interviewee); polemics; panel presentations; screening introductions; radio broadcasts; public lectures; CD liner notes;

invented case histories; and poster texts. *Foul Perfection* comprises two sections: first, a series of discussions of artists generally outside the mainstream modernist and post-Conceptualist canon (David Askevold, Öyvind Fahlström, Doug Huebler, Survival Research Laboratories, Paul Thek and fellow artist-writer John Miller); second, thematic critical essays (on caricature, architecture, UFOs, American film and the Gothic sensibility of the late 1980s).

The statements, commentaries and fictions that constitute *Minor Histories* are more various, ranging from expository analyses to declarative and persona-driven writings, such as 'Goin' Home, Goin' Home' (1995). The concatenation of puns, metaphors and elisions that make up the fictive and expressive register of Kelley's writing have few precedents in the avant-garde art world. Their closest relations might be the nonsense broadsides and 'lampisteries' of Tristan Tzara. But although they have their anarchic moments, Kelley's texts don't produce force fields of senselessness and nihilism; they offer instead a relentless stream of psycho-semantically altered pop cultural clichés, governed by free associations trawled from the TV, brand names, high art tropes and other components of the Kelleyean everyday. The seepage of style and effects of these texts into Kelley's other work creates a distinctive postmodern retort to the experimental language of the manifesto associated with the historical avant-garde. Several other artists of Kelley's generation, **BARBARA KRUGER**, Richard Prince and Sherrie Levine, also produced writings that equivocate between fiction and commentary – though theirs tend to be more abstract or narrative-driven.

Following 'Urban Gothic' (1985), with its distinct aural and incantatory qualities, the style and form of his critical writing modulated into a combination of first-person critical opinion, contextual observation and historical and thematic revisionism. What he

terms the 'library work' that underwrites his projects in different media – his commitment to research, compilation and citation, and its reassemblage, dismantling or explosion – remains a constant resource; and the notion of 'poetic' concentration or 'condensation' emerges as the key figure of this continuity in 'idea generation'.

Kelley's formative influences included the Beats, especially the cut-up techniques of William Burroughs, and early twentieth century avant-gardists like Tzara and Raymond Roussel. He has read extensively in Novalis and Lautréamont, Nathaniel Hawthorne and Herman Melville, William Beckford and Matthew Lewis, Vladimir Nobokov, Günter Grass, and Witold Gombrowicz. Among his own generation, Kelley supported the literary circle at Beyond Baroque in Venice, California, where Dennis Cooper, Amy Gerstler and Bob Flanagan made regular appearances. Early on his reading included the psychological studies of R. D. Laing and Wilhem Reich; and, in politics and social criticism, the Yippie manifestos of Abbie Hoffman and John Sinclair. He is also interested in fossilized systems of thought, like the theology of Thomas Aquinas, and pseudo- or out-of-date scientific constructions, including Jarry's 'Pataphysics' or the writings of Lucretius. With the exception of the 'eccentrics' of the genre – H. P. Lovecraft, P. K. Dick, J. G. Ballard – he dislikes science fiction. Kelley absorbed many lessons from these genres – appropriation, collage-composition, humour and irreverence, anti-institutionality, the diagnosis of repression, system construction (and parody) – all of which passed into his art practice and the composition of his writings.

A key aspect of Kelley's theory and writing is his negotiation with the modernist notion of collage, particularly the aesthetics of fracture and structure associated with the new novel and post-war experimental fiction (Thomas Pynchon, Burroughs, Genet) as well as with postmodern media practice.

Kelley separates the writing techniques he developed for performance from either Joycean stream of consciousness, or pure montage and 'cut-up' on the basis of his commitment to composition. Aware of the limitations of fracturing strategies, Kelley points out that the aesthetic of disassembling 'ultimately fails as a strategy of resistance because it emulates the sped up and ecstatic effects of the media itself' (*Tony Oursler INTROJECTION*, p. 51). While he admits to the use of 'disruption ... in a Brechtian sense', which promotes 'a return back to the real', he opposes the solicitation of more radical forms (as in the work of Burroughs), desiring instead to arrange transitions between 'a string of associations'. By simulating 'natural flow' Kelley aims to produce an 'almost ambient feel' (Interview in *Les Cahiers* [*LC*], p. 107).

In collaboration with McCarthy at the Vienna Secession (*Sod and Sodie Sock Comp O.S.O.*, 1998), Kelley offered the notion of fracture and collage, his most sustained consideration, addressing the idea of appropriated or appositional criticism. The artists' selection of texts by **GEORGES BATAILLE**, Reich and **CLEMENT GREENBERG** 'in lieu of a catalogue', is one of the many layers of reference Kelley identifies in the installation. Like the work, these texts can be read historically, formally, poetically or in any combination. The act of assembling them, and the particular intensities with which they might be consumed (or ignored) by viewers, read with or against each other, and with or against the work and its own contexts and references, reinforces Kelley's own sense of relativity, his refusal to think about texts or objects in terms of their 'content or their truth value', but rather as complex entities with their own structures and histories, blind spots and illuminations. Using these texts 'for their poetic value' but also as 'a rationale' for the materials in the exhibition, Kelley notes both his distrust of the denotative function of writing and that he has become

progressively more involved in the 'historicist' situation of texts, which superseded his 'interest in the formal aspects of ... writing'. With the provocative notion of 'socialized visual communication', Kelley attempts to draw the work, its forms, its audiences, its conceptual and historical references and the writings it occasions into a multi-layered compositional totality based on an open logic of association, consumption and repressive return (In conversation with Paul McCarthy et al. 1998).

The corrosive humour and irony in many of his texts are caught up in another focus of Kelley's work, his conviction that art is connected to ritual, and that one measure of its power is founded on 'a kind of structural analysis of the poetics of ritual' (*LC*, p. 119).

Joining with his disavowal of traditional writerly excellence, and his intermittently cantankerous style, Kelley's refusal to accept canonical histories of contemporary art is one of several measures of his 'badness' as a writer. But being bad is not simply a concession Kelley ironically grants himself: it is a symptom of the difference between normative conventions and the artistic inflection of a discourse. Kelley's flirtation with what he terms '*allowed* bad writing' reaches for the strategic permissibility of a 'bad style', the relative dysfunction and opacity of which challenge the critical operating systems that pass it by (Interview with John Miller, p. 8).

JOHN WELCHMAN

BIBLIOGRAPHY

Primary literature

Kelley, M., 'Interview with John Miller (March 21, 1991)', in *Mike Kelley*, New York: Art Resources Transfer, 1992.

Kelley, M., in conversation with Paul McCarthy, Martin Prinzhorn and Diedrich Diedrichsen, on the occasion of *Sod and Sodie Sock Comp O.S.O.* (an exhibition with McCarthy), Vienna Secession, Sept. 23, 1998, transcript, pp. 2, 6, 7.

Kelley, M., 'An Endless Script: a conversation with Tony Oursler', in Deborah Rothschild, *Tony Oursler INTROJECTION: Mid Career Survey 1976–1999*, Williamstown: Williams College Museum of Art, 1999.

Kelley, M., 'Interview with Jean-Phillippe Antoine', *Les Cahiers du Musée National d'art moderne* no. 73 (Fall 2000), p. 107.

Kelley, M., *Foul Perfection: Essays and Criticism*, ed. John C. Welchman, Cambridge: MIT Press, 2003.

Kelley, M., *Minor Histories: Statements, Conversations, Proposals*, ed. John C. Welchman, Cambridge: MIT Press, 2004.

Kelley, M., *Interviews, Conversations, and Chit-Chat*, ed. John C. Welchman, Zurich, JRP/Ringier, 2005.

Exhibitions

Three Projects: Half a Man, From My Institution to Yours, Pay for Your Pleasure, The Renaissance Society at the University of Chicago, Chicago, 1988.

Mike Kelley: Catholic Tastes, Whitney Museum of American Art, New York, 1993.

Mike Kelley, Museu d'Art Contemporani de Barcelona; Rooseum, Malmo, Sweden; Stedelijk Van Abbemuseum, Eindhoven, The Netherlands, 1997.

Day is Done, Gagosian Gallery, New York, 2005.

Curated exhibitions

Mike Kelley: The Uncanny, Tate Liverpool, Liverpool; Museum Moderner Kunst Stiftung Luwig, Vienna, 2004.

Secondary literature

Welchman, J. C., et al., *Mike Kelley*, London: Phaidon, 1999 (texts by John C. Welchman, Isabelle Graw, Anthony Vidler).

MARY KELLY (1941–)

For over thirty years, Mary Kelly has sustained an aesthetic, critical, intellectual, political project that has contributed to the formation of what we now understand as art after modernism. In addition, her monumental and thought-provoking installations have been the sites of serious debates concerning psychoanalysis and feminism, maternal desire, feminine identity and, more recently, masculinity, war and the effects of trauma. Kelly began her career in London in the early 1970s when a Marxist-feminist enquiry into the sexual division of labour was beginning to be complemented by a study of psychoanalytic theories of gender differentiation. She spent formative years in close contact with Juliet Mitchell (*Psychoanalysis and Feminism*, 1974) and Laura Mulvey ('Visual Pleasure and Narrative Cinema', 1975). Her early work critically engaged with the practice of contemporaries like JOSEPH KOSUTH and Art & Language, opening up their enquiries into the conditions of art making onto wider social and political concerns. She has been remarkably rigorous and consistent throughout her career, even though she moved back to the country of her birth, the United States, in 1987, where she worked first with the Independent Study Program at the Whitney Museum of American Art and then in the Department of Art at UCLA.

From 1970 to 1973, she collaborated on an unconventionally filmed documentary about women and work called *Night Cleaners*. The scale, complexity, attention to detail, duration and involvement in narrative which is possible in film were transposed by Kelly into a project-based art of installation. Kelly lists some of the formal features of her work borrowed from minimalist installation: 'the fragmentation of the visual field, the imposition of a temporal sequence, the intrusion of peripheral vision, the ephemeral effect of light, and above all the physical presence of the viewer in the installation' (*Imaging Desire* [*IG*], p. xxiv). Her work is a hybrid of conceptual and minimalist practices. *Post-Partum Document* (1973–79) and *Interim* (1984–89) were long-term projects that first appeared in instalments. Her subject matter demanded, as she has said, 'a rupture of the single, rather seamless, artifact'. She borrowed from film and conceptual art the use of multiple registers of signification. Joseph Kosuth's *One and Three Chairs* (1965) seems in retrospect like a prescription for such a practice, consisting as it does of a chair, a photograph of it and dictionary definition on a panel. But Kosuth didn't use the heterogeneity of the sign (found object, photograph, text) to expound anything beyond the art-idea itself. Kelly brought the potential of these various registers and their affective differences to bear on the presentation of extra-artistic subject matter.

Kelly's specific intellectual and political formation meant that she has always refused any notion of an essential femininity outside of the constitutive social institutions of family, language and the law, and this had certain consequences for her art practice. Her distinctive avoidance of iconic representations of women is partly a response to this 'constructivist' feminist position. The writings of Jacques Lacan have been very important in her effort to rethink the relationship between art practice and psychoanalysis. His imagination of the unconscious as structured like a language recommended itself to her project of trying to represent,

using the means of conceptual art, the subjective dimension of women's oppression. Following Lacan's theory of the mirror stage of infantile development, she held that the kind of feminist art practice which offers 'empowering' iconic representations of the woman's body risked delivering up the female spectator to identifications with an ideal mother, an illusory mirror image of herself as whole, self-sufficient and autonomous – in short, a female version of the bourgeois subject. She has also vigorously critiqued some women's body and performance art and this has led to a lively and still ongoing debate about the relative merits of transgressive performance-based work as opposed to Kelly's more austere and oblique art practice.

This debate is often played out in terms of a transatlantic divide with Judy Chicago's *Dinner Party* (1973–79) positioned opposite the exactly contemporary *Post-Partum Document*. It is also couched in terms of a generational shift. Some accounts of women's art of the late 1970s and 1980s drive a wedge between the work of an older generation of 'iconoclastic' artists allied with conceptualism whose work is a critique of omnipresent media images of woman, 'cut to the measure of male desire', as Laura Mulvey put it, and a younger generation who have no misgivings about appropriating these images and playing with them. Kelly is frequently cited as exemplary of the first; Cindy Sherman's performative photographic work is often invoked to represent the latter. Although this has been a contested issue for some time, Amelia Jones recently reanimated it by responding, in her *Body Art: Performing the Subject* (1998), to Kelly's critique of 1970s performance work, 'Re-viewing Modernist Criticism' (1981).

Kelly's important essay intervened in the context of a revival of painting and the commercial gallery system in the early 1980s that threatened to eclipse radical, explicitly anti-expressionist, minimalist, conceptual and photographic practices. Her strategy was to relate that work and performance to the modernist pictorial paradigm. That paradigm, defined by **CLEMENT GREENBERG** and Harold Rosenberg, among others, insists on the unity and homogeneity of the picture which is understood as expressing the essential creativity of the subject. The painterly gesture is intended 'to mark the subjectivity of the artist in the image itself' (*IG*, p. 83). If Jackson Pollock left a painterly trace of an expressive gesture, argued Kelly, then the artistic subject appeared in another form in the 1970s: 'In performance work it is no longer a question of investing the object with an artistic presence: the artist *is* present and creative subjectivity is given as the effect of an essential self-possession' (*IG*, p. 91). In many cases the body's authentic presence is guaranteed by the experience of pain. Although there were some prominent male performance artists who staged acts of self-mutilation, the similarities between women's performance work of this nature and traditional representations of female masochism made its political effectivity questionable. The problematic character of specifically feminist performance lies not in representations of pain, but in the temptation to equate the female body and feminine identity, as though it were a biological given instead of a cultural artefact. Further, the insistent presence of the artist encourages a critical practice that, as Kelly put it, converges 'on the traditional vanishing point of the artistic subject' (*IG*, p. 98). Recently, this has in turn led to the rise of a first-person, confessional, performative critical practice.

GRISELDA POLLOCK agreed with Kelly in 'Screening the Seventies', where she noted that it is difficult to distance the image of woman sufficiently in order to attain the required critical view. Amelia Jones, however, countered these claims by critiquing what she saw as an overly prescriptive definition of what counts as feminist art practice, and

by rehabilitating 'anti-Brechtian' forms of solicitation of the gaze in body art. The embodiment of the artistic subject, on this view, makes difference and identities of all kinds palpable and destabilizes both modernist and postmodernist (or post-structuralist) sensibilities. One way of going beyond the terms of this debate is to appeal to the difference between *performance* and *performativity*. 'Performance' is a unique and spontaneous event in the present tense that cannot be adequately captured on film or video. 'Performativity', by contrast, signals an awareness of the way the present gesture is always an iteration or repetition of preceding acts. It therefore points to the collective dimension of speech and action. Many, though not all, of the artists admired by Jones, such as Laurie Anderson, are distinctly performative body artists, who take pains to distance and mediate their own image, and thereby escape Kelly's and Pollock's strictures.

In fact, Kelly's art practice is not as de-personalized as her critique of performance might make it seem. After all, she also criticized the way conceptual artists tended to assume an authoritative position outside of the field of their investigations: they 'stopped dramatically short of synthesizing the subjective moment into that inquiry' (*IG*, p. xx). Kelly brought to conceptual art the question of the subject and gender difference, including her own subjective experience of that difference. Indeed, her enquiry into maternity in *Post-Partum Document* was occasioned by the birth of her son and *Interim*, about ageing and the fear of losing one's femininity, related many personal anecdotes and displayed photographs of items of her own clothes. However, these 'researches' are, for her, the raw material for finished works whose ambition is more of the order of history painting than self-portraiture. Kelly's work is characterized by formal restraint, intellectual rigour and explosive emotional content.

Kelly recently described her working procedure to Judi Carlson in an interview about the first of her installations composed of panels of compressed lint, *Mea Culpa* (2000). This installation was a continuation, or, better, the other side of *Gloria Patri* (1992), which investigated the masks of masculinity against the backdrop of the Gulf War. *Mea Culpa* (I am Guilty) is about the victims of oppression and war. It began with the accumulation of an archive of war-related atrocities. But her interest was, she says, primarily in an 'interrogation of my own preoccupation with these events' (Carson's 'Interview with Mary Kelly', p. 75). She was interested in the traumatic effects of the fragmentary reports of atrocities, images of distant disasters, which are transmitted into our everyday domestic lives. The curious grey waves that festoon the walls of the gallery turn out, on closer inspection, to be repeated 'ready-made' modules of compacted lint carefully harvested from her tumble dryer. In effect, Kelly turned the dryer into a primitive printmaking device, using it to 'silkscreen', with a dark load of laundry, tersely written short stories of torture and atrocity around the globe. Rather than circulate photo-documents of these stories, Kelly has made the lint residue suggest some soft and vulnerable substance where the traumatic information is filtered and inscribed. The work is an attempt to give mediatized, de-realized news stories the texture of the real – a fragile, soft monument. Rather than repeat the spectacle of horror, give the literal image, Kelly conjures up a sense of a muffled voice.

This anti-literalism is perhaps the foremost motive for Kelly's aniconic practice. She has said of *Post-Partum Document*, that she wanted to represent the 'affective force', rather than the literal form of the mother–child relationship. Her interest in spectrums of affect off the visible scale no doubt led her to collaborate with the composer, Michael Nyman. *The Ballad of Kastriot Rexhapi* (2001),

another lint installation arranged in the form of a sound wave, is about a child lost and found amidst the battlefields of Kosovo. The exhibition opened with a live performance of the original music composed for Kelly's libretto. All of Kelly's art attempts the representation of psychic effects as these are ciphered through social formations. In short, her installations are visualizations of the unconscious. Because Kelly's subject matter is strictly unrepresentable, her art hovers at the edge of the image.

MARGARET IVERSEN

BIBLIOGRAPHY

Primary literature

Kelly, M., 'Re-Viewing Modernist Criticism', *Screen* vol. 22, no. 3 (1981); reprinted in *Imaging Desire*, 1996.

Kelly, M., *Interim*, New York: New Museum of Contemporary Art, 1990.

Kelly, M., *Gloria Patri*, Ithaca, N.Y.: Herbert F. Johnson Museum of Art, Cornell University, 1992.

Kelly, M., *Imaging Desire: Mary Kelly Selected Writings*, Cambridge: MIT Press, 1996.

Kelly, M., *Post-Partum Document*, London: Routledge, 1983; reprinted Berkeley: University of California Press; Vienna: Generali Foundation, 1998.

Kelly, M., 'Mea Culpa', *October* 93 (Summer 2000).

Secondary literature

Adams, P., 'The Art of Analysis: Mary Kelly's *Interim* and the Discourse of the Analyst', in *The Emptiness of the Image: Psychoanalysis and Sexual Image*, London: Routledge, 1996.

Carson, J., 'Interview with Mary Kelly', *Art Journal* 59 (Winter 1999).

Iversen, M., Crimp, D. and Bhabha, H. K., *Mary Kelly*, London: Phaidon, 1997 (contains chronology and bibliography).

Jones, Amelia., *Body Art: Performing the Subject*, Minneapolis: University of Minnesota Press, 1998.

Mastai, J., Pollock, G. and Wollen, P., *Social Process Collaborative Action: Mary Kelly 1970–75*, Vancouver: Charles H. Scott Gallery, Emily Carr Institute of Art and Design, 1997.

Mulvey, L., 'Impending Time', (1986) in L. Mulvey, *Visual and Other Pleasures*, Bloomington: Indiana University Press, 1989, pp. 148–58.

Pollock, G., 'Screening the Seventies: Sexuality and Representation in Feminist Practice – a Brechtian Perspective', in *Vision and Difference: Femininity, Feminism and the Histories of Art*, London: Routledge, 1987.

JOSEPH KOSUTH (1945–)

Joseph Kosuth, born in Toledo, Ohio, USA, is one of the key figures in Conceptual art. Kosuth's significance rests principally on artworks and writings produced between 1966 and 1975. The artist's current work continues to reflect its origins in a larger field of Conceptual art practices that sought to liberate art from the theories and criticism of modernism as exemplified by the writings of **CLEMENT GREENBERG** and **MICHAEL FRIED**. Throughout the late 1960s and early 1970s, Kosuth (i) stressed the need for an art practice that reflected on its status as art; (ii) identified the principal role of the artist as a maker of meaning; and (iii) through the example of his own writings and self-promotional activities, challenged artists to scrupulously control the critical reception of their work.

In Kosuth's view, Conceptual art worthy of the name – also referred to as 'theoretical Conceptual art' in his writings of the 1970s – must remain unencumbered by traditional practices such as painting or sculpture and their attendant critical and aesthetic discourses. (Kosuth instances On Kawara's date paintings as an exception to this prohibition because here painting is pursued in an intentionally self-reflexive manner and can be read as a parody of such media.)

Since the late 1960s, Kosuth's writings have aimed to further refine the distinction between Conceptual art and all other modes of art practice, avant-garde and traditional. During the 1970s, Kosuth turned a purifying polemic on Conceptual art itself, resulting in the distinction between 'theoretical' Conceptual art and 'stylistic' Conceptual art. The former, asserted Kosuth, was the only model able to illuminate the essential kernel of art's reality by virtue of its being a self-reflexive critical practice that takes as its subject the condition of art, rather than the subject position of artist or spectator. For Kosuth, Conceptual art is essentially an objective investigation into all aspects of the concept 'art' – its social context, its logical form and its relationship to the wider culture. Above all, Conceptual art enables us to understand how art functions as a signifying process, rather than how the concept art expresses itself through any particular media. Conceptual art as conceived by Kosuth is claimed to be an overarching, transparent and objective intellectual tool – not simply a critical response to existing practice, but a meta-theory of artistic practice in general. The work of the artist is framed as an investigative activity that is advanced by whatever intellectual resources are deemed necessary to demystify conventional art practices and reveal the signifying function of art.

One of Kosuth's most controversial claims addresses the nature and function of Conceptual art's public. As Kosuth famously notes, the public of this practice is ideally comprised solely of other artists. This narrowing of the public of Conceptual art has a number of consequences. First, there is potentially no member of the audience of Conceptual art who is not, at one and the same time, a participant in the making of that art. Because of the absence of a lay public, Conceptual art can be claimed to be as 'serious' as science or philosophy. These disciplines, claims Kosuth, also have no need for a public outside that of the immediate practitioners. Finally, as an experimental practice, Conceptual art cannot be expected to have a direct effect on society at large. Taken together, these assumptions were

intended to announce the redundancy of the art historian and art critic as the principal agents for the interpretation and propagation of Conceptual art.

Kosuth maintains that an understanding of the signifying nature of all art propositions is fundamental to Conceptual art and justifies its dependence upon inscribed language as its principal mode of expression. (At the same time, it is crucial to distinguish Conceptual art from other, language-based artistic forms, such as concrete poetry. These are dismissed by Kosuth as a formalization of the poet's material.)

As cognitive rather than perceptual practice, Kosuth boldly positions Conceptual art as a rival to both philosophy and religion. Kosuth repeatedly asserts in his writings the right of Conceptual art to be valued on a par with logic, mathematics, science, anthropology or psychoanalytic theory, arguing that all these enquiries share with Conceptual art the qualities of being open-ended and theoretical. Kosuth's notion of Conceptual art also privileges language as the key frame for meaning in all art, past or present, and regardless of its material form. The crux of Kosuth's argument linking art with mathematics and science is that all these practices are in a profound sense tautological, and all present their 'findings' to the world in the allegedly universal syntax of analytical propositions.

This last claim is most controversial and Kosuth goes further in his attack on the epistemological distinction between art and science than any other artist of his generation. When Kosuth argues that art is a special kind of tautology, he means art as revealed by his practice of Conceptual art. Like logic and mathematics, Conceptual art demands that the art-idea (or work) and the concept of art are identical and self-validating. However, as pointed out by critics such as **BENJAMIN BUCHLOH** and Frances Colpitt, such a theoretical construction of art fundamentally undermines Kosuth's claim

for his practice as a thoroughgoing critique of formalist art.

Kosuth's quintessential statement on the nature of art as a concept is found in the seminal text, 'Art After Philosophy' (1969). 'Works of art', writes Kosuth, 'are analytic propositions. That is, if viewed within their context – as art – they provide no information what-so-ever about any matter of fact. A work of art is a tautology in that it is a presentation of the artist's intention, that is, he is saying that a particular work of art *is* art, which means, is a *definition* of art. Thus, that it is art is true *a priori* (which is what [Donald] Judd means when he states that "if someone calls it art, it's art").'

At times obscure, Kosuth's art theory is above all playful and informal, remaining unencumbered by the strictures of the disciplines he seeks to emulate. Drawing on Ad Reinhardt's penchant for composing polemics out of series of quotations sourced from a wide range of thinkers, artists and poets, Kosuth likewise appropriates fragments of texts by key figures in the philosophy of language (analytic philosophy and the works of Ludwig Wittgenstein), the philosophy of science, anthropology (the ideas popularized by Stanley Diamond), Marxism, critical theory (**WALTER BENJAMIN**) and psychoanalytic theory (Sigmund Freud). This practice of citation has prompted some critics to brand Kosuth as either pedantic or intellectually vacuous. Yet, the interest shown by Kosuth in resources of expression that are remote from the expected discourses of art and which reflect a vocabulary and methodology alien to modernist art criticism of the 1960s is hardly unique among artists. Many artists at the time flirted with a kind of cod-intellectualism or scientism. Kosuth's text fragments picture the case for the epistemological identity of self-reflexive Conceptual art and the logical structure of philosophy, science and mathematics. Rather than settle the argument of art's identity, they point to a possible world where art, science,

philosophy, and so forth, jostle together as cultural equals.

This intention is announced in one of the earliest of Kosuth's works of art – or 'investigations' as he called them from 1968 onwards – subtitled 'Art as Idea as Idea'. Consisting simply of negative photographic prints of dictionary definitions four-by-four feet square, these works refer explicitly to Reinhardt's dictum – 'Art-is-art; everything else is everything else' – and mirror the format of his late, near-black paintings. Along with Marcel Duchamp, Reinhardt was identified by Kosuth as a key historical precursor to Conceptual art. In an act of homage to Duchamp's 'ready-mades' of 1913, Kosuth calls his appropriated text construction the 'made-ready'. These knowing historical references remain the dominant format of Kosuth's most widely read art theoretical texts and serve to link him to a particular avant-garde tradition.

For Kosuth, the chief virtue of Conceptual art is to be found in its opposition to the formalist and allegedly 'empty' (or 'first-order') works of painters and sculptors such as Kenneth Noland, Larry Poons and Anthony Caro. Formalism was bankrupt, in Kosuth's view, because it was unable to reflect upon the concept of art in general and left the artist in a position of dependence with respect to the art critic. As construed by Greenberg and Fried, modernist painting and sculpture is eminently self-reflexive; that is, such art eschews all illusory spatial effects and references to anything outside the fact of its material constitution, be it painting or sculpture. This was seen by some Conceptual artists to be an impoverished self-reflexivity, one that prevented artists from understanding *how* art 'means'. With its repetitive geometric motifs, relative lack of internal complexity, emphasis on media specificity, and opulent use of colour, formalist paintings and sculptures were disdained as meaningless objects whose very lack of complexity and detail presented

a blank screen upon which critics could ratify their narrow taste. Formalist painting and sculpture was conceptually mute and presented a stumbling block to a higher understanding of art.

While Kosuth's early writings address formalism in these terms, his association with the Art & Language group in 1970 forced him to reconsider earlier positions and led to an accommodation of his art theory to a far more dialogical and politicized model of practice. Despite this shift, Kosuth's version of Conceptual art remained highly abstract and obscure. The academic seriousness and philosophical respectability projected by Kosuth's works from the late 1960s onwards has done much to contribute to the view of Conceptual art as a practice of difficulty and remoteness with respect to lived experience.

Ironically, the stereotypical image of the clinical Conceptual artist is potentially moderated by one of the more enduring aspects of Kosuth's career as an artist, namely an insistence on the cohesiveness of his various practices. Here, Kosuth underscores the fundamentally organic relationship that binds his role as artist, curator, writer and educator into a whole social actor. These roles not only reflect the urge towards a more complete and satisfying personal practice that resists the prerogatives of professional specialization, but also refer to the historical need of Conceptual artists to control directly the reception of their work. Kosuth, like many others of his generation, emulated the multifaceted practices of Ad Reinhardt, **ROBERT MORRIS** and Donald Judd. By aggressively controlling the terms of critical discourse that framed his own practices, and by providing a context during the late 1960s for the practices of his artistic allies, Kosuth could counter the interpretations by hostile critics that threatened to marginalize Conceptual art. According to Kosuth, the extraordinary versatility of Reinhardt was a tremendous influence on the way he

shaped his own career. Reinhardt, in fact, was a painter, a political cartoonist and activist, a writer, a student of art history, and a professor of art history. But where Reinhardt's versatility acknowledges the practical differences of these roles and therefore maintains strict epistemological divisions between them, Kosuth's version tends to be far more cohesive and self-contained. In one sense, it can be reckoned to be the social face of the tautology 'art-as-idea-as-idea'.

MICHAEL CORRIS

BIBLIOGRAPHY

Primary literature

Kosuth, J., *Investigationen über Kunst und 'Problemkreise' set 1965* (5 vols), Lucerne: Kunstmuseum Luzern, 1973.

Kosuth, J., *Art after Philosophy and After. Collected Writings, 1966–1990*, ed. Gabriele Guercio, Cambridge: MIT Press, 1993/2002.

Secondary literature

Corris, M. (ed.), *Conceptual Art: Theory, Myth and Practice*, Cambridge and New York: Cambridge University Press, 2004.

Gintz, C. and Pagé, S., *L'art conceptuel: une perspective*, Paris: Museum of Modern Art, 1989.

Goldstein, A. and Rorimer, A., *Reconsidering the Object of Art: 1965–1975*, Los Angeles: The Museum of Contemporary Art and Cambridge: MIT Press, 1995.

Harrison, C., *Essays on Art & Language*, Cambridge: MIT Press, 2001.

Lippard, L. R., *Six Years: The Dematerialization of the Art Object, 1966–1972*, Berkeley and Los Angeles: University of California Press, 1973/1997.

Meyer, U., *Conceptual Art*, New York: E. P. Dutton, 1972.

Wood, P., *Conceptual Art*, London: Tate Publishing, 2002.

BARBARA KRUGER (1945–)

Barbara Kruger is best known for her photo-text collages. These combine photographs, often culled from 1940s and 1950s photo-annuals and instruction manuals, with provocative slogans in Futura Bold Italic font. They have appeared on posters, billboards, magazine covers, book jackets, bags, T-shirts and mugs, in galleries and outside in various

urban settings. Summoning the graphic language of the modernist avant-garde (e.g. John Heartfield, Soviet Constructivism), they also invoke the tactics of commercial design.

Kruger's art career began in the late 1960s when she made crocheted and sewn hangings for gallery display. These challenged separations between art and craft, thereby probing relationships between creativity and gender. This interest in feminist concerns segued with issues specific to photographic theory when, during a visiting artist post at Berkeley in 1976, Kruger engaged with the writings of **WALTER BENJAMIN** and **ROLAND BARTHES** and their respective analyses of technically reproduced art and semiotics. Alongside her art practice, Kruger has taught, curated and written. For several years she regularly wrote criticism for *Artforum*, mainly reflecting on TV and film. Her criticism revels in discussions of TV flotsam such as The Muppets, Johnny Carson and The Home Shopping Club, and is seeded with gestures to critical theory, for example, commodity fetishism, the rhetoric of realism, and the identificatory mechanisms of camerawork. In interview Kruger has described her critical project thus: 'I'm interested in how identities are constructed, how stereotypes are formed, how narratives sort of congeal and become history' (*Barbara Kruger* [*BK*], p. 189). Her reflection on her own practice is often allusive and adopts a similar tone to that of the slogans in the photo-collages. Witness, for example, the paratactic statements in 'Irony/Passion' (1979), 'Work and Money' (1981), 'Incorrect' (1982) and 'Repeat After Me' (1992), all reproduced in *Remote Control* (1993).

Kruger began her career as a graphic designer at Condé Nast, becoming head designer of *Mademoiselle* by 1967 and working subsequently on *House and Garden* and *Aperture*. Carol Squiers stresses how Kruger's art practice emerged 'directly' from her training in selecting and cropping images (*BK*, p. 147). Eschewing distinctions between art and design, Kruger states simply that she works with 'pictures and words'. However, Kruger's practice involves moves uncommon within traditional art practice. For example, her use of previously existing image sources (which largely avoid copyright) raises questions about authorship and originality. In this respect her work can be grouped with the consciously plagiarist practice of contemporaries Sherrie Levine and Mike Bidlo. Consistent with the critique of authorship, Kruger, in turn, allowed her graphic style to be 'imitated' by the Pro-Choice Education Project in 1998, as part of their campaign for abortion rights. Kruger is not just a thief of images: 'We loiter outside of trade and speech and are obliged to steal language. We are very good mimics' (*Remote Control* [*RC*], p. 216).

Such appropriation allows examination of official discourses, stereotypes and clichés and all that appears obvious. In this respect, photography is an interesting tool. Kruger has frequently pointed to photography's mendacious ability to present the seemingly real and evidential. Such powers are 'problematic' and Kruger strives to undercut photography's rhetoric of the real 'through the textual commentary which accompanies them' (*RC*, p. 218). Photo-collages become polyvalent, assaults on photographic certainty. This exercise in suspicion carries through to her reflections on historiography, which led to co-editorship of *Remaking History*, a collection of essays by post-colonialists and post-structuralists who question 'grand narratives'. In its introduction, traditional history is characterized as 'a bulky encapsulation of singularity, a univocal voice-over, an instructor of origin, power and mastery' (*Remaking History*, p. ix).

Kruger is critical of 'power' in various forms, including the power of the academy to circumscribe critical discourse. She has insisted that theory break out of academia and invade public discourse via a 'powerfully

pleasurable language of pictures, words, sounds and structures' (*RC*, p. 222). In some sense the displacement of her work from galleries to public spaces attempts to project theory into the public realm. Certainly the works have dispatched and attracted theoretical commentary. While Kruger's writings disseminated theoretical ideas on topics such as the political nature of high/low binaries, the force of realism or power's reliance on stereotypes, her works became a hanger for the 'theory turn' of art in the 1980s.

Kruger has been interpreted in three contexts: political aesthetics, feminism and postmodern investigations of 'the gaze', and identity and power. Politically oriented readings of Kruger usually focus in one of two directions. One highlights her relation to photomontage, claiming a lineage from John Heartfield and Hannah Höch and developed by Klaus Staeck and Peter Kennard. The other is closely aligned to critical theory's reflections on ideology, alienation and enlightenment. **HAL FOSTER** provides a key example of this latter reading. Drawing on Barthes and Lacan, he interpreted Kruger's work as the calling of language into crisis, pinpointing her as a 'manipulator of signs more than a producer of art objects' (*Recodings*, p. 100). In her use of pronouns – shifting descriptors dependent on context and interpretation, thus blocking identification – and in her marshalling of disjunctures between image and text, connotation and denotation, the photo-text collages become destabilizing, critical responses to mediated, illusion-saturated environments. Foster recognizes Kruger's stated commitment to undermine stereotypes (*RC*, pp. 222/230) and he posits as ideology-critique what she terms the disruption of 'the dour certainties of pictures, property, and power' (*RC*, p. 221).

John A. Walker, in his *Art in the Age of Mass Media*, presents the other type of political reading. Kruger is a media artist in the company of political photomontagists. The overriding interpretative context is anti-capitalist art practice. The photomontage with the slogan YOU INVEST IN THE DIVINITY OF THE MASTERPIECE is read as a critique of painting, shrouded in an ideology of genius and inspiration, but actually and more importantly just another commodity (or profitable investment) in capitalist society. For Walker, Kruger's appropriation of found images challenges the 'myth of originality' fundamental to non-media art. As such it exemplifies Walter Benjamin's theses on technical reproducibility. Kruger's own analysis of artistic form concentrates less on painting's ideological freighting than photography's contradictory existence as simultaneously faux-objective (in service of power) and 'secular' (and domesticable) (*RC*, p. 218).

Brandon Taylor's *The Art of Today* emphasizes the feminist-political aspects of Kruger's practice, observing that she became a touchstone for feminists who wanted 'something direct'. Kruger herself conceives of plural feminisms, which question power and 'the clichés of binary oppositions' (*RC*, p. 223). Taylor reminds readers that Kruger was very much claimed for postmodernism. In this context it is less overt politics that are addressed in her work and rather issues of identity, visuality and power in relation to ethical concerns. Kruger's own writings certainly back this reading with their references to 'difference', inclusions' and 'multiplicities' – touchstones of postmodern ethics (e.g. *RC*, pp. 217/220). Craig Owens set the high-theoretical tone in 'The Discourse of Others: Feminist and Postmodernism' (1983), promulgating Kruger's 'poststructuralist', 'deconstructive' photographic practice against modernism's supposed insistence on artistic mastery, made graphic in the heroic labour of the brushstroke as guarantee of cultural authority and value. Indeed Owens' reading of Kruger counters the 'political' reading offered by **BENJAMIN BUCHLOH**, in 'Allegorical Procedures: Appropriation and

Montage in Contemporary Art' (1982), and Hal Foster, both of whom refer to universal alienation and ideological unmasking. For Buchloh, Kruger manipulates the languages of popular culture in order to expose the ways in which they work to enforce dominant ideology that obscures an underlying truth. Owens objects to metaphors of making visible, because, in contemporary culture, 'visibility is always on the side of the male'. For Owens, Kruger's photo-text collages map the existence of patriarchy through a critique of male desire and its annexing to the gaze, which 'objectifies and masters' (*Postmodern Culture*, p. 77).

That 'truth' is a fiction wielded by power is a stance Kruger appears to share. Truth implies certainty and the oppressive binary of non-truth. For Kruger, as for Owens, even the binary of gender is untenable. While, for Owens, there is no question that the address of Kruger's work is gender-specific, deconstruction and post-structuralism teach that signifiers are unstable, including 'I' and 'you', masculine and feminine. YOUR GAZE HITS THE SIDE OF MY FACE, a slogan from 1981, castigates a penetrating male stare, but does not naturalize it.

Similarly in the publication accompanying Kruger's retrospective at MOCA in 1999/2000, Rosslyn Deutsche observes that the addressee of you/we/I 'does not designate a pre-existing spectator with a fixed identity', but rather 'denotes a position marked and transformed by relationships with others' (*BK*, p. 81). This unfixed identity annexes to a feminist 'politics of vision', underpinned by psychoanalysis. As an explorer of how visuality informs socio-sexual identity and difference, Kruger is placed alongside artists such as Sherrie Levine, Cindy Sherman, MARY KELLY who 'disrupted a visual economy in which woman as image and, beyond iconography, coherent visual form shore up masculine fantasies of completion' (*BK*, p. 83).

Kruger disturbs sites of perfection, be that the model in the photograph or the 'hallowed' gallery. Kruger's 'direct address' reveals the presence of power in 'apparently neutral spaces' such as the gallery, now placed within the 'concrete social world'. The denigration of the 'perfect' space of the gallery is a dominant theme of post-war post-painterly critical practice. Deutsche underlines Kruger's own sense of such work as ethical. This is one more instance of how Kruger's theoretical practice coincided with the central concerns of critical theory through the 1980s and 1990s. For this reason, perhaps, she has not been subjected to critique, but has served rather as an example of choice for art critics with a theoretical bent. Critics have found reflected in her fractured works and elusive writings their own concerns.

Kruger's early work confronted a male-dominated art world. Kruger observes that the male hold has lessened and the 'overqualified understudies' (*BK*, p. 192) may now participate. Whether this is due to the energetic work of Kruger and her contemporaries is an open question. In any case, it was one they posed. Kruger's influence, according to Steven Heller, can certainly be found where she started – in graphic design, specifically contemporary advertising practice. Heller cites the 'creative advertising' embodied in a campaign such as Absolut Vodka's, which uses 'curious juxtapositions of product and image' (*BK*, p. 118). And, oddly, for all the claims around critical practice, Kruger has found herself back in the commercial world. In 2002 she designed façade banners for the Kaufhof department store in Frankfurt, Germany. Huge eyes confronted consumers menacingly: 'That is you, that is new, that is nothing, that is everything, you want it, you buy it, you forget it.' In 2003 and 2005 she provided façade banners, subway posters, billboards and bus wraps for Selfridges. These used her most iconic phrase – I SHOP THEREFORE I AM. If there was still a critical purchase to this, it is submerged. Whether

irony remains is another question, and one that urgently needs answering if Kruger is not to be seen as a 'sell-out' or simply the logical product of a postmodernism that currently privileges a vague notion of ethics over a specific sense of politics.

ESTHER LESLIE

BIBLIOGRAPHY

Primary literature

Kruger, Barbara, *Remote Control: Power, Cultures and the World of Appearances*, Cambridge: MIT Press, 1993.

Kruger, Barbara and Mariani, Philomena (eds), *Remaking History*, Seattle: Bay Press, 1989.

Barbara Kruger, Cambridge: The MIT Press, 2000.

Secondary literature

Buchloh, B., 'Allegorical Procedures: Appropriation and Montage in Contemporary Art', *Artforum* (September 1982).

Foster, H., 'Subversive Signs', in *Recodings: Art, Spectacle, Cultural Politics*, Seattle: Bay Press, 1984, pp. 99–118 (originally in *Art in America* [November 1982], pp. 88–92).

Owens, C., 'The Medusa Effect, Or, The Spectacular Ruse', *Art in America* (January 1984), pp. 97–105.

Owens, C., 'The Discourse of Others: Feminist and Postmodernism', in ed. Hal Foster, *The Anti-Aesthetic: Essays on Postmodern Culture*, Seattle: Bay Press, 1983.

Taylor, B., *The Art of Today*, London: The Everyman Art Library, 1995.

Walker, J. A., *Art in the Age of Mass Media* (revised edition), London: Pluto, 1994.

ROBERT MORRIS (1931–)

Robert Morris, born in Kansas City, USA, is one of the most controversial figures in the recent history of American art. A progenitor of minimal art, Morris was intellectually more articulate than his peers Carl Andre and Donald Judd, and furnished the 'movement' with a credible aesthetic theory. As part of a generation of young artists emerging out of the hegemony of abstract painting in the late 1950s, Morris said 'no to transcendence and spiritual values, heroic scale, anguished decisions, historicizing narrative, valuable artefact, intelligent structure, interesting visual experience' ('Three Folds in the

Fabric', 1989). Since the late 1950s his broad artistic output can be understood as successive and reflective critical encounters with emergent movements in contemporary New York art, and his constantly shifting focus was registered in his ongoing writings. His syncretism and ever changing artistic interests were, to his supporters, complex and intellectually informed; to his detractors Morris was eclectic and opportunist.

Morris's oeuvre can be roughly described in terms of periods: (i) abstract painting (1955–61); (ii) neo-Dada ready-mades (1961–64); (iii) performance art (1961–66); (iv) minimal art (1963–68); (v) process art (1967–73); (vi) land and environment art (1971–79); (vii) installation and 'public' art (1974–present); and (viii) drawings, paintings and reliefs (throughout). Projects and intellectual concerns in Morris's work overlapped or bled into one another. Morris resisted collective affiliations, and sometimes returned to earlier art practices. In San Francisco as early as 1954 Morris became interested in contemporary dance, which continued after his move to New York in 1960 where he became involved in performances with Yvonne Rainer, Carolee Schneemann and others. His enduring interest in the physical dynamics and physical context of viewing art animated both his art theory and his practice. MICHAEL FRIED's accusation that Morris's minimal art was 'theatrical' generated one of the most contentious debates in the New York art world.

Morris's theoretical output can be categorized as follows: (i) a rationale for minimal art ('Notes on Sculpture', Parts 1–3, 1966–67); (ii) a critical outline of process art, including an implicit critique of minimal art ('Anti Form', 1968, and 'Notes on Sculpture', Part 4, 1969); (iii) an integrated theory of art, aesthetic experience and creative activity ('Some Notes on the Phenomenology of Making', 1970; 'The Present Tense of Space', 1978); (iv) a critical outline of environment art, land art and proto-installation work

('The Art of Existence', 1971; 'Aligned with Nazca', 1975; 'Notes on Art as/and Land Reclamation', 1980); and (v) a general critical-historical outline of the history of art from the late 1950s to the late 1970s ('Some Splashes in the Ebb Tide', 1973; 'Three Folds in the Fabric', 1989).

Category (i) of Morris's writings were somewhat polemical and engaged in the battle between the then dominant 'autonomous formalism' (mainstream modernist abstraction as promoted by CLEMENT GREENBERG followed by Michael Fried) and emerging anti-formalist movements like minimal art. Texts (iii) and (iv) are in part manifestations of a struggle internal to this battle – a struggle to claim ownership of the central terms of the emergent discourse of phenomenology. Texts (ii), (iii) and (iv) are a genre of art criticism comparable only to the work of the sculptor-critic ROBERT SMITHSON as they attempt to forge a new general concept of art by integrating phenomenological terms with cultural theory, anthropology and environmental science. And lastly, texts (v) indicate the battle over certain historical reference points, where particular moments in art history became sites of contestation. These moments can be identified as (a) Marcel Duchamp (involving the American reception of Duchamp through Cage, Rauschenberg and Johns); (b) the legacy of the European avant-gardes of the 1920s, particularly Constructivism; and (c) abstract painting of the 1950s, particularly Jackson Pollock, but also involving the work of Ad Reinhardt, Barnett Newman and the younger Frank Stella.

Morris attempted to forge an alternative historico-conceptual narrative of modern art. It is a mistake to think of Morris's anti-formalism as anti-modernist. Morris rather attempted to reconfigure the central critical terms of the modernist theory of art – art's socio-cultural 'autonomy', 'medium-specificity', 'form' and art's 'pure' or unique

visual efficacy – in terms of emergent anti-formalist art practices. His alternative narrative of modern art maintained a major influence on the early contributors to *October* magazine, evident later in major texts like **ROSALIND KRAUSS**'s *The Optical Unconscious* (1993).

Morris's major contribution to the development of art theory was between 1966 and 1970, specifically his 'Notes on Sculpture' Parts 1–4. First, in relation to category (i) texts above, Morris concurred with the modernist theory of Greenberg and Fried on some fundamental claims about sculpture: (i) sculpture (like all individual arts) inhabits a distinct and specific medium; its medium is not determined by materials as such, but the dynamics of its occupancy of three-dimensional space; (ii) sculpture is categorically different from other objects in the world; it exceeds the realm of the empirical (ordinary experience) – it exists not as empirical 'object' but aesthetic 'shape'; (iii) 'shape' is not the sum of the material properties of the object (and is not synonymous with its compositional form) but is the structure of our perceptual engagement with it (implying that the object's identity as sculpture is not determined by technique, materials, subject matter, style, skill, etc. but the *form of experience* it makes possible); and (iv), the most fundamental characteristic of this experience is a visual immediacy or momentousness where a heightened awareness of the object provokes a simultaneous self-reflexive awareness in the subject of the perceptual conditions of that awareness – the way the objective world is constructed in and through our active perception of it.

However, in Part 1 of the 'Notes' (February 1966), Morris's points of divergence from Fried and Greenberg were apparent. He tacitly accuses Fried of denying sculpture its medium-specificity, observing that both Fried and Greenberg privileged the optical character of *painting* as paradigmatic for sculpture. For Morris, sculpture is a tactile art, and being three-dimensional, the empirical facts of light, space and materials are as much conditions of its medium as the aesthetics of scale, proportion and mass. Its specificity as an art thus lies in its 'literal' existence in 'literal' space; it achieves 'shape' not by denying its literalness, but purging itself of everything that mitigates against the literal – all detail, structural complexity and colour (all figurative allusion, visual metaphor, symbol or any other way objects become a mere function of concepts). A simple polyhedron – a 'unitary form', as he calls it – offers the most powerful instance of the literal. It produces a 'gestalt' sensation of pure visuality, bringing to consciousness the very process by which the objective interconnection of self and world is constructed through perception.

In Part 2 of the 'Notes' (October 1966), Morris simply expands on this line of argumentation. For Morris, the objective of sculpture is to set up a direct subject–object dynamic with the viewer, and for this to be done the object has to be of human scale. The aesthetic function of traditional sculpture is reversed: all internal complexity (of detail and composition) is substituted for external complexity (the dynamic of space, light and unitary form in the subject's field of vision). Where traditional sculpture attempted to *represent* the living experience of corporeality or human form, unitary forms facilitate a reflective apprehension of this very experience.

In Part 3 (June 1967) Morris outlines the nature of his polyhedrons, differentiating them from the numerous minimal-art-style objects that were appearing by late 1966. Morris refused to relinquish a claim on the term 'sculpture', as unitary forms ostensibly fulfilled traditional sculpture's aim in creating an objective expression of corporeal experience (to 'represent', or stand as a sign for, the body). Part 3 is significant in that Morris develops an idea that continues

throughout many of his later writings: the significance of sculpture is that it exemplifies 'the cultural infrastructure of forming'. 'Forming' here is the basic structure of our task-oriented interaction with the objective world. Reconstructed as art, this reveals a primordial substrate of sensible task-oriented knowledge about the world of objects. From the Neolithic to the industrial era, humankind's interaction with material nature has taken certain forms – determined by the propensities of certain materials in relation to the propensities of the human body. The most elementary form of 'forming' is the cubic or rectangle form (production) combined with the right-angled grid (distribution). The cube/rectangle became the morpheme and the right-angled grid the syntax of minimal art.

The essay 'Anti Form' (April 1968) appeared exactly a year before 'Notes' Part 4 (April 1969), and is where Morris begins to cast doubt on unitary forms (now identified as 'minimal art'), sensing their points of convergence with modernist formalism. Morris's initial concern with 'the literal' becomes clearer as he states that unitary forms embody a 'generalized usefulness' constitutive of our objective world – the 'form' of utility itself, the primordial substrate of our knowledge of the world gained through constructive needs-driven interaction with it. However, in 'Anti Form' he tentatively suggests that minimal art was mistaken in attempting to locate this substrate in an essential formal logic of cubic form and right-angled grid. Any attempt to create a single physical configuration of an essential structure of subject–object interaction becomes 'functioning idealism' – the objects become mere vehicles for conceptual speculation on the nature of reality. 'Forming' has no objective paradigms that remain constant; rather, the substrate can only be located within the process of 'making itself'. With reference to Pollock, art's central task is to 'recover process and hold onto it as part

of the work', that is, it is not to evoke the conditions for our perception of the object, but the conditions of the visual field of which objects are just a part.

In Part 4, and the essay that was to follow exactly a year later, 'Some Notes on the Phenomenology of Making' (April 1970), Morris continued this exploration, shifting the axis of his attention from objects to process – from the primacy of visual interaction to physical interaction, and despite his deepening interest in psychology and linguistics, Morris became as attentive to the location, environment and materials of production as to the dynamics of viewing. The 'medium-specificity' of sculpture became all but irrelevant. 'Shape', moreover, was not a single homogeneous gestalt but successive moments of coherence created and developed through negotiating a visual field of indeterminacy and heterogeneity. The self-reflexivity afforded by this experience of shape was not an attempt to discern the essential substrate of perception, but to generate the facility of *new* modes of perception, an interaction with the world, and thus cultural transformation.

In the early 1970s, Morris became a major point of reference for a new generation of trenchantly anti-formalist art theorists and historians. Along with Richard Serra, Morris's influence permeates seminal texts like Rosalind Krauss's *Passages in Modern Sculpture* (1977). The intellectual battle in the New York art world between 'formalism' and 'anti-formalism', though ill conceived some of the time, set the conceptual framework for subsequent international debates on postmodernism. Morris's status in the art world, as well as his intellectual progeny, was apparent with the publishing of his writings by *October* books and MIT in 1993, followed by an impressive retrospective at the Solomon R. Guggenheim Museum in 1994, co-curated by Rosalind Krauss and Thomas Krens.

JONATHAN VICKERY

BIBLIOGRAPHY

Primary literature

All the above quoted essays by Robert Morris are available in:
Morris, Robert, *Continuous Project Altered Daily: The Writings of Robert Morris*, Cambridge: MIT Press/*October*, 1993.

Secondary literature

Battcock, G., *Minimal Art: A Critical Anthology*, Berkeley: University of California Press, 1995.

Berger, M., *Robert Morris, Minimalism and the 1960s*, New York: Harper & Row, 1969.
Colpitt, F., *Minimal Art: The Critical Perspective*, Seattle: University of Washington Press, 1990.
Fried, M., 'Art and Objecthood' (1967), in *Art and Objecthood: Essays and Reviews*, Chicago: University of Chicago Press, 1998.
Krauss, R., *Passages in Modern Sculpture*, London: Thames & Hudson, 1977.
Krauss, R. and Krens, T., *Robert Morris: The Mind/Body Problem*, New York: Solomon R. Guggenheim Museum, 1994.
Strickland, E., *Minimalism: Origins*, Bloomington and Indianapolis: Indiana University Press, 1993.

ADRIAN PIPER (1948–)

Since the mid-1960s, Adrian Piper has produced conceptual art, meta-art and critical writings on racism, xenophobia and their underlying epistemic, economic, political and spiritual causes and conditions. Part of the generation of artists influenced by minimalism, and early conceptualists like Sol LeWitt, Piper immersed herself in the New York art world beginning in 1966, working and showing with influential artists and curators such as LeWitt, Vito Acconci, Hans Haacke, Lucy Lippard and Seth Siegelaub. Unlike fellow conceptual artists and critics who tended to appropriate concepts from various academic disciplines without mastering them, Piper strengthened her early interest in abstract conceptual thinking by earning a BA (1974) and a doctorate (1981) in philosophy, becoming the first tenured African American woman professor of philosophy in the United States in 1991.

The interplay between Piper's art and theoretical writings about art is fairly explicit, the interplay between her philosophical writings and art less so. The writings about

art, published in exhibition catalogues, international art publications and collected in *Out of Order, Out of Sight* (1996), can be formally categorized as meta-art and art criticism. Both genres employ a self-reflexive approach to articulate the conditions that determine and contextualize, respectively, her art practice and social status as a coloured woman artist ('Triple Negation of Colored Women Artists', 1990) relative to art and real world politics; both defend the notion that art, and the artist, can and should play a significant role in socio-political discussions. Combined with her art practice, both represent a strategic union of the personal and political that critiques the experience, and conditions that determine the experience, of xenophobia and racism.

Meta-art, a form of practice for artists, 'makes explicit the thought processes, procedures, and presuppositions of making whatever kind of work we make' ('In Support of Meta-Art', 1973). From the perspective of the artist, it helps to clarify the complexities of one's art practice, and, consequently, may effect the development of the work. In her meta-art essays, Piper describes, in sometimes intimate detail, the motivations and processes that condition her art practice. These texts show a mounting self-awareness of her socio-political position, and this awareness in turn informs her art practice, which has become more overtly political over time. From a critical standpoint, meta-art broaches a couple of still relevant issues originally addressed in critical discussions about conceptual art and art criticism. First, it calls into question and undercuts the mythologization of the artist as standing outside of social relations by exposing, through otherwise inaccessible first-person insight, the collision of personal and social forces that constitute the artist's practice. Second, and perhaps more controversially, meta-art allows the artist to assert some influence over the interpretative framework of the work, thereby questioning the role of

the art critic, as well as the artist's role, in guiding the interpretation of his or her work.

While Piper's meta-art practice helps clarify the personal and social implications of her work, her art critical writings stress both the critic's relationship to the object of criticism and its relationship to institutional practices and general social concerns. Like JOSEPH KOSUTH's rejection of the art critic as 'middleman' who makes 'objective' value judgments about art, Piper's texts challenge the myth of the critic who 'may impersonally efface herself and her subjectivity in order more accurately to deliver objectively valid pronouncements about the criticized object' ('Some Very Forward Remarks', 1996). The critic and the practice of criticism are just as embedded in economic, social and political circumstances as art and the artist. Piper provides a scathing critique of the legitimacy of the kind of criticism that relies heavily on biographical analysis in place of an analysis of the object. As she shows in an exchange with Donald Kuspit, this type of criticism often masks the critic's own agenda, effaces the work by psychologically profiling the artist or, worse, reveals the critic's racist and sexist attitudes and practices.

Piper's art critical essays helped define a form of criticism that, along with other artists and critics such as Lippard and Howardina Pindell, seeks to expose and clear away the layers of racism, sexism and other exclusionary practices in the art world. In essays such as 'Government Support for Unconventional Works of Art' (1992) and 'The Logic of Modernism' (1992) she examines tactics that exclude political art from the public domain because it contradicts the socio-political ideologies of the funders, or threatens the hegemony of Euro-ethnic art and cultural ideals. She rejects CLEMENT GREENBERG's conception of Modernism and argues that political art is inherent in the modernist tradition and vitally important to maintenance of a free and democratic society. In 'Notes on the White Man's Burden:

Multiculturalism and Euroethnic Art Criticism at the Millennium' (1991) she defends the importance of supporting non-Euro-ethnic art, while warning that inclusion in the canon, particularly under the guise of 'postmodern appropriation', comes with its own set of contradictions and dangers.

The relationship of Piper's philosophical work to her art and theoretical writing about art is less explicit. Since receiving her doctorate, philosophy has been Piper's 'day job', supporting her art practices and enabling her to remain independent of the art market. Working within the analytic tradition, her primary focus and publications have been on Kant, meta-ethics and the history of ethics. In her forthcoming book, *Rationality and the Structure of the Self*, she critiques the problems inherent in moral theories based on a Humean conception of the self, and develops a theory of the self grounded in Kant's *Critique of Pure Reason*.

Piper's philosophical investigations do not make her art 'philosophical'. Rather, Kant's philosophical analysis becomes a point of departure, providing a theoretical ground for her preoccupation with immediate perception. She seizes on Kant's fundamental idea that there are conceptual thought processes that shape our experience, and deploys it to examine the concepts that constitute our experience of race, ethnicity and xenophobia. Race, in her view, is not a fixed a-priori category, nor is it biological or genetic; it is an empirical concept open to modification. Racism takes place at the moment of concrete and immediate perception through the concepts that determine our perception. The possibility that these concepts are mutable is a source of hope, providing more resolve for Piper's mission to challenge the experience of racism.

Piper's art becomes more concrete and overtly political as she thinks more abstractly about her social and political status. Loosely divided into the pre-conceptual (pre-1966–67)

and conceptual (post-1967), her art practice is guided by a few primary strategies: the 'indexical present', or what she refers to as the immediate here and now; 'catalysis', i.e. art as a catalytic agent of change; and 'confrontation', in the sense of objectifying a subject for rational examination and, potentially, change.

The pre-conceptual work, mostly representational paintings, drawings and sculpture, seems unaware, or unaffected, by trends in minimalism and early conceptual art. Rather, her unselfconscious incorporation of expressionism, cubism and op art signifies Piper's fascination with the problem of immediate perception in the indexical present, and the location of the body in a spatio-temporal matrix. Works such as *LSD Steve Shomstein* (1966), and *Self-Portrait with Tamiko* (1966), for example, suggest the possibility that our perception of the subject is distorted by some kind of visual cover, perhaps inherent in our own perception. What seems like immediate unfiltered perception is in fact a presentation coloured by our faculties.

From 1966 to 1970 Piper began to develop a more suitable vocabulary for her examination of the conditions of perception and, later, the presentation of political content. When LeWitt stated that the 'idea of concept is the most important aspect of the work', Piper responded in her work by prioritizing content over form. Early conceptual works, such as *Here and Now* (1968) and *Concrete Infinity 6" Square* (1968), underscore the significance of content by situating ideas and concepts as objects that refer both to themselves and to ideas beyond themselves. Later works from this period, such as *Meat into Meat* (1968) and, in particular, *Hypothesis* (1968–70), exhibit a transition in the content of her work from problems of abstract temporality to the problem of locating herself as an art object in a spatio-temporal matrix.

Diverging from Kosuth's view of conceptual art as an analytic proposition, Piper,

in performances from the early 1970s, transforms herself into an art object that refers to both herself, as art object, and to concepts outside of the work. In the *Catalysis* series (1970), *Mythic Being* (1974) and *Some Reflective Surfaces* (1976), she modifies her appearance to present the viewer with an anomalous experience, such as the physical embodiment of stereotypical images. This strategy, which some have found hostile and antagonistic, initiates unmediated contact with the perception of the viewer, and enables both parties to explore the conditions of perception in the here and now, with the aim of provoking change in the viewer. Later performances, such as *Funk Lessons* (1983), adopt a more collaborative approach to break down the xenophobic presuppositions of commonly held stereotypes in order to 'restructure people's social identities by making accessible to them a common medium of communication' ('Notes on Funk I–IV', 1983–84).

The experience of direct communication with the audience carries significant implications for her later art practice. Beginning in the mid-1970s with works like *Art for the Artworld Surface Pattern* (1977), she includes more overt, object-oriented, political content. Later works, such as *Vanilla Nightmares* (1986), and multimedia installations such as *Cornered* (1988) and *What It's Like What It is #3* (1991), continue to objectify experiences of racism and xenophobia, employing stereotypes and culturally pervasive images to question the viewer's assumptions, and demonstrate the extent to which the conditions of perception are determined.

Viewed cohesively, Piper's work suggests a strategy of confrontation aimed at dissolving racial stereotypes and reconstructing concepts of self-identity free of xenophobic baggage. This strategy has become more explicit in her later works. In artist's notes to *The Color Wheel Series* (2000), Piper, a lifelong yogi, employs the vocabulary of the Western rationalist tradition and the Vedantic philosophical tradition to provide a tool to peel away the *koshas*, which are illusory impositions that obscure the true self. From the standpoint of Western rationalism, Piper draws on the examination of colour as a secondary quality that is inherent in the perceiver, not the object itself. Likewise, the ideas that go along with our conception of colour are an imposition on the object. Whether or not one agrees with the concept of a 'true self', a concept that has come under fire from postmodern quarters, Piper's questioning of racial categories presents a formidable challenge to our traditional notions of identity. Combining both traditions, the implications in terms of her social and political attacks on racism and xenophobia are clear: colour and race are not biologically or genetically fixed, but rather impositions upon the self that are open to modification and revision.

In many ways, Piper's lifelong examination of concepts is most squarely placed in the Socratic tradition. Unwavering in her conviction that rational discourse is the most effective way to combat racism, she displays a consistent willingness to objectify and submit uncomfortable truths to rational examination. Her writings are widely anthologized in books on art, philosophy, cultural studies, feminism and race, and she lectures extensively around the world. Two recent comprehensive retrospectives of her work in the US and Europe show her to have been an innovator of conceptual art practices whose formal strategies have often prefigured the work of artists such as BARBARA KRUGER and Jenny Holzer. Other artists, dealing with issues of race and xenophobia, like Glenn Ligon and Lorna Simpson, cite her as an inspiration.

ROBERT del PRINCIPE

BIBLIOGRAPHY

Primary literature

Above quoted essays available in:
Piper, A., *OUT OF ORDER, OUT OF SIGHT: Selected Writings in Meta-Art and Art Criticism 1968–1992* (vols 1 & 2), Cambridge: MIT Press, 1996.
Piper, A., 'Two Conceptions of the Self', *Philosophical Studies* vol. 48, no. 2 (September 1985).
Piper, A., 'Xenophobia and Kantian Rationalism', *Philosophical Forum XXIV*, 1–3 (Fall–Spring 1992–93).
Adrian Piper Research Archive, www.adrianpiper.com.

Secondary literature

Berger, M. and Meyers-Kingsley, D. (eds), *Adrian Piper: A Retrospective*, Baltimore: University of Maryland Baltimore County Press, 1999.
Farver, J. (ed.), *Adrian Piper: Reflections 1967–1987*, New York, N.Y.: The Alternative Museum, 1987.

ROBERT SMITHSON (1938–1973)

Robert Smithson was born in Passaic, New Jersey. He moved from New Jersey to New York City in 1957 and lived there until his accidental death in 1973. His art and writings have since come to be established as one of the most important bodies of work exemplifying American postmodernist art of the 1960s and 1970s, and continue to resonate with many contemporary artistic and intellectual concerns. Although he received some art education in his teens, including the Art Students League in

New York, Smithson was essentially self-educated, reading widely throughout his life in a number of areas besides art, including literary criticism, religion, philosophy and science. Many of these areas of knowledge became resources for his art and writings, and predictably have also been so for many later explainers of his work. Probably because Smithson's sculptural works were often either ephemeral or, where they have lasted, are in places that are difficult to get to, his writings, particularly from the time of their first collected publication in 1979, have played a prominent role in the history of the reception of his work.

Like many artists of his generation Smithson started out as a painter in the wake of abstract expressionism; but from 1964, around the same time as the work of Donald Judd, ROBERT MORRIS and other Minimal artists began to gain attention in the New York art world, he turned to sculptural work. During the next few years, Smithson expanded his practice in various directions, and his work may be divided (following Robert Hobbs) into the following categories, some of which overlap or were combined in the same work: (i) the quasi-minimalist sculptures, often based on crystallographic forms; (ii) collaged map drawings; (iii) the series of 'nonsites' begun in 1968, which drew relationships between material presented in the gallery and a site outside; (iv) travelogues and other narrative texts; (v) 'gravitational' pieces which involved the pouring of substances; (vi) monumental earthworks, such as *Spiral Jetty* (1970), which was constructed in the Great Salt Lake, Utah, and is probably Smithson's most famous work; and (vii) the land reclamation proposals that he was pursuing just prior to his death.

Smithson had a close working relationship with the dealer Virginia Dwan during the crucial years from 1966 to 1971, and most of his important exhibitions were held at either her New York or her Los Angeles gallery. Smithson's significance as an artist probably depends most on his having been the main instigator of the 'earthworks' movement, centred on Dwan's gallery. Throughout the same period Smithson was also publishing, mainly in the influential American art journal *Artforum*, highly unconventional essays that may be seen as at once a strand of his artistic practice and a theorization of that practice, as well as of recent art in general. The formalist modernist art critic MICHAEL FRIED was also publishing his important essays in *Artforum* during the same period, and in many respects the defining opposition of 1960s American art between formalist modernism and an anti-formalist postmodernism can be seen played out in the pages of *Artforum* between Fried (and other followers of CLEMENT GREENBERG) and a generation of artist-writers that included Smithson, Robert Morris, DAN GRAHAM and JOSEPH KOSUTH. Smithson recognized Fried as an important adversary, and correspondingly Fried has written that in retrospect it was Smithson's writings that represented the most important contemporary critical response to his famous 1967 critique of minimal art, 'Art and Objecthood'.

As theoretical reflections on his art practice, and on art in general, Smithson's writings are far from systematic, and were not intended to be. Nevertheless there are some common themes. In the most general terms, Smithson's worldview may be described as *anti-humanist*, in the sense that he sought to refute explanations of the world, history, nature, self, art and so on that were premised on the centrality of the human or the category of 'man' (cf. MICHEL FOUCAULT). This outlook manifested itself in several registers in Smithson's thinking. One of the most important of these was in what may be called his *materialism*, his emphasis on the priority of the material over the human. In his writings this can be seen in the frequent rhetorical strategy of giving humanly meaningful productions such as art, language and thought the attributes of

physical, material processes or conditions, a strategy that can be seen to striking effect in Smithson's essay from 1968, 'A Sedimentation of the Mind: Earth Projects'.

The most discussed of these material processes or conditions has been Smithson's appropriation of the scientific term *entropy* to refer to what he saw as a general process of material disintegration underlying and ultimately undermining all attempts by human beings to order the world. 'Entropy' describes the thermodynamic principle whereby a closed system tends to lose energy and become increasingly disordered. Smithson was drawn to marginal regions in which he could perceive the dissipation of the 'energy' associated with industrial modernization, including declining industrial areas, disused quarries and the architecture of urban sprawl, the latter of which he associated with contemporary (mainly minimal) sculpture in his first major published essay, 'Entropy and the New Monuments' (1966).

Similarly, Smithson's conception of history was opposed to the usual sense in which it is thought of as consisting of a progressive sequence of events meaningful in narrative terms. He saw historical time as rather a mere series of frozen states lacking any overarching order. Smithson frequently used the metaphor of crystal formation, and especially the crystallographic principle of *mirroring*, to suggest this process, as in his 1967 essay 'A Tour of the Monuments of Passaic, New Jersey': this was a photographic and textual record of one of several excursions made by Smithson to his native New Jersey (often in the company of artist-friends such as Carl Andre, Robert Morris or Dan Graham). Here he described the civil engineering projects being built in the city of Passaic as 'ruins in reverse', thereby representing such instances of historical 'progress' as mirror images of the city's industrial decline, and so 'freezing' them in time.

Smithson also applied such scepticism regarding historical progress to what he saw as the reliance on 'progress' in the formalist modernist accounts of the development of modern art put forward by Greenberg and Fried. He criticized them for their separation of art from such modes of temporality as generalized entropic disintegration, and the actual process of producing art by the artist, which he claimed never resolved itself into the 'fiction' of the art *object*: 'Criticism, dependent on rational illusions, appeals to a society that values only commodity type art separated from the artist's mind ... Separate "things", "forms", "objects", "shapes", etc., with beginnings and endings are mere convenient fictions: there is only an uncertain disintegrating order that transcends the limits of rational separations.' In 'A Sedimentation of the Mind: Earth Projects' (from which the words just quoted come), the 'rational separations' that secured the coherence of the art object for a formalist critic such as Fried were contrasted to a radically decentred absence of boundaries and lack of focus, which Smithson referred to using the psychologist Anton Ehrenzweig's term *dedifferentiation*.

Smithson's sculptural works also often attempted to undermine the formalist emphasis on the art object, most notably in his series of nonsites (begun in 1968). In their display of material gathered from a site outside the gallery (a quarry for instance) these drew attention to the *relationships* – between sign and referent, centre and margin – between such a work in the gallery and the site outside (usually also referred to by way of maps, photographs and other documentary material). The problem with such subversions of the art object from the perspective of Greenberg's and Fried's modernism would be the loss of the distinctiveness of painting or sculpture based on a tradition of formal self-criticism, and hence the loss of a special mode of aesthetic response. Following such critiques of the art

object, Smithson (in texts such as 'Cultural Confinement', his 'contribution' to the 1972 Documenta exhibition) became one of the first artists or critics to question seriously the whole institutional framework of museums and galleries which underwrote the isolated mode of existence of the work of art (DANIEL BUREN was another).

Smithson's essays typically combined both textual and visual material, the text frequently playing a graphic role in the overall 'look' of the piece. Consistent with his criticisms of 'rational separations', Smithson refused to apportion the activities of reading and looking according to the textuality or visuality of the material at hand, as can be seen in his short chiasmic text announcing the first of the Dwan Gallery's 'Language' exhibitions, 'Language to be Looked At and/or Things to be Read' (1967), and in his essay 'A Museum of Language in the Vicinity of Art' (1968). Smithson frequently represented his surroundings – physical-geological, architectural, visual-cultural – in linguistic terms, an approach that was supported by his reading of structuralist thinkers such as ROLAND BARTHES and Claude Lévi-Strauss (for whom language provided a model for cultural and anthropological analyses). Smithson saw language itself as having a material condition prior to its capacity to take on meaning, a view that some subsequent writers on Smithson have related to the contemporaneous literary-philosophical theoretical approach, 'deconstruction' (cf. JACQUES DERRIDA). The importance that Smithson gave to language and textuality considerably complicates any straightforward understanding of his materialism, since his emphasis on the materiality of language precludes any simple relationship of exteriority materiality might have with respect to consciousness.

In the late 1970s, Smithson's work became an important element in emerging theories of postmodernism, such as ROSALIND KRAUSS's account of sculpture's transgression of modernist medium-specificity to constitute a new 'expanded field'. Even more influential in Smithson's specific case was Craig Owens's claim that Smithson's foregrounding of the textual in his practice constituted *the* characteristic postmodernist artistic gesture, the textual having been excluded in formalist modernism as extraneous to art practices delimited by the concept of medium-specificity. Smithson's work was seen by Owens as typical of an 'allegorical impulse', where allegory was defined in WALTER BENJAMIN's terms as a disjunctive, disarticulating principle always at work in textual meaning, a principle that was recognized as being at work in Smithson's foregrounding of the materiality of language and his entropic view of history.

More recent writers on Smithson have often felt it necessary to distinguish their own approaches from this postmodernist interpretation, sometimes asserting the importance of a theory of history in Smithson's thinking or situating Smithson's art and writings in more social-historical terms. Smithson's subversions of historical time have recently been criticized by Jennifer L. Roberts for their tendency to conceal real historical conflicts that have in fact determined Smithson's approach to the historical material in the first place. Even as Smithson's work changes from being an object of criticism to an object of history, however, the ramifications of his ways of working and thinking are still being played out in recent art and art theory, and can be seen as influential in such areas as site-specificity, classificatory and museological art practices, and in the recent intersections between art and ecology.

DOMINIC RAHTZ

BIBLIOGRAPHY

Primary literature

Above quoted essays by Smithson are collected in:
Flam, J. (ed.), *Robert Smithson: The Collected Writings*, Berkeley, Los Angeles and London: University of California Press, 1996.

Secondary literature

Boettger, S., *Earthworks: Art and the Landscape of the Sixties*, Berkeley, Los Angeles and London: University of California Press, 2002.
Hobbs, R., *Robert Smithson: Sculpture*, Ithaca: Cornell University Press, 1981.

Owens, C., 'Earthwords' and 'The Allegorical Impulse: Toward a Theory of Postmodernism', in *Beyond Recognition: Representation, Power and Culture*, Berkeley: University of California Press, 1992.
Reynolds, A., *Robert Smithson: Learning from New Jersey and Elsewhere*, Cambridge and London: MIT Press, 2003.
Roberts, J. L., *Mirror-Travels: Robert Smithson and History*, New Haven and London: Yale University Press, 2004.
Shapiro, G., *Earthwards: Robert Smithson and Art after Babel*, Berkeley: University of California Press, 1995.
Tsai, E. (ed.), *Robert Smithson*, Berkeley, Los Angeles and London: University of California Press, 2004.

JEFF WALL (1946–)

Jeff Wall is a Canadian-based artist who, besides achieving immense commercial, institutional and critical success through his photography, has assembled a body of writings that deserve recognition as a decisive contribution to thinking about contemporary art. It is difficult, and probably mistaken, to dissociate these texts from Wall's artworks. Yet they are neither of that genre of 'artist's writings' that claim to be artworks themselves; nor are they expressive or personalized documents. They conform to the conventions of academic texts, albeit with an uncommon rhetorical flare and stripped

of ornamental referencing. As such, they offer their claims and arguments for critical scrutiny.

The parallel development of Wall's writing and artwork has been enabled by his background in academic art history, which often informs his photographs very directly. But it is also symptomatic of Wall's early engagement with, and subsequent criticism of, Conceptual art, which produced texts that were intentionally ambivalent and transgressive as to whether they were artworks or some form of supplementary document (like Art & Language's *Index 01*). Wall does not seek this transgression, but a more conventional observance of genres in his writings, as in his artworks. Despite their often occasional and delimited scope, Wall's writings combine to outline a remarkably consistent and coherent project: a reinvention of the painting of modern life, generated through a critique of conceptual art.

Wall interprets conceptual art as presenting a crisis for artistic modernism in general that continues to define art today, not merely a historically discrete grouping of artists and artworks. Conceptual art exposed a fundamental limitation in the conception of modernist art that prevailed in the late 1960s, especially as propagated by CLEMENT GREENBERG. For Wall, as for many others, this produced the opposed consequences of (i) the collapse of modernism into an affirmative form of commodity production, in which the values of art are overtaken by the values of the market, and (ii) the radical rethinking of the terms of a critical art practice: hence the profoundly contradictory terrain of what is often referred to with misleading unanimity as 'postmodernism' or 'post-conceptual art'. What distinguishes Wall's project is his commitment to renewing the mid-nineteenth-century origins of modernism as a critical project. He does not propose its immediate recovery – i.e. simply returning to painting à la Manet – but rather a reinvention that is mediated by the

experience of the intervening avant-garde movements, culminating in conceptual art. Wall's 'painting of modern life' is only possible *after* conceptual art, as an alternative form of 'post-conceptual art'.

Conceptual art's critique of modernism focused on the way in which its privileged forms (abstract painting and sculpture, and minimalist works) had, by the late 1960s, come to function affirmatively within late capitalist culture, often despite the intentions of the artists. This modernist art did not simply withdraw from the instrumental forms of the culture industry (cf. ADORNO), as was often claimed, but also imitated them uncritically, unconsciously mimicking the alienating forms of corporate capitalism. Conceptual art recovered the memory of the radical European avant-gardes between 1910 and 1930 that had been suppressed by Greenberg – particularly Duchamp's antipathy to aesthetics and his deployment of readymades – and sought to expose the institutional and ideological mechanisms constituting art. While Greenberg had presented modernism as a process of self-critical reduction to the aesthetic properties of the artistic medium, conceptual art radicalized this process to its breaking point: reducing the aesthetic dimension of art to zero and making the imitation of non-art the criterion of art's self-criticism. It thereby sought to free itself from the prejudices of taste in which it saw the ideology of the bourgeoisie and the reduction of art to commodification.

Wall's critique of conceptual art draws attention to the contradictoriness of this strategy of self-criticism and its political significance. Conceptual art sought a radical criticism of art as a form of capitalist culture, extended to the point of art's complete negation. However, unlike the historical avant-gardes that it repeated in this strategy, it did not seek the dissolution of art into life or politics or some other utopian goal, but to make art. (In these terms, conceptual

art corresponds precisely to what Peter Bürger calls a 'neo-avant-garde'). However, this was not proposed as an intra-artistic utopia, but, at least for the more politically minded artists, the melancholic symbol of a post-capitalist world that art itself could not achieve. Consequently, Wall brands conceptual art 'the reinvention of defeatism'. What made this contradictory self-criticism convincing was the extent to which conceptual art managed to occupy the art world without affirming its forms of institutionalization and commodification. But in a culture of generalized commodification this was utopian, and once it did become institutionalized and commodified, the critical dimension of mimicking the alienating structures of the art world was lost and it became merely imitative, its negativity aestheticized as an art world 'look'. Conceptual art is revealed as the dark *döppleganger* of its nemesis, pop art, and reduced to uncritically mimicking the culture industry. Wall diagnoses conceptual art's defeatism as the result of its inability to represent the social world other than negatively or ironically, which it had unconsciously inherited from modernism's taboo on social content, generated in reaction to totalitarian propaganda art in the 1930s and 1940s. Wall's reinvention of the painting of modern life is therefore proposed as a 'reinvention of social content in modernist art' that would overcome the crisis of avant-gardism.

Baudelaire's conception of the 'painting of modern life' subjects the rigid hierarchy of the genres of academic painting to the experience of 'the new', modernity's social forms. Wall sees this as the beginning of an art that attempts to picture the drama of modern capitalism, presenting it critically in terms of the antagonisms and suffering it generates. But it is not immediately apparent how Wall's defence of genre-based photography is indebted to Baudelaire, who rejected photography as a decadent form

of industrialized naturalism. It only makes sense if we read Baudelaire in reverse, from the perspective of the crisis of the avant-garde that Wall diagnoses.

Wall argues that photography becomes an autonomous art form, developing through self-criticism, only via conceptual art's use of it in the late 1960s and early 1970s. It was only then that photography criticized its establishment as an autonomous art form in the 1940s and 1950s, conscious of its own non-painterly form of picturing, which it had achieved through the factographic and 'anti-painting' photography of the 1930s. However, unlike the self-criticism of other arts, like painting, this autonomy was not won through the exclusion of social content, which, Wall argues, remained inextricable from photography's depictive medium. It was as such that Wall's own practice emerged from conceptual art in the early 1970s as a post-conceptual art-photography, able to reinvent a modernist art of social content. Photography therefore provided the framework for rethinking the crisis of avant-gardism through a return to the origins of a painting of modern life.

In his analysis of Manet, Wall argues that the painting of modern life began as a crisis of the Renaissance concept of the picture, in which the drama of the figure as painted and as represented in perspective is staged and harmonized. This harmonious unity was enforced through the ideal social spaces of the church and state. Wall argues that this concept of the picture was undermined by photography, not because it was a new technique of picturing – one-point perspective had been well-established since the Renaissance – but because photography's mechanization of perspective was associated with the alienating, fragmenting mechanics of capitalist modernity. The exclusion of photography from painting therefore demanded a new form of non-representational or abstract painting that enabled the exclusion of social content from

modernism, but which as a consequence, Wall argues, found itself helplessly mimicking the abstract, fragmented and alienating effects of capitalism. In sum: post-conceptual art-photography is able to reinvent the painting of modern life as the picturing of the contemporary drama of capitalist life, recovering the repressed social-historical content of painting's genres from their occlusion by the limits of the avant-garde; it does this through a photography that is free of instrumental naturalism and constructs its pictures self-consciously or, as Wall has described his practice, 'cinematographically'.

The response to Wall's photographic project has been remarkably sympathetic and uncontroversial – certainly, his detractors have kept relatively quiet to date. Wall's 'cinematographic pictorialism' seems matched only by the serialized documentary of the Bechers in its influence on the terms of contemporary art-photography. Furthermore, the responses to Wall's work have largely remained within the parameters that he has outlined in his writings. A remarkable feature of this response has been the convergence of otherwise opposed positions. Thus, Wall's attempt to recover an alternative genealogy of modernism in the light of the lessons of Conceptual art is largely consistent with the transformation of academic art history from the 1970s, which rejected Greenberg's formalist modernism and revised his account of late nineteenth- and early twentieth-century modernism (cf. Thomas Crow, 'Profane Illuminations'). However, Wall elaborates autonomous art-photography as the self-criticism of its medium, and understands avant-garde experimentation as productive of the autonomy and tradition of art, rather than its negation, in a way consonant with Greenberg. THIERRY DE DUVE has argued that, in photographs like 'Picture for Women' (1979), Wall remains true to Greenberg's preoccupations by revealing the picture plane specific to photography.

This convergence should not be mistaken for reconciliation, but it begs the question of what approach a more radical critique of Wall's project might take. Ostensibly, this would revolve around a reassertion of the claims of the early avant-gardes, which Wall has consistently positioned himself against (remarkably, Bürger does not criticize him for this). Wall's retrospective reading of the painting of modern life has sought to suppress its avant-gardist legacy, recovering a critical academicism, against its utopian transgression. But we need to question whether this has not abandoned the terms of criticism inaugurated by the painting of modern life. Wall's insistence on the art historical precedents of his pictures, studiously followed by his commentators, often renders them 'contemporary dress dramas' that are just as withdrawn from the contemporary image culture in which they need to be judged as the history painting Baudelaire denounced. And his pictures have failed to achieve the scandalousness that marked Manet's critical academicism.

Wall's rejection of avant-gardism is premised on the need for a critical practice of picturing the drama of capitalist life within the terms of autonomous art. However, this does not silence the early avant-garde's objection that such criticism is circumscribed by art's autonomy: that the capacity of art to adequately picture the drama of capitalist life is due to a suppression of its antagonisms within the idealized space of the art institution – a modern extension of church and state. The 'beauty' that Wall increasingly seeks in his pictures is not so much a critique of the fragmentation of capitalist life, as the mimicry of its consolidation: a disintegration of the painting of modern life into aestheticism.

STEWART MARTIN

BIBLIOGRAPHY

Primary literature

Writings by Jeff Wall quoted above, along with a comprehensive bibliography, appear in: *Jeff Wall: Photographs*, Vienna: Walther König, 2003.

Wall, J., *Dan Graham's Kammerspiel* (1985), Toronto: Art Metropole, 1991.

Wall, J., '"Marks of Indifference": Aspects of Photography in, or as, Conceptual Art', in eds A. Goldstein and A. Rorimer, *Reconsidering the Object of Art: 1965–1975*, London and Cambridge: MIT Press, 1995.

Wall, J., 'Unity and Fragmentation in Manet', in *Jeff Wall*, London: Phaidon Press, 1996.

Wall, J., 'Monochrome and Photojournalism in On Kawara's Today Paintings', in eds Cooke and Kelly, *Robert Lehman Lectures on Contemporary Art*, Dia Centre for the Arts, New York, No. 1, Warminster: Dia Center for the Arts, 1996.

Secondary literature

Crow, T., 'Profane Illuminations: The Social History of Jeff Wall', in *Modern Art in the Common Culture*, New Haven and London: Yale University Press, 1996.

de Duve, T., 'The Mainstream and the Crooked Path', in *Jeff Wall*, London: Phaidon Press, 1996.

Bürger, P., 'On a Critique of the Neo-Avant-Garde', in *Jeff Wall: Photographs*, Vienna: Walther König, 2003.

Roberts, J., 'Jeff Wall: The Social Pathology of Everyday Life', in *The Art of Interruption: Realism, Photography and the Everyday*, Manchester and New York: Manchester University Press, 1998.

Art Theory and History

INTRODUCTION

This section brings together art historians and theorists whose writings are characterized not simply by an acute attention to the specificity of their object (whether that be traditional fine arts such as painting and sculpture, the wider domain of visual culture or the expanded field of contemporary art practice) but also by a broader intellectual project underpinning their claims about specific works and cultural products. As such the labels 'art historian' and 'art theorist' tend to apply to one and the same author here, in so far as their historical claims (claims about works of art) tend to embody their more substantive underlying art theoretical agendas (concerning the broader cultural significance of art, the relation between art, constructions of identity and the self, or the relation between art, social history and politics).

The intellectual backdrop for many of these authors' concerns (sometimes positively, though much more often negatively) is Clement Greenberg, the chief theorist and advocate of modernism in the visual arts. Though not all the figures included here have responded at length to Greenberg directly (though Clark, Fried, de Duve, Krauss and Pollock have all done so) he is one common point of reference to the extent that he is synonymous with modernism in the visual arts, and the values it has come to be associated with (the autonomy of art, the separation of the arts, the intrinsic relation between art and aesthetic value, the distinction between high art and mass art, and the focus on 'form' to the exclusion of issues of content, context and meaning). By contrast to Greenberg, who belongs to the same intellectual generation as Adorno, the more recent historians and theorists canvassed here are in one way or another associated with the expansion of artistic or theoretical possibilities that signalled the demise of modernism.

Krauss, de Duve and Fried have all responded to Greenberg head-on – Krauss as the former acolyte whose work on modern sculpture breached the strictures of modernist theory from within. Like Foster she has since been associated with the study of Surrealism in particular, which is notable in this regard as the artistic movement most conspicuously written out of Greenberg's history of modernism. Perhaps more than any of the other thinkers represented here, the work of theorists like Krauss and Foster, and the journal *October* that has been its primary vehicle, has come to be synonymous with postmodern art history and theory. This is less true of de Duve, as his work has been less overdetermined by reaction to both modernism and Greenberg. Fried is a special case. Widely regarded as Greenberg's leading inheritor, and still infamous for his critique of minimalism in 1967, Fried has since distanced himself from Greenberg's own theorization of modernism, if not his 'canon' of privileged artists and artworks.

Buchloh, on the other hand, has focused on the legacy of the historical avant-garde – generally regarded as the competing tradition to modernism in art, in so far as it foregrounds art's embeddedness in the social world, as opposed to stressing its autonomy – particularly the rekindling of various avant-garde aspirations in more recent 'neo-avant-garde' form. To understand the critical nature of contemporary artistic practice in the light of its recent history

and historical precursors is a concern Buchloh shares with Foster. Outside these *Octoberist* responses to modernism, T. J. Clark has helped transform the practice of mainstream art history, since the 1970s, by bringing a form of Marxist analysis to bear on art as an expression of the broader social history of modernity. Meanwhile Nochlin and Pollock have, in different ways, addressed the exclusion of women from both the historical canon and the categories through which that canon is promulgated. Pollock in particular initiated a debate between the social history of art and feminism by arguing that this remained true of Clark's stress on issues of class to the detriment of questions concerning gender in his analysis of art's modernity. And she has gone on to develop an ambitious theory of the aesthetic, unique for being aligned with a feminist practice of art and art history, rather than being its target.

Elkins and Mitchell come from rather different perspectives, both from one another, and from the theorist-historians already discussed. Mitchell has maintained a long-standing concern with the relation between pictorial and linguistic representation, which eventually extended into a broader investigation of the cultural economy and circulation of imagery more generally. This even helped to found a new sub-discipline: 'visual culture' or 'visual studies' as it is sometimes known. While Elkins, who shares Mitchell's interest in the wider cultural realm of imagery, particularly scientific imagery, writes from a standpoint of radical empiricism that marks him out from some of the more abstruse theoretical reflections and language of other thinkers included here. The other exception is Bourriaud, a leading contemporary curator. We have included Bourriaud because his ideas, notably that of a 'relational' aesthetic, have had exceptional currency in the art world over the last decade. This 'rise of the curator' in recent art discourse, theory and practice reflects a broader cultural shift: it shows the extent to which the relation between an individual artwork and viewer at the core of modernist theories of art and aesthetics is now contested in the realm of creative practice, by artists, curators, theorists alike.

NICOLAS BOURRIAUD (1965-)

Nicolas Bourriaud is an independent curator, and was co-director, with Jerôme Sans, of the Palais de Tokyo in Paris (1999–2005). Prior to this he ran the literary quarterly *Revue Perpendiculaire*, co-founded and edited the contemporary art magazine *Documents sur l'Art* (1992–2000) and curated numerous exhibitions including *Aperto* (Venice Biennale 1993), *Traffic* (Capc Bordeaux, 1996), *Touch* (San Francisco Art Institute, 2002), *GNS* and *Playlist* (Palais de Tokyo, 2002 and 2003 respectively); he was also co-curator of the First Moscow Biennale and the 8th Lyon Biennale (both 2005). Bourriaud's career reflects the rise of the curator as a dominant influence on contemporary art discourse in the 1990s.

Bourriaud is best known among English speakers for his publications *Relational Aesthetics* (2002) and *Postproduction* (2000). *Relational Aesthetics* in particular has come to be seen as a defining text for a wide variety of art produced by a generation who came to prominence in Europe in the early 1990s. The book attempts to identify and characterize what is distinctive in contemporary European art as compared to that of previous decades. It does so by approaching it in a way that ceases 'to take shelter behind Sixties art history' (*Relational Aesthetics* [*RA*], p. 7), and instead seeks to offer different criteria by which to analyze the often opaque and open-ended works of art of the 1990s. To address this work Bourriaud imports the language of the 1990s Internet boom, using terminology such as 'user-friendliness', 'interactivity' and 'do-it-yourself'. Indeed, Bourriaud describes *Relational Aesthetics* as a book addressing

works that take as their point of departure the changing mental space opened by the Internet (*Postproduction* [*PP*], p. 8).

Bourriaud defines as 'relational', art which takes as its theoretical horizon 'the realm of human interactions and its social context, rather than the assertion of an independent and *private* symbolic space' (*RA*, p. 14). In other words, relational art seeks to establish intersubjective encounters that *literally* take place – in the artist's production of the work, or in the viewer's reception of it – or which exist *hypothetically*, as a potential outcome of our encounter with a given piece. In relational art, meaning is said to be elaborated *collectively* (*RA*, p. 18) rather than in the space of individual consumption. Relational art is thus conceived as the inverse of the privatized space of modernism as articulated differently by **CLEMENT GREENBERG** and **ROSALIND KRAUSS**: rather than a discrete, portable, autonomous work of art that transcends its context, relational art is beholden to the contingencies of its environment and audience. In some manifestations of this art, such as the performance-installations of Rirkrit Tiravanija, viewers are addressed as a social entity, and are even given the wherewithal to create a community, however provisional or utopian.

Most of the artists cited in *Relational Aesthetics* seem to be relational primarily through their working process; their interest in 'intersubjective' relations takes place *before* being presented to viewers in the gallery (for example the sculpture, video and photographic work of Maurizio Cattelan, Douglas Gordon, Pierre Huyghe,

Phillippe Parreno and Gillian Wearing).
A smaller number of artists confront the
viewer first-hand with *literal* presentations
of social relationships (for example the
hybrid performance-installations of Vanessa
Beecroft, Christine Hill, Rirkrit Tiravanija).
A smaller number again thematize social
relationships as the rationale leading
to formal concerns that elaborate on
architecture and design (e.g. Liam Gillick,
Dominique Gonzalez-Foerster, Jorge
Pardo). Bourriaud regards the Cuban
artist Felix Gonzalez-Torres (1957–96) as
an important precursor of relational art,
since his sculptures concern the joint
presence of spectators before the work
(such as piles of sweets to be taken away by
visitors). Joseph Beuys's concept of Social
Sculpture is considered less relevant, since
he approached the democratization of art
through the belief that 'everyone is an artist',
rather than through interactive procedures in
the work itself.

Relational Aesthetics cites a large number
of theorists and philosophers, including
Louis Althusser, Guy Debord, GILLES
DELEUZE, Emmanuel Lévinas and Karl Marx,
with Félix Guattari (1930–92) as the most
frequently cited thinker. Bourriaud takes
from Guattari the idea that the work of art is,
like subjectivity, a process of becoming: it is
a collectively produced and open-ended flux
that resists fixity and closure. Bourriaud's
interest in open-endedness can also be
compared to Marcel Duchamp (see his 'The
Creative Act', 1957), Umberto Eco (*The Open
Work*, 1962) and ROLAND BARTHES ('The
Death of the Author', 1968), all of whom
argued for the audience's active role in
creating a work of art's meaning. However,
for each of these authors *all* works of art
are open-ended entities; for Bourriaud, only
relational works have this quality. Bourriaud
implies that because of this generosity
towards the viewer, relational art presents
a superior ethical and political model to
traditional art forms such as painting.

To date, *Relational Aesthetics* has been
widely referenced and debated, but has
received only two sustained critiques.
George Baker ('Relations and Counter-
Relations', 2002) contrasts two installations
organized around the convivial consumption
of food: one by Rirkrit Tiravanija (arguably
the paradigmatic relational artist) and one
by Christophe Philipp Müller (an artist not
discussed by Bourriaud). Baker argues
that once relational art is canonized in the
museum – specifically, the Palais de Tokyo
– it becomes indistinguishable from leisure
and entertainment. Ultimately, he argues,
relational aesthetics is 'a compensatory move
made in the face of the overwhelming lack
of relationality in contemporary social life'
(p. 135). Instead, and referring to Jean-Luc
Nancy's *The Inoperative Community* (1991),
Baker approves the 'counter-relational'
art of Müller that foregrounds a lack at the
centre of social space; unlike Tiravanija's
escapism, Müller's work has critical
potential. In a similar vein, this author has
contested Bourriaud's claim that relational
art is a political and emancipatory mode
of artistic practice, and questioned the
prevalent view that dialogue between viewer-
participants is automatically 'democratic'.
Referring to Ernesto Laclau and Chantal
Mouffe's *Hegemony and Socialist Strategy*
(1985), which maintains that democracy
is not marked by consensus but a state of
irresolvable antagonism, I have argued that
the model of political subjectivity underlying
relational artworks by Rirkrit Tiravanija and
Liam Gillick is founded on the harmonious
identification of full subjects, by comparison
to the dis-identified, partial and 'antagonistic'
subject position produced in certain works
by Santiago Sierra and Thomas Hirschhorn
('Antagonism and Relational Aesthetics',
2004).

Other objections to *Relational Aesthetics*
tend to focus on Bourriaud's apparent
disregard for art historical precedents
('editorial introduction', 2004) and his

theoretical framework, in which a wide variety of philosophers are cited without sustained engagement (see Dagen, 1999; Sausset, 2004). Without referring to Bourriaud directly, Jacques Rancière has questioned the rhetoric of relational art and its attempts to strengthen a fantasmatic social bond. Despite these criticisms, *Relational Aesthetics* should be recognized as a serious and timely attempt to pinpoint important developments in 1990s art, thereby allowing artists and critics to articulate and situate their practices.

Postproduction is a shorter and more focused study, and discusses many of the same artists. The book claims that many contemporary artists can be compared to computer programmers or DJs: they take pre-existing cultural products (including other works of art), and remix them to produce new cultural meanings. Bourriaud offers five emblematic types as a way to demonstrate this idea: reprogramming existing works (such as Mike Kelley and Paul McCarthy's *Fresh Acconci*, 1995, a video restaging of 1970s performances by Vito Acconci); inhabiting historicized styles and forms (e.g. Liam Gillick diverting minimalism towards an 'archaeology of capitalism'); using pre-existing images (e.g. Douglas Gordon's *24 Hour Psycho*, which slows down Hitchcock's original film to last a whole day); using society as a catalogue of forms (e.g. Jens Haaning relocating a sweatshop into the Middelburg Kunsthalle); investing in fashion and media (e.g. Vanessa Beecroft's performances using models in designer shoes). Taking his cue from Michel de Certeau's claim that to use an object is to interpret it (*The Practice of Everyday Life*, 1984), Bourriaud regards these practices as empowering alternatives to globalization: 'artists reactivate forms by inhabiting them, pirating private property and copyrights, brands and products, museum-bound forms and signatures' (*PP*, p. 88). Techniques of sampling and remaking permit an active

and creative approach to our surroundings; they urge us to consider global culture as a 'toolbox', and open onto a multiplicity of narratives rather than accepting a dominant production line: 'Instead of prostrating ourselves before works of the past, we can use them' (*PP*, p. 88).

Unlike *Relational Aesthetics*, *Postproduction* makes few theoretical references and focuses primarily on a discussion of individual practices. Nevertheless, the text seems indebted to post-structuralist investigations into Jackobsonian linguistics (in particular the assertion that the meaning of a given element varies according to its syntagmatic position in the chain), and to Deleuze and Guattari's euphoric understanding of 'rhizomatic structures'. Such works can be seen as musical scores or unfolding scenarios that challenge passive, hierarchized culture in a de-territorializing 'line of flight'. However, it remains questionable to what extent remixing alone can produce an aesthetically valuable work. Art historically, Bourriaud situates postproduction as the most recent incarnation of appropriation art, noting the importance of Marcel Duchamp, *Nouveau Réalisme*, Pop art, Sherrie Levine and Jeff Koons as precursors. The Situationist idea of *détournement* is also alluded to, but the comparison is not pursued. Postproduction also cries out for comparison to ideas in literary theory and the social sciences: Claude Lévi-Strauss's *bricolage*, Oswaldo de Andrade's *anthropofagia* and Edouard Glissant's *créolisation*.

Relational Aesthetics attempted to lay out a mode of judgment for the works discussed, and *Postproduction* offers a similar set of criteria – albeit one that produces precarious and provisional judgments. Bourriaud argues that 'It is up to us to judge artworks in terms of the relations they produce in the specific contexts they inhabit' (*PP*, p. 88), without providing specific examples of such relations and contexts. The filmmaker Jean-Luc

Godard is invoked as a precursor for this ethic of individual responsibility: 'If a viewer says, "the film I saw was bad", I say, "it's your fault; what did you do so that the dialogue would be good?"' (*PP*, p. 29.) A good work of art is therefore one that allows viewers to engage with both the art and its context – and since the latter is open to constant renegotiation in every presentation of the work, judgments are only ever partial.

As Sausset observes apropos *Postproduction*, and by extension *Relational Aesthetics*, 'Few critical works are so full of flashes of ideas one would love to see deepened and developed… Few books, too, are this annoying in their discursive dead ends, their appropriation of certain ideas and their dogged will to convince readers, especially by means of a citational eclecticism'. Bourriaud's 'toolbox' approach to critical theory, and the apparent contradiction between his left-leaning discourse and the commercial phenomenon of the Palais de Tokyo, has prompted intense debate; it has also occasioned a backlash among a subsequent generation of artists for whom recent world events have prompted the need for a more politically engaged art that addresses specific contexts less opaquely. Bourriaud's curatorial position is ultimately both his strength and weakness: on the one hand close dialogue with artists has given him permission to ingeniously reframe contemporary practice unfettered by older models; on the other hand his texts are symptomatic of curatorial writing in preferring to furrow many paths lightly, overly focusing on the present instead of grounding observations within a broader historical and theoretical context. It is perhaps fitting that his writing articulates the convergence of artistic practice with the mediatory role of the curator – the relational remixer par excellence.

CLAIRE BISHOP

BIBLIOGRAPHY

Primary literature

Bourriaud, N., *Formes de vie. L'art moderne et l'invention de soi*, Paris: Editions Denoël, 1999.
Bourriaud, N., *Postproduction: Culture as Screenplay: How Art Reprograms the World*, New York: Lukas & Sternberg, 2000.
Bourriaud, N., *Relational Aesthetics*, Paris: Presses du reel, 2002.

Secondary literature

Baker, G., 'Relations and Counter-Relations: An Open Letter to Nicolas Bourriaud', *Contextualise/Zusammenhänge herstellen*, Kunstverein Hamburg and Köln: DuMont Verlag, 2002, pp. 134–46.
Baker, G., 'Editorial Introduction', *October* 110 (Fall 2004), pp. 49–50.
Bishop, C., 'Antagonism and Relational Aesthetics', *October* 110 (Fall 2004), pp. 51–79.
Dagen, P., 'Vague propos sur l'art', *Le Monde* (26 March 1999).
Gillick, Liam, 'Contingent Histories: A Reply to "Antagonism and Relational Aesthetics"', *October* 115 (Winter 2006), pp. 95–106.
Rancière, J., *Malaise dans l'esthétique*, Paris: Galilée, 2004.
Sausset, D., '*Playlist* at Palais de Tokyo' (review), *Art Press* 302 (2004), pp. 74–76.

BENJAMIN BUCHLOH (1941–)

Benjamin Buchloh is co-editor of *October* and teaches modern art at Harvard University. The significance of Buchloh's work lies in its expansion of the modern art canon, the demonstration of the critical potential of art, and the straddling of micro and macro levels of history. Buchloh's scholarship on art in post-war Europe or on unconventional media has broadened previous, particularly American, understandings of modern art.

A rigorous historical researcher, Buchloh always also assumes the role of critic, insisting on the critical responsibility of art vis-à-vis history and the present, while cautious about its limits. He maintains that one core function of art is to present the illusion, if not the realization, of a suspension of power (*Neo-Avantgarde*, p. xxiv; cf. **ADORNO**). In keeping with this, Buchloh often writes on artists of his own generation whose practice and thinking he knows intimately, and on artists who share his commitment, most importantly conceptual artists of the late 1960s and 1970s. Buchloh's combined roles as historian and critic spearheaded the merger of art history and art criticism that today defines writing on post-war art. Finally, Buchloh's thinking interweaves macro and micro perspectives on art, anchoring broad historical arguments in formal and material details; he demonstrates, as in his writings on the 'neo-avantgarde', historical and hermeneutic differences between seemingly similar artistic practices, and the similarities between ones seemingly different. Buchloh, in short, demonstrates why art matters.

Buchloh's intellectual formation pushed him in these directions. He came of age during post-war German reconstruction and studied in the country's hotbed of 1960s student protests (he received an MA in German literature with a minor in art history from the Freie Universität Berlin in 1969). The West German student movement had galvanized not only around the brutalities of Vietnam, and increasingly repressive tendencies of its own government, but also around continuities with the National Socialist regime and the nation's inability to work through its fascist past. Against this background, student and public discussion questioned the social and political relevance of cultural and artistic expression, fuelled by Frankfurt School Critical Theory (cf. Adorno and **BENJAMIN**), the mounting political influence of the news media, an omnipresent culture industry and the market for American painting. Following two years spent in London writing fiction, Buchloh entered the German art world in 1971. He worked as an editor, notably on the last two issues of *Interfunktionen*, a leading post-war European art magazine. He worked as a teacher – from 1975 to 1977 he was lecturer on contemporary art history and criticism at the Staatliche Kunstakademie in Düsseldorf, where his students included Isa Genzken, Thomas Schütte and Thomas Struth. And he worked as a (co-)curator of one-man shows (such as Marcel Broodthaers, **DAN GRAHAM**, and Gerhard Richter, at Rudolf Zwirner Gallery), on a survey of art exhibitions in Europe since 1946 and the first retrospective of Sigmar Polke, both at Düsseldorf's Städtische Kunsthalle in 1976.

The Polke exhibition bore the seeds of Buchloh's intellectual career. The exhibition catalogue, Buchloh's first publication on art and one of the first scholarly treatments of a post-war European artist, attends to the relationship between art and the culture industry and the former's critical potential. Polke's trivial, appropriated iconography and techniques, Buchloh argued, negate traditional conceptions of the creative artist while questioning their own evasion of communication. The exhibition itself formed an important early moment in German art's slow process of working through the historical weight of the Holocaust years. For the Düsseldorf venue of the exhibition, Polke presented his major paintings wrapped up in plastic and leaning against the back of a gate he had built carrying the insignia *Arbeit Macht Frei*, recalling the entrance to the Auschwitz concentration camp. The provocative display caused a scandal because it embodied, interrogated and ended a long silence. A year later Buchloh moved to North America. Eager to leave the 'strictures of the highly overdetermined cultural identity of postwar Germany', the new continent promised a welcome 'model of a postnational cultural identity' (*Neo-Avantgarde*, p. xvii). Buchloh produced the majority of his writing on art following this move. Its threefold significance can be traced in three central topics: post-war European art, conceptual art, and the 'neo-avantgarde'.

Writings on post-war European artists redress the widespread exclusive focus on American figures. The German painter Gerhard Richter forms the most significant and sustained subject of Buchloh's work, including his dissertation and more than ten essays, partially collected in a retrospective catalogue. Richter's art, for Buchloh, is deeply dialectical, engaging visual traditions and historical conditions while simultaneously questioning and opposing them. Richter's multiple pictorial strategies – blurred representational paintings and abstract paintings of gestural strokes, monochromes or grids – probe each other's validity. Reference points are modern European and post-war American artists, historical and contemporary conditions of mass culture, and crucial moments in German history like National Socialism and the divided Germany which Richter, himself an émigré from the GDR, experienced first-hand. The gestural paintings hover ambivalently between mechanical emptiness and sublime detail, between affirmation of and resistance to mass culture. Likewise, Richter's painterly blurring of mass media and family photographs references and resists practices of amateur photography and banal photojournalism, the realist premises of Socialist Realist and National Socialist painting, and the deskilling and montage techniques common to politically engaged art before the Second World War. Central paintings for Buchloh are *Onkel Rudi* and *18. Oktober 1977*, because they figure the unrepresentability of (German) history while insisting on the role of art to commemorate; and *48 Portraits*, because they project a 'post-traditional identity' that acknowledges the impossibility of a national, historical and cultural identity in post-fascist Germany.

Other European post-war artists are in Buchloh's estimation less successful in acknowledging the difficulties and complexities of working through national identity, history and mass culture. An essay on Joseph Beuys, widely discussed and earning Buchloh the reputation of a scathing critic, hinged on two points. He demonstrated that the autobiographical story which Beuys presented as the source of meaning in his work – a plane crash in the Crimean as a Nazi fighter pilot and his survival in the hands of Tartars who treated him with felt and fat – was pure fiction. Further, that Beuys' art was not only private and obsolescent, but also reactionary, even totalitarian, given its self-declared efforts to transfer politics into art. Aesthetic meaning

retreated from critical history into uncritical fiction and privacy.

Buchloh's writings on conceptual art and artists practising 'institutional critique' demonstrate the critical potential of art while also attending to its problems. The seminal essay 'Conceptual Art 1962–1969' (1990, hereafter *CA*) lays out a historical genealogy of the term and practice and argues that an aesthetic vocabulary of administration initially employed by proto-conceptualists and conceptualists was transformed into a critique of the institutional frameworks of art in the hands of other artists. The former replaced the transcendental, visual and material foundations of art making with a set of aesthetic strategies related to the vernacular realm of administration. Examples during this period include: the linguistic turn in the art of Sol LeWitt, who worked with contradictions between visual and verbal signs; legal documents in/as works of art such as ROBERT MORRIS's Statement of Aesthetic Withdrawal and Piero Manzoni's certificates of authenticity; vernacular forms of distributing art like Dan Graham's publication of *Homes for America* in *Arts Magazine*; arbitrary and abstract methods of quantification in Ed Ruscha's commercially produced books like *Twentysix Gasoline Stations*; and the architectural determination of art in Robert Barry's square canvas to be placed in the exact centre of the display wall. Artists practising institutional critique furthered the critical potential of this aesthetic of administration by using it to critique the social and artistic institutions which are themselves based on the logic of administration.

Artists like Lawrence Weiner, Hans Haacke and DANIEL BUREN demonstrated that art – its making, materials and display – is 'always already inscribed within institutional power and ideological and economic investment' (*CA*, p. 136) and turned by these institutions into a 'tool of ideological control and cultural legitimation' (*CA*, p. 143). The

Belgian Marcel Broodthaers (like Richter, central to Buchloh's thinking) dialectically and farcically enacted that critical potential, while also drawing attention to the implicit, devastating erosion of the sphere of art. Buchloh distinguished JOSEPH KOSUTH from his conceptual line-up; not only does he question the artist's dating of his well known *Proto-Investigations* to 1965 or 1966, but he charges him with perpetuating a self-reflexive modernism that fails to engage its context critically.

The concept 'neo-avantgarde' features prominently in Buchloh's thinking and in his hands becomes a powerful tool for thinking across the full span of twentieth-century art while simultaneously tending to individual artists and works. The term originates in literary theorist Peter Bürger's 1972 book *Theorie der Avantgarde* (first translated 1984) where the avant-garde between 1910 and 1930, with its critique of artistic autonomy, is contrasted with a post-war 'neo-avantgarde', which merely institutionalizes the original critique. Buchloh deems Bürger's reading faulty and reductive. In fact, all his writings on post-war art in one way or another demonstrate more complex and concrete ways in which it can be thought of in relation to pre-war art, ways in which the re-emergences of earlier pictorial strategies like the grid, the monochrome, the ready-made, collage and photomontage are not merely repetitions.

In 'The Primary Colors for the Second Time' (1986), he argues that historical context, especially reception histories, is essential in understanding post-war art beyond influence, imitation and authenticity. Thus, post-war French painter Yves Klein's self-proclaimed invention of the monochrome, along with his blue, red and gold monochromes, cannot be understood as simply repeating pre-war Russian artist Alexander Rodchenko's *The Last Painting* (1921), a red, yellow and blue monochrome triptych. Instead, while the latter sought

to abolish traditional aesthetic notions of myth and cult, the former revives practices of negation and esoteric experiences at a time when mass culture began to eliminate oppositional art practices and individual experience. In essence, reference points over the course of thirty years shifted from bourgeois art to corporate state. In other cases, Buchloh stresses similarities between pre- and post-war art to reveal unexpected continuities in meaning. In 'Figures of Authority, Ciphers of Regression' (1981), he argues that the relation between traditional modes of representation in European art of the 1920s and 1930s and the rise of fascism reveals a new authoritarian attitude and politically oppressive climate underlying the return to figuration in 1980s neo-expressionism.

Buchloh's critics have generally targeted his few sustained critiques of artists. Thus Donald Kuspit, a champion of neo-expressionism, challenged Buchloh to acknowledge that modernism had become an empty stereotype of itself and that neo-expressionism simply revealed the artificial nature of expression in a technological society where immediate experiences were no longer possible. Joseph Kosuth defended himself by stressing that Buchloh's critique was based on his writings rather than his art and by explaining the dating of his early work. Buchloh's attack on Beuys led scholars Peter Nisbet and Gene Ray to clarify the historical emergence of Beuys's autobiographic story and its role in Beuys's art. In the introduction to *Neo-Avantgarde and Culture Industry*, Buchloh discusses problems with his earlier work ranging from its exclusion of women artists to efforts to elevate artists to canonical stature. Such self-critique may be the true mark of critical competence.

CHRISTINE MEHRING

BIBLIOGRAPHY

Primary literature

Buchloh, B., 'Polke und das Große Triviale (mythisch oder pythisch?)', in *Sigmar Polke: Bilder, Tücher, Objekte: Werkauswahl 1962–1971*, Tübingen: Kunsthalle Tübingen, 1976.

Buchloh, B., 'Figures of Authority, Ciphers of Regression', *October* (Spring 1981).

Buchloh, B., 'The Primary Colors for the Second Time: A Paradigm Repetition of the Neo-Avantgarde', *October* (Summer 1986).

Buchloh, B., 'Conceptual Art 1962–1969: From the Aesthetics of Administration to the Critique of Institutions', *October* (Winter 1990).

Buchloh, B., *Gerhard Richter. Band II: Texte*, Bonn: Kunst- und Ausstellungshalle der Bundesrepublik Deutschland, 1993.

Buchloh, B., *Neo-Avantgarde and Culture Industry: Essays on European and American Art from 1955–1975*, Cambridge: MIT Press, 2000.

Secondary literature

Christine, M., 'Continental Schrift: The Magazine *Interfunktionen*', *Artforum* (May 2004).

Crow, T., 'Committed to Memory', *Artforum* (February 2001).

Ray, G. (ed.), *Joseph Beuys: Mapping the Legacy*, New York: D.A.P., 2001.

Kosuth, J. and Siegelaub, S., 'Reply to Benjamin Buchloh on Conceptual Art', *October* (Summer 1991).

Kuspit, D., 'Flak from the "Radicals": The American Case against Current German Painting', in *Expressions: New Art from Germany*, Munich: Prestel, 1983.

T. J. CLARK (1943–)

T. J. (Timothy James) Clark pioneered the social history of art in its contemporary form and remains its principal representative. As such, he was a leading figure in the emergence, in the 1970s, of 'the New Art History'. He was educated at the Courtauld Institute of Art. He taught at Essex University, Camberwell School of Art and Leeds University in the late 1960s and 1970s, then moved to the United States in 1980, first to Harvard University and then to the University of California at Berkeley.

Clark's writings are concerned mainly with the history of modernist painting in nineteenth- and early twentieth-century France, and in the United States during the 1940s and 1950s. His first two books, which appeared together in 1973, look at the relationship between art and politics in France during and after the 1848 revolution. *Image of the People* focuses on Courbet, *The Absolute Bourgeois* on Daumier, Millet and Delacroix. From the mid-1970s, he turned to the study of Manet and the Impressionists, culminating in *The Painting of Modern Life* (1985), arguably his most influential book.

A third phase, from the mid-1980s, builds towards the publication in 1999 of *Farewell to an Idea*, featuring seven more moments in modern art from David to Abstract Expressionism. Its subtitle, 'Episodes from a History of Modernism', can be said to describe Clark's art historical writings as a whole. They consist of analyses of exemplary moments at which modernist painting, typically in what it fails to be able to do, makes vivid the prevailing conditions of social life; that is, the consequences of capitalism and technocracy, for which Clark, in a tradition of Marxist cultural theory, uses the term 'modernity'. It is tempting to fit

the earlier work on mid-nineteenth-century France into the chronology of *Farewell to an Idea* to create the impression of a single history of modern art from the French Revolution to the Cold War. To unify his work in this way, however, would be to conceal both the changing mood of his thinking over thirty years, and the ways in which each phase responds to the political circumstances of the time at which he was writing.

The first two books were written (in 1969–70) in the aftermath of the miscarriage of the revolutionary potential of the 1960s. They offer Marxist rewritings of the ways in which, around 1848, modern art became intertwined with processes of revolution and counter-revolution. In their aims, values and method the books marked a clear break with orthodox art history. In 1974, Clark wrote an influential essay for the *Times Literary Supplement*, 'The Conditions of Artistic Creation', which can be seen as a reflection on method to complement his two books, and a manifesto for the social history of art. In this essay, he is critical of what he sees as the decline of art history from a discipline central to human self-understanding, in the nineteenth and early twentieth centuries, to one which, in the post-war period, had arguably become little more than a vehicle for connoisseurship in the service of the art market. Clark argues that earlier art historians such as Riegl and Panofsky were able to ask more fundamental questions (e.g. about the nature of representation) by virtue of the dialectical methods, drawn from Hegel, which enabled them to analyze complex relationships between subjective and objective moments in visual phenomena. Clark then proposes a renewal of art history involving a return to dialectical methods

but, against the idealizations of early art history, drawing upon a materialist Marxist-Hegelian tradition represented, for example, by Lukács. This 'social history of art' would have among its constitutive concerns (i) the relationships between style and ideology (in the Marxist sense of ideology as a regime of representation that naturalizes class hierarchies); and (ii) the conditions and relations of artistic production in specific cases, which determine any particular relationship between style and ideology.

The Painting of Modern Life offers a social history of the art of Manet and the Impressionists. In opposition to traditional studies' focus on stylistic innovations, Clark's book explores the relationship between those innovations and the new forms of social life, and myths of modernity, which appeared in Paris and its environs at the time. Its chapters deal with representations of the new environments of Second Empire Paris, especially the new spaces for leisure, such as the café-concerts, expositions and the day-trip destinations along the Seine. Just as his books on the post-1848 period address politics post-1968, so *The Painting of Modern Life* is written for the even less propitious circumstances, as they seem to its author, of the 1980s. Second Empire Paris provides a context in which to analyze the extension of capitalism into new areas of everyday life (specifically, those concerned with public pleasure), the consequences for social identities, and the problems of representation – issues which became vivid in the 1970s and 1980s. Much of the book is concerned with how the process of remaking Paris as a coherent set of images (in the period of Baron Haussmann's urban replanning) was a means for the bourgeoisie to enforce greater social control.

This process is understood as the creation of 'spectacle', a term drawn from Guy Debord's *The Society of the Spectacle* (1967), the most influential theoretical text produced by the Situationist movement. (Clark was a member of the Situationist International in 1966 and 1967; Situationist thinking remained an important frame of reference for him.) For Clark, the achievement of paintings such as Manet's *The 1867 Universal Exposition* (1867) is that they show spectacle to be a process, and so allow some critical distance from its products. The unresolved and disorderly aspects of Manet's paintings are seen as ways of making visible how Paris at that time was a construction site for the production of spectacle.

Clark's work on Manet and the Impressionists attracted criticism from feminist perspectives. GRISELDA POLLOCK argued that Clark's emphasis on class as the fundamental category of social analysis means that he is unable to account for the importance of sexual difference in the contexts he studies. She drew attention to how male perspectives were privileged in the new public spaces of modernity, and how Clark's account of modernity is generically 'male'. In the preface to the second edition of *The Painting of Modern Life*, Clark accepts feminist criticisms of the book as among the most significant.

Clark's treatment of canonical modernist works is a challenge to CLEMENT GREENBERG's dominant theory of modernism. The terms of the debate are set out in an exchange of essays between Clark and MICHAEL FRIED from 1982 (reprinted in Frascina, 1985). In 'Clement Greenberg's Theory of Art', Clark recognizes the Marxist agenda of Greenberg's early essays but questions his account of modernity and the theory of modernism that follows from it. On the basis of closer socio-historical attention to the conditions under which modernist art exists, he argues (i) modernist art is not 'autonomous', it cannot entirely possess its own values (let alone secure its value against a devalued culture at large) but that its values always exist in a dialectical interplay with those of the bourgeois class to which modernism belongs; (ii) the idea of autonomy misses the ideological dimension

of modernism's formal and material characteristics, not least those foregrounded by Greenberg (e.g. 'flatness' in painting can be an analogue for 'the popular' or 'the workmanlike'); and (iii) Greenberg misses the essentially negative character of modernism. For Clark, modernism is an art that acts against the conditions of its own value in order to act indirectly against the prevailing conditions of value in the social world.

The subsequent exchange with Fried is something of a missed encounter, each refusing to recognize the other's premises. Fried argues that Clark's insistence on the negative character of modernism prevents him from accounting for, what Fried himself sees as, the positive and independent aesthetic value of particular modernist works; Caro's sculptures are his prime example. Fried's claims for modernism's positive value entail a denial of the conditions of modernity as determined by capitalism. Clark refuses to admit Fried's particular aesthetic judgments as grounds for an argument about the value of modernism and denies that the aesthetic achievement of Caro's sculptures (or other works from Fried's canon) must be acknowledged. Clark also argues that his account allows, in principle, a wider range of modernist practice, including, for example, photography and Dada. This is significant since his own later history of twentieth-century modernism conspicuously does not cover those other practices. Although the introduction and conclusion to *Farewell to an Idea* refer to an expanded modernism – which includes film and photography – the seven case studies all concern themselves with painting. Since the 1980s, however, Clark and Fried have developed a mutually productive dialogue. This is probably because they value approximately the same canon of modernist painting, including notably the art of Jackson Pollock, and share, albeit for very different reasons, a disregard for both art after modernism and modern visual culture beyond art.

Clark's pessimism is even deeper in *Farewell to an Idea* than in previous books. His view is that capitalism has now extinguished the remaining possibilities for modernism's moments of critical detachment and social hope. The book presents itself as an archaeology of the modernist past which aims to recreate, in each case, the world to which fragments of modernist practice gave rise, even though those fragments cannot be taken up as models for current practice. It is in this respect that Clark is at odds with dominant tendencies in the history of modern art since the 1980s. More influential writers such as ROSALIND KRAUSS, HAL FOSTER and BENJAMIN BUCHLOH are all, in various ways, committed to the idea that rewriting the canon of modern art, with more attention to the practices disregarded by Clark (Dada, Surrealism, photography), can reveal critical possibilities in the art of the present. Clark's distance from these approaches is indicative of (i) his commitment to painting, (ii) his low regard for Duchamp and his legacy and (iii) his antipathy to postmodern and post-structuralist theories on the grounds that they forego the attempt to grasp the problem of modernity, that is, capitalism, in its totality.

Although Clark's work (and, for the most part, its influence) has remained within the study of an established Western canon of modernist painting, it is not clear that his approach is necessarily limited to it. It is central to his thinking that modernist painting's critical work on the representation of the social always involved some work *against* both the medium of art and its place in society, and he nowhere argues that that work is proper only to modernist painting. However, adapting Clark's account of modernism's critical work to admit other, maybe more recent, practices would entail finding equivalent aesthetic resources in technologies other than painting, and resisting his view that the processes of modernity are now complete.

DOMINIC WILLSDON

BIBLIOGRAPHY
Primary literature

Clark, T. J., *The Absolute Bourgeois: Artists and Politics in France, 1848–51*, London: Thames & Hudson/Berkeley: University of California Press, 1973/1999.

Clark, T. J., *Image of the People: Gustave Courbet and the 1848 Revolution*, London: Thames & Hudson/Berkeley: University of California Press, 1973/1999.

Clark, T. J., 'Clement Greenberg's Theory of Art' and 'Arguments about Modernism: a Reply to Michael Fried', in ed. Francis Frascina, *Pollock and After: the Critical Debate*, London: Harper & Row, 1985.

Clark, T. J., *The Painting of Modern Life: Paris in the Art of Manet and his Followers*, London: Thames & Hudson, 1985/1999.

Clark, T. J., 'The Conditions of Artistic Creation', (1974) in ed. E. Fernie, *Art History and its Methods*, London: Phaidon, 1995.

Clark, T. J., *Farewell to an Idea: Episodes from a History of Modernism*, New Haven: Yale University Press, 1999.

Secondary literature

Fried, M., 'How Modernism Works: A Response to T. J. Clark', in ed. Francis Frascina, *Pollock and After: the Critical Debate*, London: Harper & Row, 1985.

Pollock, G., 'Modernity and the Spaces of Femininity', *Vision and Difference: Femininity, Feminism and the Histories of Art*, London: Routledge, 1988.

THIERRY DE DUVE (1944–)

You might think that the arrival in the art world of everyday, abject and literary objects brought with it the end of the relevance for aesthetic theory of Kant's philosophy of form and judgment. And you might believe that this transformation – one version of the end of artistic modernism – was ushered in by Marcel Duchamp's ready-mades. Once bottle-racks, urinals and boxes of paper have muscled their way into the artistic canon, you couldn't be blamed for thinking that the Kantian idea that art is the occasion for cognitively significant exercises of aesthetic judgment is at the end of its rope. And if you feel that the concepts proffered by this antiquated theory of aesthetic experience impede your comprehension of art, and therefore that we need fresh theories capable of synthesizing our distance from all that happened in the age of modernism, you'd certainly find that you have plenty of company these days. But if, after a careful study of the postures available in the current art field, you find no room at all for a contemporary Kantian account of art and judgment, then your survey could not be complete, because you'd have neglected the work of Thierry de Duve.

De Duve is a curator, critic, historian and theorist. His major works in English

include historical and critical interpretations of Duchamp (*Pictorial Nominalism: On Marcel Duchamp's Passage from Painting to the Readymade* (1991) and *The Definitively Unfinished Marcel Duchamp* (1993), which he edited), a philosophical reanimation of Kant for contemporary aesthetic theory (*Kant after Duchamp,* 1996), a study of CLEMENT GREENBERG (*Clement Greenberg Between the Lines,* 1996) and a catalog from his exhibition devoted to passages through modernism (*Look: 100 Years of Contemporary Art,* 2000). De Duve has also authored critical essays on modern and contemporary artists from Edouard Manet to Jeff Wall, but it is Duchamp he recurrently champions in unexpected Kantian terms. In concluding *Kant after Duchamp*, a text that integrates history, theory and criticism, de Duve says that his aim, when all is said and done, is to understand why Duchamp is such a great artist. To understand de Duve we must comprehend from his point of view (i) what a fresh defence of Duchamp, whose influence in contemporary art seems undeniable, achieves at this moment in art's history; (ii) how such a defence can serve as the medium for a reanimation of Kant for contemporary aesthetic theory; and (iii) why Clement Greenberg, by common opinion a resolute nemesis of Duchamp's, should remain central to writing and thinking about art after modernism.

Duchamp stands at the head of that river of twentieth-century art that veers away from sensuous experience towards an ever expanding conceptualism. This claim puts in a theoretical voice the perception that Duchamp stands at the beginning of the end of the tradition of Western art that took painting, the art of sensuous immediacy par excellence, as paradigmatic for artistic experience. But because it is no business of de Duve's to deny this truism about Duchamp's break with painting, it is startling when he argues that even as Duchamp was giving himself the programme of ceasing to

paint in 1911–12, he was not, in fact, simply stopping painting. Rather, he was finding new and unexpected strategies to achieve what painting itself had long aspired to: 'If [Duchamp's] abandonment of painting was strategic, this strategy was not different in principle from the abandonment of chiaroscuro by Manet, of perspective by Cezanne, of figuration by Malevich' (*Pictorial Nominalism* [*PN*], p. 151).

Even, then, of Duchamp's bottle-rack and hair-comb, we cannot say that they are not paintings, or at least not on principled theoretical or historical grounds. De Duve finds that Greenberg also concedes this point, albeit obliquely, when,

> concerned to show that 'modernist painting' only deconstructs the historical conventions of painting one by one, in order to better anchor it to its irreducible being, [he] ends up localizing this being on the formal and technical qualities of an unpainted canvas, a readymade bought in an art supply store! Why stop there, and why not accept calling Duchamp's urinal a painting?' (*PN*, p. 156–57)

That de Duve puts his challenge to a firm distinction between painting and art that is not patently painting in the form of a question is not mere rhetoric, for Duchamp's artistic achievement, he argues, is to have turned the normal discursive practice of designating things as art by locating them in the history of their proper media into a persistent, perpetual problem of judgment. 'The readymade does not put the concept of painting into contradiction with itself; it renders the act of naming the painting undecidable' (*PN*, p. 159).

De Duve takes the concept of 'undecidability' from deconstruction in isolating how the use of the name 'painting' became uncertain; however, his argument takes a surprising turn to connect the problem of artistic naming in general to a reinterpretation of Kant's theory of aesthetic

judgment. De Duve's argument, detailed in *Kant after Duchamp*, is hard to compact, but in rough outline it is this: Duchamp's abandonment of painting does not deny the centrality of painting to modernist art. Rather, in the specific ways he departs from painting – from that art and no other – Duchamp redirects the fate of whatever was at stake in the experience of paintings towards an expanded realm of practice and experience. In this sense, Duchamp's project is not readily distinguishable from the practices of abstraction that constitute standard histories of modernist painting. However, 'Duchamp put his abandonment of painting on the record. *Fountain* spoke of art, or prompted people to speak of art in connection with it. We have passed from the specific to the generic, and this passage is a switch of names. Exit the painter, enter the artist, the artist in general' (*Kant after Duchamp* [*KD*], p. 194).

Duchamp made the relation of art to abandoned norms – the distance of 'art in general' from the conventions that had historically sustained the art of painting – an explicit problem for the practice of art. Thus, de Duve argues that when Duchamp tried to slip *Fountain* past the jury-that-was-no-jury at the New York Independents in 1917, he addressed thereby the 'crowd at large', and so '[gave] the crowd something it could judge on its own scale: art at large' (*KD*, p. 273). And it is with this category of 'art at large' – modern art that addresses no one in particular but rather anyone who can judge; modern art that arises out of the abandonment of the specificity of media and thereby makes the burden of judgment universal; modern art that transfers the authority of the Kantian tribunal of historical experts to all possible audiences for art – that de Duve's Duchamp begins to speak a version of the language of Kant. 'Duchamp's urinal is the outcome of an aesthetic judgment as surely as non-art is a "category" of art' (*KD*, p. 273). As art leaves behind the realm of experts, it merges with practices of judgment unanchored by expertise. In other words whereas for the Kant of the eighteenth century aesthetic judgment takes the form 'X is beautiful', for de Duve's post-Duchampian Kant the exemplary aesthetic judgment is 'X is art'. Thus, Kant's antinomy of taste – rational disputation about taste entails that judgments of taste are based on universal concepts while the singularity of such judgments entails that they are based not on concepts but on feelings – becomes an antinomy of art:

> Thesis: Art is not a concept.
> Antithesis: Art is a concept.

After Duchamp, the concept of art – the rule of inclusion in and exclusion from the world of artistic experience – is tainted with the same lack of decisive conceptual meaning that led Kant to postulate a *sensus communis* (shared faculty of feeling) as the ground of taste. Here we arrive again at the undecidability of naming art. According to de Duve, historical concepts no longer save us from the task of aesthetic judgment. Rather, they express aesthetic judgments. 'It is part of the postmodern heritage of modernity that [aesthetic] judgment should be anyone's ... what to do with our modern past cannot be decided by collective agreement. The sentence "this is art" is uttered individually and applies to individual works' (*KD*, p. 325). Persistent dispute now opens before us as the unending tribunal of judgments of art.

The claim that 'X is (or is not) a work of art' is an aesthetic judgment and not a matter of fact implies that there is no theoretical exit from the space of judgment. When the conventions of an art – painting, say – sustained that art on the basis of a tacit pact between artists and cultivated spectators about what instances of the art should achieve, the question of what counts as art could not arise. (That's the glory

of tacit conventions.) But once Duchamp has made the normative dimension of naming art explicit, two paths open up, as will happen when one struggles with an antinomy. One path aims to reground the 'art' concept theoretically; for de Duve, however, who is no stranger to sophisticated aesthetic theory, this misunderstanding of the function of art theory amounts to an avoidance of the problem that, in our moment after modernism, a work of art can arise whose significance as art simply is the undecidability of its status. The other path is Greenberg's. 'The good art critic', says de Duve of Greenberg 'doesn't deprive himself of theorizing, but he always proceeds intuitively' (*Clement Greenberg* [*CG*], p. 25).

In using 'intuition' here, de Duve embraces the Kantian notion that our subjectivity is staked to the convincingness of our experience. 'Greenberg writes in such a way that the speaking subject never disappears behind the subject of the sentence, but also in such a way that we feel that this assignation of the subject to different places does not dissolve the writing into subjectivism' (*CG*, p. 17). That the condition of aesthetic judgment after Duchamp offers no place to hide (from) the judge's subjectivity is the challenge Greenberg's criticism accepts. De Duve thus argues, contrary to much contemporary art theory, that Greenberg was right: in the end, it is the quality of art that critics judge. In other words since the test of the validity of an intuition is (as Kant had it) its ability to compel the *assent* of others, but at the same time (as Duchamp has it) intuition can find no respite from the *dissent* of others in a self-arrogation of tacit, expert knowledge of the right conventions, judgment comes down to quality, which is to say, to form. Because, after Duchamp, we are all addressed by art as members of the crowd and not as experts, the critic must take on his own shoulders the burden of experiencing art properly despite uncertainty about whom art is addressing. De Duve claims to learn from Greenberg that 'everything begins with the address, and the address is a demand for a pact' (*CG*, p. 64), that is, a new consensus forged through changed artistic conventions, but he adds the worry that we can never rest assured that this demand has been met.

The importance de Duve attaches to art's address is clear when he divides his exhibition *Look* (2000) into three parts: 'Here I Am', 'Here You Are', 'Here We Are'. But the matter of address is equally apparent in *Kant after Duchamp*, a highly theoretical text that begins: 'Imagine yourself an ethnologist...'. Because art after modernism has no settled address, the Greenbergian insistence on offering your experience to others in judgment is inescapable. De Duve's coupling of Duchamp and Greenberg may seem perverse, yet it provides the twist needed to keep the story of modernism's end from ending once and for all.

GREGG HOROWITZ

BIBLIOGRAPHY

Primary literature

de Duve, T. (ed.), *The Definitively Unfinished Marcel Duchamp*, Cambridge: MIT Press, 1991.
de Duve, T., *Pictorial Nominalism*, Minneapolis: University of Minnesota Press, 1991.

de Duve, T., *Clement Greenberg Between the Lines*, Paris: Dis Voir, 1996.
de Duve, T., *Kant after Duchamp*, Cambridge: MIT Press, 1996.
de Duve, T., *Look: 100 Years of Contemporary Art*, Amsterdam: Ludion, 2000.

JAMES ELKINS (1955–)

James Elkins was trained as both a painter (MFA, University of Chicago, 1983) and art historian (Ph.D., University of Chicago, 1989); he currently holds positions at the School of the Art Institute of Chicago and in the Department of the History of Art at University College, Cork. Much of his written work can be described as a critique of academic art history from the perspective offered by his experience of the studio, but this critique is nested within a larger enterprise, an effort to liberate our engagement with images from unnecessary conceptual constraints of all kinds. His writings might thus be divided between academically oriented texts that interrogate traditional art history from within, so to speak, and works addressed to a wider, non-academic audience. Few writers move so easily from one genre to the other; his work is impressive for the energy and assurance with which it assimilates wide-ranging interests and approaches, and perhaps even more so for its intellectual independence.

Elkins' first book, *The Poetics of Perspective* (1994), attempts to show that art historical scholarship has superimposed a false unity of aim and method onto the development of geometric perspective since the Renaissance, and thus normativized and rationalized what is actually a much richer and more chaotic phenomenon. This critique of art history is elaborated in a series of books that followed in the course of the next few years: *Our Beautiful, Dry, and Distant Texts* (1997) examines some of the conventions of art historical writing, attempting to show how the discipline is hampered by its self-imposed obligation to posture as a rigorous science or form of philosophical enquiry; *On Pictures and the Words that Fail Them* (1998) probes the limitations of language-based analytical techniques in dealing with visual imagery; *Why Are Our Pictures Puzzles?* (1999) considers the hypertrophy of writing about art in the twentieth century and interprets it as a sign of anxiety about the ways in which images fundamentally resist reduction to meaning. *The Domain of Images* (1999), perhaps the most satisfying of the books in the series, is an effort to survey the entire range of what can be classified as images and to suggest how it might be comprehended within analytical practice that greatly exceeds the scope of art history.

Critiques of art history are far from unusual. The so-called 'new art history', which began in the 1970s and 1980s, sought by a number of different means to overcome what it saw as the stultifying limitations of traditional practices, and Elkins shares many of its prevalent assumptions and strategies. The notion that 'art', understood as 'high art', needs to be displaced as the privileged object of enquiry, for instance, is now widespread: its original motivation was largely political, an effort to subvert the elitist cultural perspective that a fixation on high art objects seemed to reinforce. Elkins shares the desire to shift the emphasis away from high art, but he has gone further than any new art historian in suggesting that images of all kinds – not just 'low' art objects, but things like charts, scientific diagrams and advanced forms of computer imaging – also demand attention. Another well-established theme of the new art history, related to the first, is dissatisfaction with the predominantly Eurocentric quality of traditional art history. Again, Elkins has gone further than most towards redressing this situation with projects such as *Chinese Landscape Painting as Western Art Theory*

(1999), a text published in Chinese and in China. A similar project, *Why is Indian Painting Not Known in Europe?*, to be published in India, has been delayed.

In some respects, however, his position differs from that of most new art historians. Where much of their work has involved the application of 'theory' – interpretative methods developed in the fields of literary criticism, psychoanalysis and sociology – Elkins is critical of such adaptation when it seems to him to oversimplify the issues specific to visual experience. His review of **HAL FOSTER**'s *Compulsive Beauty*, a much-admired book about Surrealism, for instance, takes issue with the usefulness of psychoanalysis as an interpretative tool; in this review he makes use of the scepticism of traditional empiricists while also arguing the need for both a more intensive critical engagement with the limitations of empiricism and a more radically creative exploitation of its possibilities. *On Pictures and the Words that Fail Them* is a sustained critique of semiotics, which Elkins regards as but another form of 'logocentric' art historical rationalism. His insistence that images are fundamentally 'meaningless', open to criticism on a number of fronts, is perhaps best understood as a tactical overstatement intended to emphasize the way in which the need to find meaning inhibits our ability to see what is actually there before our eyes.

The book *Visual Studies: A Skeptical Introduction* (2003) surveys one of the most important developments associated with the new art history, the emergence of 'visual culture' studies. While some of the more ambitious proponents of the new field have argued that it should supplant art history altogether, they have also disagreed among themselves in fundamental ways, and these disagreements have threatened to undermine the entire enterprise. Elkins considers a variety of practices and possibilities, suggesting ways in which the field might constructively redefine itself. In *On the*

Strange Place of Religion in Contemporary Art (2004) he addresses an issue that critics and new art historians have taken care to avoid, attempting to initiate an enquiry into a source of interest suppressed even by those who consider themselves progressives. While he thus clearly extends the project begun by the new art history, he can also be seen as subjecting it to much-needed, productive critique.

Perhaps the most fundamental criticism that can be made of Elkins's work is its dependence on the concepts of 'image' and 'visual'. He is not unaware of the fact that they are problematic, that they are cultural and historical constructs as much as natural categories, yet by proceeding as if they constitute the unchallenged foundation for the kind of enquiry he offers in place of art history, he might be thought to run the risk of 'visual essentialism'. A radical art history, after all, might begin by questioning whether the history of art is in fact congruent with, or even only concentric with, a history of images, or of specifically visual experience, whether art is not always more conceptual than visual. Yet most art historians, even most progressives, would not be willing to go that far, to abandon the assumption that the path beyond the limitations of traditional art history must take us through a more intensive engagement with the 'visual' quality of 'images' that do not necessarily qualify as art.

In so far as such an emphasis on visuality could be seen as supporting a naturalistic grounding of reality in unmediated sense experience, it might also be thought to be unhistorical; but Elkins's interest in the visual is complemented by an almost equally intense concern with the challenge of writing about art and a sensitivity to the historicity of discourse about art, so that his approach works to reconstruct a historical perspective that in other respects it may seem to dismantle. His most recent book to date, *Master Narratives and Their Discontents*

(2005), is a critical survey of the various historiographic models that have been developed to explain artistic modernism and postmodernism. By objectifying them historically, it offers a fresh perspective on their dogmatic underpinnings, and hence performs a useful critical service. Turning history against history, so to speak, it points towards the role that history might play in the comprehensive approach to the visual that Elkins advocates.

The idea of meaning, which Elkins's academic work is often at pains to undermine, is frequently invoked in his popular writing. *What Painting Is* (1998) offers an extended meditation on the relation between painting and alchemy; the exercise

is worthwhile because, for Elkins, both practices are 'serious and sustained attempts to understand what substances are and how they carry meaning'. *How to Use Your Eyes* (2000) consists of thirty-three short essays on various features of the visible world and the way in which an informed attentiveness to them can help one to experience the world as 'thick with meaning'. Such essays, reminiscent of Joycean epiphanies, reveal the deep liberatory ambition of Elkins's project, its affinity with the liberatory ambition of high modernism. This quality may prove to be the most critical, most forward-looking thing about it.

ROBERT WILLIAMS

BIBLIOGRAPHY

Primary literature

Elkins, J., 'Art History without Theory', *Critical Inquiry* 14 (1988), pp. 354–78.

Elkins, J., *The Poetics of Perspective*, Ithaca: Cornell University Press, 1994.

Elkins, J., 'Review of Hal Foster, *Compulsive Beauty*', *Art Bulletin* 76 (1994), pp. 546–48.

Elkins, J., *The Object Stares Back: On the Nature of Seeing*, New York: Harcourt Brace, 1997.

Elkins, J., *On Pictures and the Words That Fail Them*, Cambridge: Cambridge University Press, 1998.

Elkins, J., *What Painting Is: How to Think about Oil Painting, Using the Language of Alchemy*, New York: Routledge, 1998.

Elkins, J., *The Domain of Images*, Ithaca: Cornell University Press, 1999.

Elkins, J., *Why Are our Pictures Puzzles? On the Modern Origins of Pictorial Complexity*, New York: Routledge, 1999.

Elkins, J., *Xi fang mei shu xue zhong de Zhongguo shan shui hua. Chinese Landscape Painting as Western Art History*, trans. Pan Yoachang and

Gu Ling, Hangzhou: National Academy of Art, 1999.

Elkins, J., *How to Use Your Eyes*, New York: Routledge, 2000.

Elkins, J., *Our Beautiful, Dry, and Distant Texts: Art History as Writing*, Pennsylvania: Penn State University Press, 1997.

Elkins, J., *Visual Studies: A Skeptical Introduction*, New York: Routledge, 2003.

Elkins, J., *On the Strange Place of Religion in Contemporary Art*, New York: Routledge, 2004.

Elkins, J., *Master Narratives and Their Discontents*, New York: Routledge, 2005.

Secondary literature

Bal, M., 'Semiotic Elements in Academic Practices', *Critical Inquiry* 22 (1996), pp. 573–89.

Duskova, K., Review of 'James Elkins, *What Painting Is*; *The Object Stares Back: On the Nature of Seeing*; *Our Beautiful Dry, and Distant Texts: Art History as Writing*; *On Pictures and the Words That Fail Them*; *How to Use Your Eyes*', *Art Bulletin* 84 (2002), pp. 186–88.

Williams, R., 'Sticky Goo', *Oxford Art Journal* 25 (2002), pp. 97–102.

HAL FOSTER (1955–)

Hal Foster's intellectual formation was constituted, initially as a critic, then as a critical art historian, in the fraught cultural context of New York in the late 1970s and 1980s. In 1978 he began to write art criticism for *Artforum* that was marked by a precocious ability to theorize postmodernism through critical theory. The strength of his early writing quickly established Foster as a major presence in the New York art scene: from 1981 to 1987 he was an associate, then senior editor at *Art in America*; in 1983 he edited a seminal collection of essays on postmodernism, *The Anti-Aesthetic: Essays on Postmodern Culture*; and in 1985 he published his first collection of essays, *Recodings: Art, Spectacle, Cultural Politics*.

After the appearance of *Recodings*, Foster's semi-independent position as an art critic shifted towards a more academically oriented position as an art historian. In 1987 he became the Director of Critical and Curatorial Studies at the Whitney Independent Study Program, and in 1990, after receiving his Ph.D. from CUNY Graduate Center (his dissertation on Surrealism, published as *Compulsive Beauty*, was directed by ROSALIND KRAUSS), he assumed a position in the Art History Department at Cornell University. Foster joined the editorial board of *October* in 1991, and in 1997 he was made Professor at Princeton University.

Along with other members of the *October* editorial board, and an older generation of critic-historians whom Foster cites as intellectual models – MICHAEL FRIED, Rosalind Krauss and T. J. CLARK – Foster has consistently assumed the double role of critic and historian. As he has stated, 'I've never seen critical work in opposition to historical work: like many others I've

tried to hold the two in tandem, in tension. History without critique is inert; criticism without history is aimless' ('Polemics, Postmodernism, Immersion, Militarized Space', p. 322). This dialectical imperative of history conceived through criticism stems, in large part, from the cultural context in which Foster first began to write criticism: at the juncture of late modernism and emergent postmodernism. For Foster, as for other like-minded critics, postmodernism offered the potential of an artistic rupture with the past, while crucially *maintaining* ties to historical and neo-avant-garde movements. As he describes in *The Return of the Real*, this often vexed relation between historical continuity *and* discontinuity strikes to the heart of the avant-garde problematic: 'Crucial here is the relation between *turns* in critical models and *returns* of historical practice ... how does a *reconnection* with a past practice support a *dis*connection from a present practice and/or a development of a new one?' (*Return of the Real*, p. x). The continued avant-garde negotiation between social-political critique and historical engagement is, for Foster, the core challenge of art in the wake of modernism.

The urgency during the 1980s of articulating a historically critical postmodernism stood in opposition to a countervailing, pluralistic postmodernism that proclaimed the failure of the avant-garde. 'Against Pluralism', the opening essay of *Recodings*, took direct aim at this brand of postmodern eclecticism, charging the embrace of historical pastiche with market complicity and outmoded aestheticism. In *Recodings*, Foster posits two mutually exclusive directions for postmodernism: *either* a historical continuation of avant-garde

criticality – moving vertically (diachronically) through history while horizontally (synchronically) widening the social fabric of art; *or* the abandonment of a historically necessitated criticality in favor of traditional conceptions of artistic expression, taste and style. As Foster writes: '[with pluralism] old values are revived, ones necessary to a market based on taste and connoisseurship, such as the unique, the visionary, the genius, the masterpiece… Style, that old bourgeois substitute for historical thought, is preeminent once again' (*Recodings*, p. 17).

In opposition to a pluralistic, pick-and-choose-style postmodernism, Foster championed a generation of early to mid-1980s artists including Martha Rosler, Sherrie Levine, Louise Lawler, Dara Birnbaum, BARBARA KRUGER, Jenny Holzer, Krzysztof Wodcizko and Allan McCollum. Crucial to what Foster calls the 'situational aesthetics' ('special attention to site, address, and audience') of these artists is their extension of the neo-avant-garde institutional critiques advanced by such artists as DANIEL BUREN, Michael Asher, Hans Haacke and Marcel Broodthaers. Foster writes, 'just as the conceptual artists extended the minimalist analysis of the art object, so too these later [postmodern] artists have opened up the critique of the art institution in order to intervene in ideological representations of languages and everyday life' (ibid., p. 100).

Foster argues for a variety of ways in which postmodernism furthers the work of the neo-avant-garde. First, postmodernism expands the site of critique beyond the infrastructure and institutions of art (gallery, museum, art market) into a more extended public sphere (bus shelters, baseball stadiums, taxi cabs, etc.). Second, moving beyond a restricted institutional framework enacts a shift away from conventional media (such as painting and sculpture) as the objects of ideological and ontological critiques towards media, images and language such as advertising, television or political rhetoric. Third, while minimalism and post-minimalism activated the body of the viewer, postmodernism no longer assumes this body to be indifferent to the conditions of gender, race or class. Finally, postmodernism develops new strategies by which to resist the institutionalization of 'institutional critique' itself – to resist, that is, the relentless appropriation of avant-garde critique into the professionally sanctioned folds of mere expertise.

Foster has also criticized 'visual culture' studies, accusing it of 'a loose, anthropological notion of culture, and a loose, psychoanalytic notion of the image'. Douglas Crimp has led the counter-attack in his article in *Social Text* in 1999, 'Getting the Warhol We Deserve: Culture Studies and Queer Culture', arguing that Foster's emphasis on the historicity of the avant-garde suppresses the broader cultural network in which it is situated. Crimp is particularly critical of Foster's elision of sexual identity in his treatment of Andy Warhol in *The Return of the Real*.

Despite the advances of early postmodernism, by the mid-1990s the future viability of a postmodern avant-garde had, for Foster, entered a state of crisis. The necessary dialectical tension between the vertical/historical axis of continuity and the horizontal/social axis of discontinuity had broken down such that, 'sometimes the vertical axis is neglected in favor of the horizontal axis, and often the coordination of the two seems broken' (*Return of the Real*, p. xi). For Foster, this breakdown resulted not from the avant-garde's failure, but from its success.

The seeds of this crisis can be traced, he claims, to the avant-garde's efforts to shift from a historically grounded criterion of *quality*, to a critically determined criterion of *interest*. Locating the dialectical breakdown of contemporary art in the success, rather than failure of the avant-garde, is a strategic move on Foster's part, allowing for the

open acknowledgement of avant-garde crisis, while resisting the despondency of critical and historical surrender. Taking aim at Peter Bürger's influential *Theory of the Avant-Garde* (1984)– a work that asserts not only the failure of the historical avant-garde, but posits a cycle of farcical repetition within its 'neo-avant-garde' counterpart – Foster argues for a dialectical model by which to redeem these purported failures. 'Immodestly enough', he writes, 'I want to do to Bürger what Marx did to Hegel: to right his concept of the dialectic' (*Return of the Real*, p. 15). To this end, Foster puts forward an alternative model of the neo-avant-garde's engagement with historical antecedents. Using the example of Marcel Duchamp's ready-mades, Foster grants *limited* credence to Bürger's claim that Duchamp failed to undermine bourgeois notions of artistic expressivity or to push artistic autonomy into the everyday. This initial failure, Bürger claims, is not only repeated in the neo-avant-garde ready-mades of Jasper Johns, but, worse, the latter actually nullify Duchamp's initial critiques, such that the avant-garde is institutionally affirmed and legitimized within mainstream artistic production. While Foster grants Bürger partial due, he insists that this view misses what is essential to the advances of the neo-avant-garde – namely the ways in which it uses the historical avant-garde's initial failures and institutional appropriations to provide the *very objects of critique* that allow for neo-avant-garde continuity and discontinuity. Thus, the multiple historical incarnations of the ready-made do not simply echo a distant origin in Duchamp, but diachronically and synchronically open the Duchampian ready-made into ever expanding areas of critique.

Where Foster advocates a recuperative dialectic for the first generation of neo-avant-garde postmodernism, he finds the dialectical engine of history and critique inadequate by the mid-1990s, observing: 'Different models of causality, temporality,

and narrativity are required; far too much is at stake in practice, pedagogy, and politics not to challenge the blindered ones that are in place' (*Return of the Real*, p. 28). Instead, he proposes a radically non-dialectical model based on the Freudian notion of 'deferred action' (*nachträglichkeit*). According to this model of deferred action, the historical and epistemological significance of the avant-garde is never fully apprehended in the first instance. Nor can it ever be, as the avant-garde is registered as a form of trauma – as a hole in the symbolic order of history. Thus, while the historical avant-garde struggled to work through the traumas of modernity, the neo-avant-garde responds to, and attempts to work through, the deferred action of this initial trauma. In place of a succession of avant-garde movements building on preceding movements (an evolutionary model of historical progress), Foster posits a new temporal model of the avant-garde in which the future-anterior tense of deferred action – the *will-have-been* – replaces the stable, self-contained temporality of the 'past', 'present' and 'future' tenses (that is, 'past' artistic movements advanced by 'present' and 'future' movements). The future anterior thus marks the temporality of an avant-garde that is never fully present to itself because it will never have *fully* taken place in the first instance.

In his model of deferred action, Foster has an unlikely ally in another influential thinker of the postmodern, JEAN-FRANÇOIS LYOTARD. Although there are many differences between these two theorists, they share a view of avant-garde production as the necessary working through of historical trauma. As Lyotard describes this process:

> We would have to compare [avant-garde] work with anamnesis, in the sense of psychoanalytic therapy. Just as patients try to elaborate their current problems by freely associating apparently inconsequential details with past situations – allowing them to uncover hidden meanings in their lives

and their behavior – so we can think of the work of Cézanne, Picasso, Delaunay ... as a working through performed by modernity on its own meaning. If we abandon that responsibility, we will surely be condemned to repeat, without any displacement. ('Note on the Meaning of "Post-"', in *The Postmodern Explained*, pp. 79–80)

Equally committed to the responsibility of an avant-garde that works through the traumatic ruptures of history, Foster also refuses to accept repetition without displacement. For avant-garde repetition, Foster claims, is never simple repetition – never mere redundancy or outright failure – but a symptomatic displacement of an initial failure that must be continually worked through and never fully understood. In the end, the historical returns of the avant-garde constitute, for Foster, a history of the Real that returns not only from the past, but also from future avant-gardes that will attempt, and fail, to work through a breakdown in the symbolic order at the heart of history and criticism.

GORDON HUGHES

BIBLIOGRAPHY

Primary literature

Foster, H., *Recodings: Art, Spectacle, Cultural Politics*, Seattle: The Bay Press, 1985.

Foster, H., *Compulsive Beauty*, Cambridge: MIT Press, 1993.

Foster, H., *The Return of the Real*, Cambridge: MIT Press, 1996.

Foster, H., *Design and Crime (and other Diatribes)*, London: Verso, 2002.

Foster, H., *Prosthetic Gods*, Cambridge: MIT Press, 2004.

Foster, H., with Krauss, R., Bois, Yves-Alain and Buchloh, B. H. D., *Art Since 1900: Modernism, Antimodernism, Postmodernism*, New York: Thames & Hudson, 2004.

Foster, H. (ed.), *The Anti-Aesthetic: Essays on Postmodern Culture*, Seattle: The Bay Press, 1983.

Foster, H. (ed.), *Vision and Visuality: Discussions in Contemporary Culture, No. 2*, Seattle: The Bay Press, 1988.

Foster, H. with Hughes, Gordon (eds), *October Files: Richard Serra*, Cambridge: MIT Press, 2000.

Smith, Marquard, in conversation with Hal Foster, 'Polemics, Postmodernism, Immersion, Militarized Space', *Journal of Visual Culture* vol. 3 (2004).

Secondary literature

Bürger, P., *Theory of the Avant-Garde*, trans. Michael Shaw, Minneapolis: University of Minnesota Press, 1984.

Lyotard, J.-F., *The Postmodern Explained*, Minneapolis: University of Minnesota Press, 1992.

MICHAEL FRIED (1939–)

Michael Fried's early reputation was established by a body of criticism written between 1961 and 1970 that has proved central to understanding the American art of the period and continuously controversial. This is particularly true of 'Art and Objecthood' (1967), an attack on minimalism which has set the terms for discussion of that movement and so also for the ways in which critics and art historians have taken up its relation to particular movements and bodies of work, as well as larger questions concerning a putative 'postmodernism' that surfaced in the visual arts from 1980 onwards.

Fried effectively withdrew from the field of contemporary art around 1970 and has since been primarily active as an art historian, producing an interlocking series of studies of Diderot, Courbet, Manet, Eakins and Menzel, as well as a number of essays that point to other projects still underway – one on 'literary impressionism', another on Caravaggio and a third on large-scale photography that marks a return to contemporary art. The relations between the two sides of Fried's work are not easy to sort out; in the introduction to a recent collection of his criticism from the 1960s, Fried writes:

> [B]etween myself as historian of the French antitheatrical tradition and the critic who wrote 'Art and Objecthood' there looms an unbridgeable gulf... The present writer ... sees no way of negotiating the difference between the priority given in his criticism to judgments of value both positive and negative and the principled refusal of all such judgements in the pursuit of historical understanding... (*Art and Objecthood: Essays and Reviews* [*AO*], p. 51)

This is said with respect to historical writings that have the clearest relation to the criticism; the task of offering an overall account of Fried's work becomes still more difficult given Fried's ongoing attention to work that appears independent of the particular French tradition that Fried takes to inform his criticism.

This same introduction includes an autobiographical sketch in which Fried notes a number of formative influences and relationships: his undergraduate friendship at Princeton with Frank Stella and, through Stella, Darby Bannard, both of whom he later championed as painters; his early acquaintance with CLEMENT GREENBERG; and two years spent in England (initially on a Rhodes Scholarship) notable for his criticism as a London correspondent for *Arts Magazine*, a period of philosophical tutelage with Stuart Hampshire and RICHARD WOLLHEIM and, perhaps most importantly, his first encounter with the work of Anthony Caro – an experience that secured for him the place of conviction within critical response and gave him a continuing and crucial touchstone.

Returning to the US in 1962, Fried entered Harvard's graduate programme in art history while continuing to write criticism (primarily for *Arts International*). During this period he also curated the 1965 exhibition *Three American Painters: Kenneth Noland, Jules Olitski, and Frank Stella* at the Fogg Art Museum, writing his first major critical essay for that catalogue. It was at Harvard that Fried met STANLEY CAVELL; the value and intensity of their conversations have been repeatedly acknowledged by both figures, and significant stretches of their individual works are not fully comprehensible without

reference to the other's. A self-confessed 'philosophical groupie', Fried's work has unfolded in continuous conversation with philosophy: in addition to Cavell, MERLEAU-PONTY has been a major reference and resource throughout Fried's career, and particular works have drawn on the writings of Derrida, Kierkegaard and Wittgenstein. Fried's acknowledgements also underline the importance to him of developments and arguments in literary theory from the early 1970s onwards; the literary critic Walter Benn Michaels is prominent among the many interlocutors whose influence Fried acknowledges.

In the mid-1960s Fried's critical essays began appearing in *Artforum*, which under the leadership of Philip Leider constituted a sustained experiment in criticism, publishing an extraordinary range of essays by both critics and artists, and establishing itself as the decade's foremost journal of contemporary art. 'Art and Objecthood' appeared in *Artforum*'s June 1967 issue devoted to 'American sculpture'. The March 1969 issue was subsequently given over in its entirety to publication of Fried's dissertation, *Manet's Sources: Aspects of His Art, 1859–1865*, marking the beginning of Fried's turn away from criticism and towards art history, a turn roughly coinciding with both his departure from Harvard for Johns Hopkins University and the acrimonious break up of *Artforum*.

The controversies of the 1960s have continued to strongly condition the reception of Fried's work, both critical and historical. In particular, he and Greenberg – whose early influence on him is indubitable – have been repeatedly linked under the rubric of 'Kantian formalism', a rubric that has led to a range of further simplifications. It is important to note then that while 'Art and Objecthood' advances judgments that are, as a matter of taste, largely in line with Greenberg's (with the proviso that Greenberg never shared Fried's support of Frank Stella's work), the essay marks a significant theoretical break

with Greenberg that has deepened over time. The particular point of disagreement is over the status of 'medium' – Greenberg holding to an untenable notion of a timeless essence underlying each of the individual arts, and Fried holding a much more markedly conventionalist and historicist notion of a medium's 'essence':

> [T]he crucial question is not what those minimal and, so to speak, timeless conditions are, but rather what, at a given moment, is capable of compelling conviction, of succeeding as a painting. This is not to say that painting *has no* essence; it *is* to claim that that essence – i.e. that which compels conviction – is largely determined by, and therefore changes continually in response to, the vital work of the recent past. (*AO*, p. 169)

The qualification 'at a given moment' suggests that for Fried we do not know what a form is apart from a strong grasp of its appropriate context, and Fried's historical work does indeed reflect a strong contextualist orientation – the account offered of Courbet consists largely in close interpretations of a number of individual works, the account of Manet draws more heavily on both contemporary criticism and the evidence of certain kinds of compositional difficulty evident in the work of Manet's generation, and the account of Menzel locates him in relation to a nineteenth-century discovery of the ordinary that Fried finds well-glossed by Kierkegaard's Judge William (as well as Cavell's Thoreau). At the same time, Fried's goal across these books is to render the work visible – that is, to elaborate the terms in which the work most fully shows itself to be what it is. Arguably, a sense that the work remains in need of showing is the underlying motive of 'formalism', particularly in contrast with other modes that take the exposition of meaning to be the primary task.

Understood this way, Fried's proposed contrast between his historical and critical

activities is less marked than may first appear: the point would simply be that critical judgments cannot be deductively justified by a history (and vice versa). This feeling for the continuing openness of past and present to one another informs Fried's writing from the beginning of his career. In this sense, art history is for Fried, as it is for Michael Baxandall, essentially a branch of art criticism. Seeing this helps in seeing something that Fried's remark about the contrast between 'the priority given ... to judgments of value' and 'the principled refusal of all such judgment' threatens to gloss over: critical judgment in Fried's writing is never a matter of something like a decision based on descriptive or other evidence; judgment is rather the fact of description itself. Thus one core version of the argument of 'Art and Objecthood' is: if this is indeed the experience in question, this is not the experience of a work of art.

Fried's description of the experience of minimalist work has been widely accepted as definitive; that many of his critics think they can then simply reverse his judgment of its value is deeply peculiar, and indeed the peculiarity of that thought must for him be of a piece with the peculiarity of minimalism itself, as if minimalism were something like the mistaking of its own initiating experience. Imagine someone going through a museum taking careful notes on what everything in it means, and then sitting down to make something meaningful of his own; you might say that he or she failed to see that those things were paintings, or took that feature of them to be some 'mere convention' floating – or perhaps imposed – on the deeper substance of meaning. Minimalism on Fried's account is something like that, inviting us into deep confusions about the relations between the fact of a work and something we'll be tempted to distinguish as its value. That value and description mesh in the experience of art means that the difference between criticism and history is a matter of dialectical accent in a situation where there is no final punctuation for art's history and so no definitive parsing of its rhythms nor any definitive way of locating one's self securely within them – a point powerfully made by Cavell in his two key early essays in aesthetics, 'Music Discomposed' and 'A Matter of Meaning It' (both 1967).

If there is a certain 'Kantianism' at the heart of Fried's view of art, it has very little to do with Greenberg's arguments about a modernist imperative for the arts to hunt themselves back to their areas of irreducible competence (a notion loosely derived not from Kant's aesthetics but from the introduction to the First Critique), and everything to do with the thought that there is something like a judgment of experience – a judgment integrally embedded in experience and registered in a voice that is not exactly one's own and so given to testing its shareability. If we can get that far paraphrasing Kant in the vicinity of Fried, one would have to add the further, very unKantian, thought that experience is not to be had apart from its various modes of self-evasion and self-refusal. This is one way to state the interest Fried continues to find in Cavell and Wittgenstein, in DERRIDA and Kierkegaard.

That art matters for Fried in no small part because it is a place where we test or discover our capacity for experience is one way of phrasing the ethical or political animus so palpable just beneath the surface of his writing. Like T. J. CLARK, Fried's concern is less with the ins and outs of our stories about modernism and postmodernism than with the larger fate of modernity, and the ways in which we are and are not able to find or live our lives within it.

STEPHEN MELVILLE

BIBLIOGRAPHY

Primary literature

Fried, M., *Absorption and Theatricality: Painting and Beholder in the Age of Diderot*, Berkeley: University of California Press, 1980.

Fried, M., *Realism, Writing, Disfiguration: On Thomas Eakins and Stephen Crane*, Chicago: University of Chicago Press, 1987.

Fried, M., *Courbet's Realism*, Chicago: University of Chicago Press, 1990.

Fried, M., *Manet's Modernism or, The Face of Painting in the 1860s*, Chicago: University of Chicago Press, 1996.

Fried, M., *Art and Objecthood: Essays and Reviews*, Chicago: University of Chicago Press, 1998.

Fried, M., *Menzel's Realism: Art and Embodiment in Nineteenth-Century Berlin*, London: Yale University Press, 2002.

Secondary literature

Caveli, S., *The World Viewed: Reflections on the Ontology of Film*, New York: Viking Press, 1971.

Cavell, S., *Must We Mean What We Say?*, Cambridge: Cambridge University Press, 1976.

de Duve, T., *Kant after Duchamp*, Cambridge: MIT Press, 1996.

Frascina, F. (ed.), *Pollock and After: The Critical Debate*, New York: Harper & Row, 1985.

Melville, S., *Seams: Art as a Philosophical Context*, Amsterdam: G+B Arts International, 1996.

Michaels, W. B., *The Shape of the Signifier: 1967 to the End of History*, Princeton: Princeton University Press, 2004.

Mulhall, S., 'Crimes and Deeds of Glory: Michael Fried's Modernism', *British Journal of Aesthetics* vol. 41, no. 1 (January 2001).

Pippin, R., 'Authenticity in Painting: Remarks on Michael Fried's Art History', *Critical Inquiry* vol. 31, no. 3 (Spring 2003).

Ross, T., Robert, M. and Beaulieu, J. (eds), *Refracting Vision: Essays on the Writings of Michael Fried*, Sydney: Power Publications, 2000.

CLEMENT GREENBERG (1909–1994)

Clement Greenberg was probably the most influential art critic and theorist of the twentieth century. His first articles appeared in *Partisan Review* in the late 1930s. At *Partisan Review* he was part of a circle of highbrow, Marxist intellectuals and critics. Greenberg became an editor of the magazine for two years in 1941, and served as art critic to *The Nation* throughout the 1940s, before focusing on longer articles, catalogue essays,

and organizing exhibitions during the 1950s. Throughout this period he was an associate editor of *Commentary*. His reputation was built on championing New York School painting, which he took to be inheriting, and extending, the formal advances of pre-war School of Paris.

In 1961, *Art and Culture*, his first collection of his essays and criticism, appeared, and became hugely influential for both followers and detractors. The fact that Greenberg, a highly partisan critic, supplemented his income as an advisor to galleries such as French & Co. only added to the controversy surrounding him. This was compounded when the USIA (United States Information Agency) broadcast 'Modernist Painting' as a 'Voice of America' radio lecture as part of its effort to project an image of America's cultural freedom during the Cold War. When historical and sociological analysis of Greenberg's role in American culture began in the early 1980s, this fact led to a deepening perception of a theoretical *and* political retrenchment in Greenberg's views in his later work.

But as early as the mid-1960s Greenberg's position came under pressure from a range of movements, including Minimalism, Conceptual art and Pop art, that flouted the strictures of modernist theory. At the same time, Greenberg's increasingly dogmatic pronouncements about an art world that had rejected his canon, and the taste that underwrote it, made him something of a hate-figure during the 1970s and 1980s. This changed with the publication of his *Collected Essays and Criticism* in 1986 and 1993; the seriousness of his criticism was acknowledged once more, for all its trenchancy and exclusions, and his work received renewed attention from art historians and theorists not involved in the bitter rejection of his views the first time round.

Greenberg's work can be divided into an early, mature, and late period. His early

position is encapsulated in 'Avant-Garde and Kitsch' (1939) and 'Towards a Newer Laocoon' (1940), his mature work by 'Modernist Painting' (1960) and 'After Abstract Expressionism' (1962), and his late work by the 'Bennington Seminars' (1971). Despite appearances to the contrary, Greenberg's position remained consistent, though its emphasis shifted: where Greenberg's early work focused on the historical and social question of *why* modernism arose, and his mature work on the formal or artistic question of *how* it worked, his late work addressed the *aesthetic* theory underpinning this account. This increasing concern with modernism's autonomous development and questions of taste, at the expense of his earlier social theory, is the reason Greenberg is often said to have abandoned his early artistic and political radicalism in favour of a conservative defence of artistic values for . their own sake.

Greenberg offered a variety of reasons for *why* modernism arose, including the social turmoil of mid-nineteenth-century France, which politicized artists while leaving them unsure of who their work addressed, and the preference for the 'positive', 'concrete' and 'immediate' in modern experience. But he is best known for the claim (in 'Avant-Garde and Kitsch') that avant-garde art was under threat on two fronts. The stagnation of the French Academy by the latter half of the nineteenth century threatened art with vacuity and irrelevance; while the need to feed the new urban mass's desire for distraction and entertainment gave rise to 'kitsch', a debased surrogate for authentic culture that raided the latter for whatever it could strip away and represent in predigested form (cf. **ADORNO** on 'culture industry'). In the face of this dual threat to its existence, Greenberg claimed high art turned in on itself in order to survive.

Looking back over a century of modernism, Greenberg claimed (in 'Modernist Painting') that one could – if only in retrospect – trace

this inward turn as each art tried to show that it offered a form of experience not to be found elsewhere. This is the root of his account of *how* modernism works. Each art foregrounded the 'unique and irreducible' properties of its medium as the source of whatever was specific to the experience it had to offer. Painting, for example, showed that it consisted minimally and essentially of 'flatness and the delimitation of flatness' ('After Abstract Expressionism') because adhering to these two 'constitutive conventions or norms' sufficed to create an object that could be experienced as painting. As a result, painting foregrounded flatness as the guarantor of its specificity as an art, and hence its unique source of value. In Greenberg's narrative, this process led from Manet, through Impressionism and post-Impressionism, via Cubism (and the flagrant marginalization of Dada and Surrealism), to culminate in European abstract artists like Mondrian and Miro, before it was taken up by post-war Abstract Expressionism in New York.

By the mid-1960s this narrative forced Greenberg (and his follower **MICHAEL FRIED**) to reject the majority of work then occupying the art world's attention. In this respect the first critics of Greenbergian modernism were those artists whose work flouted its constraints: Pop art contested its distinction between high art and popular culture; minimalism refused any a-priori division between the arts in terms of media; and conceptual art rejected taste as an adequate measure of artistic value. Greenberg responded by dismissing them all, leading to his own increasing marginalization. In response, Greenberg sought to fortify his position by appealing to Kant's aesthetics. This inaugurates the late period in Greenberg's work, in which he sought to philosophically ground the notions of aesthetic experience and value that implicitly underpinned his theory and criticism. In the 'Bennington Seminars' Greenberg considers the nature of both aesthetic judgment and works of art as privileged objects of such judgment. He maintains, controversially, that aesthetic experience boils down to positive or negative judgments of taste predicated on a work's form, that such judgments can be shown to be objective by appealing to the record of taste converging over time, and that such judgment derives from an attitude that 'distances' the judge from his or her everyday concerns.

From the mid-1960s onwards, various criticisms were levelled at Greenberg's work. The first was internal: Michael Fried, Greenberg's leading follower, claimed that his theory of modernism was flawed because it relied on an untenable conception of an artistic medium. Drawing on **STANLEY CAVELL**, Fried argued that, rather than seeking the *irreducible* essence' of each art, modernist artists seek to 'compel conviction' that their work bears comparison to the highest achievements of past art in their discipline. On this view, the 'essence' of an artistic medium is a *conventional* product of the ongoing practice of the discipline. As conventions change historically, so too does essence. However, Fried's work was soon criticized in turn for its equal inability to deal with art (such as minimalism) that refused to respect the modernist boundaries between artistic media.

From a different direction, Greenberg's work was criticized by social art historians, such as Thomas Crow and **T. J. CLARK**. Clark claimed that his later work failed to explain what made 'flatness' vital *symbolically* at a particular historical juncture. Clark suggests various things flatness might have stood for in an attempt to reintroduce the urgency of the 'why' back into the 'how' of Greenbergian theory. But Clark and the general approach of social art history have been sanctioned in turn (not least by Fried) for their tendency to reduce abstraction to a covert representationalism. On a different tack, Crow has objected to Greenberg's one-sided

view of the relation between high and low culture. Crow argues that modernism also reinvigorated itself by drawing on popular culture, and cites the use of mass-cultural products and references in cubist painting and collage. More generally, Greenberg's belief that high art had to maintain its 'purity' from culture at large at all costs, if it was to survive, made his theory appear increasingly irrelevant given the ways in which this divide began to break down during the 1960s.

More recently a generation of critics associated with the journal *October* have thematized the work that Greenberg was forced to ignore in order to construct his narrative of modernism. ROSALIND KRAUSS and Yves-Alain Bois, for example, have sought to retrieve the impulse, repressed by Greenberg's emphasis on taste and good form, towards 'formlessness' in modern art. While Krauss and HAL FOSTER have drawn attention to the absence of Dada and Surrealism from this narrative. This raises a key question in Greenberg's interpretation: does Greenberg reject movements like Surrealism because the terms of his theory *oblige* him to reject them (for blurring the boundaries between media), or because he judges them to be bad art by dint of taste alone? If the former, modernist theory is shown to be prescriptive: it has to rule out certain kinds of art a priori. If the latter, this raises a question as to the *status* of Greenberg's narrative: how can a narrative founded on a series of value judgments determining what it admits be historical or descriptive in any straightforward sense? While it might describe Greenberg's *taste*, can it really be said to chronicle (modern) *art*?

THIERRY DE DUVE has shown how the belief in the 'objectivity' of his own taste underwriting this narrative violates the Kantian framework Greenberg appealed to in his later work. Greenberg resorted to the supposed fact that taste converges over time to argue for its alleged 'objectivity', when Kant maintained that judgments of taste only *lay claim* to validity over all judging subjects, this being insusceptible to proof. Moreover, Greenberg conflated Kant's notion of 'disinterest' as a necessary *precondition* for a judgment counting as aesthetic with his own psychological idea of an 'aesthetically distanced' *state of mind*. Despite this, the art world continues to take Kant largely at Greenberg's word. Even ARTHUR C. DANTO uses Greenberg's recourse to Kant as evidence for inadequacy of Kantian aesthetics as a basis for a theory of art today. For Danto, Greenberg's inability to deal with questions of content in art follows directly from his recourse to Kant's formalism. It reflects a failure to distinguish beauty in general (including that of nature) from the historical and cultural complexity of artistic value. Whether this is fair to Kant is highly controversial.

Nonetheless, the range and diversity of critical response that Greenberg's work has elicited demonstrates the significance of his work, as the leading theorization of modernism in art, for later postmodernism. Indeed the question that postmodern art theory is only now addressing is the extent to which its own claims are an *inverted* modernism. While postmodern theory devalues what Greenberg valued, and values what he devalued, it remains – for this reason – part of Greenberg's legacy. If this is correct, then much postmodern art theory may be hostage to the conceptual framework it has most vociferously contested – namely Greenberg's.

DIARMUID COSTELLO

BIBLIOGRAPHY

Primary literature

Greenberg, C., *The Collected Essays and Criticism* (vols I–IV), ed. John O'Brian, Chicago: University of Chicago Press, 1986/1993.

Greenberg, C., *Homemade Esthetics: Observations on Art and Taste*, New York: Oxford University Press, 1999.

Greenberg, C., *Late Writings*, ed. Robert C. Morgan, Minneapolis: University of Minnesota Press, 2003.

Secondary literature

Bois, Y.-A. and Krauss, R., *Formless: A User's Guide*, Zone Books, Cambridge: MIT Press, 1996.

Costello, D., 'Greenberg's Kant and the Fate of Aesthetics in Contemporary Art Theory', *Journal of Aesthetics and Art Criticism*, Vol. 65, no. 2 (Spring 2007).

Danto, A. C., *After the End of Art: Contemporary Art and the Pale of History*, New Jersey: Princeton University Press, 1997.

de Duve, T., *Clement Greenberg Between the Lines*, Paris: Dis Voir, 1996.

de Duve, T., *Kant after Duchamp*, Cambridge: MIT Press, 1996.

Frascina, F. (ed.), *Pollock and After: The Critical Debate*, London: Routledge, 1985/2000 (includes papers by Greenberg, T. J. Clark, Thomas Crow, Michael Fried, Serge Guilbaut, Fred Orton and Griselda Pollock, among others).

Fried, M., *Art and Objecthood*, Chicago: Chicago University Press, 1998.

Jones, C. A., *Eyesight Alone: Clement Greenberg's Modernism and the Bureaucratization of the Senses*, Chicago: Chicago University Press, 2005.

Krauss, R., *The Optical Unconscious*, October Books, Cambridge: MIT Press, 1993.

Kuspit, D., *Clement Greenberg: Art Critic*, Madison: University of Wisconsin Press, 1979.

ROSALIND KRAUSS (1940–)

Rosalind Krauss's substantial and varied body of writing is characterized by a rigorous consideration of form linked to an ongoing interrogation of theoretical method. With particular attention to sculpture, and later photography, she countered a modernist approach centered around painting with her early articulation of a postmodernist reading of twentieth-century art. Combining breathtaking scope with a combative stance that oscillates between refreshing and alarming, she has deployed her theoretical arsenal to take apart assumptions about originality and authenticity, and the

application of these categories to the construction of the artist's oeuvre. She has also made significant contributions as an editor, curator, teacher and translator.

Krauss began her career in the circle of CLEMENT GREENBERG, a connection that she, like MICHAEL FRIED, established while pursuing graduate work at Harvard. The most obvious fruit of this association was her dissertation on David Smith, completed in 1969 and published in 1971. Starting in 1966 she also joined Fried as a regular writer for *Artforum*, publishing reviews and then longer articles in which one can trace her move away from Greenberg's critical method and approved list of artists. The more dramatic statement of their break appeared, however, in a 1974 *Art in America* article, 'Changing the Work of David Smith', in which she outlined a series of decisions after Smith's death to transform sculptures that he had left primed but without their final coats of paint, either by stripping the primer or by leaving the works outside, prey to forces of nature that would gradually achieve the same end. In making the decision to strip the works, Greenberg brought the sculptures into line with his aesthetic preference for surfaces free from applied colour; and in revealing his decision to do so, Krauss demonstrated the degree to which his power as a critic had declined in the face of the rise of the very artistic practices to which Krauss had turned her attention.

Krauss's 1977 *Passages in Modern Sculpture* [*PMS*] opens with the example of Gotthold Lessing's treatise on the *Laocoön*, also a starting point for Greenberg's early statements about the purity or uniqueness of medium. Krauss, however, uses *Laocoön* to argue for the inseparability of space and time in the experience of modern sculpture. Her theoretical allegiance at this point was twofold – phenomenology and structural linguistics – in both of which, she claims, 'meaning is understood to depend on the way that any form of being contains the latent experience of its opposite: simultaneity always containing an implicit experience of sequence'; this is relevant to her expanded definition of the medium of sculpture, 'located at the juncture between stillness and motion, time arrested and time passing' (*PMS*, p. 5). Key points of reference include both Ludwig Wittgenstein's emphasis on meaning as inseparable from the lived use of language and MAURICE MERLEAU-PONTY's insistence on the primacy of unfolding perception over a-priori abstractions. Repetition, already hinted at by Auguste Rodin's recycling of key figures, becomes explicit in the serial logic of Donald Judd's progressions and many other works read by Krauss according to an experience of exteriority, an understanding of meaning found not in reference to a private self, but in the 'sum of our visible gestures' (*PMS*, p. 270). The precipitating force is suggested by the book's second illustration, ROBERT SMITHSON's *Spiral Jetty*, which, along with the work of Richard Serra, compelled Krauss to articulate a definition of sculpture that could account for the impact of their work.

The reading of earlier work against insights gained from the experience of minimalist and post-minimalist work in *Passages in Modern Sculpture* is an example of a tendency that runs through Krauss's criticism: the recognition of a shift, often tied to a particular historical moment, forces a reconsideration of the critical tools brought to its assessment; yet once recognized, she looks for evidence of the same approach across a broad chronological spectrum. This dynamic is fully apparent in a number of the essays published in the late 1970s and early 1980s, and brought together in *The Originality of the Avant-Garde and Other Modernist Myths*. The essay 'Grids', for example, describes a particular kind of flatness that resists narrative by suggesting the spatial logic of structuralist readings of myth. 'Notes on the Index' opens by citing various practices

of the 1970s as a motivation for deploying the linguistic category of the shifter, and the idea of the index, but quickly turns to Marcel Duchamp. And there is GEORGES BATAILLE's concept of the *informe*, and Krauss's related emphasis on the horizontal, that appears in 'No More Play' and continues to orient much subsequent work. On the other hand, part of the enduring power of 'Sculpture in the Expanded Field' is the specificity of her application of a structuralist diagram adapted from A. J. Greimas to an array of earthworks and related phenomena that takes off from sculpture (not-landscape and not-architecture) to include marked sites (landscape and not-landscape) and site-constructions (landscape and architecture). Understood in relation to this diagram, modernist autonomy is not so much contested as undermined, as its logic occupies one point in a range of possibilities, and this array in turn opens up comparisons to the site-embedded nature of earlier monument traditions.

Although elements of structuralism persist, Krauss's articulation of postmodernism during this period is increasingly linked to French theoretical discourse, including deconstruction, which also came to characterize the journal *October* that Krauss and Annette Michelson joined forces to found in 1976. The decision was precipitated by conflicts about *Artforum*'s editorial direction, as well as a notorious advertisement by Lynda Benglis, nude with a dildo, in the November 1974 issue (seen by many as a rejoinder to ROBERT MORRIS's macho display in a poster for his 1974 exhibition at the Castelli and Sonnabend Galleries). Taking its name from a Sergei Eisenstein film in which revolutionary politics were presented through an equally radical aesthetic, and carrying on its cover the heading 'Art / Theory / Criticism / Politics', *October* announced a programme for criticism that would use the format of a quarterly, not beholden to gallery advertising, to publish speculative or theoretical arguments not sustained elsewhere.

Key aspects of this political agenda have been an insistent attention to the discipline of art history and criticism itself, including the various ways in which a rhetoric of authenticity is embedded in market forces, and a focus on the institutional structures of the art world. A rift with Douglas Crimp in the late 1980s, however, indicated Krauss's resistance to another emergent area of criticism centered around issues of identity. Here an undercurrent of Greenberg reappears. While Krauss does not make judgments of quality the primary goal of the critic, a sense of threat to formal complexity is registered by her resistance, in turn, to 'identity politics', and the analysis of art as part of a broader visual culture. Even when Krauss published a book comprised entirely of essays on women artists, she simultaneously suggested her aversion to such framing through the title *Bachelors* (drawn from a work by Sherrie Levine that recontextualized forms from the bachelor section of Duchamp's *Large Glass*).

Krauss's reach as a critic has also been extended by her work as a curator, with several important publications linked to major exhibitions. *L'Amour Fou*, co-organized and written with Jane Livingston, reoriented the study of Surrealism by insisting on the centrality of photography to a movement previously framed around painting and sculpture. In 1994 she and Thomas Krens organized *Robert Morris: The Mind/Body Problem* for the Guggenheim Museum, New York, entering into disputes about the significance of his work so entrenched that the catalogue already contains David Antin's rebuttal to a condemnation of Morris's stylistic inconsistency that Roberta Smith would revive in her *New York Times* review of the show. Krauss's contribution to the catalogue also used Bataille's critical dictionary as a model open to unexpected juxtapositions – thereby continuing the

refusal of transparency most pronounced in *The Optical Unconscious*, which is marked by the interplay between a dizzying array of examples and the interruption of a more anecdotal 'counter-text' in italics. Yet this extension of her interest in form into an increasingly evident engagement with the shape of the argument itself, combined with the sheer number of references to sometimes disparate theoretical models, can work against the clarity that distinguished her early essays.

The ongoing importance of Bataille, and particularly the *informe*, or 'formless', as a counterpoint to modernist formalism, is central to her collaboration with Yves-Alain Bois on *L'Informe: Mode d'emploi* at the Centre Georges Pompidou in Paris in 1996. There they take Bataille's formless as an interpretative frame not just for work of the 1920s and 1930s (where it operates counter to André Breton), but also for a rereading that cuts across twentieth-century art through four associations with the *informe* – horizontality, base materialism, pulse and entropy – that are opposed to a modernist emphasis on verticality, visuality, instantaneity and sublimation. The application of an idea generated in response to circumstances of the 1930s to work of the 1980s and 1990s need not be considered arbitrary, however, since by that time Bataille had been the subject of a major critical revival spearheaded by critics associated with *October*.

In several essays of the late 1990s, including 'A Voyage on the North Sea', Krauss returns to her early contest with Greenberg in a re-examination of medium despite the dissolution of modernist categories. This

attention to art's 'post-medium condition' is clearly a post-conceptual return, yet it also reprises her early interest in the play between stillness and movement, now identified as the medium for James Coleman's slide projections. While it is impossible to reduce Krauss's substantial body of work to a single perspective, there are, as this example suggests, a number of interrelated concerns.

One, evident in her engagement with postmodernism and the culture of the copy, reads backwards to encompass the role of repetition in the work of Rodin or Ingres, or the related issue of pastiche that runs through *The Picasso Papers*, and forwards into photographic work of the 1980s. Then there is the ongoing consideration of spatial implications, found in the phenomenological reading of minimalism or earthworks, but also evident in an attention to orientation that appears in her consideration of Duchamp's *Fountain*, rotated to its back on a pedestal, Jackson Pollock's drip paintings, removed from the floor to the wall, or the horizontality of Cindy Sherman's body within many of her most provocative photographs. Or there is the continuation of her early engagement with time in the idea of the pulse and other interruptions to a modernist emphasis on pure visuality. Finally, the reiteration of these interpretative models in *Art Since 1990*, produced in collaboration with *October* colleagues **HAL FOSTER**, Yves-Alain Bois and **BENJAMIN H. D. BUCHLOH**, demonstrates the degree to which Krauss has stamped her imprint on the interpretation of twentieth-century art.

MARTHA BUSKIRK

BIBLIOGRAPHY

Primary literature

Krauss, R., *Terminal Iron Works: The Sculpture of David Smith*, Cambridge: MIT Press, 1971.

Krauss, R., *Passages in Modern Sculpture*, Cambridge: MIT Press, 1977.

Krauss, R., *The Originality of the Avant-Garde and Other Modernist Myths*, Cambridge: MIT Press, 1985.

Krauss, R. (with Livingston, Jane), *L'Amour Fou: Photography & Surrealism*, Washington, D.C.: Corcoran Gallery of Art, New York: Abbeville Press, 1985.

Krauss, R., *The Optical Unconscious*, Cambridge: MIT Press, 1993.

Krauss, R. (with Krens, Thomas), *Robert Morris: The Mind/Body Problem*, New York: Guggenheim Museum Foundation, 1994.

Krauss, R. (with Bois, Yves-Alain), *Formless: A User's Guide,* New York: Zone Books, Cambridge: MIT Press, 1997.

Krauss, R., *The Picasso Papers*, New York: Farrar, Straus & Giroux, 1998.

Krauss, R., *'A Voyage on the North Sea': Art in the Age of the Post-Medium Condition*, London: Thames & Hudson, 1999.

Krauss, R. (with Foster, Hal, Bois, Yves-Alain and Buchloh, Benjamin H. D.), *Art Since 1900: Modernism, Antimodernism, Postmodernism*, London: Thames & Hudson, 2004.

Secondary literature

Newman, A., *Challenging Art: Artforum, 1962–1974*, New York: Soho Press, 2000.

Carrier, D., *Rosalind Krauss and American Philosophical Art Criticism*, Westport: Praeger, 2002.

W. J. T. MITCHELL (1942–)

W. J. T. Mitchell teaches English and art history at the University of Chicago, where since 1978 he has also been the editor of *Critical Inquiry*, one of the leading journals of interdisciplinary research in the humanities and social sciences. Through a substantial body of work, Mitchell has emerged as one of the foremost scholars of the interplay between language and vision in literature, art and media. In particular, his ideas have had a profound impact on the way we think about the visual arts and about the visual in general, playing a crucial role in creating a new (and at times hotly debated) field of study: visual culture (or 'visual studies').

In *Blake's Composite Art* (1978), an expansion of his Johns Hopkins doctoral dissertation in English, Mitchell analyzed the interaction of words and images in the illuminated books of the English poet and painter. This specific problem led him to the more general themes of *Iconology* (hereafter, *Ic*; 1986). In using the term iconology, Mitchell did not intend to resort to its familiar art historical connotation as the interpretation of the meaning of works of art in their cultural context. Instead, he transformed iconology into a reflection on the answers of a wide variety of authors to two fundamental questions: 'i) What is an image? ii) What is the

difference between images and words?' (*Ic*, p. 1). Mitchell examined ancient optics, Plato, Aristotle, Hume, Locke and Wittgenstein, and focused on Goodman, Gombrich, Lessing, Burke and Marx. As a result, he put forward the following three related claims.

(i) It is impossible to provide a true and universally valid definition of the image based on its '*essential* difference' from words (*Ic*, p. 49). The arguments and oppositions typically used to try to do so (nature vs. convention; space vs. time; eye vs. ear) can easily be reversed, and the characteristics claimed to be exclusive to images can be shown to be pertinent also to words.

(ii) A true and universally valid theory of the *essential* difference between images and words is impossible because each theory of images is ultimately based on systems of beliefs and 'conceptions of social, cultural, and political value' (*Ic*, p. 2) – ideologies – that are historically specific. Thus, the task of the iconologist is both to critique the analytic rigour of those theories, and to understand the manifold 'values' that 'terms like nature and convention, space and time, the visual and the aural' 'enforce and screen off' in each given context (*Ic*, p. 154).

(iii) Not only are the analytic terms of theories of images always value-laden, but the idea of 'the image' itself mobilizes deeply felt emotions, which make it a very peculiar scientific object, seemingly impossible to treat with scholarly detachment. Thus, iconology 'turned out to be, not just the science of icons, but the political psychology of icons, the study of iconophobia, iconophilia, and the struggle between iconoclasm and idolatry' (*Ic*, p. 3; *What Do Pictures Want?* [*WDPW*] will develop this perspective).

After studying theories of the image as such, Mitchell turned to the analysis of a wide-ranging set of pictures – 'the concrete,

representational objects in which images appear' – *Picture Theory* (hereafter *PT*; 1994, p. 4), his most influential book to date. For Mitchell, this shift to pictures was a way to address what he called the 'pictorial turn' in contemporary public culture and critical theory – the anxiously and 'widely shared notion that visual images have replaced words as the dominant mode of expression in our time' (*WDPW*, p. 5).

Mitchell contests the commonplace assumption that in the contemporary age everything is visual. For him, the pictorial turn is 'a postlinguistic, postsemiotic rediscovery of the picture as a complex interplay between visuality, apparatus, institutions, discourse, bodies and figurality' (*PT*, p. 16). Importantly relying on Wittgenstein and FOUCAULT (especially as interpreted by DELEUZE), Mitchell claims that pictures are and have *always* been involved in an 'inextricable weaving together' and 'imbrication' with language (*PT*, p. 83). The implications of this claim are far-reaching and can be defined as follows:

(i) 'there are no "purely" visual or verbal arts' (*PT*, p. 5): 'all arts are "composite arts" (both text and image)' (*PT*, pp. 94–95; cf. this in opposition to CLEMENT GREENBERG and MICHAEL FRIED);

(ii) 'all media are mixed media, combining different codes, discursive conventions, channels, sensory and cognitive modes' (*PT*, p. 95).

(iii) Because 'the interaction of pictures and texts is constitutive of representation as such ... all representations are heterogeneous' (*PT*, p. 5).

By means of these claims, Mitchell intended to make possible two key tasks:

(a) to conceive the relation between pictures and language not as binary, but as dynamic and dialectical, and therefore

(b) to analyze how, and in the name of what values, in different historical contexts

and conditions, pictures and language peacefully co-operate (for instance illustrated newspapers and cartoon pages); how they seem to ignore each other (the photographic essays of the photographer Walker Evans and the writer James Agee); or how they fight and want to repress each other and yet always require and give life to each other (such as abstract painting's rejection of discourse and yet its dependence on theory for being viewed and understood, ever since the writings of the early abstractionists up to the criticism of Greenberg, Fried and ROSALIND KRAUSS).

Mitchell formulated his claims not only with regard to the masterpieces of the history of art, but extended them from Velázquez to *MAD* magazine cartoons, from Malevich to Spike Lee, from ROBERT MORRIS to CNN news. This was not because Mitchell wanted to level the distinction between art and non-art, but because the questions he asked about the nature of pictures and of their relationship to language cut across traditional disciplinary divisions and 'strategies of containment', in order to address 'the need for a global critique of visual culture' (*PT*, p. 16) – a 'visual culture' that includes both artistic and 'vernacular' pictures.

This expansion of the area and problems to investigate in the realm of the visual has deeply affected other scholars. In fact, *Picture Theory* and Mitchell's subsequent work have been decisive in establishing 'visual culture' as a field of enquiry in its own right, which by now has a recognizable institutional profile with publications, journals and university programmes across the world. Art history responded in different ways to Mitchell's work.

First, some quarters quickly welcomed Mitchell and his challenge to think about art within a broader field of objects and problems. In 1995, Mitchell was invited to present his perspective in *Art Bulletin*, the voice of tradition in the English-speaking art history academic community, published by the College Art Association of America, which in 1996 also awarded *Picture Theory* the prestigious Morey Prize for 'an especially distinguished book in the history of art'.

Second, in 1996 in a special issue (no. 77) of *October*, the journal of radical postmodernism, reacted with much more alarm to visual culture. For Krauss, scholars of visual culture, because they do not focus on the concrete aesthetic specificity of artworks, must rely on a 'non-materialist' conception of the image as 'disembodied' (*October* 77, p. 96); and such a conception is ultimately shaped by the kind of images produced with ever growing pervasiveness by the 'electronic media' that 'are now reorganizing vast segments of the global economy' (ibid., p. 84). For HAL FOSTER, visual culture's concentration on these mass-mediated images is a 'commodity-image fetishism' (ibid., p. 117) that obscures the degree to which they are 'fundamental' 'to capitalist spectacle' (ibid., p. 107). Thus, for *October*, visual culture 'is helping ... to produce subjects for the next stage of globalized capital' (ibid., p. 25).

On his part, in the same issue of *October*, Mitchell pursued a question that would become his latest book: *What Do Pictures Want?* (2005). Mitchell meant to shift attention from the interpretation of the meaning, artistic value or ideology of pictures to how human beings attribute agency, subjectivity and even life to both immaterial images and their materializations in concrete pictures (artistic and non-artistic), and how, therefore, images and pictures are the source and target of love and desire, but also fear and hatred. Three main points emerge from the book.

First, Mitchell does not look down on responses to images and pictures that transform them into subjects to be

worshipped (idolatry), hated and destroyed (iconoclasm), obsessed over (fetishism) or out of which social bonds can be created (totemism). Instead, Mitchell makes these responses the core of his historical and theoretical reflections, and turns them into the key analytical tools to approach the 'lives and loves of images', showing – through examples that range from the biblical Golden Calf to abstract art up to the cloned sheep Dolly – that these reactions have been with us since time immemorial, but are still very much alive, albeit in sometimes disguised and sophisticated forms. (For Mitchell, who discusses among others Greenberg, Fried, Krauss and Foster, modernist and postmodernist reactions to art and mass media incorporate the gamut of idolatry, iconoclasm, fetishism and totemism.)

Second, in exploring the conditions that enable the life of images and pictures, Mitchell attributes a crucial role to their medium, which he proposes to conceive in an expanded field as 'habitat or ecosystem'. By so doing, he questions 'the received idea that a medium has something called "specificity"' (cf. Greenberg, Fried and Krauss). For Mitchell, 'the medium is more than the material ... more than simply the image plus the support': the medium includes 'the entire range of practices that make it possible for images to be embodied in the world as pictures'; the medium of painting, for instance, is thus 'not just the canvas and the paint ... but the stretcher and the studio, the gallery, the museum, the collector, and the dealer-critic system' (WDPW, p. 198).

Finally, the notion of the visual as a 'social field' (WDPW, p. 47) is central for Mitchell, who claims that one of the most important contributions of the study of 'visual culture' is not only the understanding of 'the social construction of the visual field', but of 'the visual construction of the social field' (WDPW, p. 345). 'Looking', Mitchell insists with Lacan and Sartre, is first and foremost looking at others and being looked at by others. This intersubjective looking, which is also fraught with intense positive and negative affects, is constitutive of individual and then social identity (and to some extent, of human nature). This is why for Mitchell it is essential to explore our more specialized looking at images and pictures as encounters with other subjects rather than just with objects, and to ask What Do Pictures Want?

The first reactions to these claims (Holly, Mirzoeff, Bryson) clearly indicate that Mitchell's work will continue to be a major force to reckon with for those who study the visual arts and visual culture.

RICCARDO MARCHI

BIBLIOGRAPHY

Primary literature

Mitchell, W. J. T., *Blake's Composite Art: A Study of the Illuminated Poetry*, Princeton: Princeton University Press, 1978.

Mitchell, W. J. T., *Iconology: Image, Text, Ideology*, Chicago: University of Chicago Press, 1986.

Mitchell, W. J. T., *Landscape and Power*, Chicago: University of Chicago Press, 1994/2002 (a collection of essays edited by Mitchell; two by himself).

Mitchell, W. J. T., *Picture Theory: Essays on Verbal and Visual Representation*, Chicago: University of Chicago Press, 1994.

Mitchell, W. J. T., 'Interdisciplinarity and Visual Culture', *The Art Bulletin* vol. 77 no. 4 (December 1995), pp. 540–44.

Mitchell, W. J. T., *The Last Dinosaur Book: The Life and Times of a Cultural Icon*, Chicago: University of Chicago Press, 1998.

Mitchell, W. J. T., *What Do Pictures Want? The Lives and Loves of Images*, Chicago: University of Chicago Press, 2005.

Secondary literature

In parentheses, the authors of key essays
 appearing in these volumes:
Bryson, N., 'Their So-Called Life', *Artforum* 44
 (November 2005), pp. 27–28.
Dikovitskaya, M., *Visual Culture: The Study of the
 Visual After the Cultural Turn*, Cambridge: MIT
 Press, 2005.
Holly, M. A. and Moxey, K. (eds), *Art History,
 Aesthetics, Visual Studies*, Williamstown,
 Mass.: Sterling and Francine Clark Art

Institute, 2002 (Mitchell, Pollock, Stephen
 Melville, Foster, David Carrier).
Mirzoeff, N., *The Visual Culture Reader*, London:
 Routledge, 1998/2002.
October 77 (Summer 1996) (nineteen responses
 to a 'Questionnaire on Visual Culture';
 Mitchell, Krauss, Foster).
'Responses to Mieke Bal's "Visual Essentialism
 and the Object of Visual Culture"', *Journal
 of Visual Culture* 2 (Aug 2003), pp. 229–68
 (Mitchell, Norman Bryson, Elkins, Michael
 Ann Holly, Pollock and Bal.)

LINDA NOCHLIN (1931–)

Linda Nochlin was one of the main
protagonists of American feminist art
history and theory in the late 1960s. She has
since become one of the most influential
art historians of the late twentieth century.
Nochlin, born in Brooklyn, New York, in
1931, began her career as a graduate
student in the late 1950s at the Institute of
Fine Arts, New York University (her current
institution); her first research project was the
political significance of Gustave Courbet's
mid-nineteenth-century realist aesthetic.
It was in 1969 while teaching at Vassar
College (previously a women's university)
that Nochlin became a committed feminist
and instigated the discipline's first course in
feminist art history, for which she gleaned
methodological tools from more established
feminist critiques in the disciplines of
literature, sociology, psychology and history.
She has remained committed to 'questioning
the possibility of a single methodology'
('Memoirs of an Ad Hoc Art Historian', 1999),
arguing that feminist art history is a general

political and philosophical commitment
which can utilize a number of specific
strategies of interpretation, whether these
are drawn from Marxist theories of ideology,
structural linguistics, psychoanalysis or
more traditional art historical methods of
pictorial and iconographic analysis. Broadly,
however, Nochlin can be identified with the
social history of art, despite her criticism
of this academic tradition for consistently
prioritizing the historical over the visual ('The
Politics of Vision', 1989).

In 1971, Nochlin published the essay for
which she is most well known: 'Why Have
There Been No Great Women Artists?' Her
basic thesis laid the foundations for an
emerging feminist critique of art history
that has maintained a lasting impact on
the discipline. Since the polemical essay
of 1971 Nochlin's writings have functioned
as an accessible barometer of discursive
developments in the field of feminist theory,
not least when compared to the writings of
British art historian **GRISELDA POLLOCK**,

her principal respondent. Nochlin's feminism was formed in the political context of the US equal-rights movement, according to which, women constituted the oppressed half of a binary seeking equality under the existing system of liberal democracy. She has described her project as 'thinking art history Otherly' ('The Politics of Vision', 1989). Critics of Nochlin have claimed that without a more systematic (i.e. Marxist) model for political change, the discipline of art history and the position of women more generally can only be reformed, not transformed.

Nochlin's interrelated research areas may be categorized as follows: (i) realism as an aesthetic category; (ii) nineteenth-century art; (iii) women's artistic practice; (iv) the female body in visual representation; (v) the representation of ethnic identity. Principally an essayist, her major work has been published in a series of collections (*Women, Art and Power*, 1988; *The Politics of Vision*, 1989; *Representing Women*, 1999) demonstrating the development of her ideas on the politics of representation over four decades. A number of these interests originated in Nochlin's influential writings of 1971–72: (i) *Realism*, 1971; (ii) 'Why Have There Been No Great Women Artists?', 1971; (iii) 'Eroticism and Female Imagery in Nineteenth-Century Art', 1972.

Though aimed at a general reader, *Realism* (text i) was a historical analysis of the dominant mid-nineteenth-century pictorial idiom that demonstrated Nochlin's philosophical engagement with the nature of mimetic representation, informed by Roman Jakobson's structural linguistics. Balancing its claims to objective empiricism with reference to pictorial conventions, including metonymic devices (chains of contiguous meaning generated by the smallest pictorial detail – Jakobson had identified metonymy as typical of all realist literature), Nochlin championed realism (particularly Courbet's 'materialist' and 'democratic' realism), for its commitment, if not ability, to represent

the social conditions of contemporary experience. In a discursive context still dominated by the modernist aesthetics and formalist orthodoxy identified with CLEMENT GREENBERG, Nochlin argued for both the political significance of art objects (their formal properties in particular) and a pictorial mode that included experience rather than abstracting it. Ultimately, for Nochlin, realism signalled democracy: the representation of the under-represented.

In the same year Nochlin produced her most significant contribution to the history of art history (text ii). 'Why Have There Been No Great Women Artists?' was an insistent question demanding a methodologically credible feminist response. For Nochlin, there had been no great women artists and all attempts to claim otherwise would fail by ultimately reinforcing the dominant perception of women's inferiority. In the contemporary climate of emergent feminist art history this seemed like a terrible betrayal. Contemporary feminism was committed either to (i) reintroducing forgotten women artists to the Western canon or (ii) claiming a different kind of greatness for women. (Nochlin enacted a reversal of her position on (i) when in 1976 she co-produced an exhibition and book cataloguing the biography and work of 'Women Artists: 1550–1950'.)

Nochlin answered her own question by locating in social repression the historical causes of women's lack: institutional discriminations, cultural prejudices and psychological formations. Nochlin's call to substitute mythic constructions of artistic creation for sociological analysis linked her work to that of contemporaries ROLAND BARTHES, MICHEL FOUCAULT and PIERRE BOURDIEU. Nochlin insisted that 'the woman question' must not remain on the academic margins; it must become paradigmatic for disciplinary change: 'a catalyst, a potent intellectual instrument, probing the most basic and "natural" assumptions of all intellectual inquiry'. As a result, she

predicted, the position of women artists and art history would be transformed.

Nochlin's 1972 essay (text iii) focused on erotic representations of the female body. She argued for (i) the social as opposed to personal basis of erotic fantasy; (ii) connections to be made between the representation of women as sexual objects in artistic and 'popular' imagery; and (iii) consideration of the dominant audience for sexually explicit images: 'the very term "erotic art" is understood to imply the specification "erotic-for-men"'. (The last claim was certainly reductive, but more nuanced theories of 'the gaze' as developed by feminist film theorists including Laura Mulvey had yet to be formulated.) The female body's sexual objectification for a male viewer was not, according to Nochlin, the result of a male conspiracy; it was a reflection 'in the realm of art of woman's lack of her own erotic territory'. Notoriously, Nochlin illustrated this claim by juxtaposing a photograph she herself had made of a semi-naked man holding a tray of bananas close to his exposed genitals with a nineteenth-century photograph of a semi-naked woman holding a tray of apples (thereby reversing the conventional association in popular and artistic imagery of breasts with fruit). Again Nochlin made a bold prediction that feminism would produce an imminent change in the nature of erotic imagery: 'the growing power of woman in the politics of both sex and art is bound to revolutionize the realm of erotic representation'.

In the many essays published since the polemical writings of the early 1970s, Nochlin has developed a large body of work analyzing the sexual politics of nineteenth-century art. In 'Lost and *Found*' (1978) Nochlin analyzed the pictorial means by which sexual ideologies were constructed in Victorian paintings. Conversely, in 'Manet's *Masked Ball at the Opera*' (1983) she claimed that Manet used pictorial synecdoche (or body fragments) to deconstruct the

commodification and exchange of women's bodies in Parisian society. Nochlin has extended her concern for the sexual politics of representation to the politics of ethnicity, arguing that there is no transparent relationship between the subject position of the artist and the representation of ethnic identity – anti-Semitic artists do not necessarily produce anti-Semitic images ('Degas and the Dreyfus Affair', 1989; *The Jew in the Text*, 1995). In her most ambitious essay to date, Nochlin returned to the subject of her original research, Gustave Courbet ('Courbet's Real Allegory', 1988). Nochlin structured this essay as a binary opposition. 'As an art historian' she argued for the radical significance of Courbet's art in the political climate of the Second Empire (1852–70) and 'as a feminist' informed by psychoanalytical theory she critiqued her 'art-historical' subject position by arguing against Courbet's phallocentric approach to the representation of the female body.

As might be expected, many of Nochlin's critics have been unsympathetic to feminist politics. Others, including T. J. CLARK and MICHAEL FRIED have implicitly or explicitly detected an overly simplistic identification of political radicalism with pictorial avant-gardism in Nochlin's work on Courbet. Criticism has also come from within the field of feminist art history. In 1974, Marxist-feminist Lise Vogel critiqued the photographic reversal Nochlin enacted in 1972 (text iii), arguing that substituting women's sexual exploitation for that of men's ultimately maintained the system of 'alienated and objectified sexual relations' ('Fine Arts and Feminism', p. 21). In 1977, Nochlin's most consistent respondent, Griselda Pollock, claimed that the value of this reversal was precisely its failure, since 'there is a basic asymmetry, inscribed into the language of visual representation which such reversals serve to expose' ('What's Wrong with "Images of Women"', p. 137). Both were, in effect, criticizing the binary

opposition model of gender relations to which Nochlin subscribed.

In *Old Mistresses* (1981) Pollock and co-author Roszika Parker took up the issues of Nochlin's 1971 polemic (text ii). They argued that had the institutional and other historical restraints that Nochlin proposed been effective then there would have been *no* women artists. The implication being that Nochlin had inadvertently reproduced modernist art history's refusal to acknowledge the existence of women artists. Ultimately, Parker and Pollock argued that the category of negative femininity functioned to constitute the discourse of art history itself and therefore a 'total deconstruction of the discipline is needed *in order* to arrive at a real understanding of the history of women and art' (*Old Mistresses*, p. 48). This would entail the dismantling, not reformation, of 'the ideological structures of which discrimination is but a symptom'. In 1982 Pollock reconfirmed the Marxist-feminist basis of her critique, claiming that Nochlin's 'liberal bourgeois' feminism had lead her to reinforce both the criterion of artistic value and 'the patriarchal definition of man as the norm of humanity, woman as the disadvantaged other' ('Vision, Voice and Power', p. 50). Clearly, the different political roots and interests of US and British feminism were seen to be implicated in Nochlin's and Pollock's different approaches to the issue of women artists.

The feminist critique Nochlin helped to instigate has not only functioned as a catalyst for broader disciplinary change, but has also placed feminist issues at the centre of the discipline (despite the general decline in political activism among Western feminists). It remains, however, a matter of debate and political philosophy whether one considers the disciplinary practices of art and art history to have been simply reformed or more radically transformed as a result of Linda Nochlin's contribution.

FRANCESCA BERRY

BIBLIOGRAPHY

Primary literature

Nochlin, L., *Realism*, New York: Penguin Books, 1971.
Nochlin, L., *Women, Art and Power*, New York: Harper & Row, 1988 (includes 'Eroticism and Female Imagery in Nineteenth-Century Art'; 'Lost and *Found*'; 'Why Have There Been No Great Women Artists?').
Nochlin, L., *The Politics of Vision: Essays on Nineteenth-Century Art and Society*, New York: Harper & Row, 1989 (includes 'Degas and the Dreyfus Affair'; 'Manet's *Masked Ball at the Opera*').
Nochlin, L., and Garb, T. (eds), *The Jew in the Text: Modernity and the Construction of Identity*, London: Thames & Hudson, 1995.
Nochlin, L., *Representing Women*, London: Thames & Hudson, 1999 (includes 'Courbet's Real Allegory').

Secondary literature

Clark, T. J., *Image of the People: Gustave Courbet and the 1848 Revolution*, London: Thames & Hudson, 1973.
D'Souza, A., *Self and History: A Tribute to Linda Nochlin*, London: Thames & Hudson, 2000.
Fried, M., *Courbet's Realism*, Chicago: University of Chicago Press, 1990.
Parker, R. and Pollock, G., *Old Mistresses: Women, Art and Ideology*, London: HarperCollins, 1981.
Pollock, G., 'What's Wrong with "Images of Women"', (1977) in eds R. Parker and G. Pollock, *Framing Feminism: Art and the Women's Movement 1970–1985*, London: Pandora Press, 1987.
Pollock, G., *Vision and Difference: Feminism, Femininity and the Histories of Art*, London: Routledge, 1988 (includes 'Vision, Voice and Power: Feminist Art Histories and Marxism', 1982).
Vogel, L., 'Fine Arts and Feminism: The Awakening Consciousness', *Feminist Studies* vol. 2, no. 1 (1974).

GRISELDA POLLOCK (1949-)

After studying modern history at Oxford University in the late 1960s, Griselda Pollock took up the study of art history at the Courtauld Institute, London. Faced with what she saw at the time as the intellectual poverty of 'institutionally dominant' art history, and motivated particularly by feminist objections to many of the discipline's assumptions, Pollock set about examining the silences and prejudices embedded within art historical research and debate. Since 1977 she has produced a number of influential feminist rereadings of canonical modernist artists and their marginalized female peers. She is also known for her theoretical volumes and collaborative work with Roszika Parker and Fred Orton, and critical accounts of contemporary female artists and thinkers, such as **MARY KELLY**, Eva Hesse and **JULIA KRISTEVA**.

Pollock was galvanized by the 'social' art history of **T. J. CLARK** in 1973. She also pursued other theoretical trajectories outside the discipline, both within the politically engaged debates of the women's movement (Pollock and Parker were founder members of the London Women's Art History Collective in 1972), and the radical theoretical discourse emerging within film studies (indeed Pollock went on to join Mary Kelly on the editorial board of *Screen* in 1980). *Screen* magazine pioneered the reception of then current French structural Marxism, psychoanalysis and semiotics. Within these analytical frameworks Pollock was able to displace the focus on painterly styles and artistic genius found in much academic art history, and instead began to interrogate the way works

of art generate cultural meanings and help produce and reproduce social relations. As Professor of Social and Critical Histories of Art at the University of Leeds, Pollock continues to bring together (i) a consideration of the historical and social conditions at the time the art was being made or viewed, and (ii) an examination of the way individual subjects conceive of themselves, and relate to society and the cultural products around them.

Fervently contradicting T. J. Clark's assertion in 1974 – that feminist enquiry is merely a fashionable supplement to art historical analysis – Pollock has always insisted that it is of central importance to any critical understanding of both art and culture. While acknowledging the value of Marxism's central tenet – that society is structured by relations of material inequality – Pollock contends that it is *equally* structured by sexual inequality and gender divisions, considerations which are often neglected by Marxist analysis (*Vision and Difference* [*VaD*], 1988). There is therefore an urgent need for forms of contestation that can expose *all* of society's notions of 'naturalness' as socially constructed. Pollock argues for a combination of (i) new feminist analyses of sexuality, kinship and gender identity, with (ii) the rigour and historical materialism of established Marxist approaches. Pollock has always been concerned with the interface between ethics, aesthetics and politics. Lately she has begun to advocate for the power of 'transdisciplinary' encounters to generate productive 'exchange and confrontation' between different intellectual

approaches, and thus avoid narrow, academic insularity.

In response to the question 'Why have there been no great women artists?', **LINDA NOCHLIN** argued in 1971 that because women have been compromised by various social and educational restrictions over the centuries, their work inevitably has less claim to 'greatness'. Meanwhile Germaine Greer in her 1979 book *The Obstacle Race* insisted that women suffer debilitating psychological conflicts from living as a 'castrated' version of the dominant male in a patriarchal society. But in their focus on the obstacles to professional recognition, neither writer sufficiently calls into question the parameters within which the canon is constructed – 'the rules of the game' as Roszika Parker puts it. Pollock's first book with Roszika Parker, *Old Mistresses: Women, Art and Ideology* (1981), observes that although women have been consistently involved in producing art, and contemporaneous critics have commented on their work as professionals in their field, most twentieth-century art history fails to record this fact. Women artists have been 'written out' of E. H. Gombrich's famous *Story of Art* (1950), for example.

In asking why it has been apparently *necessary* to denigrate female artists and disqualify them as candidates for canonical greatness, the authors conclude that the discipline of art history is itself tied to 'bourgeois ideology'. In the history of art, as in bourgeois society as a whole, the superiority of 'masculine' qualities (intellect, power, inventive genius and so on) is perpetuated in binary opposition to particular constructions of femininity (instinct, compassion, craft skill and so on). Forms of aesthetic appreciation do not take account of specific historical circumstances and socially determined subject positions, but rather posit a timeless, universal and supposedly natural set of criteria. These criteria do not simply 'reflect' bourgeois ideology, but actively work to keep it in place.

Parker and Pollock are emphatic in resisting a purely reflectionist argument (one that reads cultural production as entirely constrained by, and therefore wholly reflective of, the dominant ideological character of the era). In *Vision and Difference*, Pollock praises **MICHEL FOUCAULT**'s notion of 'discourse formation', which identifies how the range of statements or representations relating to a particular subject builds up into a field of knowledge (*VaD*, p. 15). This field is unstable and ever evolving. It has limits and blind spots; ideology is operating, but there is scope for play and resistance. Thus, cultural producers should not be seen as merely representatives for their class or gender. As Pollock observes, 'artists work in but also on ideology'.

Appraising contemporary feminist art practice in their anthology *Framing Feminism* ([*FF*] 1987) Pollock and Parker identify a move from 'practical strategies to strategic practices'. In her preface to the exhibition *Sense and Sensibility in Feminist Art Practice* (1982) Pollock champions Mary Kelly, Susan Hiller and others who have found ways of working that do not simply enumerate the symptoms of oppression, but rather seek to expose the 'structural determinations' that allow such oppression to operate. In other words she applauds feminist artists who, following Bertolt Brecht, employ distanciation strategies 'to break the spell of illusion' and insist upon making the audience 'both critical and aware of the social and the real' (*FF*, p. 247). Pictorial strategies like collage and montage (collating and juxtaposing disparate elements, often of found material) and what she terms 'scripto-visual' installation (interrelated presentations of text and image within a continuous exhibition space) are amenable to the 'play of contradictions' (*FF*, p. 247). Rather than presenting a single-perspective picture, they map a process (such as collating newspaper cuttings, or taking serial photographs).

In highlighting the processes of making, such strategies reflect on how meaning is constructed; and by including conflicting viewpoints in one work, they also consider how meaning is constructed in the world. Such strategies tend to confound the apparent self-sufficient 'wholeness' of any single term – instead, terms are shown to be defined in relation to others in a signifying chain ('woman', for instance, is defined in contrast to 'man', or as equivalent to 'mother').

In advocating scripto-visual practices with such vigour, Pollock attracted criticism in the 1980s from Katy Deepwell, for effectively de-legitimizing other art forms, like painting, as viable arenas for feminist artists. Pollock responded by pointing out that it was precisely the modernist claim for the singularity and distinction between artistic media that feminism had tried to overthrow; it was necessary, however, to formulate a feminist theory of painting that would uncover the ways in which semiotic meanings were inscribed in colours, shapes and gestures. In her most recent book, *Looking Back to the Future* ([*LBF*] 2001), Pollock insists that her focus on scripto-visual practices does not amount to a blanket endorsement of all instances of them, nor is it a 'value judgement'. It is rather a 'tactical manoeuvre' that allows her to track the 'creation of feminism as a structurally altering signifying space' (*LBF*, p. 17).

The notion of signifying space comes from Julia Kristeva, and is crucial for Pollock. Works that might produce a 'structurally altering signifying space' are 'texts' in which a variety of cultural quotations 'blend and clash' (here she cites ROLAND BARTHES' characterization of the text after the 'death of the author'). Each reader activates, and makes sense of, these 'multiple textualities' for herself. Texts that invite the reader to consider the implications of the context in which the text is being presented also create a signifying space. Pollock suggests that

the reader is compelled to think about her own 'structural positionality' and subjectivity as a reader, in relation to the work and the artist's 'positionality' as producer (*LBF*, p. 17). The new thoughts and statements that arise within these discursive spaces change the shape of the discourse as a whole.

For Pollock, it is the labour and pleasure of thinking through these works that gives them value. 'Textualities do refer to many sites, many systems, and draw upon diverse drives and pleasures, scopic as well as invocatory, spatial as well as tactile. At once cinematic, sculptural, graphic, visual, the point is the invitation to decipherment, the invocation to reading as a complex social subjectivity within yet always transgressing the limits of power' (*LBF*, p. 19). The activities of assembling one's own meanings and deciphering intertextual references yield particular pleasures (related to the fascination for puzzles and patterns that seems to appear in most cultures). Pollock deploys decipherment as a rival aesthetic sensibility to the 'mere aesthetic evaluation' adhered to by CLEMENT GREENBERG. Unravelling and reconstituting multiple references gives rise to what she calls an 'aesthetic dimension of knowing'. Strikingly, this aesthetic dimension is perceptual and conceptual at the same time – it is not the pure vision of Greenberg, but nor is it confined to linguistics.

Peggy Phelan, in her introduction to the anthology *Art and Feminism*, recalls the disdain within the second wave of 1980s feminism towards the 'essentialism' of some 1970s work: they felt that its uncritical adoption of a notion of 'womanhood' betrayed an insufficient level of theoretical awareness. In particular, she recalls Pollock and Parker's anxiety about artworks that depicted or incorporated female bodies on the grounds that they might be co-opted by a patriarchal culture that sought to identify women with their biology. While acknowledging the political naivety of much of this work, Phelan

nevertheless speculates that Pollock's kind of theorization might have been (and may still be) inadequate in dealing with art that tries to make direct connections between visual images and the experience of embodiment, precisely because such work is resistant to (or at least incompatible with) language. Perhaps Pollock is now addressing this issue of the limits of language, in her focus on the incantatory repetitive pleasures of decipherment, which derive, at least in part, from a primal curiosity in visual pattern. The 'aesthetic dimension of knowing' is not the same as knowledge per se – the experience is visceral, the knowledge is always incomplete and one revels in the continual striving towards understanding.

Pollock has been indefatigable in urging art historians to think politically and analytically about every assumption within their discipline. If she has neglected aesthetic considerations in the past (as Peter Fuller and Anne Wagner have complained), it has been, she says, in order to address urgent political issues. Even as her interest in the area of aesthetics grows, she speaks of the need to maintain an ethical position in deference to the practical needs of female artists – somehow balancing the contradictory roles of 'advocacy and perspective, appreciation and analysis, partisanship and explanation' (*LBF*, p. 14).

KIRSTIE SKINNER

BIBLIOGRAPHY

Primary literature

Pollock, G. and Parker, R., *Old Mistresses: Women, Art and Ideology*, London and Henley: Routledge & Kegan Paul, 1981.

Pollock, G., *Vision and Difference: Femininity, Feminism, and Histories of Art*, London: Routledge, 1988/2003.

Pollock, G., *Differencing the Canon: Feminist Desire and the Writing of Art's Histories*, London: Routledge, 1999.

Pollock, G., *Looking Back to the Future: Essays on Art, Life and Death*, Amsterdam: G+B Arts International, 2001.

Secondary literature

Harris, J., *The New Art History: A Critical Introduction*, London and New York: Routledge, 2001.

Phelan, P., *Art and Feminism*, London: Phaidon, 2003.

Pollock, G. and Parker, R. (eds), *Framing Feminism: Art & the Women's Movement 1970–85*, London and New York: Pandora, 1987.

Pollock, G. and Orton, F. (eds), *Avant-Gardes and Partisans Reviewed*, Manchester: Manchester University Press, 1996.

Philosophy of Art and Aesthetics

INTRODUCTION

'The philosophy of art' and 'aesthetics' both consider questions of a general nature, that is, questions that are taken to generalize to all instances of a given phenomenon, problem or kind: all artworks, say, or all representations, or all beings (namely human beings) endowed with a given set of faculties and so on. Questions such as: What is the value of art? Is there something that all works of art, and only works of art, have in common? Does art reflect broader social transformations? Does it make a 'truth-claim'? Is a relation to historical precursors an essential feature of all works of art? Is art primarily an affective or cognitive domain of experience, or both? Does something come to be classed as a work of art in virtue of having some set of distinctive features or function, or in virtue of certain institutional or other procedural conditions applying? What is the relation between valuing works of art, and other domains of value?

Though the philosophy of art and aesthetics share a good deal of common ground, in terms of the level of generality at which they pose these questions – they are not concerned, unlike art history and theory, for example, with the historical precedents of a *particular* work or body of art – they do tend to have somewhat different starting points, and this dictates the kinds of question they ask and, on occasion, the kinds of solution to which these give arise. The philosophy of art, not surprisingly, begins with philosophical questions *about art*, its ontology, definition, function, value and so on. Aesthetics, by contrast, begins from philosophical questions about our *experience of* art, questions about the structure of aesthetic judgment, the role of imagination in interpretation and so on.

These different starting points, namely whether a philosopher starts from an analysis of the *object of* experience (the work), or with the *experience of* the work (hence with the subject), often reflect different kinds of underlying motivation or interest. An aesthetician, or an aesthetic theory, for example, might be concerned with art as a privileged domain of human experience more generally, and hence about the relation between aesthetic and other forms and objects of experience invested with value by human beings. A philosophy of art, by contrast, is more likely to be driven by an interest in a particular class of object, and what is distinctive or valuable about such objects. But in so far as they are concerned with a similar set of problems, albeit approached from different starting points, it is not surprising that these questions significantly overlap. Kant and Hegel offer a striking instance of this difference that is foundational for the discipline in its modern forms.

A further broad difference of approach in evidence here is that between 'analytic' and 'continental' philosophy and philosophers. Whereas the former tend to be concerned thematically with particular problems and the range of solutions that have been proposed to those problems, the latter tend to be concerned with particular philosophers and their relation to particular traditions of enquiry. Similarly, where conceptual questions are often prioritized by the former, requiring an analytic approach, questions of inheritance and interpretation are often prioritized by the latter, requiring a more historical, textual approach. That said, these

are generalizations, and as such not without exception. Moreover, such differences really do not begin to capture the range of approaches represented here. For even within these broad differences, the philosophers gathered here come from markedly different traditions and intellectual formations.

They include: several generations of critical theorists (Adorno, Wellmer and Bernstein), who share a desire to bring together philosophical analysis and empirical social critique, and a conception of art as a microcosm of, and repository for, wider social forces and tensions; phenomenological theories of art, such as Merleau-Ponty's, which relate the experience of art to the broader spatio-temporal conditions of embodied subjectivity and being in the world; and what might be broadly called 'post-phenomenological' tradition, including Deleuze and Lyotard, for whom art is fundamentally understood as a kind of 'shock to thought', an occasion for, or event of, intense feeling or sensation that disrupts existing conceptual categories. The latter is something these philosophers share with Derrida, in so far as deconstruction attempts to 'undo' or problematize habitual categories of philosophical thought, and their claims to systematicity.

On the other side of the analytic/continental philosophical divide the approaches are similarly diverse. They include the institutional and anti-aesthetic theories of Dickie, Danto and Carroll, who are all concerned, albeit in different ways, with the definition of art, that is, with the kind of conditions in virtue of which something is categorized as a work of art. Similarly, all give an answer that does not rely on artworks' 'manifest' properties: Danto in terms of 'enfranchising theories', indexed to the increasing self-understanding of art over time; Dickie in terms of 'candidacy for appreciation' by members of the art world; and Carroll in terms of 'historical narratives' in virtue of which something may be identified (rather than defined) as art. Like Carroll in this respect, Wollheim eschews the search for necessary and sufficient definitions of art, and is best known for his rich and substantive account of painting as art that, unusually for an analytic philosopher, brings psychoanalytic insights to bear on questions of artistic creation. As with Cavell, the resulting theory makes intention central to the understanding of art. Though unlike Wollheim, Cavell's aesthetic theory is forged by bringing Wittgensteinian insights into the nature of criteria and conventions into conjunction with his own, distinctive, conception of scepticism, and experience of modernism in art.

As such, the range of approaches exemplified by these thinkers is exceptionally broad. And all of them have impacted, beyond the confines of academic philosophy, not only on artistic practice but also, to varying degrees, on its theories and history, and broader cultural debates.

THEODOR ADORNO (1903–1969)

Theodor Adorno was a member of the Institute for Social Research in Frankfurt (aka the Frankfurt School of Critical Theory) and, like Max Horkheimer and most other members, was forced to flee Nazi Germany in 1934 because of his Jewish heritage. After four years in Oxford, Adorno settled in the United States during the Second World War, returning to Frankfurt in 1949, and becoming the director of the Institute in 1958. He is mostly known in the English-speaking world for *Dialectic of Enlightenment* (with Horkheimer, 1944), *Philosophy of Modern Music (1973)*, *Minima Moralia (1974)*, *Negative Dialectics (1973)* and *Aesthetic Theory (1994)*.

Adorno was born at a major turning point in modern society and art, when two world wars and numerous revolutions in art were soon to erupt. His writings on art are efforts to understand it in its social-historical context. Because the complexity of this context is mirrored in Adorno's writing style, he is a philosopher who is probably quoted more often than read. Fortunately, he also wrote critical essays (mostly on music and literature) that, in contrast to his philosophical texts, are quite accessible (see 'The Essay as Form' in *Notes to Literature*, vol. I). So Adorno readers are advised to read his essays before the theoretical texts. If followed, this advice will allow readers to appreciate that Adorno's mixture of theoretical-critical writings makes him especially promising for a philosophical-critical engagement with contemporary art.

Adorno's aesthetic theory has a number of key concepts. Some are materialist interpretations of classic aesthetic concepts such as mimesis, beauty, semblance and autonomy, while others are original contributions to materialist aesthetics. I will focus on the latter, and in particular on Adorno's idea of the 'truth content of art' because, given the conceptual web that Adorno creates around it, clarification of this will also illuminate the structure of his aesthetic theory.

Adorno believed that art reflects the truth of society, understood in social-economic-political-technological terms, and he calls such materialist reflection (or mimesis, aka imitation) the truth content of art. If society is failing (e.g. if its laws are unjust), art will reflect that failure; if society is progressing, art will reflect that too. A third possibility is the 'culture industry' (e.g. Hollywood films) that produces art that collaborates with the *un*truth of society while denying art any truth content (other than such collaboration). Since Adorno's assessment of modern industrial societies, whether democratic or not, was not positive (see *Dialectic of Enlightenment*), he generally focused on art that embodies this negative assessment. In doing so, he demonstrated how truth content works in very subtle ways. For example in Adorno's interpretation of Samuel Beckett, to whom *Aesthetic Theory* was (to be) dedicated, the focus is on the literary form of his work rather than any message it might contain. The work seemingly defies meaning not because Beckett embraces meaninglessness, as some existentialists have argued, but because modern society has undermined the traditional structures of meaning without providing any alternatives. The truth content of Beckett's work reflects this social as well as literary fact (see 'Trying to

Understand *Endgame*' in *Notes to Literature*, vol. I).

Adorno's notion of art's truth content has implications for art's autonomy (i.e. independence from religion, politics, metaphysics), often thought to be a defining mark of modern art; for art that reflects society cannot be fully autonomous from it. So art is both determined by society (i.e. artistic forms are shaped by social developments), yet sufficiently autonomous from it to take on a critical function. This is a precarious balancing act and one that Adorno traced and sustained in his writings, particularly those on individual artists (Berg, Beethoven, Mahler, Wagner).

The notion of truth content also helps to clarify Adorno's account of the 'semblance' character of art (i.e. art as illusion). Art does present illusions, but they are illusions with truth content because they reflect not only what society is not, but also what it *could* and *should* be. Here, art's truth content becomes utopian and, at the same time, art's capacity for critique emerges because society is held accountable, through art, for not being what it could and should be. Adorno's idea of beauty in art can be seen in this light. For when truth content becomes the central concept in aesthetics, art is said to reflect the semblance of beauty, that is, beauty lost or as it might someday be restored in society. As such, artistic beauty is modelled on natural beauty, with history mediating between them; according to Adorno, natural beauty is 'suspended history', a lost possibility.

Artistic and natural beauty are linked because both reflect historical possibilities that are imperative for us to pursue. Even Adorno's controversial preference for high modernist art over popular or low art is understandable in this light, because 'low' art is defined, in effect, by its inability to realize art's truth content (cf. GREENBERG). In turn, the relationship between aesthetics and politics is naturally a central issue for Adorno because of the social-political dimension of art's truth content (see 'Commitment' in *Notes to Literature*, vol. II). Similarly, all other aesthetic concepts, as well as more concrete questions about art (e.g. which forms are appropriate today), are to be addressed relative to the larger question of how art can best realize its truth content and thus its capacity for critique. So, clearly, 'truth content' is the heart of Adorno's aesthetics.

It is also important here to clarify a general issue underlying all Adorno's writings on art, namely the relationship between contemporary art and philosophy. He is well known for claiming at the start of *Aesthetic Theory* that nothing concerning art is self-evident anymore, not even its right to exist today. While some Adorno readers, myself included, might emphasize the scepticism about art embodied in this claim, in this context I would also like to emphasize its historical specificity. For example Adorno claimed that lyric poetry after Auschwitz is difficult, if not impossible, but he did not declare the end of lyric poetry, only its social condition today. To make this point salient for contemporary art, think of the difficulty that artists face in responding to the recent terrorist attacks or natural disasters around the world. More generally, Adorno believed that modern society makes it increasingly difficult to realize or gauge the truth content of art. Since truth content constitutes art, uncertainty at this level raises deep doubts about art's possibility today. Despite Adorno's doubts, however, he was determined that art continue; for art not only reflects the truth about society but is also the refuge for society's future possibilities. In principle, this utopian dimension offsets scepticism about art.

Adorno's scepticism was extended to aesthetics as well, where there is also an underlying utopian moment. Scepticism arises in aesthetics because art is the realm of *particular* things that resist concepts (the 'non-conceptual'), whereas philosophy is dependent on *universal* concepts in trying

to understand art. This does not seem like a happy match, yet Adorno cautions us not to doubt aesthetics simply because of its dependence on concepts. But he also warns that this dependence not be turned into a virtue that grants aesthetics any priority over art because of its ability to label art with the concept of 'non-conceptuality'. As Adorno points out, the very notion of the non-conceptual is an artefact of philosophy, so any mention of it points back to a *limitation* of philosophy (i.e. the limited reach of its concepts).

Then what are philosophers to do, if contemporary art is beyond the reach of universal concepts yet philosophy cannot understand art without using them? Adorno advises that philosophers appreciate that artworks will remain partly beyond the concepts used to understand them, but this does not mean that aesthetic concepts are to be avoided as we attempt to understand these works. This is a complicated relationship indeed: art is 'immediate' in so far as it is beyond the grasp of universal concepts, and philosophy can neither grasp art in its immediacy nor fully understand art using its concepts. At the same time, art resists philosophy's efforts to get beyond art's immediacy by identifying its truth content, as Adorno does. Such identification unavoidably involves concepts, so art resists its own truth content as a way to reassert its immediacy.

This strange dance is art interpretation informed by philosophy and, if this sounds shaky, Adorno's own essays on music and literature are models demonstrating that it can be performed well. If it is still hard not to see this dance as simply a flatfooted approach to art only proving that philosophers just can't dance, note that art is no less drawn to philosophy than philosophy is to art. Though I leave it to artists to describe this draw, I am confident of its presence because philosophical reflection on art is an extension of artists' efforts to achieve self-understanding (cf. Section I of this volume). True, artists want to achieve and express their self-understanding in artistic terms, and they often do that very well. But self-understanding, in art or anywhere, just is a philosophical endeavour.

Some critics of Adorno may still worry that his doubt about art's possibility perpetuates the traditional efforts by philosophers to control art and its effects, which is as old as Plato's *Republic*. Evidence for this worry, critics believe, is Adorno's concept of art's truth content because it is typically in relation to truth that art is deemed deficient. This worry can be allayed, however, if we remember the earlier point that any limitation philosophy faces in trying to understand art is a limitation of philosophy, not of art. Moreover, Adorno draws something positive from this limitation by offering it as a guide to aestheticians. For example it would be an illusion for philosophers to expect to capture art in an essentialist definition, i.e. in necessary and sufficient conditions (as **DANTO** seeks to do). So essentialism in aesthetics should give way to a historical-materialist account of art. Adorno uses the notion of truth content to provide an objective basis for this account and, at the same time, to distinguish his approach from the institutional theory of art (cf. **DICKIE**). Even if this notion has traces of idealism incompatible with materialism, the materialist approach displays its capacity for critique by detecting those traces.

Adorno offers promising philosophical insights into contemporary art and, through them, the society that makes art and aesthetics possible, while restricting their potential. As we resist these restrictions, Adorno provides philosophical tools for understanding our resistance and giving us hope we will succeed. He is famous for insisting on hope but also infamous for refusing to give hope any content. This hope/denial dialectic is a hallmark of Adorno's legacy but equally of modern society – and, he would add, of contemporary art.

MICHAEL KELLY

BIBLIOGRAPHY

Primary literature

Adorno, T. W., *Negative Dialectics*, trans. E. B. Ashton, New York: Continuum, 1973.

Adorno, T. W., *Minima Moralia: Reflections from Damaged Life*, trans. E. F. N. Jephcott, London: Verso, 1974.

Adorno, T. W., *Kierkegaard: Construction of the Aesthetic*, trans. Robert Hullot-Kentor, Minneapolis: Minnesota University Press, 1989.

Adorno, T. W., *Notes to Literature: Volume I & II*, trans. Shierry Weber Nicholsen, New York: Columbia, 1991/92.

Adorno, T. W., *Aesthetic Theory*, trans. Robert Hullot-Kentor, Minneapolis: Minnesota University Press, 1994.

Adorno, T. W., *The Culture Industry: Selected Essays on Mass Culture*, New York: Routledge, 2001.

Adorno, T. W., *Essays on Music*, trans. Richard Leppert, ed., and Susan H. Gillespie, Berkeley: California University Press, 2002.

Adorno, T. W. and Horkheimer, M., *Dialectic of Enlightenment: Philosophical Fragments*, Stanford: Stanford University Press, 2002.

Secondary literature

Bernstein, J. M., *The Fate of Art: Aesthetic Alienation from Kant to Derrida and Adorno*, Cambridge: Polity, 1992.

Huhn, T. (ed.), *Cambridge Companion to Adorno*, New York: Cambridge University Press, 2004.

Jay, M., *Adorno*, Cambridge: Harvard University Press, 1984.

Kelly, M., *Iconoclasm in Aesthetics*, New York: Cambridge University Press, 2003.

Menke, C., *The Sovereignty of Art: Aesthetic Negativity in Adorno and Derrida*, Cambridge: MIT Press, 1998.

Wellmer, A., *The Persistence of Modernity: Essays on Aesthetics, Ethics, and Postmodernism*, Cambridge: MIT Press, 1991.

Wiggershaus, R., *The Frankfurt School: Its History, Theory, and Political Significance*, trans. Michael Robertson, Cambridge: MIT Press, 1994.

Zuidervaart, L., *Adorno's Aesthetic Theory: The Redemption of Illusion*, Cambridge: MIT Press, 1991.

J. M. BERNSTEIN (1947–)

J. M. Bernstein is a philosopher and critic in the Adornian tradition. In 1975, having been a student of the influential Kant scholar W. H. Walsh, he obtained his Ph.D. from the University of Edinburgh for a thesis on Kant's epistemology. He went on to become a lecturer and later professor in the philosophy department at the University of Essex, where he played a crucial role in establishing its reputation as a stronghold of continental philosophy in Britain. In his period at the University of Essex, which lasted until 1997, Bernstein published a number of influential books, including *The Philosophy of the Novel: Lukács, Marxism and the Dialectic Form* (1984), *The Fate of Art: Aesthetic Alienation from Kant*

to Derrida and Adorno (1992) and *Recovering Ethical Life: Jürgen Habermas and the Future of Critical Theory* (1995). In 1988–91, he was an editor of the *Bulletin of the Hegel Society of Great Britain*, and the many conferences he organized and participated in allowed him to confront his growing theoretical edifice with an increasing number of interlocutors.

In 1998, Bernstein took up a position as professor of philosophy at Vanderbilt University, and since 2001 he has been a professor in the Graduate Faculty at the New School for Social Research in New York. During this period, his aesthetic interest has primarily been focused on modern visual art, in particular the nature and implication of abstract expressionist painting and its subsequent impact on the American and European art scene. In 2001, Bernstein published a major study of THEODOR ADORNO's ethical and practical philosophy, *Disenchantment and Ethics*. He has also produced a number of important essays, collected in *Against Voluptuous Bodies: Late Modernism and the Idea of Painting* (2006), on painting and modernism that have established him as a leading critic and philosopher of art in the USA. Much of the work of the last decade has contained sharp criticisms of both Habermas and Derrida, as well as of post-structuralist and postmodernist thought in general. In bringing radical epistemological, ethical and political claims to bear on his account of aesthetic experience, he has successfully inherited the legacy of Adorno's modernism.

Bernstein's early work in aesthetics deals with literature rather than visual art. In his dense but rewarding study of Lukács' theory of the novel, *The Philosophy of the Novel* (1984), he offers an account of the literary artwork, which set the stage for much of his later theorizing. In particular, the study of Lukács reveals the Hegelian and especially Marxist roots of Bernstein's thinking. (After all, Lukács' theory of the novel blends Hegelian motives into his reading of Marx in order to create what Bernstein characterizes as a Hegelian Marxism.) Drawing on Hegel, Bernstein (following Lukács) adopts an emphasis on social totality (the historically constituted world as a whole) as the reference point of social analysis, as well as an ambition to decipher the dialectical meaning of cultural objects. Drawing on Marx (and again Lukács), Bernstein argues that capitalist modernity must be accounted for in terms of reification, where reification is associated with alienation, rationalization, atomization and the deactivation of the subject. Capitalism is a social formation whose dominant forms of representation are exchange value and the commodity form understood as a socially structuring force that externalizes the subject from the object, explaining the rise of a cold, socially isolated and calculative lifestyle.

Bernstein is adamant that pre-modern social arrangements were made possible and indeed constituted by participation in communal practices. Whereas pre-modern life was predicated on the existence of a seamless web uniting identities and the social structure as a whole, modernity suffers from a radical split between subject and object, identity and social structure, and individual aspiration to happiness and the law. The novel, and the dialectic of form which it historically unfolds, is the most sophisticated means there is to both represent the world of rationalized modernity and to anticipate its overcoming. The novel is Kantian, Bernstein writes, in that it 'attempts to write the world as it is in terms of how it ought to be' (*The Philosophy of the Novel*, p. xviii). By progressively divesting itself of the means whereby pre-modern narratives (most notably the epic) achieved temporal coherence and form, the modernist novel is self-reflective to the point of embodying an uncompromising ironical stance. From a relatively autonomous standpoint it becomes a vehicle of radical, totalizing critique.

The Philosophy of the Novel is Bernstein's most overtly Marxist work. It makes constant reference to categories such as 'the proletariat' and 'class praxis', and inscribes the novel in a revolutionary scheme. In his next work in aesthetics, *The Fate of Art*, he appears to have downplayed or perhaps even abandoned Lukács' theory of class consciousness and programme for urgent social change. Drawing instead on the social, historical and aesthetic views of Adorno, *The Fate of Art* offers a genealogy of philosophical aesthetics that ranges from Kant to Heidegger, DERRIDA and Adorno himself. Its central claim is that aesthetic modernism represents the only fully adequate ethical and political response to the triumph of rationalized, disenchanted modernity. What aesthetic modernism, starting with Kant's account of reflective judgment and ending with Adorno's theory of aesthetic truth, aims at is to defend and express the claims of sensuous particularity in a world dominated by the demands of universality, subsumption, procedure and instrumentality. In addition to interpreting and defending Adorno, the book provides strong readings and criticisms of Heidegger and Derrida. Whereas Heidegger's influential philosophy largely ignored the essential difference between traditional and modernist art, Derrida drives aesthetic experience out of the historical and into an ethically irresponsible encounter with the sublime.

In his two subsequent books, *Recovering Ethical Life* and *Disenchantment and Ethics*, Bernstein brings an Adornian social analysis to bear on problems of ethical and political theory. Attacking what he calls 'moral centralism', according to which some central term such as 'good' or 'right' has a meaning prior to and independently of more specific terms like 'cruel' or 'vicious', his ambition is to locate an ethical demand in the experience of vulnerable bodies and objects.

Bernstein's approach to art is in line with his ethics. Operating as an antithesis of formal rationality, philosophical and aesthetic experience confronts the spectator with the promise of some form of expressive reconciliation with the otherwise dominated other. Art, and especially expressionist painting, thus partakes in a larger political and metaphysical project aimed at criticizing modernity from within. Divorced from science and morality and without any well-defined claim to determinate objectivity, advanced art represents the otherwise excommunicated claims of nature, particularity and ultimately human (corporeal) happiness.

Based on his reading of Adorno's aesthetics, Bernstein constructs an elaborate dialectic in order to defend this claim. Despite their separation from the world of universality, utility and determinate objectivity, the experienced 'concreteness' of advanced artworks remains illusory – mere 'semblance' (or appearance) – just art. However, in rebelling, as Beckett's novels or Pollock's paintings do, against this status, they shed their beauty and adopt abstraction and dissonance as their constitutive principles of form. Remaining illusory, they nevertheless – in their resolute abstraction and subsequent fragmentation – anticipate a reconfigured relation between universality and particularity, form and content, concept and intuition. In their dark moments of formal self-divestiture such works contain a residue of sensuous material meaning that acts both as a stand-in for the social reality of the sign (thus compensating for the lost social 'we') and as an anticipation of a restored materiality in general.

In his engagement with T. J. CLARK's *Farewell to an Idea* (1999), a theorist with whom his work bears many affinities, Bernstein elaborates on this claim by contesting Clark's idea that modernism failed historically. If modernism failed, Bernstein argues, then it was not because the hope of enlightened modernity, namely socialism, was not redeemed, but because modernism's failure suggested the failure of culture itself.

Indeed, modernism's failure is paradoxically what is most alive about it. According to Clark, by adopting the aesthetics of vulgarity, abstract expressionism provided the self-reflexive, self-denying finale to the history of modernism. By contrast, Bernstein argues that abstract expressionists like Pollock and de Kooning continue to help make sense of ourselves as wholly natural creatures inhabiting a material world.

In a similar vein, Bernstein also establishes a conception of medium and medium-specificity that is explicitly critical of CLEMENT GREENBERG's formalism. Whereas Greenberg saw the medium in terms of painting's own desire to purify and refine itself, Bernstein considers it as a plenipotentiary for nature as a source of meaning in an otherwise rationalized modernity. In Chaim Soutine, an artist Greenberg viewed as having failed to live up to the stern demands of artistic modernism, Bernstein thus sees repressed nature, that aspect of nature that has proved resistant to cultural forming, returning and being salvaged as painting.

One objection that can be levelled at Bernstein's more recent work is that by ascribing to art a specific metaphysical responsibility that it somehow needs to negotiate and express, it may fail to appreciate other norms (formal or otherwise) or sources of value that do not conform to the demands of the metaphysics. Bernstein typically focuses on abstract expressionism and offers powerful interpretations that seem to contain both formalist and anti-formalist (materialist) elements. Yet what about subsequent developments such as conceptualist and neo-avant-garde art practices? In most cases they seem to reject the value of expression completely. Does Bernstein dismiss such practices for failing to live up to the demands of aesthetic modernism, or does he try to redescribe them in terms that can be linked, whether directly or by way of negation, to his and

Adorno's expressionism? If the former, aesthetic modernism becomes too restrictive for its own good; it rules out a priori the most advanced contemporary art practices on which its critical spirit was meant to have rested. If the latter, the result may either be highly original but contentious (as in Bernstein's account of Cindy Sherman as a 'tragic modernist' in his essay 'The Horror of Non-Identity: Cindy Sherman's Tragic Modernism' in the recent *Against Voluptuous Bodies*) or simply the unfortunate clash between a general philosophical agenda and the irreducible heterogeneity of culture.

A more scholarly question is whether Bernstein, despite his sophisticated and inspiring readings, interprets Adorno adequately. It could be objected that Bernstein's tendency to develop idealized, positive accounts of such categories as pre-modern social life or nature sits uneasily with Adorno's stern demands for a negative dialectic. Whereas Adorno tries to avoid appealing to immediacy, seeking instead to develop concepts by practices of determinate negation, Bernstein seems to commit himself to a number of affirmative anthropological and aesthetic claims. It remains an open question whether he can do so and still subscribe to Adorno's doctrine of a negative totality.

Both philosophically and in terms of its specific claims about art, Bernstein's work is a powerful rejoinder to postmodern art theory. By drawing on intellectual resources from Hegel and Romanticism to Marx, Lukács and especially Adorno, Bernstein offers a strong case for the abiding importance of modernism – in both its metaphysical, ethical and political register. Although it remains to be seen whether modernist values will reappear more widely in contemporary art theory, such work brings a welcome exception to the abstract negation (or mere inversion) with which they have often been rejected.

ESPEN HAMMER

BIBLIOGRAPHY

Primary literature

Bernstein, J. M., *The Philosophy of the Novel: Lukács, Marxism and the Dialectics of Form*, Brighton: Harvester Press/Minneapolis: University of Minnesota Press, 1984.

Bernstein, J. M., *The Fate of Art: Aesthetic Alienation from Kant to Derrida and Adorno*, Oxford: Polity Press/University Park, Pa.: Penn State Press, 1992.

Bernstein, J. M., *Recovering Ethical Life: Jürgen Habermas and the Future of Critical Theory*, London: Routledge, 1995.

Bernstein, J. M., *Adorno: Disenchantment and Ethics*, Cambridge and New York: Cambridge University Press, 2001.

Bernstein, J. M., 'The Death of Sensuous Particulars: Adorno and Abstract Expressionism', *Radical Philosophy* 76 (March–April 1996), pp. 7–16.

Bernstein, J. M., '"The Dead Speaking of Stones and Stars": Adorno's *Aesthetic Theory*', in ed. Fred Rush, *The Cambridge Companion to Critical Theory*, Cambridge and New York: Cambridge University Press, 2004.

Bernstein, J. M., *Against Voluptuous Bodies: Late Modernism and the Idea of Painting*, Stanford: Stanford University Press, 2006.

Secondary literature

Hammer, E., 'Romanticism Revisited', *Inquiry* 40 (1997), pp. 225–42.

NOËL CARROLL (1947–)

Noël Carroll belongs to a generation of American philosophers, schooled in the analytic tradition, who cultivated the revival of interest in the philosophy of art after the ground-breaking work of Nelson Goodman, RICHARD WOLLHEIM and ARTHUR DANTO. Carroll's work addresses a variety of mainstream topics within the philosophy of art, including the problem of definition, the relation of art to morality, the problem of authorial intention and the relation of art to the emotions. Turning to less conventional topics, Carroll has put forth 'a philosophy of horror' and 'a philosophy of mass art'. The main focus of his work, however, has been on film, or, more accurately, on 'moving images', a transmedia category comprising film, video, television, moving computer-generated technology, that is, all mass-produced moving images.

Carroll stirred up controversy within film studies with two early polemical books, *Philosophical Problems of Classical Film Theory* (1988) and *Mystifying Movies: Fads and Fallacies in Contemporary Film Theory* (1988) in which he staged a two-tier attack against the essentialism of earlier theoretical writings on film and against more recent Marxist, psychoanalytic and semiological, Lacanian and Althusserian approaches respectively. Carroll's critique of the essentialism of classical film theory

in *Philosophical Problems of Classical Film Theory* marks the beginning of his long-standing critique of the idea of the specificity of the medium. His original targets were the theories of Rudolf Arnheim, André Bazin and Victor Perkins, which sought to establish the status of cinema as an art by analyzing and safeguarding the true nature of film as a medium.

The assumption of medium-specificity is evident, for example, in Bazin's thesis that 'the realism of the cinema follows directly from its photographic nature' (*What is Cinema?*, p. 108), in Arnheim's condemnation of sound because it contravenes the true essence of cinema and, more generally, in the very idea of the 'cinematic'. Carroll's aim was to dismantle the philosophical foundations of these theories. Specifically, he rejects the idea that the determination of the nature of the medium imposes stylistic directives or specifies a range of desirable aesthetic effects. In other words he wishes to undermine the idea of a transition from medium to style, and, further, the idea of the transformation of technological media into art forms on the basis of their technical characteristics. A further consequence of this line of argument is that no evaluative criteria can be established on the basis of an investigation of the alleged nature of the medium.

Carroll has extended his critique to further theories, such as Kracauer's, and by extension to CLEMENT GREENBERG's main thesis in 'Modernist Painting' (1960), and went as far as to declare that the notion of the medium is of no theoretical use whatsoever ('Theorizing the Moving Image' in *Theorizing the Moving Image* [*TMI*], 1996) or that we should simply forget the medium ('Forget the Medium!' in *Engaging the Moving Image*, 2003). In philosophical terms, Carroll rejects the claim that artistic media should be regarded as 'natural kinds' with predetermined essences that can be captured by necessary and sufficient conditions, and

argues instead that 'it is the use we find of the medium that determines what aspect of the medium deserves our attention. The medium is open to our purposes; the medium does not use us to its own agenda' (*TMI*, p. 13).

Building further on a hostile review of Stephen Heath's *Questions of Cinema*, published in *October* (which prompted an equally hostile reply by Heath, leading to the Heath/Carroll debate), *Mystifying Movies* is a relentless attack on what Carroll calls 'Grand Theory', i.e. semiotic, psychoanalytic and Marxist theories in the Lacanian and Althusserian tradition (as applied predominantly by Christian Metz, Jean-Louis Baudry and Stephen Heath). Carroll mobilized the resources of analytical thinking in order to expose weak analogies, ambiguous concepts, and generally fallacious patterns of reasoning in these highly influential writings (one such example being his analysis of Baudry's 'apparatus theory' as a piece of inductive reasoning relying on invalid analogies). Arguing that there is no empirical evidence to support psychoanalytic theories and ideas, such as Lacan's 'mirror stage', and that psychoanalysis is of no relevance when adequate rational explanation is available, he defended the thesis that we should rely instead on the rational explanations provided by cognitive psychology in order to understand the powerful effects of movies on their spectators.

The claim that contemporary film theory has been 'nothing short of an intellectual disaster' as well as the specifics of his polemics met with great animosity (*Mystifying Movies*, p. 108). Carroll's logical analyses were seen as bizarre attempts to take theories that relied on an entirely metaphorical use of terms literally, and Carroll was accused of being a diehard empiricist and a 'positivist' (the latter used, as is often the case in art historical debates, as a term of abuse in a way that does not correspond to its original philosophical usage). More interesting is the

objection that the mode of analytic critique, adopted by Carroll, proceeds in a peculiarly ahistorical manner, and is not capable of appreciating the significance of these texts within the highly politicized cultural context that generated them. However, this valuable insight was effectively lost in the highly polemical atmosphere of the debate and as a result its significance was missed.

Carroll proceeded to develop a framework for film theory relying on the idea of small-scale or 'piecemeal' theorizing. He defined this as a mode of theorizing that is attentive to the various devices, modes, genres, techniques and mechanisms of film, without referring them back to some conception of the essence of cinema, or to an overarching, unified theory, and argued that many of these piecemeal theories are cognitivist theories. Such a cognitivist approach was applied to horror fictions in *The Philosophy of Horror, or Paradoxes of the Heart* (1990).

The anti-essentialist orientation of Carroll's thinking is also evident in his philosophy of art. Even though Carroll concedes that the search for necessary and sufficient conditions has heuristic value as a method in helping us understand the richness of our concept of art (*Philosophy of Art*, p. 10), he has argued that we should seek an alternative to the definitional approach. In a series of papers (collected in *Beyond Aesthetics*, Part II), he put forth a theory of art historical narratives, which are meant to provide a means of *identifying*, rather than *defining*, art. In this respect, the theory recaptures the neo-Wittgensteinian insight that even though a definition of art is not possible, we may still possess ways of identifying art. However, it diverts from this line of thinking by not relying on the idea of 'family resemblances', that is, mere patterns of similarity, as the basis for such identification.

The influence of GEORGE DICKIE, and in particular his recommendation that any definitional attempt should rely on 'relational' (i.e. non-exhibited) rather than 'manifest'

(i.e. exhibited) properties of artworks, as well as his scepticism towards the aesthetic, is evident in Carroll's approach. Carroll proposes that identification should be seen as a cultural practice located within an evolving tradition, and argues that the starting point for such an approach should rest on the historical conjecture that the history of the philosophy of art has been driven by the developments of the avant-garde, and more particularly by works that give rise to the question 'but is it art?' Accordingly, an 'identifying narrative' establishes the art status of a work by linking a disputed work to antecedently acknowledged art by way of narrating a satisfactory account of how this work emerges intelligibly from previous artistic practices.

Overall, the theory of identifying narratives avoids the difficulties of Dickie's institutional theory, while retaining many of the advantages. It is a 'procedural' rather than 'functional' theory, that is, it relies on procedures of establishing the art status of works, rather than defining art in terms of the distinctive experience it provides. Finally, the theory provides a satisfactory account of how art status is conferred on disputed works by offering an adequate criterion (i.e. the existence of an intelligible narrative link to earlier artworks).

This conception of the identification of art as relying on narration is closely linked to Carroll's notion of interpretation as conversation. In the theory of interpretation, Carroll espouses a position he describes as 'modest actual intentionalism' (*Beyond Aesthetics*, pp. 197–213). As opposed to 'extreme intentionalism', which regards meaning as fully determined by actual intentions, modest intentionalism merely claims that authorial or artistic intentions are *relevant* to interpretation. The idea is that artistic intentions constrain the range of possible interpretations of the work. The correct interpretation should thus be seen as the one compatible with (rather than

fully determined by) artistic intentions and supported by the work.

'Actual intentionalism' is open to attack from two fronts. First, from the point of view of 'anti-intentionalism', which can follow two further lines of thinking. Hence, it can be argued, on epistemological grounds, that intentions are irretrievable, or, on interpretative grounds, that attempts to locate intentions divert attention from the most relevant features of works of art, or impose undesirable constraints on the richness of possible interpretations. Second, from the point of view of 'hypothetical intentionalism'. This approach takes the epistemological argument into account, and proceeds to argue that interpretation should not be regarded as being constrained by actual intentions but rather by the 'ideal reader's' (well-warranted) hypotheses as to what the artist intended. Hypothetical intentionalists (such as Jerrold Levinson) challenge the continuity Carroll's theory postulates between the interpretation of art and ordinary interpretative practices (such as conversation) and point to the distinctive character and aims of the former.

The theory of identifying narratives has been criticized from a rigidly analytic point of view as non-philosophical on the grounds that it effectively makes the philosophy of art collapse into art history and reduces the philosophical question 'what is art?' to mere description. The theory, however, retains its philosophical character in providing a philosophical explanation of the identifying role of narratives. It could also be claimed, contrary to this criticism, that the distinctive advantage of Carroll's theory of identifying narratives lies, precisely, in endorsing art history and promoting a model of philosophical theorizing informed by artistic and critical practices. What comes across as a broad recommendation in this area has been fully implemented by Carroll in his philosophy of film.

The transition to the era following Danto's grand speculative venture has been described as that from the age of the hedgehog, who knows one big thing, to the age of the fox, who knows a lot of little things (Kivy, 'Foreword' to *Beyond Aesthetics*). This is an apt way of describing Carroll's preferred mode of theorizing on a small-scale and in a substantive manner.

KATERINA REED-TSOCHA

BIBLIOGRAPHY

Primary literature

Carroll, N., *Mystifying Movies: Fads and Fallacies in Contemporary Film Theory*, New York: Columbia University Press, 1988.

Carroll, N., *Philosophical Problems of Classical Film Theory*, Princeton, N.J.: Princeton University Press, 1988.

Carroll, N., *The Philosophy of Horror, or Paradoxes of the Heart*, New York: Routledge, 1990.

Carroll, N., *Theorizing The Moving Image*, Cambridge: Cambridge University Press, 1996.

Carroll, N., *Interpreting the Moving Image*, Cambridge: Cambridge University Press, 1998.

Carroll, N., *A Philosophy of Mass Art*, Oxford: Clarendon Press, 1998.

Carroll, N., *Philosophy of Art: A Contemporary Introduction*, London and New York: Routledge, 1999.

Carroll, N., *Beyond Aesthetics: Philosophical Essays*, Cambridge: Cambridge University Press, 2001.

Carroll, N., *Engaging the Moving Image*, New Haven and London: Yale University Press, 2003.

Secondary literature

Arnheim, R., *Film as Art,* Berkeley: University of California Press, 1975.

Bazin, A., *What is Cinema?*, trans. H. Gray, Berkeley: University of California Press, 1967.

Levinson, J., 'Intention and Interpretation in Literature', in *Pleasures in Aesthetics,* Ithaca: Cornell University Press, 1996.

On the Heath/Carroll debate:

Heath, S., *Questions of Cinema,* Bloomington: Indiana University Press, 1981.

Carroll, N., 'Address to the Heathen', *October* 23 (Winter 1982).

Heath, S., 'Le Pere Nöel', *October* 26 (Autumn 1983).

Carroll, N., 'A Reply to Heath', October 27 (Winter 1983).

STANLEY CAVELL (1926–)

Stanley Cavell was born in Atlanta, Georgia. After receiving an AB in music from the University of California, Berkeley, he abandoned plans to study composition in New York, and instead acquired a Ph.D. in philosophy from Harvard. After teaching at Berkeley for six years, he returned to Harvard to take up the Walter. M. Cabot Chair of Aesthetics and the General Theory of Value, from which he retired in 1997. He has written extensively on film, literature and painting; on politics, ethics and religion; on psychoanalysis; on American transcendentalism and pragmatism; and on a range of significant European thinkers, including Kierkegaard, Nietzsche, Heidegger, DERRIDA, Levinas and Lacan. One of his most significant contributions in aesthetics has been to the debates surrounding modernism. Partly through his early exchanges with MICHAEL FRIED (which

began during their time at Harvard in the 1960s), partly through his own work on music and cinema (particularly Hollywood cinema of the 1930s and 1940s), he conceives of art and artistic media, and hence reconceives artistic modernism, in ways that deserve far more critical appreciation than they have yet received.

Cavell's philosophy is informed by the writings of Austin and Wittgenstein. These (misleadingly labelled) 'ordinary language philosophers' regarded the logic or grammar of speech as a means of revealing the essence of whatever that speech might be about, suggesting that we can come to understand what it is for something to be a particular kind of thing by recounting what we do and do not say (what it does and does not make sense to say) about that kind of thing. These grammatical conditions or limits (Cavell calls them criteria) tell us what

counts in a double sense: they specify that without which something wouldn't count as an instance of a certain kind; and those specifications are themselves expressions of our interests in the things we encounter, revealing what matters or counts to us about them. Criteria are thus as much articulations of value as of identity.

Cavellian criteria are neither merely conventional (as if rearrangeable by individual or collective fiat, like the Highway Code), nor essentially a priori or timeless (as if reflecting eternal verities utterly beyond alteration). Rather, embedded as they are in particular cultural expressions of the human form of life, criteria participate in the flexible inflexibilities of that life. They are as resistant (and as open) to change as are the broader patterns of human behaviour, reaction and response into which they fit – as fixed (and as optional) as our routes of feeling and interest, our modes of response, our sense of what is significant and what is not, of what is similar to what else and so on.

If agreements in natural reactions do change over time, as our sense of what is natural to us as humans, or as this group of humans here and now, shifts, so will our mutual attunement in criteria; and since, even at any given moment, nothing guarantees or underwrites those agreements, we must always be prepared for any claim we make to mutuality in speech to be rebuffed. In other words for Cavell (unlike many other Wittgensteinian philosophers), grammatical investigations investigate the necessities of a particular historical period (however extended that period may be); and they are explorations of the extent to which we do agree, in our criteria and so in our forms of life, not a way of assuming that we must so agree, or of enforcing such agreement.

This picture of criteria as allowing evaluative, historically specific revelations of essence informs Cavell's basic conception of the domain of art. For a grammatical

investigation grounds his claim that an art object is one in which people take a certain kind of interest, investing them with a value which we otherwise reserve only for other people. Artworks mean something to us, not just in the way statements do, but in the way people do – we speak of them in terms of love and affection, or scorn and outrage; and they are felt as made by someone – we use such categories as personal style, feeling, dishonesty, authority, inventiveness, profundity and meretriciousness in speaking of them. In particular, the category of intention is as inescapable in speaking of works of art as in speaking of what human beings say and do, although in specific ways (the work of art doesn't express specific intentions, but rather celebrates the fact that human beings can intend their lives at all, that their actions are capable of coherence and effectiveness).

Cavell takes the concept of a medium to be indispensable in differentiating kinds of artwork, and in understanding specific instances of those kinds; but it must be seen as referring not simply to a physical material but to a material-in-certain-characteristic-applications, and hence as having a necessarily dual sense. Sound, for example, is not the medium of music in the absence of the art of composing and playing music. Musical works of art are not the result of applications of a medium that is defined by its independently given possibilities; for it is only through the artist's successful production of something we are prepared to call a musical work of art that the artistic possibilities of that physical material are discovered, maintained and explored. Such possibilities of sound, without which it would not count as an artistic medium, are themselves media of music – ways in which various sources of sound have been applied to create specific artistic achievements, e.g. in plainsong, the fugue, the aria, sonata form. They are the strains of convention through which composers have been able to create,

performers to practice and audiences to acknowledge specific works of art.

Cavell's account of cinema involves a parallel dual deployment of the concept of a medium in relation to that of its material basis. He begins by analyzing the material basis of film (in terms of photography in its relation to reality); he then characterizes the medium of film as a succession of automatic world projections, and identifies various film media – that is, the character types and genres whose particular applications in good movies disclose the artistic potential of these media in this medium.

Many critics reject Cavell's characterization of photographs as presentations of nothing less than reality; but it is worth emphasizing that his claim is not that a photograph of Greta Garbo just *is*, or is indistinguishable from, Garbo herself – it is that such a photograph is *of* Garbo herself and not some surrogate or likeness of her. Others (such as **NOËL CARROLL**) have claimed that Cavell's work is just another argument from medium-specificity – an attempt to read off an art form's generic and specific possibilities from the independently given properties of its medium. But this misrepresents both aspects of Cavell's concept of a 'medium'. First, the terms of Cavell's specification of the medium of film are not read off from merely material properties of photography, but accrue their highly idiosyncratic sense from his critical interpretations of specific films and specific achievements of film. And the same is true of his characterizations of the various media of film. He does not analyze the genres of remarriage comedy and the melodrama of the unknown woman by first specifying the features necessary and sufficient for membership, and then testing individual candidate films against that specification. Rather, each member is seen as mounting a critical study of the conventions hitherto seen as definitive of that genre (say by establishing that the absence of one such convention can be compensated for in certain ways); it

thereby discovers new possibilities of that generic medium, and hence of the medium of film. Once again, however, nothing can count as a discovery of either kind unless we are prepared to count the specific object before us as a work of art; everything comes down to specific acts of critical judgment.

For Cavell, modernist art is art which is *nothing but* a critical study of its own inherited conventions, of its media and its medium; the modernist artist is unable simply to take for granted his or her capacity to engender genuinely valuable work. What, if anything, is to count as a contribution to his tradition of artistic endeavour (say painting) is unclear; what is at stake in each painting is whether or not it is a painting at all, and hence what, if anything, is to count as painting as such. Such work, being condemned to take the conditions of its own possibility as its primary concern, becomes a kind of grammatical investigation. Here, the question of whether a work of art is good – that is, whether it merits comparison with great work of the recent and distant past – and the question of whether it is a work of art at all converge; to be work that counts and to count as a work are one and the same.

Consequently, Cavell significantly revises **CLEMENT GREENBERG**'s influential characterization of the modernist project in painting (in ways convergent with Michael Fried's work). Greenberg argued that modernist paintings identified the timeless essence of painting as such; and this essentially cognitive achievement was seen as distinct from the further task (also taken on by these artists) of establishing what constituted *good* painting as such. For Cavell (and Fried), however, since these works could only establish anything about painting as such if they elicited conviction in their quality, the two tasks were essentially inseparable; and what was thereby established was an identification of those conventions that, at that given historical moment, were alone capable of establishing the work's identity as

painting. Such identification could not ensure that another work invoking those conventions would automatically elicit conviction; neither could it show that other works acknowledging other conventions would fail to do so, now or in the future. In short, the modernist artist's grammatical investigation of essence is essentially historicized, with each work standing or falling on its own terms, in its own time; and the fate of every such work ultimately depends on its capacity to elicit acknowledgement as a work – that is, as the discovery of a possibility of the medium – from its audience.

For Cavell's modernist, the past is an undismissable problem. The history of his art sets the terms for his own creative investigation of his medium and media; and to reject those terms altogether would mean entirely losing interest in whether one's work matters in the ways (or in ways intelligibly related to the ways) the great work of the past matters to us – losing interest in the idea of artistic greatness, or artistic value, altogether. Cavell has, consequently, been accused of building a dislike of postmodernism into his definition of art, as opposed to clarifying what is at stake in the future development of any art once it attains the modernist condition. Certainly, recounting the grammar of art, or of an artistic medium, cannot guarantee the continuation of an interest in past artistic achievement. It can only remind us of what is lost by its loss: the continued human inhabitation of a realm in which objects can be made that mean something to us the way people do, and that celebrate the sheer fact of the human capacity to make meaning in the face of indifferent nature and determined society. It remains far from obvious that issuing such a reminder is no more than the defensive gesture of a humanist left behind by history.

STEPHEN MULHALL

BIBLIOGRAPHY

Primary literature

Cavell, S., 'Aesthetic Problems Of Modern Philosophy', 'Music Discomposed' and 'A Matter of Meaning It', in *Must We Mean What We Say?*, Cambridge: Cambridge University Press, 1969.

Cavell, S., *The World Viewed: Reflections on the Ontology of Film* (expanded edition), Cambridge: Harvard University Press, 1979.

Cavell, S., *Pursuits of Happiness: The Hollywood Comedy of Remarriage*, Cambridge: Harvard University Press, 1981.

Secondary literature

Beardsley, M. and Margolis, J., 'Comments on Cavell', in eds Capitan and Merrill, *Art, Mind and Religion*, Pittsburgh: University of Pittsburgh Press, 1967.

Carroll, N., *Theorizing the Moving Image*, Cambridge: Cambridge University Press, 1996.

Fried, Michael, *Art and Objecthood*, Chicago: University of Chicago Press, 1998.

Rothman, W. and Keane, M., *Reading Cavell's* The World Viewed: *A Philosophical Perspective on Film*, Detroit: Wayne State University Press, 2000.

ARTHUR C. DANTO (1924-)

Arthur Danto made his reputation as a philosopher in the 1960s and early 1970s publishing books on Nietzsche, historiography, the theory of action, and epistemology. In 1964 he wrote a short essay on the philosophy of art called 'The Artworld', which was inspired by a visit to an exhibition of Andy Warhol's sculpture where Danto realized that a new definition of art was needed: he had to explain why *Brillo Box* (1964), a sculpture that looks very much like the banal brillo box found in grocery stores, was art. 'The Artworld' discussed pop art and interpretation, and a structuralist theory of art history, all of which were further developed in 1981 in *The Transfiguration of the Commonplace*.

In the opening essay of *The Transfiguration of the Commonplace* Danto asks us to imagine a sequence of visually identical red surfaces: this comprised a painting showing the Egyptians who pursued the Israelites drowning in the Red Sea; a Moscow landscape called 'Red Square'; *Red Table Cloth*, a still life by a follower of Matisse; and an unpainted canvas primed in red. According to Danto, these visually indistinguishable red surfaces have very different meanings. They demonstrate that interpreting art requires knowing more than meets the eye. After contrasting works of art and mere physical objects, Danto develops theories of interpretation, representation and the nature of metaphor.

Danto's definition of art was inspired by Warhol's exhibition. A century earlier, when art was figurative, it would have been hard to imagine this analysis taking place. But Danto's argument can be developed in purely abstract terms using thought experiments. In the twentieth century, many new art forms were developed: cubism led to surrealism and on to abstract expressionism, and then there was earth art, minimalism, and video and so on. Many critics and some aestheticians concluded that art had no essence. Defining art, they argued, depends upon conventions, and since many novel forms of art have been developed, why should this process not continue? The World Wide Web makes possible forms of art unimagined even by Warhol. Danto was never tempted by this argument. As an essentialist, he believes that art has a non-conventional nature.

In 1995 Danto presented the Mellon Lectures at the National Gallery, Washington (*After the End of Art* [*AEA*]), where he discussed Hegel's claim that the history of art has 'ended'. In his late 1820s lectures, Hegel claimed that art, come to full self-consciousness, was being superseded by philosophy; art's history, arguably, had effectively ended. Admitting that Hegel had dated this ending too early, Danto claims that Warhol's art achieved just that self-consciousness. He lays out an explicit definition. 'To be a work of art is to be (i) *about* something, and (ii) *embody its meaning*' (*AEA*, p. 195). A work of art is something that 'refers'. It can be a representation, like an old master painting, or an artefact linked to theorizing, like an abstract painting or *Brillo Box*. Many things that are not works of art are about something: books on aesthetics or art history, for example, are about art but are not themselves works of art. The second part of the definition introduces Danto's Hegelian claim. Art critics tell us in so many words what *Brillo Box* means. Warhol's sculpture presents that meaning in a more direct way, by embodying it. Danto's definition explains why we need to interpret art. To

know what meaning a work of art embodies commentators need to articulate it.

The Mellon Lectures join Danto's earlier philosophy of art to a discussion of historiography. Since his *Analytic Philosophy of History* (1965) had already discussed Hegel, this stage in his development was well prepared. Traditionally art historians have constructed large-scale narratives; Ernst Gombrich told the story of art from Cimabue through to Constable and argued that abstract expressionism had a late place in this tradition; CLEMENT GREENBERG showed how old master illusionism was followed by the modernist tradition in which the art of Manet and his successors leads to cubism, and later on to Pollock. But in the 1980s many American critics and art historians rejected such master narratives. Some critics said that art's history was exhausted; others claimed that mass art or new media like video made traditional art obsolete; some claimed that artists should stop making paintings and sculptures. The buzzword 'postmodernism' was used to describe this situation. Danto offered something different, a philosophical argument. The history of art ended because Warhol finally got the question of art's nature into 'the correct philosophical form', thereby enabling Danto to discover that the nature of art inheres in what distinguishes two indistinguishable objects or events, only one of which is a work of art. After Warhol revealed art's essence, no further development was possible. Once the nature of art had been discovered, the history of art had ended. Henceforth we live in a post-historical era.

Danto's thesis has been much discussed and often misunderstood. He was not saying that no interesting new art was being made. He admired Sherrie Levine, Robert Mangold, Robert Mapplethorpe, Mark Tansey, Cindy Sherman, Saul Steinberg and Sean Scully; these artists indeed do something 'new'. Mapplethorpe's erotic images go further

than Warhol's; Scully's paintings are very different from those of his acknowledged precursors, Mondrian and Rothko. In our post-historical era, any and everything is possible. Hegel argued that not only art history, but also history as such had come to an end. Recently Hegel's thesis about the end of history has been defended by Francis Fukuyama. Fukuyama in his famous book *The End of History and the Last Man* (1992) argues that the demise of Communism and fascism makes liberal democracy the only viable form of government. Danto does not make this claim. And Marxists like Frederic Jameson linked the novel forms of art to broader social changes; Danto does not. For him, the end of art's history does not tell us anything about broader historical developments. Danto is not apolitical, but he does not find these ways of describing the relationship between art and politics productive.

The Abuse of Beauty (2003) supplements this argument. In the 1990s American critics discussed the disappearance of beauty. Certainly *Brillo Box* is not beautiful. Good art need not be beautiful, but the pleasures provided by beauty are essential to everyday life. In *The Abuse of Beauty*, Danto links the pleasure of art with what might be called the politics of everyday life in new ways. His philosophy of art always has been tied to broader social concerns, and to understand *Brillo Box* we need to know something about American culture in the 1960s, and about how a gay man like Warhol viewed his society.

Danto's aesthetic is part of a broader philosophical system, which was developed in his early books on action, epistemology and historiography, and then summarized in *Connections to the World* (1997). Descartes' philosophy provides the basic structure for Danto's. Like Descartes, Danto is interested in how we know and act upon the world. When I see my computer, a mental representation is created; thanks to some brain activity, I view that machine, and when I write, I act upon the world. My

wish to act causes my fingers to move. Such simple cases of knowing and acting are the necessary basis of the elaborate ways in which our historians and scientists reveal the true causal order of the world. Our representations are mental states, and so we can always ask whether they are truthful. We test a representation by examining its ability to match reality.

Like Descartes, Danto is a dualist. Descartes believed that there were physical and spiritual things, which were connected in perception and action. Danto says that there are representations and what they represent, the world, but he makes no commitment to spiritual substances like Cartesian souls. Most likely, he has suggested, our mental representations are material brain states. What defines philosophy, Danto argues, is this concern with the relationship between the world and its representations. Scientists and historians describe the facts; philosophers explain how it is possible for us to have knowledge of the facts. Art too fits into this system. Like our mental states that provide us with knowledge, works of art are both mere things within the world and representations of the world. *Brillo Box* seems to be a mere physical object like the brillo box, but is actually something more. Thanks to the theory of art it embodies, *Brillo Box* is a work of art.

According to Danto, all philosophical problems involve indiscernibles. If two things appear visually indiscernible but are actually very different, we need a philosophical theory to tell them apart. When Descartes asked whether perception was truthful, he studied dreams. I seem to see my computer. But suppose that I am asleep, dreaming that I am writing, then my mental representation would not be truthful. Only epistemology can show that our mental representations are trustworthy. An analogous claim can be made about the distinction between *Brillo Box* and the mere physical brillo box. Since they look exactly the same, only a theory of art can explain why Warhol's *Brillo Box* is a work of art. If you could subtract away these theories, then all that would remain of *Brillo Box* is the brillo box. In the grocery store, brillo box is just an object, but in the museum *Brillo Box* is a work of art, in virtue of such a theory.

A few years after *The Transfiguration* appeared, Danto also started writing art criticism for *The Nation*. In the 1980s much of the most prestigious American criticism was devoted to theorizing. As **ROLAND BARTHES**, **JACQUES DERRIDA** and **MICHEL FOUCAULT** were translated into English, many critics were inspired to develop highly theorized accounts of contemporary art. These writers did not impress Danto. His own criticism, he has always emphasized, comes out of direct experience of art, not art theory. In that way, he has more in common with Denis Diderot and Charles Baudelaire than with the many art writers fashionable in the 1980s who were associated with **ROSALIND KRAUSS** and her highly influential journal *October*.

For this reason, someone could accept Danto's philosophical system yet offer very different critical judgments. A philosophy of art must be general. Danto's critical judgments gain no authority from his philosophy of art. As a pluralist, he believes that immensely diverse forms of great art are possible right now. The philosophy of art and art criticism have essentially different concerns. Art criticism is a form of rhetoric, in which the critic works to get viewers to see things his way. Philosophy has a different, deeper concern, describing the world as it really is.

DAVID CARRIER

BIBLIOGRAPHY

Primary literature

Danto, A. C., 'The Artworld', *The Journal of Philosophy* 61 (15 October 1964), pp. 571–84.

Danto, A. C., *Analytical Philosophy of History*, Cambridge: Cambridge University Press, 1965.

Danto, A. C., *The Transfiguration of the Commonplace: A Philosophy of Art*, Cambridge: Harvard University Press, 1981.

Danto, A. C., *After the End of Art: Contemporary Art and the Pale of History*, Princeton: Princeton University Press, 1997.

Danto, A. C., *Connections to the World: The Basic Concepts of Philosophy*, Berkeley, Los Angeles and London: University of California Press, 1997.

Danto, A. C., *The Abuse of Beauty: Aesthetics and the Concept of Art*, Chicago and La Salle, Ill.: Open Court, 2003.

Danto, A. C., *Unnatural Wonders: Essays from the Gap Between Art and Life*, New York: Farrar, Straus & Giroux, 2005

An autobiographical memoir devoted to his work is forthcoming in the 'Library of Living Philosophers' series:

Auxier, Randall E. (ed.), *The Philosophy of Arthur C. Danto*, Chicago/La Salle: Open Court Publishing, forthcoming.

Secondary literature

Carrier, D. (ed.), 'Danto and His Critics: Art History, History and After the End of Art', *History and Theory*, Theme Issue 37 (December 1998).

Carrier, D., *Rosalind Krauss and American Philosophical Art Criticism: from Formalism to beyond Postmodernism*, Westport, Conn. and London: Greenwood/Praeger, 2002.

Danto, A. C., Gilmore, J., Horowitz, G., and Rush, F. 'Symposium: Arthur Danto, *The Abuse of Beauty*', *Inquiry*, Vol. 48, No. 2 (April 2005).

Haapala, A., Levinson, J., and Rantala, V. (eds) *The End of Art and Beyond: Essays After Danto*, New Jersey: Humanities Press, 1995.

Hegel, G. W. F., *Aesthetics: Lectures on Fine Art*, trans. T. M. Knox, Oxford: Clarendon Press, 1975.

Rollins, M. (ed.), *Danto and His Critics*, Oxford: Blackwell, 1993.

GILLES DELEUZE (1925–1995)

The philosophical work of Gilles Deleuze attempts to equate philosophy and its creation of concepts with modes of vital expression and creativity in art. His work on art is marked by an explicit suspension of critical judgment in order to attend to the full implications of the different materials and techniques utilized by the artist. His early work consisted of bold and original studies of historical philosophical figures such as Hume, Bergson and Spinoza. In 1968 he published his first work of independent philosophy, *Difference and Repetition*, which marked him out as a thinker of significance

and formed the substantial philosophical basis for all his subsequent work. This was followed by, among others, *The Logic of Sense* (1969), *Francis Bacon: The Logic of Sensation* (1981), two volumes on cinema: *The Movement-Image* (1983) and *The Time Image* (1985); *The Fold: Leibniz and the Baroque* (1988) and *Essays Critical and Clinical* (1993). He collaborated with the psychoanalyst Félix Guattari on a number of highly influential works, including *Anti-Oedipus* (1972), *A Thousand Plateaus* (1980) and *What is Philosophy?* (1991).

Deleuze constructs a materialist philosophy by conceptually explicating the real material forces of life. Here ontology (the theory of 'being' or the 'real') becomes a study of the subterranean processes of individuation, that is, the invisible processes responsible for actualized phenomena within space and time. Deleuze seeks to go beyond traditional ontology's attempt to think 'being' via notions of fixed essences or substrates and develop a more dynamic account of 'being' as a process of *becoming*.

For Deleuze, individuated 'beings' result from *becoming* and always contain more than their seemingly fixed forms would suggest, and it is precisely this 'excess' which needs to be thought. His more dynamic ontology thus concentrates upon thinking the very genesis of actualized 'being' in space and time, and is best described as a theory of 'onto-genesis'. Thus philosophy must attempt to transfigure itself from a concern with the fixed phenomenal realm (the 'actual') to the realm of pre-phenomenal forces of becoming that operate as the condition of all individuated things (the 'virtual'). The 'virtual' is Deleuze's concept for the embryonic multiplicity of pre-phenomenal forces coiled inside the realm of individuated and actual 'being'. His creative ontology of becoming ceaselessly strives to go beyond mere surface fixities associated with the 'actual' (for example the existing conditions of current culture and society) in the effort to assemble a conceptual

discourse capable of conveying pre-individual impersonal forces, energies, fluxes, flows and sensations that actual socio-historical situations occlude, reify and domesticate into rational orders, conceptual systems and clichéd patterns of representation and intelligibility.

For Deleuze the dynamic movement of ontogenesis (the movement from 'virtual' to 'actual') always takes place by a process of differentiation, and thought must attempt to pursue these divergent paths; rather than following a natural line of development from the 'virtual' to the 'actual', thought must be effectively 'counter-natural', it must creatively pursue the virtual by travelling backwards from the 'actual' (Deleuze terms this movement 'counter-effectuation'). In order to genuinely think the virtual, thought must dissemble the 'actual' and return to a point where there are no longer any pre-existing co-ordinates or points of reference. It is this effort towards counter-effectuation that entails such an intimate relationship between philosophy and the non-philosophical.

All of Deleuze's philosophical work (often in conjunction with Guattari) is marked by a fundamental affinity with the arts. For Deleuze the 'art of philosophy' as the creation of concepts only emerges in the face of a vital encounter with something 'outside' thought; thought is always moved from without, as a result of some shock or encounter. Deleuze repeatedly calls upon an encounter with art as a means for guiding philosophical thought out of the habitual 'images of thought' under which philosophy often labours. It is no longer feasible to posit reason, common sense and pre-existing powers of recognition at the origin of a philosophical construction of concepts. Rather, contemporary philosophy must creatively construct its concepts 'outside' its own conceptual field, from within science, the visual arts, literature and cinema. Philosophy must actively engage with and emulate non-philosophical realms in order to begin constructing its activity of

thought upon the ground of 'something that does not think' philosophically, to relate itself to an unthinkable and imperceptible exteriority. This exteriority, Deleuze argues, 'calls forth forces in thought which are not the forces of recognition, today or tomorrow, but the powers of a completely other model, from an unrecognised and unrecognisable *terra incognito*' (*Difference and Repetition*, p. 172). Hence, the creative activity of philosophy necessarily rests upon it being intertwined and co-implicated with the 'autopoiesis' (the creatively autonomous movement of self-positing) of the non-philosophical realms.

Deleuze privileges the specifically 'autopoietic' forces and rhythms present in works of art, that is, the intrinsic self-ordering and creative self-positing associated with the different materials utilized by artists – paint, stone, cinematic movement and time image, and language. Thus, the matter of an artwork is never simply a homogeneous substance that passively receives preconceived forms, but is an emergent autopoietic line of divergent becoming. He argues that all forms of art seek to invent or create the means for harnessing and rendering visible the 'virtual' intensities of life through negotiation with the 'autopoietic' traits of material. Indeed, the creative activity of art is capable of reaching and harnessing the virtual movement of differentiation and becoming, the chaotic plane of 'virtual multiplicity' folded imperceptibly within the actual. Art becomes creatively vital through its immersion within the 'autopoietic' realm of virtual forces and intensities; this is a realm without concepts or individuated forms, capable of dissolving all settled organic forms into pre-individual zones of intensive forces where one can no longer differentiate human from animal, vegetable and mineral.

Artists are engaged in 'creating' the plastic methods and techniques for handling the 'autopoiesis' associated with the different materials involved in the multiple practice of art in order to engage in an act of 'co-creation' with the 'autopoietic' forces of the 'virtual'. Through these materials are created what Deleuze and Guattari term consistent 'beings of sensation' (or 'haecceities') that are independent of any specific perception, affection and sentiments associated with the human. Works of art are independent 'beings of sensation' capable of providing an affective encounter through what they term 'percepts' and 'affects' (pure 'beings of sensation' that are extracted from the perceptions and affections of everyday corporeal experience). Artists express pure forms of perception and sensation ('percepts' and 'affects') that are independent of the pre-existing conceptual identity of any given thing. These have the affect of destabilizing us, drawing us out of and beyond ourselves by expressing (or bringing to expression) a world of potential movements and new varieties of possibilities that associate our actual existence with something different or external to it.

For Deleuze it is a matter of concentrating upon the way in which an artist uses a specific material – how his or her materials become inherently expressive of sensation rather than merely a vehicle for a pre-existing idea of a specific sensation. It is here that the genuinely 'self-ordering' (autopoietic) virtual potentials of matter operating as the condition of individuation can be 'thought' and developed aesthetically. Individuated forms become something suggested by the different materials; sensible varieties of possibility emerge from the virtual potentials of matter. Artists thus surrender to matter, follow its virtual singularities and, by attending to these virtual traits, allow material to speak to their 'instinct'.

While Deleuze has written on many different art forms, including literature, cinema and architecture, one of his most significant texts is a work on the visual arts, *Francis Bacon: The Logic of Sensation*. Here the specificity of Bacon's paintings is utilized to develop a number of new

concepts, allowing him to move away from a standard representational view of painting towards an understanding of painting capable of presenting intensive forces and affects. Deleuze seeks to explicate the fact that for many painters paint has its own specific 'logic', or indeed multiple logics, its own meanings, its own expressions and its own 'analogical' language. In *The Logic of Sensation* he develops a bold and original understanding of how Bacon's work constitutes an 'analogical' language in and of paint, a specifically painterly 'logic of sensation' that emerges instinctively from an intimate negotiation with the autopoietic material traits of paint. Bacon's abstract figural work is conceived as being paradigmatically concerned with the expressive materiality of paint, and conveying intense beings of sensation. His paintings, by circumventing narrative relations, are able to concentrate on expressing impersonal sub-representational 'matters of fact', and explore the possibilities of what can be achieved through the virtual traits of the materiality of paint.

Deleuze's understanding of Bacon's paintings rests upon seeing them as conveying a very special type of violence, a violence not of the represented spectacle of horror but of sensations linked to a unique encounter with virtual forces. It is, Deleuze insists, a specific violence associated with the vital autonomy of colour and line. As he writes in *Difference and Repetition*, it is only through a certain abandonment of figuration and representation 'that we find the lived reality of a sub-representational domain'. Bacon's paintings should thus be understood as rhythmic experiments in painting sub-representational sensations of virtual becoming. Throughout the study Deleuze analyzes in detail Bacon's specific handling of the conflicts between chaos and order, chance and control, and his negotiation with the realm of the 'unthought' in the act of painting. He concentrates upon the specific techniques Bacon develops for handling the autopoietic traits of paint – techniques developed for productively utilizing 'virtual' traits immanent within paint as a means for creative fabulation and figuration. Bacon's work ultimately exemplifies a radically material form of expression with its own specific 'sense' and 'logic'; colour and line schemas in Bacon's work are thus elevated to the state of a pre-representational analogical language capable of conveying and bearing the sensation of virtual becoming. Deleuze concludes that it is through the elaboration of a pure painterly logic of sensation that painters like Bacon are able to liberate themselves from the figurative co-ordinates of conventional representations and thereby release the multiple possibilities of invention according to an uncoded analogical language.

What Deleuze's study of Francis Bacon exemplifies is his insistence, evident within all his philosophical work on art, on how philosophers must become increasingly attentive to artists' pre-conceptual and pre-verbal understandings of the material with which they create. Philosophers need to listen more closely to how artists negotiate with the autopoietic aspects of the different materials they use in order that lessons for philosophy and its own efforts towards a ceaseless creative activity of 'thinking the virtual' in concepts can be genuinely learnt.

In recent years there have been a number of contemporary critics of Deleuze's philosophy, including Žižek and Badiou. However, it is Jacques Rancière's work that has paid the most consistent critical attention to Deleuze's aesthetics. In a recent work, *The Politics of Aesthetics*, he argues that Deleuze's aesthetics serves to occlude questions regarding the different ways in which aesthetics is 'politicized', i.e. how the visible and the invisible, the audible and the inaudible, the sayable and the unsayable come to be politically circumscribed.

DARREN AMBROSE

BIBLIOGRAPHY

Primary literature

Deleuze, G., *Cinema 1: The Movement-Image*, London: Continuum, 1989.
Deleuze, G., *Cinema 2: The Time-Image*, London: Continuum, 1989.
Deleuze, G., *The Logic of Sense*, London: Continuum, 1990.
Deleuze, G., *The Fold: Leibniz and the Baroque*, London: Continuum, 1993.
Deleuze, G., *Difference and Repetition*, London: Continuum, 1994.
Deleuze, G., *Francis Bacon: The Logic of Sensation*, London: Continuum, 2003.

With Félix Guattari:

A Thousand Plateaus, London: Continuum, 1988.
What is Philosophy?, London: Verso, 1994.
Anti-Oedipus, London: Continuum, 2005.

Secondary literature

Ansell-Pearson, K., *Germinal Life: The Difference and Repetition of Deleuze*, London: Routledge, 1999.
Bogue, R., *Deleuze on Music, Painting and the Arts*, London: Routledge, 2003.
Colebrook, C., *Gilles Deleuze*, London: Routledge, 2002.
Rajchman, J., *The Deleuze Connections*, Cambridge: MIT Press, 2000.
Rancière, J., *The Politics of Aesthetics*, London: Continuum, 2004.

JACQUES DERRIDA
(1930–2004)

Jacques Derrida was born in Algiers, in the then French colony of Algeria, in 1930. He moved to Paris in 1950, studying and later teaching at the École Normale Supérieure. In the latter half of his life he was director of studies at the École des Hautes Études en Sciences Sociales, Paris, and visiting professor at a number of US universities. He helped found Groupe de Recherches sur L'Enseignment Philosophique (GREPH) and the Collège international de philosophie (CIPh), Paris.

The primary concern of Derrida's formative writings is to draw out the binary oppositions structuring philosophical texts, and show how the history of philosophy has tended to accord one of the binary terms priority over the other, such as the signified over the (merely empirical, merely material) signifier, and the voice over (merely supplemental, merely graphic) writing. This hierarchization is symptomatic, argues Derrida (closely following Heidegger), of a general and metaphysical valuing of presence: that which *is*, be it the world that can be seen, a consciousness that can be reflected upon or a self identical to itself, in the present moment of an actual 'here and now' or 'living present' (the term is Husserl's); while that which is opposed to presence, absence, is deemed to be derived and secondary and contingent.

Derrida then proceeds to do two things: (i) reveal how in fact the subordinate term is necessary for the maintenance of the

dominant one, to the extent that in principle it is always possible to reverse them; (ii) problematize not simply the hierarchy but the very oppositionality of the two terms, the border between them, the ways in which what is 'inside' either term is claimed to be essential, necessary or natural, by 'reinscribing' them back into the texts in question minus the hierarchy of one over the other. The former could not be carried out without the space created by the latter. The aim is to undo binarisms, decompose them and de-sediment their historical privilege and external hegemony, not from a position 'outside' the text, as if deconstruction were an operation performed authoritatively 'on' it, but by showing how texts deconstruct themselves; and not as a negative operation but as a way of freeing texts up, 'multiplying the differences' and allowing for the possibility of readings no longer governed by the value or presupposition of presence.

It is not difficult then to see why the notion of 'the frame' might interest Derrida. But it was not until the mid-1970s that Derrida sought to demonstrate how deconstruction could be performed on canonical texts in the philosophy of art, and how art objects could themselves be deconstructive of philosophical and historical discourses on art. This took the form of two papers engaging with Kant's critical project, 'Economimesis' and 'Parergon', and two catalogue essays on artists contemporary with Derrida: Adami and Titus-Carmel. Together with 'Restitutions', Derrida's response to Heidegger's 'The Origin of the Work of Art' (and Meyer Schapiro's critique of it), the last three papers appear in *The Truth in Painting* (1978), Derrida's major contribution to the study of art.

The two essays on Kant question the coherence of a system which tries to locate a separate domain called the 'aesthetic': 'Economimesis' does this by showing how, in his attempt to free the productive imagination from nature, Kant succeeds only in reincorporating aesthetic creation ever more firmly into an economy of imitation and repetition; 'Parergon' does so by taking those aspects conventionally considered to be ornamental, which Kant names *parerga* (such as the frame, drapery of statues, or the columns of temples) and, by reinscribing them, demonstrates how Kant finds it difficult to assign them a stable place without importing a logical frame from elsewhere in the system. Derrida shows how *parerga* supplement a 'lack' internally constitutive of the works they frame such that they cannot be said to be either inside or outside. 'Restitutions' focuses on how both Heidegger and Schapiro ascribe features or properties to a painting by van Gogh for which there is no *internal* evidence guaranteeing the identification or the claims of verisimilitude. All these essays are concerned one way or another with the frame, with the distinction inside/outside and what sustains or reinforces that distinction, and the ways in which what is claimed or conventionally thought to be outside might in fact be functioning formatively, to figure or maintain the inside.

The essays on Adami and Titus-Carmel, as well the late essay on the artist Atlan, bring to the fore the 'traits' of artworks, such as the line and the brushstroke, which might equally disaffirm as affirm the truth of the concepts around which discourses on art organize themselves. And playing on a term invoked by Artaud – the 'subjectile'– allows Derrida to show how the material support of a work of art, for instance the paper or the canvas, at the same time withdraws from it and becomes invisible. This questioning of medium-specificity is further pursued in two texts on the moving image, featuring pieces in which Derrida appears, a video by Gary Hill and a film by Ken McMullen respectively: 'the specificity of a "new art" ... is not in a relation of irreducible dependence ... and especially of synchrony with the emergence of a technical generality or a

new "support"' ('Videor', p. 178); 'When the very first perception of an image is linked to a structure of reproduction, then we are dealing with the realm of phantoms...' ('Ghost Dance', p. 61).

Perhaps all of Derrida's writing on art can be characterized by the attempt to show how on the one hand discourses on art tend to desire, claim or assume authority over the 'mute' work of visual art, and thereby subordinate the visual to the discursive; and on the other show how ostensibly 'mute' works are authoritative, indeed authoritarian, in their very silence – that is, how works of art are already saying something all the more powerful for their silence, an authoritarianism from which discourses on art, discourses no less concrete and material than the object talked about, might seek to liberate themselves. Interpretations of art for Derrida are always situated between and tensed by these two poles: 'Thus there are two interpretations – one is always between the two, whether it is a question of sculpture, architecture, or painting' ('The Spatial Arts', p. 13). It is precisely this indeterminacy and heterogeneity at the site of interpretation which is exploited by philosophers of art interested, unlike Derrida, in retrieving the ontological status of artworks – witness Andrew Benjamin's notion of 'anoriginal difference', where the art object is not the origin of the interpretation, but nor is there anything prior to it, hence anoriginal, an origin that is not original.

All works of art for Derrida are always already 'textualized' in his expanded sense, one which is not purely discursive or linguistic or literary not least because it carries with it a spatiality which we might more conventionally associate with the visual arts. And art, for Derrida, has always been complicit with its philosophical determination, in the sense that it has borrowed from philosophy the means with which to define, explicate, legitimize and historicize its practices. But this brings us

to what some perceive to be a problem with Derrida's writing on art: its privileging of the discursive over the non-discursive or the visual. It may be, as Derrida himself suggests, 'that a certain general theoretical formalization of the deconstructive possibility has more affinity with discourse (than with the non-discursive, non-verbal, spatial, or visual)' ('The Spatial Arts', p. 14) – an important admission. But if visual art resists deconstruction it is not immune from it. And besides, the 'formalization' of deconstruction is something philosophers and writers on the discursive arts themselves might wish to resist. One explanation for Derrida's reticence, if we can call it that, is suggested by Geoff Bennington as a suspicion of a moment of sensory or perceptual presence: 'I suspect that what we say about having a feeling for art presupposes the very things that Derrida is busily undoing in one way or another' (*Deconstruction: Omnibus Volume*, p. 77), something Bennington contrasts with JEAN-FRANÇOIS LYOTARD's insistence on just that.

But there is a more critical interpretation, one which would hold Derrida to account for a classical privileging of philosophy over art practice. One such charge is made by Michael Kelly, who argues that *Memoirs of the Blind* (1990), the catalogue accompanying an exhibition at the Louvre curated by Derrida, inscribes a philosophical interest, in this case Derrida's disinterest in looking at art, into what is in fact an aesthetic theory held by Derrida (*Iconoclasm in Aesthetics*, p. 110). This fits Derrida into a history of iconoclasm. Moreover, for Derrida to begin his enquiry with what drawing is not, its blindness and powerlessness, which Kelly reads as drawing's failure, is to begin with philosophy rather than with art practice. A related criticism is made by PIERRE BOURDIEU, for whom Derrida, because he 'never withdraws from the philosophical game', 'cannot truly tell the truth about the Kantian philosophy of art and, more generally, about philosophy

itself, which his own discourse has helped to produce' (*Distinction*, p. 495). According to Bourdieu, Derrida never deconstructs himself as a philosopher, thus Derrida's work can be viewed as an exemplary form of philosophical denial.

Deconstruction has attempted to narrow the gap between theory and practice from the side of practice – to realign writing with the visual arts and broaden its conception by encompassing technics, the audio-visual and the compositional (see, for example, Greg Ulmer's notion of 'applied grammatology'). When Derrida spoke, as he did throughout his career, of the need for new sorts of knowledge and communication (for instance a 'university to come' in which a 'new humanities' would welcome the transformative effects of the practical aspects of art making), the emphasis was always on literature and the performative force of the linguistic speech act. Derrida has little to say about aesthetic education and those facets of it which may be productive of a positive difference to the teaching of humanities subjects. But there is still much work to be done in drawing out the full implications of Derrida's texts on visual art for philosophy, and of his thinking for visual art.

JONATHAN LAHEY DRONSFIELD

BIBLIOGRAPHY

Primary literature

Derrida, J., 'Economimesis', (1975) trans. Richard Klein, *Diacritics* 11 (1981), pp. 3–25.

Derrida, J., *The Truth in Painting*, (1978) trans. Geoff Bennington and Ian McLeod, Chicago: University of Chicago Press, 1987.

Derrida, J. (with Plissart, Marie-Françoise), *Right of Inspection*, (1985) trans. David Wills, New York: Monacelli Press, 1998.

Derrida, J. (with Thévenin, Paule), *The Secret Art of Antonin Artaud*, (1986) trans. Mary Ann Caws, Cambridge: MIT Press, 1998.

Derrida, J., *Memoirs of the Blind: The Self-Portrait and Other Ruins*, (1990) trans. Pascale-Anne Brault and Michael Naas, Chicago: University of Chicago Press, 1993.

Derrida, J., 'Videor', in eds David Bellour and van Assche, *Passages de L'Image*, Barcelona: Fundacio Caiza de Pensions, 1990, pp. 174–9.

Derridua, J., *Atlan Grand Format: De la couleur à la lettre*, Paris: Gallimard, 2001.

Interviews

'Deconstructing Vision: Jacques Derrida in discussion with Terry Smith', in eds Patton and Smith, *Jacques Derrida: Deconstruction Engaged: The Sydney Seminars*, Sydney: Power Publications, 2001, pp. 14–53.

Brunette, P. and Wills, D., 'The Spatial Arts: An Interview with Jacques Derrida', trans. Laure Volpe, in eds Brunette and Wills, *Deconstruction & the Visual Arts: Art, Media, Architecture*, Cambridge: Cambridge University Press, 1994, pp. 9–32.

Payne, A. and Lewis, M., 'The Ghost Dance: An Interview with Jacques Derrida', trans. Jean-Luc Svoboda, *Public* 1 (1987), pp. 60–73.

Secondary literature

Benjamin, A., *Art, Mimesis, and the Avant-Garde: Aspects of a Philosophy of Difference*, London: Routledge, 1991.

Bourdieu, P., *Distinction: A Social Critique of the Judgement of Taste*, (1979) trans. R. Nice, Cambridge: Harvard University Press, 1984.

Brunette, P. and Wills, D. (eds), *Deconstruction & the Visual Arts: Art, Media, Architecture*, Cambridge: Cambridge University Press, 1994.

Kelly, M., *Iconoclasm in Aesthetics*, Cambridge: Cambridge University Press, 2003.

Papadakis, A., Cooke, Catherine and Benjamin, Andrew (eds), *Deconstruction: Omnibus Volume*, London: Academy Editions, 1989.

Ulmer, G., *Applied Grammatology: Post(e) Pedagogy from Jacques Derrida to Joseph Beuys*, Baltimore: Johns Hopkins University Press, 1985.

GEORGE DICKIE (1926–)

Born in Palmetto, Florida, George Dickie received his Ph.D. in philosophy from UCLA in 1959 and from 1967 to 1995 was Professor of Philosophy at the University of Illinois, Chicago, where he is currently Professor Emeritus. Dickie has been one of the most prominent aestheticians of the past forty years, having since the 1960s made a number of significant contributions to important topics in philosophical aesthetics. He was accordingly appointed vice-president, and subsequently president of the American Society for Aesthetics in 1991–92 and 1993–94 respectively. His voluminous output is represented by a number of monographs, the highly influential, co-edited *Aesthetics: A Critical Anthology* (1977), and a large range of articles, including current work, dealing among other things with the following subjects: the definition of art, the evaluation of art, the role of intention and the nature of critical principles. Dickie has also written extensively on eighteenth-century aesthetic theories, but his most important and influential work consists in his objections to contemporary aesthetic theories, and the development in a number of versions of his well-known institutional theory of art.

These last contributions to philosophical aesthetics and art theory marked a turning point in contemporary debates, making Dickie a seminal figure in the field. At the same time, however, criticism of Dickie's institutional theory has been fierce and persistent since its first inception, and its influence has been further shaken by the emergence over the intervening years of a number of powerful rival theories of art. Meanwhile, Dickie's attempts to answer his critics have so far met with rather limited success, and it is too early to discern whether

his latest attempt to defend the theory, articulated in the 2001 book *Art and Value*, will manage to silence them.

Dickie's most important early work consisted in a series of attacks on contemporary aesthetic theories. Such theories aimed to demarcate and define the concept of the 'aesthetic', and hence to identify the nature of aesthetic appreciation and the perception of aesthetic qualities by appeal to a special type of experience or attitude that is distinguishable from other types of experiences or attitudes. The aesthetic attitude was typically held to depend on a special psychological state, such as 'disinterestedness', which involved the lack or suppression of ulterior purposes or 'interests' when regarding an object aesthetically. In his classic paper 'The Myth of the Aesthetic Attitude' (1964) Dickie argued, however, that special aesthetic states of mind are a myth and that 'disinterested' refers merely to the (lack of) ulterior interests with which someone may regard an object. There is, he insisted, only one way of attending to an object, although this may be subject to varying degrees of distraction. In light of this, cases of supposedly interested attention are really more accurately described simply as cases of inattention.

Hence, Dickie argued, the notion of a disinterested attitude simply collapses into that of undistracted attention to something, about which there is nothing peculiarly aesthetic. In a long-running debate with Monroe Beardsley, Dickie took a similarly dim view of the notion of aesthetic experience, arguing that the criteria cited as demarcating it, such as 'wholeness', 'unity', 'coherence', can be properly attributed only to objects, particularly artworks. To hold otherwise,

he maintained, is simply to confuse the experience of the properties of objects with the properties of the experience itself (*Art and the Aesthetic [AA]*, 1974).

These arguments are symptomatic of Dickie's antipathy to psychologizing in aesthetics; that is, they are born out of, and depend partly upon, his view that we should not indulge in introspection, but turn to objects and their properties in order to examine and explain the 'aesthetic'. They also entail a rejection of aesthetic theories of art, namely the idea that artworks can be defined in terms of their aesthetic function, such as to cause aesthetic experiences.

Throughout the 1950s and 1960s traditional projects of essential definition – the search for the jointly necessary and sufficient conditions of art – appeared to have been undermined by the neo-Wittgensteinian arguments of philosophers such as Morris Weitz. Taking their cue from the manifold, problematic developments of avant-garde modern art, they held that (i) art cannot be defined because it is an open concept lacking any essence, and (ii) art can be identified instead through the notion of 'family resemblance'. While agreeing that traditional essential definitions of art failed, however, Dickie objected that this scepticism was also misplaced because (a) the family resemblance method could not plausibly be used to identify art, since everything resembles everything else to some extent, and (b) an essential definition need not, contra Weitz, preclude originality and creativity in art (*AA*). Following an idea of Mandelbaum's, Dickie argued that traditional essential definitions failed because they were concerned only with the 'exhibited' or perceptual properties of objects, rather than with their non-exhibited relational properties. Instead, drawing on **ARTHUR DANTO**'s concept of 'the artworld' (1964), he urged that we must look to the complex social and cultural network in which artworks are embedded to understand their essence.

Dickie's formulation of the institutional theory of art went as follows:

> A work of art in the classificatory sense is (1) an artefact (2) a set of the aspects of which has had conferred upon it the status of candidate for appreciation by some person or persons acting on behalf of a certain social institution (the artworld). (*AA*, p. 34)

This definition (i) provides jointly necessary and sufficient conditions for something to be art; (ii) is intended to cover all the arts; and (iii) is classificatory rather than evaluative. Part of Dickie's intention was to explain the art status of avant-garde art, such as Duchamp's *Fountain*, which was physically indistinguishable from ordinary non-art objects. Artworks could be anything so long as their status was conferred in the right way, by those with the appropriate authority vis-à-vis the right institutional context, the art world. It is important to realize, however, that the status conferred is not that of 'artwork' but 'candidate for appreciation'. Although admitting that the notion of the art world is vague, consisting of a 'loosely organised, but nevertheless related, set of persons ... [in fact] every person who sees himself as a member of the artworld', Dickie maintained that the 'bundle of systems' of which it is constituted nonetheless amounts to a social institution (*AA*, pp. 33–35).

After a decade of intense criticism, Dickie reformulated the institutional theory (*The Art Circle [AC]*, 1984), providing the new definition: *A work of art is an artefact of a kind created to be presented to an art world public.* This is supported by four further propositions:

(i) An artist is a person who participates with understanding in making a work of art.

(ii) A public is a set of persons whose members are prepared in some degree to understand an object that is presented to them.

(iii) The art world is the totality of all art
 world systems.
(iv) An art world system is a framework for
 the presentation of a work by an artist to
 an art world public
(reprinted in *Art and Value*, p. 28)

Abandoning talk of institutions and the
formal sounding 'conferral of status', Dickie
stresses that art can exist only 'in a cultural
matrix, as the product of someone fulfilling a
cultural role' (*AC*, p. 55).

Despite various criticisms of specific
points, many of Dickie's original and cogent
objections to aesthetic theories have
remained persuasive even if they have not
succeeded in ridding aesthetics altogether
of the use of notions such as the aesthetic
attitude and aesthetic experience. As
Beardsley pointed out, for example, without
some notion of aesthetic experience, it is
difficult to account for the distinctive nature
of the appreciation of art (*The Aesthetic Point
of View*, 1982). This, in fact, also amounts to a
criticism of the institutional theory, in which
the notion of appreciation on which Dickie
relies – 'in experiencing the qualities of a
thing one finds them worthy or valuable' – is
clearly not specific enough to differentiate art
from other objects (*AA*).

Indeed, almost every term of Dickie's
original formulation of the theory has been
subjected to analysis and questioning,
and strong objections have been mounted
in particular to the analogy with formal
institutions (**NOËL CARROLL**, 'Beyond
Aesthetics'), and with respect to the
possibility, apparently denied by the
institutional theory, that someone could
make art that was never exhibited or offered
as a candidate for appreciation with reference
to the art world (see Beardsley, 1982 and
Davies, 1991). Yet even if the institutional
theory can be tightened up to counter these
particular problems, as Dickie has indeed
attempted, the most trenchant criticisms
have been seen by many to undermine the

whole project. These centre on the circularity
and emptiness which are claimed to afflict
both versions of the institutional theory.

As noted originally by Walton, the conferral
of status as candidate for appreciation occurs
in many settings outside the art world. The
question thus arises as to how Dickie's
definition distinguishes these conferrals from
art-making ones, the only answer to which
seems to be, by referring to the art world and
its practices. But without explaining further
what it is about these that marks them off
from other status-conferring practices,
in other words in offering no independent
account of the art world, Dickie's definition
becomes circular because art and the art
world are part of the definiens. And an exactly
parallel problem of circularity arises for the
revised version in which no independent way
of distinguishing art world systems from
other systems of presentation and production
is given.

Dickie (*AC*) has admitted this circularity
but strenuously denies that it is vicious,
that is, that it undermines the validity of
his definition. Rather, he asserts that it
accurately reflects the 'inflected' nature of
art, namely the necessary interdependency
on one another of a set of practices in which
the central concepts of 'art', 'art world',
'artist' cannot be understood independently
of one another.

This stance has, however, met with a great
deal of scepticism, leading to arguments
that Dickie's theory is essentially empty,
and hence not really a definition at all, for it
does not tell us anything about art qua art.
RICHARD WOLLHEIM thus pointed out in
respect of the original version that it says
nothing about the sorts of reasons required
for conferring the relevant status, leaving the
basis on which decisions are made entirely
opaque. In respect of the revised version,
Carroll similarly argues that although 'art' is
mentioned throughout, the overall framework
could be filled in with the names of other
complex communicative practices, 'such as

philosophy'. At best, he argues, Dickie has formulated the necessary features of such practices in general, but he has not told us anything at all about art.

Despite these many criticisms and problems, and although drawing on some of the ideas of contemporary thinkers, in particular Danto, it is fair to say that Dickie's initial formulation of the institutional theory almost single-handedly rescued the intellectual respectability of the philosophical project of defining art from the scepticism that had undermined this project in the previous two decades. Moreover, Dickie's emphasis on the social, contextual nature of art helped to initiate an important shift in philosophical thinking on the topic that has remained as deeply influential as his objections to aesthetic theories. Added to his ongoing engagement with contemporary debates on various issues in aesthetics, Dickie's work remains an important point of reference for discussions about the nature and value of art.

CAIN SAMUEL TODD

BIBLIOGRAPHY

Primary literature

Dickie, G., 'The Myth of the Aesthetic Attitude', *American Philosophical Quarterly* (1964).
Dickie, G., *Art and the Aesthetic: An Institutional Analysis*, London: Cornell University Press, 1974.
Dickie, G., *The Art Circle: A Theory of Art*, New York: Havens, 1984.
Dickie, G., *Evaluating Art*, Philadelphia: Temple University Press, 1988.
Dickie, G., *Art and Value*, Oxford: Blackwell, 2001.

Secondary literature

Beardsley, M., *The Aesthetic Point of View*, eds Wreen and Callen, Ithaca: Cornell University Press 1982.
Carroll, N., *Beyond Aesthetics: Philosophical Essays*, Cambridge: Cambridge University Press, 2001.
Danto, A., 'The Artworld', *Journal of Philosophy* 61 (October 1964), pp. 571–84.
Davies, S., *Definitions of Art*, Ithaca: Cornell University Press, 1991.
Walton, K., 'Review of *Art and the Aesthetic: An Institutional Analysis*', *The Philosophical Review* (1977).
Wollheim, R., *Art and its Objects*, Cambridge: Cambridge University Press, 1980.

JEAN-FRANÇOIS LYOTARD (1924–1998)

Jean-François Lyotard was born in Versailles, France; he died in Paris on April 21, 1998. His earliest works were a critical introduction to phenomenology (*Phenomenology*, 1954) and a series of articles on the Algerian war for independence and struggle for revolution in the socialist journal *Socialisme ou barbarie* (1955–63). These articles reflected his years teaching in a lycée in Constantine (Algeria) from 1950 to 1952. From the 1960s up to the 1990s, Lyotard taught in Paris at the University of Nanterre and at the Collège international de philosophie, of which he was a founder member. Whilst at Nanterre, Lyotard was strongly involved in the political events of May 1968; he remained politically engaged throughout his career and this activity is important in understanding his work on art. Lyotard taught at universities worldwide, most notably in the United States at Emory and the University of California, Irvine. He was a leading international intellectual from the publication of *The Postmodern Condition* (1979) through to his death.

A useful way of understanding Lyotard's work on art and artists can be found in his friend GILLES DELEUZE's concept of the assemblage: a combination of different machines that come together and function to change themselves and their context – perhaps fleetingly. Lyotard's work is not on art, but with art; he constructs art-philosophy-politics assemblages that are designed to make points and transform arguments across all three subjects. At the same time, these assemblages are designed to function aesthetically, rather than comment on external aesthetic objects.

This quality comes out strongly in Lyotard's works on individual artists, notably his books on Jacques Monory (*The Assassination of Experience by Painting – Monory*, 1998) and Marcel Duchamp (*Duchamp's TRANS/formers*, 1990). An introduction to this attempt to combine different areas and practices can be found in Lyotard's best-known book, *The Postmodern Condition* (1984).

The term 'postmodern' for Lyotard does not mean an artistic epoch (postmodernity) or specific works (postmodern art). Instead, the postmodern is a function of artworks when they trigger feelings that lead to a fragmentation of the narratives that surround them. For example a work of art can cause a feeling of shock associated with a newfound disbelief in established ways of categorizing and explaining the importance of art. This happens with the 'avant-garde' – a key concept for Lyotard, for the avant-garde redefines what art means and how it is done. The art then becomes political, in the sense that well-recognized values are challenged. It is also social and cultural, in the sense that long-standing and pervasive ways of explaining social existence and cultural value lose their power. The postmodern is therefore a process that goes from large-scale accounts or narratives, through a troubling feeling and artwork, and towards a new fragmented state. This latter state also includes the artwork in an insecure but creative moment: the work is a demand for a response, but with no established rule for determining that response. This unity of work and response is an important facet of Lyotard's work. We do not have a clear

division of the work and its reception – we have a complex interaction of the work, how it is made, how it is received, and how all three alter wider contexts.

The combination of feeling with a form of discourse or narrative and with a material experience triggered by the artwork is a constant through Lyotard's work. At different stages of his career he explained it through original concepts or through a transformation of established ones. The main ideas correspond to the main periods of his output; these can be linked to his three main books: *Discours, figure* (French 1971), *Libidinal Economy* (French 1974) and *The Differend* (French 1982). Respectively, the new concepts are the 'figural', the 'libidinal disposition' and the 'sublime'. It is perhaps too early to say, given that there is still much critical work to be done on Lyotard's last works, but a further concept of matter in relation to time may have to be added too, in particular given the beauty and artistic significance of Lyotard's late output, notably *Soundproof Room: Malraux's Anti-aesthetics* (French 1998) and the collection *Misère de la philosophie* (2000).

The 'figural' is that element in artworks that defies representation and identification; instead, it appears through feelings as they disrupt discourse in terms of its order, values and reference. For example, a work may introduce elements that are significant, but which cannot be accounted for in terms of our current understanding of relations in space and time, nor in terms of our current ways of judging the relative and connected values of things. In *Discours, figure*, Lyotard speaks of drawn lines that express human flesh or the spaces we inhabit but that do not conform to geometric standards or expectations. Art can bring together conflicting geometries yet it still remains significant, in the sense of making us feel new truths about flesh and other referents. Art is not only capable of putting language into question, but with it, reality too.

The concept of the figural is expanded to include broader economic and structural meanings in *Libidinal Economy* and the important essay 'Painting as a Libidinal Set-up' in *Des dispostifs pulsionnels* (1973 – translated in *The Lyotard Reader and Guide*). Here, art is defined as any colourful mark accompanied by a 'libidinal event', such as a desire or an affect. These events occur in structures, such as a form of discourse or economic exchange, that channel and exploit them. Lyotard is interested in the way these intense events are hidden or dissimulated within language and economic structures, because they present an opportunity for art to disrupt and resist a settled order or system by releasing that intensity into different structures. There are many heterogeneous structures making different claims on our desires and channelling them in different directions. Artworks are 'libidinal dispositions' that reveal the limits of those structures and introduce novel and intense libidinal events, breaking structures apart, taking them to the limit and inviting them to change. They therefore have a revolutionary aspect, but only transiently and always in a way resistant to political formalism, for example, in the shape of an ideological Marxism on the left or an orthodox market-based liberalism on the right.

From his early socialist essays onwards, Lyotard retained a strong connection to Marx, but without being able, after the early 1960s, to subscribe fully to Marxist analyses. The libidinal event is political, since it resists and disrupts fixed and established structures and their exploitation of desire, but it is not political in offering a new programme or set of goals. Instead, artists and others should seek to be 'good conductors of intensity' – to invite new intensities passively and with no promises as to good outcomes. This passivity and related idea of the unconscious channelling of desires owes much to Freud, though like Lyotard's relation

to Marx, this is not a full subscription to Freudian psychoanalysis. This 'drift away' from Marx and Freud, but closeness to their fundamental insights and instincts, situates Lyotard squarely within views of art that criticize its tendency to become just another part of the market, or a support for cultural and social tradition. These factors are inevitable, according to Lyotard, and yet to be resisted through creative experimentation.

In the lead-up to *The Differend*, Lyotard turned away from the wide set of desires and structures covered in his early work in order to focus on a more specific affect, the feeling that signals irresolvable conflicts, and on a more specific and paradoxical aesthetic problem: how to present that which cannot be represented? This new turn was influenced by an original reading of Kant's aesthetics (*Lessons on the Analytic of the Sublime*, 1991). For Lyotard, the feeling of the sublime combines pleasure and pain, attraction and repulsion, horror and delight. This combination means that the feeling draws us towards the possibility of action and knowledge through representation, while also halting any such action and making us aware of the limitations of representation. In his collection *The Inhuman* (1988), Lyotard explains this combination in terms of events that leave us in a questioning state – 'Is it happening?' – rather than with a set of facts, a grasped thing or a plan of action. He expands on this through a commentary on Barnett Newman's sublime paintings, and their resistance to set references and figures, despite close association with religious and ethical motifs.

Newman's paintings are sublime because they resist representation of a referent – an object, landscape or figure, for example – yet they also oblige us to reflect upon their sense, on the significance of the impossibility of representation and of shared meaning. For Lyotard, this obligation forces us to bear witness to that which cannot be represented, to an injustice for which there are no current words or an ethical command that cannot be

set into a specific course of action or forms of words (here Lyotard shares Barnett's interest in Judaism, which he sets alongside other positions such as a pagan love of paradox). This development of the sublime in art away from representation (in landscape for instance) and towards a spare material abstraction leads Lyotard to describe and defend minimal 'limit experiences' in art where matter is not allowed to rest within a particular form of knowledge and perception. Instead, matter, as captured in the arts (writing, painting and cinema), is a revivifying transformer of our expectations, experience and creative capacities.

There are at least two strains of criticism that have been drawn up against Lyotard's work with art. First, politically, it is resolutely anti-traditional. It can therefore be accused of a lack of responsibility and of advocating artworks that break with historical values at the expense of all possible norms (his love for the works of **DANIEL BUREN** could be a sign of this, were we to view Buren's architectural and sculptural works as betrayals of classical art and architecture). A possible response could be that value independent of result and effect is irrelevant to Lyotard's work. He is interested in what a work does; this may involve breaks with the past, but not necessarily; it must involve the emergence of new values in the form of new intense experiences and desires. Second, Lyotard can be accused of writing an abstract theory about art, rather than working in a more detailed and empirical art history. Answers to this accusation are easier, since close work on his books and articles shows that Lyotard does not write theory, but combines very deep knowledge with a creative interaction and transformation. His legacy is therefore not only in terms of the better-known 'theories' but also in the detailed creative styles he brought to art and philosophy. This rich resource remains to be fully studied and developed.

JAMES WILLIAMS

BIBLIOGRAPHY

Primary literature

Lyotard, J.-F., *The Postmodern Condition: A Report on Knowledge*, trans. G. Bennington and B. Massumi, Manchester: Manchester University Press, 1984.

Lyotard, J.-F., *The Differend: Phrases in Dispute*, trans. G. Van Den Abbeele, Manchester: Manchester University Press, 1988.

Lyotard, J.-F., *Duchamp's TRANS/formers*, Venice, Calif.: Lapis Press, 1990.

Lyotard, J.-F., *The Inhuman: Reflections on Time*, trans. G. Bennington and R. Bowlby, Cambridge: Polity Press, 1991.

Lyotard, J.-F., *Libidinal Economy*, trans. I. Hamilton-Grant, London: Athlone Press, 1993.

Lyotard, J.-F., *Political Writings*, trans. and eds B. Readings and K. P. Geiman, London: University College London Press, 1993.

Lyotard, J.-F., *Toward the Postmodern*, eds R. Harvey and M. S. Roberts, N.J.: Humanities Press, 1993.

Lyotard, J.-F., *Lessons on the Analytic of the Sublime*, trans. E. Rottenberg, Stanford: Stanford University Press, 1994.

Lyotard, J.-F., *The Assassination of Experience by Painting – Monory*, trans. R. Bowlby, London: Black Dog, 1998.

Lyotard, J.-F., *Soundproof Room: Malraux's Anti-aesthetics*, trans. R. Harvey, Stanford: Stanford University Press, 2001.

Lyotard, J.-F., Crome, K. and Williams, J. (eds), *The Lyotard Reader and Guide*, Edinburgh: Edinburgh University Press, 2005 (with partial translation of *Discours, figure*).

Secondary literature

Malpas, S., *Jean-François Lyotard*, London: Routledge, 2002.

Sim, S., *Lyotard and the Inhuman*, Melbourne: Totem, 2001.

Williams, J., *Lyotard: Towards a Postmodern Philosophy*, Cambridge: Polity, 1998.

Williams, J., *Lyotard and the Political*, London: Routledge, 2000.

MAURICE MERLEAU-PONTY (1908–1961)

Merleau-Ponty was one of the leading philosophers in the flourishing of French intellectual life immediately after the Second World War. Closely allied with Jean-Paul Sartre at the start of his career, like Sartre he was inspired by the recasting of Cartesian and Kantian understandings of the subject in the phenomenological writing of the German philosophers Edmund Husserl and Martin Heidegger. Merleau-Ponty's critique of Cartesian or rationalist models of consciousness and perception had a

significant impact on critical writing on the visual arts in the English-speaking world in the 1960s.

Merleau-Ponty's theory of the interconnectedness of bodily and mental processes in any apprehension of things provided a clear alternative to traditional models of perception posited on a clear separation between viewing subject and viewed object. As such, it fed into reactions against purely optical understandings of a viewer's interaction with a work of art of the kind championed by modernist critics such as CLEMENT GREENBERG. His most widely read publication was his *The Phenomenology of Perception* (1945; English 1962). He wrote several important essays on the visual arts, the most widely read of which was 'Cézanne's doubt' (1948; English 1964; in *The Merleau-Ponty Aesthetics Reader*, hereafter *MPAR*). These, however, proved less influential for critics and artists than his philosophical writings, partly because his analysis focused on a few canonical masters of modern painting such as Cézanne and Matisse rather than more contemporary work.

Merleau-Ponty made his reputation with the book *The Structure of Behaviour* in 1942 (English translation 1965) where he initiated his lifelong enquiry into the grounding of thinking and consciousness in the self's bodily interactions with and perceptions of the material world. He collaborated with Sartre on the editing of Sartre's journal *Les Temps Modernes*, possibly the leading intellectual journal of cultural and political commentary in France in the post-war period. At this point he became known, not just for his philosophical writings but also for his Marxist political analysis.

In *Humanism and Terror: Essays on the Communist Problem* (1947), he controversially sought to arrive at some understanding of the deformed revolutionary logic of Stalin's show trials. In the early 1950s, the Korean War prompted him, like a number of intellectuals on the left, to become deeply critical of official Communism. While he distanced himself from his earlier Marxist political commitments, and broke with Sartre over what he saw as Sartre's increasing ultra-leftism, he was no anti-Marxist apostate, and continued to see Marx as a key social and political thinker. With his appointment to the Chair of Philosophy at the Collège de France in 1952, he secured a position as a leading figure of the French philosophical establishment. Just before his early death in 1961, he was working on *The Visible and the Invisible*, the incomplete manuscript of which was published posthumously in 1964 (English 1968). Here he critiqued the residual reliance on models of consciousness in his earlier studies of perception, and engaged in a more radical undoing of philosophical understandings of subjectivity and subject/object relations that was heavily influenced by Heidegger, and which anticipated later post-structuralist concerns.

What precisely was it in Merleau-Ponty's thinking that proved so suggestive for critical writing on art? His recasting of traditional understandings of perception came to notice just at the time when art historians and critics were becoming less exclusively focused on the artist's creative act and were turning their attention to viewer response. This was the moment when Gombrich initiated a study of 'the beholder's share' in his widely read *Art and Illusion* (1960). Artists were experimenting with practices that invited much more active participation on the part of the viewer. However, even in his most fully developed discussion of visual art, in the essay 'Eye and Mind' (1960; English 1964; in *MPAR*), Merleau-Ponty himself never sought to analyze the distinctive nature of the encounter between a viewer and work. For the most part he simply assumed that the viewer was able to enter into the perception of and encounter with things depicted in a work through a process of empathetic identification with the artist. More fruitful for speculation on the

phenomenology of viewing a work of art were his more general, but at the same time very vivid and concretely articulated, discussions of visual perception.

His materialist phenomenology, if taken seriously as a basis for understanding what happens when we are looking at works of art, shifted attention from the artwork itself to the phenomenon constituted in the viewer's encounter with it. Simultaneously subjective and objective, such a phenomenon could not simply be envisaged as a response occurring in the viewer's mind. Viewing became situated viewing, not a disembodied apprehension of things seen at a distance and set out before the mind's eye. Jean-Paul Sartre, in his essay on Giacometti's sculpture, 'The Search for the Absolute' (1948), brought these ideas more directly to bear on the discussion of visual art than Merleau-Ponty did himself. At the same time, Merleau-Ponty's idea that viewing should be conceived as a process taking place in some larger environment, in which both viewer and thing viewed were situated, was clearly suggestive for new understandings of three-dimensional art as 'installation' and 'site' rather than autonomous sculpture.

Merleau-Ponty's understanding of situatedness was very unlike Sartre's existentialist one in which consciousness confronted an inert materiality. For him, a viewer's apprehensions were in their very essence bodily as much as mental, and brought into play a sense of the kinesthetic and tactile as well as purely visual interactions between one's body and the world which one inhabited. His point was that seeing was never purely optical – seeing something involved one's being aware of its placing in relation to one's own body and how one might move around and interact with it if one came close to it. One does not just look out at a landscape, for example, but is constantly projecting what it might be like to inhabit it. Equally, an object that one sees as having strongly tactile qualities is not

envisioned as such by way of inference from purely visual clues. Rather, an immediate feeling of tactile qualities is there in the very process of seeing it. By contrast, the viewing invoked in formal analysis, from Wölfflin's categories of seeing to Greenberg's opticality, was imagined as operating in the first instance in isolation from other sense perceptions and other kinds of interactions with things. Merleau-Ponty's ideas provided a suggestive theoretical tool, both for critiquing such models and their emphasis on pure visuality, and for envisioning other more hybrid understandings of what takes place when a viewer encounters a work of art.

Another central theme in Merleau-Ponty, as in earlier phenomenological writings such as Husserl's, was his foregrounding of the temporality and the projective dynamic of perception. He represented seeing not as a process of looking at a series of static, quasi-photographic images implanted on the retina, but as a constantly changing apprehension of things unfolding in time, shaped by our bodily movements. For him, what we see is anchored both in what we have just seen and what we are about to see. This feature of Merleau-Ponty's discussion of perception has affinities with the 'ecological' theories being developed at the time by psychologists such as J. J. Gibson. Perhaps the most suggestive feature of Merleau-Ponty's dynamic understanding of visual perception is the emphasis placed on how our viewing of the world is bound up with our bodily, motor interactions with it. This imbrication of acting in seeing may help to explain why Merleau-Ponty became important for later writing about performance-based art.

Writers on art whose thinking has been shaped by Merleau-Ponty's materialist emphasis on the bodily grounding of our apprehensions of the world divide roughly into two camps. On the one hand there are those such as David Sylvester and **MICHAEL FRIED** whose ideas have clear affinities with Merleau-Ponty's own reflections on

the visual arts. Their analyses focus on a viewer's physical responses to the figure or environment that is perceived as being represented in a work of art, often operating with an empathetic model whereby the viewer projects a sense of his or her own body onto a motif or scenario. On the other hand there are those such as ROSALIND KRAUSS (*Passages in Modern Sculpture*, 1977) and ROBERT MORRIS ('Notes on Sculpture' Parts 1 and 2, 1966) who focus, not on the body image presented by a work, but on the ever shifting interaction between work and viewer that mobilizes a viewer's internal sense of his or her own body. The divide between these divergent uses of Merleau-Ponty's phenomenology came to a head in debates about minimalism in the later 1960s and the 1970s, with Fried critiquing what he saw as the minimalists' privileging of an open-ended process of encounter that in his view lacked a stabilizing focus on some powerfully configured art object, and writers such as Morris and Krauss seeing this as precisely what made minimalism such a significant new development in contemporary art.

The phenomenological approach enjoyed its heyday in the 1960s when the focus on immediate, bodily responses was envisaged as a way of escaping traditional, ideologically hidebound framings of the artwork as a privileged kind of object. However, once contemporary art took a conceptual turn, it began to fall into disfavour. Those resistant to dominant understandings of art became critical of the idea that an artwork operated at a purely bodily, perceptual level, and instead advocated work that would critically engage the viewer's mind. Criticism of the assumption that the essence of art lay in non-conceptual, pre-linguistic interactions with things could in many ways apply to Merleau-Ponty's own writing on art, particularly his late essay, 'Eye and Mind'. For him, art

functioned as a way of thinking about the primordial levels of interaction with the world that formed the basis for any conceptual, linguistically articulated apprehensions.

Two features of his more recent writing though should give us pause before we see him as a champion of the pre-linguistic. His later publications, including *Signs* (1960) and *The Visible and the Invisible*, engage in a sustained exploration of language and utterance, drawing (like the French structuralists and semioticians that are often, wrongly, seen as operating in outright opposition to his phenomenological approach) on Saussure. He stops short of a categorical distinction between the linguistic and the non-linguistic because he is aware, not just that as language-using beings we can never project ourselves back into a pre-linguistic world, but also that any genealogy of language needs to posit a pre-linguistic interaction with and response to things that will lay the basis for linguistic utterance. There is also his incisive critique of André Malraux's celebration of the 'voices of silence' supposedly emanating from the objects gathered in the 'imaginary museum' ('Indirect Language and the Voices of Silence', 1952; in *MPAR*): 'painting seen in its entirety presents itself ... as an aborted effort to say something that always remains to be said'.

Implicit in Merleau-Ponty's understanding of the blurred boundary between a linguistic and conceptual articulation of things on the one hand and a non-linguistic and bodily interaction with them on the other is the potentially productive idea that a work of visual art might be conceived as a quasi-utterance. His assumption, widely shared at the time, that an aesthetic response to art was incompatible with a cognitive one, blinded him to the fully hybrid nature of what happens in our encounter with a work.

ALEX POTTS

BIBLIOGRAPHY

Primary literature

Merleau-Ponty. M., *The Phenomenology of Perception*, London: Routledge, 1962.
Smith, M. B. (ed.), *The Merleau-Ponty Aesthetics Reader: Philosophy and Painting*, Evanston: Northwestern University Press, 1993.

Secondary literature

Fried, M., *Art and Objecthood: Essays and Reviews*, Chicago: Chicago University Press, 1998.

Krauss, R., 'Richard Serra, A Translation', in *The Originality of the Avant-Garde and Other Modernist Myths*, Cambridge: MIT Press, 1985, pp. 261–64.
Potts, A., 'Art Works, Utterances and Things', in eds D. Arnold and M. Iversen, *Art and Thought*, Oxford: Blackwell, 2003, pp. 91–110.
Potts, A., 'The Phenomenological Turn', in *The Sculptural Imagination*, New Haven and London: Yale University Press, 2001, pp. 207–34.
Prendeville, B., 'Merleau-Ponty, Realism and Painting: Psychological Space and the Space of Exchange', *Art History* (September 1999), pp. 364–68.

ALBRECHT WELLMER
(1933–)

Albrecht Wellmer is a German philosopher, who undertook his doctorate at Frankfurt am Main, and has held positions at the University of Toronto, the New School for Social Research in New York, the University of Konstanz and the Free University of Berlin.

From the outset, that is, from the beginning of the 1980s, Wellmer's philosophy of art has circled around the question of how THEODOR ADORNO's aesthetic theory can be developed further. Following the great popularity Adorno and the Frankfurt School enjoyed around 1968, there emerged in the early 1970s a severe settling of accounts with Adorno's philosophy of art. The essays of Bubner and those authored jointly by Baumeister and Kuhlenkampf, for example, charged

Adorno with having done a twofold injustice to art. According to them, Adorno, with too great a naivety, conceived of art wholly in terms of social critique and thus denied art its own particular logic. And second, going beyond such a position and ultimately in contradiction to it, Adorno declared art to be the site of any possible social critique. Adorno was able to do this, in the view of these critics, only because he made art into an absolute and utopian, indeed a (negative-) theological yardstick of critique.

These two critical observations constituted the starting point of the first phase of Wellmer's philosophy of art: his intellectual project can be described in terms of three distinct phases. His first goal was to show

that the critical relationship of art to society postulated by Adorno did not exclude the autonomy of art. He began with a critique of Adorno's metaphysics of art, resulting in the monograph *The Persistence of Modernity* (German 1985; English 1991) and the essays 'Metaphysics at the Moment of its Fall' and 'Adorno, Modernity, and the Sublime'. Wellmer views Adorno's rendering of art into an absolute as the result of his critique of reason, expressed most radically in *Dialectic of Enlightenment* (first published in 1944 and co-authored with Max Horkheimer). This critique of reason made Adorno, much like Nietzsche, into a postmodern thinker *avant la lettre*. According to Wellmer, what Adorno shares with Nietzsche (and with BATAILLE, and with representatives of postmodernism such as JEAN-FRANÇOIS LYOTARD, JACQUES DERRIDA and MICHEL FOUCAULT) is a radical critique of reason, in which reason is taken to be identitarian and totalizing, i.e. excluding everything that does not conform to the rigid rules of rationality. As Adorno himself already well knew, this led to a serious self-contradiction: who could still presume to say anything at all about reason, and with what form of reason, if reason itself can only ever speak a totalitarian untruth?

In order not to fall victim to cynicism and relativism, Adorno seeks and finds a way out in art: Autonomous modernist art distinguishes itself so radically from all other social practices that it must therefore be understood as a critique of that which is presented as the sole possible reality. Against this line of thought, Wellmer shows that Adorno's radical critique of reason is internally contradictory, and this entails exceedingly problematic consequences for his theory of art. Wellmer in fact turns against all interpretations of postmodernity that encompass a radical critique of reason. In order to show that reason has not arrived at a dead end where it no longer possesses absolute standards, Wellmer calls upon the philosophies of language of Wittgenstein and

Habermas, as well as upon Pragmatism. According to these theories, human reason is indeed in a position to put forward a local critique of itself, and, further, this restriction to its own particular location is also an advantage: reason can never place itself entirely in question.

Wellmer's extended defence of a modernity enlightened as to its own nature involves a more modest conception of art than, for instance, Adorno's. Under the conditions of a modernity that knows its own limitations and potentials, one can accept, in Wellmer's view, only a theory of art in which art is to be assessed solely according to its own standards. By contrast, Adorno had made the logic of art into the standard for all thought and action, and precisely in so doing he denied the specificity of art's norms as opposed to other norms (for instance those of the truth of judgments, or the morality of actions).

Wellmer calls attention to the fact that Adorno, like many philosophers before him, speaks in a highly ambiguous manner about the truth of art and thus consistently confuses two things: (i) the aesthetic success of the artwork as an artwork (according to aesthetic norms and purely artistic criteria), and (ii) the extra-aesthetic truth of works of art (such as an artwork's potency in influencing society, or the statements, contents, references that play a role within an artwork yet which always constitute only part of the work of art). Wellmer calls the separation of these two dimensions of artistic truth the product of his 'stereoscopic reading' of Adorno. By this he means that these two dimensions of artistic truth can certainly be found in Adorno, but that Adorno did not realize that here two different things are at issue.

In the second phase of Wellmer's philosophical development (for instance in 'Das musikalische Kunstwerk', [The Musical Work of Art] and 'Sprache – (Neue) Musik – Kommunikation' [Language – (new) Music – Communication]) he constructed a theory

of the autonomous logic of art. Drawing upon Adorno's *Aesthetic Theory* (1970) and Martin Heidegger's essay 'The Origin of the Work of Art' (1935/6), he claims that specifically aesthetic experience consists in the continual dissolution, by virtue of the materiality of its semantic elements, of whatever is semantically comprehensible in an artwork. In other words whatever the work of art appears to say, it also crosses out at the very same time. Here Wellmer speaks of a dialectic of semanticization and de-semanticization. With this, art seems to have become a game with this or that content, a process in which the dynamic between semanticization and de-semanticization is more important than whatever it is that is de-semanticized or semanticized. This means that art risks losing its critical force, for the mere difference between aesthetic and non-aesthetic experiences does not necessarily imply a critique of non-aesthetic experiences. Relationships where the elements related are different can just as easily be relationships of indifference as of critique or of affirmation.

During the 1980s Wellmer had already claimed, yet without really demonstrating it, that the critical aspect of artworks resides in their power of world-disclosure – their ability to change our attitudes, ways of seeing and practices. It is only recently, in his third phase of development (such as in 'On Music and Language'; 'Über Negativität und Autonomie der Kunst' [On Negativity and Autonomy in Art]), that he has attempted this, and does so in an examination of Adorno's favourite art – music. Once again, Wellmer's conception of art's post-metaphysical autonomy confronts Adorno's claim that art has a role to play as a critique of society.

Wellmer's most recent texts must be understood as an attempt to redeem Adorno's claim by means of new arguments, despite the criticism that has been raised against it. Against Wellmer, and with reference to Wellmer's stereoscopic reading of Adorno, Martin Seel (e.g. in 'Kunst, Wahrheit, Welterschließung' [Art, Truth, World-disclosure] 1991) has argued that the articulation of 'ways of seeing' is indeed at issue in works of art. Yet Seel insists that genuine aesthetic validity has nothing to do with the question of whether or not the way of seeing that is opened up in aesthetic experience is an acceptable one. In other words, in aesthetic experience the opening up of a specific and potentially critical world is not of substantial importance. Any opening of a world would fulfil the semanticizing task of aesthetic experience, which is basically the experience of an oscillation between semanticization and its opposite. To the extent that oscillation is all that counts, the opening of a world (not to speak of a critically specific world) plays only a functional and indeed a subordinate role in aesthetic experience. If Seel is right, the very issue of the world being opened up by an artwork in an appropriate, productive, true way is just superfluous. And the question of whether an artwork's world is related in a *critical* fashion to already existing worlds is not, from the point of view of aesthetics, of the slightest concern. Thus it seems simply impossible for there to be a critical relationship between aesthetic experiences and those of any other kind.

In his most recent texts, Wellmer has set himself the goal of identifying the extent to which a critical relationship to the world, the opening up of worlds that serve to critique the existing one, must necessarily be attributed to all art. He provides an answer in terms of music, the art form that appears to stand at the furthest remove from the semantic dimension. In order to account for the linguistic dimension of music, he calls upon the insight that all the arts lay special emphasis upon some particular dimensions of everyday language, which is constituted in a fundamentally synaesthetic manner (encompassing graphic qualities, sonority, gesture, semantic elements, etc.). They do so, however, without ever entirely

eclipsing other dimensions of experience not emphasized. Music may be purely sound, but this does not entail that its relationship to the world is suspended. For relationships to the world are also inherent in the sonority of everyday language, as one may easily realize if one considers the various forms of expressivity of sounds and noises. In this line of thinking Wellmer also examines so-called 'pop' culture art forms and analyzes the degrees of difference between the respective relationships that serious and popular music have to the world. Thus, in popular music a much larger role is played by, for instance, the physical, which may eventuate in dance or by the staging of the performance.

The extent to which the alternative worlds made possible by artworks refer only to possibilities unknown, or on the contrary are necessarily related in a critical way to worlds that presently exist, still remains to be determined. Here Wellmer seems to assume that the de-semanticizing subversion of the worlds opened up in aesthetic experience, a subversion which is of constitutive importance for the latter (a point developed in the second phase of his work), does not mean that world-disclosure by means of art is impossible. He holds that the mere fact that it is one and the same person who has experience of worlds disclosed in art and who, alongside this experience, is immersed in other relationships to the world (of a moral, political, strategic, etc. kind) buttresses the assertion that art possesses the potential for (social) critique. In other words: once different worlds exist for someone, the relationships in which they stand are necessarily those of critique and not of mere indifference.

RUTH M. SONDEREGGER

BIBLIOGRAPHY

Primary literature

Wellmer, A., *Zur Dialektik von Moderne und Postmoderne*, Frankfurt/Main: Suhrkamp Verlag,1985 (translated in part under the title *The Persistence of Modernity: Essays on Aesthetics, Ethics, and Postmodernism*, Cambridge: MIT Press, 1991).

Wellmer, A., *Endspiele: Die Unversöhnliche Moderne*, Frankfurt/Main: Suhrkamp Verlag, 1993 (*Endgames: The Irreconcilable Nature of Modernity: Essays and Lectures*, Cambridge: MIT Press, 1998).

Wellmer, A., 'Das musikalische Kunstwerk', in eds A. Kern and R. Sonderegger, *Falsche Gegensätze: Zeitgenössische Positionen zur Ästhetik*, Frankfurt/Main: Suhrkamp Verlag, 2002, pp. 133–75.

Wellmer, A., 'On Music and Language', in *Identity and Difference: Essays on Music, Language, and Time*, Leuven: Leuven University Press, 2004, pp. 71–131.

Wellmer, A., 'Sprache – (Neue) Musik – Kommunikation', in eds W. Ette, G. Figal, R. Klein and G. Peters, *Adorno im Widerstreit: Zur Präsenz seines Denkens*, Freiburg and Munich: Verlag Karl Alber, 2004, pp. 289–323.

Wellmer, A., 'Über Negativität und Autonomie der Kunst: Die Aktualität von Adornos Ästhetik und blinde Flecken seiner Musikphilosophie', in ed. Axel Honneth, *Dialektik der Freiheit*, Frankfurt/Main: Suhrkamp Verlag, 2005, pp. 237–78.

Secondary literature

Baumeister, T. and Kuhlenkampf, J., 'Geschichtsphilosophie und philosophische Ästhetik: Zu Adornos "Ästhetischer Theorie"', *Neue Hefte für Philosophie* vol. 5 (1973), pp. 74–104.

Bubner, R., 'Über einige Bedingungen ästhetischer Erfahrung', *Neue Hefte für Philosophie* vol. 5 (1973), pp. 38–73.

Seel, M., 'Kunst, Wahrheit, Welterschließung', in ed. Franz Koppe, *Perspektiven der Kunstphilosophie: Texte und Diskussionen*, Frankfurt/Main: Suhrkamp Verlag, 1991, pp. 36–80.

RICHARD WOLLHEIM (1923–2003)

Richard Wollheim was born in London. His father was a theatrical impresario who worked with, among others, Diaghilev. He attended Westminster School, and, after service in the Second World War, went to Balliol College, Oxford, where he achieved first-class degrees in first history and then philosophy. He was given a lectureship at UCL by A. J. Ayer, where he became Grote Professor of Mind and Logic in 1963. There he remained until 1982 when he moved to America, only returning to London shortly before his death in 2003.

Wollheim had an unusual (and unusually wide) range of interests for a British philosopher in the second half of the twentieth century, including aesthetics, art and psychoanalysis. He published a novel and a memoir. It was said that he would talk to anyone, and was a popular guest whether at dinner with leading members of the establishment or in his spare time in the Colony Room in London's Soho. A concern with socialism, humanism and culture pervades his work.

Wollheim was not one for facile generalizations – he was a systematic and rigorous thinker. There is a line of thought that runs through his work that captures several of his important contributions to the debate about art. In his 1970 paper, 'The Work of Art as Object', published in *Studio International*, he argues that art is produced under the concept 'art'. 'An activity cannot be engaged in, except inadvertently, unless the agent possesses the concept of that activity' (*On Art and the Mind* [*OAM*], p. 113). It is correct to describe someone as 'boiling an egg' rather than 'making tea' if their actions are performed with the overarching intention that an egg be boiled rather than tea be made. This is true even if there are events that each of these activities has in common (such as boiling water).

From this beginning, Wollheim goes on to criticize what he takes to be the dominant theory of modern art (a version of Greenbergian modernism, although Wollheim does not call it that): 'a theory that emphasises the material character of art, a theory according to which a work is importantly or significantly, and not just peripherally, a physical object' (*OAM*, p. 118). Wollheim makes three telling points against this.

First, he denies the contrast drawn between modern art and the old masters: the latter never regarded the properties of the support as accidental or contingent facts about art. Second, 'in talking of a surface, the theory is irreducibly or ineliminably referring to the *surface of a painting*' (*OAM*, p. 121). Painters produce objects under the concept art, and thus produce surfaces under the description 'surface of a painting'. On its own the instruction 'make us aware of the surface' means as much, says Wollheim, as 'make it average-sized'. The third point follows: it is the use of the surface not the fact of the surface that is relevant, and this 'attributes to modern art a complexity of concern that it cannot renounce' (*OAM*, p. 125). If this argument is correct, which it surely is, the theory does not mark a distinction between modern and pre-modern painting: all paintings are concerned with the surface of

paintings – the modern artist inherits all that this meant to the pre-modern artist.

What, then, did Wollheim take to be 'the complexity of concern' entailed by a surface being the surface of a painting? The surface of a painting is one of which we have a distinctive kind of visual experience. When faced with a differentiated surface, we can see objects 'in' it: we can see Wagnerian conductors in clouds, or figures in frosted glass. This capacity is 'biologically grounded'; all functioning human beings possess it from a young age. The characteristic of 'seeing in' is twofoldness: we are simultaneously aware of the surface ('the configurational aspect'), and of something else 'in' the surface ('the recognitional aspect'). These are two aspects of a single experience. What it is to produce a surface as the surface of a painting is to manipulate the paint in such a way that the spectators are able to see something in the surface. What it is correct to see in the surface is, according to Wollheim, for what is seen to match the intentions of the painter.

A number of things follow from this, of which I will pick out two. First, Wollheim denies any great significance to the distinction between 'representational' and 'abstract' paintings. In both cases, we are required to see depth in the surfaces – it is only that in the first case what we see in there are the objects such as figures and furniture, and in the second, generally, coloured surfaces or volumes which are not figures and furniture. Reserving the term 'representational' for those surfaces in which we can see depth, it follows that most if not all paintings are representational. The distinction is that some representational paintings are figurative and others non-figurative. Second, encountering a painting is a visual matter. Thus Wollheim opposes the semiotic view – the theory that claims a picture represents what it does in virtue of belonging to a symbol system. Instead, what a picture represents is what it is correct to see in it. Wollheim has an independent

argument as to why the semiotic view is inadequate: it cannot cope with 'transfer'. It is a fact that any theory of pictorial representation should explain, that, provided we are familiar with pictures, being able to recognize a dog is sufficient to be able to recognize a pictorial representation of a dog. The semiotic view cannot explain this, as it cannot explain why knowing the visual appearance of an object would enable us to recognize a symbol for that object.

The content of a picture is not exhausted by what can be seen in it. In addition, we have a capacity to see a picture expressing, for example, melancholy – or some other fine-grained state that eludes capture in language. Wollheim's account of expression is grounded in a psychoanalytic mechanism of projection – of externalizing our emotions. Starting at this thought Wollheim argues to a conclusion that some parts of the world can be experienced as being 'of a piece' with our emotions. What an artist tries to do is to give his or her painting a look which a spectator would see as of a piece with the emotion that was causing the artist to paint as he did. Wollheim also discusses further ways in which a picture accrues content: through the internal spectator, through textuality and borrowing, and through metaphor. In all cases Wollheim's explanations go through the psychology of the artist, that is what the artist intends the spectator to experience in looking at the picture.

Wollheim's criticism of Greenbergian modernism seems to have been well received. His account of pictorial representation, however, has attracted more criticism. There are three possible objects of experience in play: (i) the configurational aspect, (ii) the recognitional aspect and (iii) the experience we would have were we to see what we see in the surface face to face. Criticism has focused on the nature of (ii), on the nature of the relation between (i) and (ii), and on the nature of the relation between (ii) and (iii).

In the 1992 Festschrift for Wollheim (*Psychoanalysis, Mind and Art* [*PMA*]) Malcolm Budd and Kendall Walton have argued that Wollheim provides no account of (ii) – what it is to see a milkmaid in a picture. Walton, in particular, has attempted to supplement Wollheim's account with his own – grounded in the imagination. In addition, Budd has argued that Wollheim's failure to give an account of the relation between (ii) and (iii) is a weakness: 'the recognitional aspect cannot properly derive the only description it can be given from an experience with an incomparable phenomenology' (*PMA*, p. 271). Something needs to be said about the relationship between seeing a milkmaid in a picture and seeing a milkmaid face to face, in order for the former to be described in terms that describe the latter.

Finally, Robert Hopkins has attempted to supplement Wollheim's account by providing his own account of the relation between (i) and (ii): we experience the former as resembling the latter in what Hopkins calls 'outline shape'. Wollheim was aware of, and rejected, these criticisms. He maintained that his account did not need the proffered help. Anyone familiar with paintings would know the experience to which he was referring, and philosophical supplementation either introduces elements which properly belong to some causal, psychological story about how we came to have the experience of seeing in, or is not true to the phenomenology.

A further element of Wollheim's theory that has attracted criticism is his 'intentionalism'. The claim that the standard of correctness for criticism is given by the actual intentions of the artist appears to suffer from an insuperable objection: in the circumstances in which a competent spectator experiences the painting as meaning *p*, and the actual intentions of the painter were that it did not mean *p*, the former is a better guide to the meaning of the picture than the latter. However, it is unclear that anyone has ever held this view, least of all Wollheim, who states, repeatedly, that it is only through what can be seen when the picture is looked at that the picture carries meaning. However, if the competent spectator can get what they need from looking at the picture, why the need for a reference to intention?

Wollheim has a negative and a positive answer to this. The negative is the failure of alternative strategies (indeed, it is unclear that the strategy of scrutinizing the surface of the painting without regard to intentions – either actual or hypothetical – is coherent. What would one be looking for?). The positive argument is to remind us, first, that painting is an intentional activity and the standard pattern of explanation which aims at understanding for all such activities is to see them in the light of those intentions. Furthermore, Wollheim makes good use of his intentionalism.

First, intention allows in some matters that pertain to a work that are of critical interest, which are not manifest in the work. For example one cannot understand Gibb's façade to St Martin-in-the-Fields in London unless one understands it as the solution to the problem of how to combine a portico with the English demand for a west tower. Second, we are able to incorporate psychoanalytic hypotheses about what certain matters meant to an artist, and what he or she intended to show. Third, it enables Wollheim to distinguish between a painting displaying a content, and a painting having that content as part of its meaning. For the latter to be the case, the paintings have to show that meaning to have gone through the intentions of the artist.

Wollheim did not participate in many of the debates that characterized post-1960s aesthetics. For example he rejected the presuppositions that grounded the debates concerning the putative problems raised by two visually indiscernible objects one of which was art and the other not. His writing was broader than my focus on his analytic

theories would suggest: four of the six chapters his later book, *Painting as an Art* (1987), are discussions of works of art rather than of theory. He also wrote many pieces of criticism for art magazines. There are some true generalizations about his work (the route to understanding and appreciation of art is through experience); however, it is the detail of the argument in which its true worth is found. He believed strongly that the artist needed to be a spectator of his or her own work; by being such they could manipulate the work so that the competent spectator would see what he or she was intended to see. This presupposes 'a universal human nature' – the common ground that underpinned Wollheim's commitment to both painting and socialism.

DEREK MATRAVERS

BIBLIOGRAPHY

Primary literature

Wollheim, R., *On Art and the Mind*, London: Allen Lane, 1973.
Wollheim, R., *Art and Its Objects* (second edition), Cambridge: Cambridge University Press, 1980.
Wollheim, R., *Painting as an Art*, London: Thames & Hudson, 1987.
Wollheim, R., *The Mind and Its Depths*, Cambridge: Harvard University Press, 1993.

Secondary literature

Hopkins, J. and Savile, A. (eds), *Psychoanalysis, Mind and Art: Perspectives on Richard Wollheim*, Oxford: Blackwell, 1992.
Hopkins, R., *Picture, Image and Experience*, Cambridge: Cambridge University Press, 1998.
Van Gerwen, R. (ed.), *Richard Wollheim on the Art of Painting*, Cambridge: Cambridge University Press, 2001.

Theory
and
Philosophy
of Culture

INTRODUCTION

Culture as a subject of analysis tends to resist academic specialization, because it involves such a broad reach of subject matter: from language, to images of representation, the use of public and private space, to the codification and governance of the body, the construction of gender and disciplinary control of sexuality and so on. It is only fitting, then, that this section includes a far greater diversity of subject matter than that of other sections, from the communication and organizational systems through which art is produced (Luhmann, Bourdieu, Foucault) to the deep cultural content of the human psyche (Butler, Klein, Kristeva). The subject of psychoanalysis may seem a long way from 'culture' as such, but as the entries on Butler, Klein and Kristeva indicate, the processes that create a self-conscious subject involve deeply embedded cultural patterns of moral norms, gender relations and family life.

The very concept of culture, as in the case of psychoanalysis, has become intrinsic to most academic fields. The expression 'the cultural turn' has come to describe the way traditional academic disciplines have been forced, to varying degrees, to acknowledge that their attempts to construct an independent body of knowledge are not independent of the dynamics of culture. Especially when, as Georges Bataille reminds us, 'culture' involves broad historical traditions and protocols, values, ethics, morals and beliefs (often of religious origin), the uses of language, creative expression and even a relation to the environment. Traditionally, however, culture has been conceived as the moral and philosophical orientation of a society, securing some form of collective participation, allegiance and identity. As such, it is taken to be distinct from, or independent to, the social, legal, political and economic constraints that govern society in general. Such 'idealist' conceptions of culture tend to be accompanied by the belief that art is completely 'autonomous' from social systems and patterns of economic activity.

In this section we find thinkers, like Foucault and Bourdieu, who do not make a categorical distinction between the cultural and the social, and would say that cultural values, beliefs and practices are social in origin. For both these thinkers, culture is not a realm of free creative thinking and activity, but involves regimes of power and control. Where they differ is that Bourdieu continues the Marxist concern with the way culture articulates class and privilege, whereas Foucault deliberately jettisons Marx's legacy, and formulates a new concept of society based on 'discourse'. Nonetheless, Foucault or Bourdieu agree that art and culture do have a form of 'autonomy' in that, as Luhmann would say, they operate according to their own systems of thought.

An attentiveness to language, and the way in which language mediates knowledge and knowledge mediates power, characterizes the work of most of the thinkers here. Barthes demonstrated how even a basic conception of the function of language (as sign systems) can provide a framework for the analysis of cultural products (from magazines to sporting events) and the 'myths' that make them meaningful. 'Myths' (drawing on Marxist notions of 'ideology') was the term Barthes used for the sign systems through which we explain the world around

us, in so far as what is historical and constructed comes to be regarded as natural and self-evident. However, Barthes, like Foucault, moved away from Marxist thinking, and consequently the 'politics' of his work after 1960 (as with that of many of his peers) becomes much more complicated and less doctrinaire.

Benjamin is a good early example of a thinker who worked out an explicit political standpoint as part of his broader investigation into culture. All the thinkers in this section in one way or another (save Melanie Klein) felt compelled to construct a political dimension to their thought. Benjamin uses Marxist concepts like 'bourgeois' or 'class' but draws upon a range of philosophical insights to explain the way changing economics and technology effect the very perception and experience individual people have in viewing the world they live in. Jameson has similarly attempted to extend Marxist categories into a deeper understanding of literature and artistic expression, emphasizing, like Benjamin, the 'cognitive' function of culture (how art and cultural activity is a means of thinking about and 'processing' complex socio-economic changes that are difficult to think in terms of ordinary language).

For Jameson, culture articulates the conditions of contemporary sensibility (or perception and experience), and analyzing cultural forms tells us a lot more about the implications of our socio-economic systems than does analyzing society or economics directly. Baudrillard takes the study of culture one step further and asserts that culture has become the means through which social and economic forces reproduce and extend their power. The cultural activity of image making or visual representation has become hegemonic for Baudrillard – the primary means through which society and economics operate. From factual information ('the news' and its media imagery) to product branding (markets structured by consumer desire), the aesthetics of the image reveals the central dynamic to social existence. For Baudrillard, as for all the thinkers in this section, art and culture is where political, social and economic conditions of our existence emerge at their most perceptible.

ROLAND BARTHES (1915–1980)

Barthes is one of the most influential disseminators of both structuralist and post-structuralist theories. He held research appointments with the Centre National de la Recherche Scientifique (1952–59), served as director of studies at l'École Pratique des Hautes Études (1960–76) and was awarded the prestigious Chair of Literary Semiology at the Collège de France (1976–80). Barthes drew his semiotics initially from the modern linguistics of Ferdinand de Saussure (1857–1913) and then from the structural anthropology of Claude Lévi-Strauss (1908–). Barthes' impact, however, derives from his application of semiotics to a wide array of media, including advertising, sporting events, fashion, theatre, photography, film, art and literature. Semiotics posits communication and representation as complex systems of signs and symbols. Barthes pays particular attention to the arbitrary nature of language and its constructs, privileging at times the linguistic sign over all other forms of expression. In his post-structuralist phase, which emerged in the late 1960s and became fully apparent in his 1970 publication, *The Empire of Signs*, Barthes reconsiders the power and unique qualities of the visual. While never abandoning his love affair with words, Barthes offers insightful commentaries on photography and film, in particular, as well as the image in general.

In the 1950s Barthes wrote a series of monthly essays on topics suggested by current events, a selection of which makes up the 1972 English translation, *Mythologies* ([M] 1957). Not only did this book introduce Barthes widely in England and America, it also includes an afterword, 'Myth Today', which articulates his concept of semiological analysis. Barthes describes a myth as structured by interdependent layers of signs and meanings. He defines key terms that will remain in his lexicon throughout his writing career: *sign* – the culturally constructed entity of signifier and signified, which appear as one but exist only in relation to one another; *signifier* – the perceptual image of the sign; *signified* – the idea expressed by the signifier. These essays are motivated by Barthes' desire to debunk the apparent naturalness promulgated in mass culture between object and meaning: 'I resented seeing Nature and History confused at every turn, and I wanted to track down, in the decorative display of *what-goes-without-saying*, the ideological abuse which, in my view, is hidden there' (*M*, p. 11).

There is a clear critique here of political and social convention – a Marxist attitude towards consumption, power and ideology. One representative piece concerns the exhibition, *The Family of Man*, the masterwork of Edward Steichen's tenure as director of the Department of Photography at the Museum of Modern Art, New York. Rather than trumpet the long-awaited appreciation of the art of photography, to which the exhibition and its curator appear to testify, Barthes takes issue with the exhibition's morality and sentimentality, challenging Steichen's suppression of individuality (the subjects of the photographs) in order to promote 'the alibi of a "wisdom" and a "lyricism" which only makes the gestures of man look eternal the better to defuse them' (*M*, p. 102).

It is ironic, however, that by the time the English-language translation of *Mythologies* was published, Barthes' ideas and essays had moved significantly past his work of the 1950s. A delay occurs in both academia and art criticism in England and the United States: the dissemination of Barthes' structuralism in the 1970s falls more than a decade behind its currency in France, while a post-structuralist text such as *The Empire of Signs* appears in English translation twelve years after its debut in France.

The Responsibility of Forms ([*RF*] French 1982; English 1991) begins with three of Barthes' most famous articles on photography, film and the image, and includes a consideration of whether painting is a language, as well as analyses of artists Erté, Giuseppe Arcimboldo, André Masson, Cy Twombly and Bernard Réquichot. 'The Photographic Message' and 'The Rhetoric of the Image' reflect Barthes' focus in the 1960s on the structure of communication. Each essay, therefore, discusses the layers of code embedded in the visual sign. Barthes identifies three messages of the image: the 'linguistic' concerns words within or accompanying an image; the 'denoted' refers to the resemblance between an object and its representation; and the 'connoted' considers all the qualities of composition that create symbolic meaning. Barthes' post-structural turn can be found in his 1970 essay on some photographic stills from the films of Sergei Eisenstein: he posits a third meaning (distinct from the informational and the symbolic levels of communication, which are obvious), which he labels the 'obtuse meaning'. The obtuse meaning defies description because it copies nothing; it sits apart from the film's exposition (its story) and its narrative message. Barthes locates the third meaning only by means of the stills, since the tyranny of film projection does not allow him to linger and thereby to isolate the obtuse meaning within Eisenstein's art. Barthes refers to this surplus meaning, which becomes apparent

by means of the photographic still, as the *filmic*. Through Eisenstein's work Barthes argues the possibility of a depth to film art and lays groundwork for film theory: 'film is not to be simply seen and heard but *scrutinized* and closely listened to, *studied* by eye and ear alike' (*RF*, p. 62).

In 'The Photographic Message' Barthes first articulates that the photograph is a message without code, a notion at the heart of his longer treatise on photography. Perhaps the most radical and troublesome concept for photographers and theorists alike, the idea of a photograph as a message without code appears not only to marginalize the photographer as artist but also to ignore photographic technique. In the early 1960s Barthes appears content to place 'the human interventions in the photograph (framing, range, light, focus, speed, etc.)' (*RF*, p. 33) at the level of connotation. He also argues in 'The Rhetoric of the Image' that 'cinema is not an animated photograph' (*RF*, p. 34), a fact that explains how film history does not offer a radical break from the previous arts of fiction. The new register to be found in these 1970s' essays in *The Responsibility of Forms* is that of desire and the body, which together create an idiosyncratic path of enquiry that may appear systematic – given Barthes' nomenclature – but that, in fact, strives to acknowledge and express that which systematic thought excludes.

Among the influences that move Barthes beyond his structural analysis of the 1950s and 1960s is his association with *Tel Quel*, the French avant-garde literary review published from 1960 to 1982. *Tel Quel* served as a forum for cultural and intellectual debate in the 1960s and 1970s and became the locus for the shift from structuralist to post-structuralist thought (cf. **KRISTEVA, DERRIDA**).

The last work published in Barthes' lifetime, *Camera Lucida* ([*CL*] French 1980; English 1981), is a commissioned book on photography. Eagerly anticipated by the

photographic community, the seemingly slight volume remains one of Barthes' most controversial yet compelling texts. More often than not it is this work that is cited in the art world, particularly by those discussing either the art or the theory of photography. The conundrum of *Camera Lucida* rests with the apparent simplicity of the prose (a fragmentary style comprising short narratives that may or may not flow into one another, as well as a two-part text in which a new methodological direction is pursued in Part II, requiring a reconsideration of what has come before). Barthes argues that the essence of the photographic medium is *reference*: he cannot deny that the subject or objects in a photograph (unless it is a trick photograph) existed at some past moment in time before the camera. The quality of 'having-been-there' (introduced in 1960 in 'The Photographic Message') becomes 'that-has-been' in *Camera Lucida* and is one of Barthes' principal assertions about the medium. In addition, Barthes refuses to consider 'Photography-according-to-the-Photographer', thereby giving the impression that he fails to appreciate the art and craft of the photographer.

Most cited of all, however, are the neologisms introduced: *studium* and *punctum*. The former refers to the potential of a photograph to appeal to Barthes' interest in history and culture – how one dressed in the past, for example; the latter is first linked to a detail in a photograph that 'pricks' Barthes, touching a pathos within him that may or may not reflect another viewer's response. Part II, however, declares that the photographic *punctum* is not simply a detail but is, in fact, time – a concept consistent with Barthes' commentary on photography since the 1950s.

At the time (at the beginning of this book: already far away) when I was inquiring into my attachment to certain photographs, I thought I could distinguish a field of cultural interest (the *studium*) from that unexpected flash which sometimes crosses this field and which I called the *punctum*, I now know that there exists another *punctum* (another 'stigmatum') than the 'detail.' This new *punctum*, which is no longer of form but of intensity, is Time, the lacerating emphasis of the *noeme* ('*that-has-been*'), its pure representation. (*CL*, pp. 95–96)

The literary and art communities tend to interpret *Camera Lucida* differently and either admire or disdain it in distinct ways. For the former much of the critique centres on the book as an elegy for his recently deceased mother, with Diana Knight arguing as early as 1994 that the Winter Garden photograph referenced in Part II – the one of Barthes' mother and her brother, ages five and seven respectively – does not really exist but is instead imaginary. Margaret Olin concurs with Knight's assertion by comparing the composition of the described (but not published) Winter Garden photograph with the one family photograph reproduced in *Camera Lucida*. In 2005 MICHAEL FRIED and JAMES ELKINS debate *Camera Lucida* in *Critical Inquiry*: Fried invokes Barthes' notion of the *punctum* to continue his long-standing discussion of the 'anti-theatrical tradition', while Elkins argues against the use of such an episodic, personal text for theorizing photography.

Barthes' post-structural writing embraces paradox and refuses to limit itself to the logical, let alone the absolute. Tzvetan Todorov best articulates his friend's sensibility and outlook: 'Barthes never wanted to assume the discourse of the Father ... He did not seek to impose truth on others, not even himself' (in Knight, *Critical Essays*). As a cultural theorist of the second-half of the twentieth century, Barthes provides entry to two intellectual movements: structuralism and post-structuralism. Because post-structuralism can be seen as an argument against structuralism, a summary of Barthes' theories can appear contradictory.

Barthes, however, always moves beyond any systematic thought that gains ascendancy and threatens to dominate enquiry.

The cultural debunking of the 1950s, which leads to his embrace of semiotics, is necessary for the time but problematic by the late 1960s, when semiotics is at risk of becoming an intellectual tyranny. Yet it is this initial structural exploration that affords the insights and deepening of perspective of his post-structural writings. He allows his thoughts to evolve not only from the philosophical questioning of structuralism by Jacques Derrida but also by his readings of and associations with other intellectuals of the 1960s and 1970s, such as Jacques Lacan and Julia Kristeva. Barthes' ability in *Camera Lucida* to blend a theoretical essay on photography with a memoir continues to entice readers. At the same time, the text has been cherry-picked by theoreticians and practitioners in disciplines from literature to photography to theory, engendering ongoing interpretative debates.

NANCY SHAWCROSS

BIBLIOGRAPHY

Primary literature

Barthes, R., *Camera Lucida*, trans. Richard Howard, New York: Farrar, Straus & Giroux, 1982.

Barthes, R., *Mythologies*, ed. and trans. Annette Lavers, New York: Farrar, Straus & Giroux, 1972.

Barthes, R., *The Responsibility of Forms*, trans. Richard Howard, Berkeley: University of California Press, 1991.

Barthes, R., *Oeuvres complètes* (vols I–V), ed. Eric Marty, Paris: Seuil, 2002.

Secondary literature

Elkins, J., 'Critical Response: What Do We Want Photography To Be? A Response to Michael Fried', *Critical Inquiry* vol. 31, no. 4 (2005), pp. 938–56.

Fried, M., 'Barthes's *Punctum*', *Critical Inquiry* vol. 31, no. 3 (Spring 2005), pp. 539–74.

Knight, D. (ed.), *Critical Essays on Roland Barthes*, New York: G. K. Hall, 2000.

Olin, M., 'Touching Photographs: Roland Barthes's "Mistaken" Identification', *Representations* (Fall 2002), pp. 99–118.

Rabaté, J.-M. (ed.), *Writing the Image after Roland Barthes*, Philadelphia: University of Pennsylvania Press, 1997.

Shawcross, N. M., *Roland Barthes on Photography*, Gainesville: University Press of Florida, 1997.

GEORGES BATAILLE (1897–1961)

Barely recognized during his lifetime, and virtually absent from Anglo-Saxon discourse at the time of his death, Georges Bataille has come in recent years to be recognized as a major critical theorist of the twentieth century whose influence on today's art – both on its theory and practice – has been incalculable. Bataille had a wide range as a writer, incorporating philosophy, sociology, anthropology, religion, literature, political economy as well as art. He also wrote a series of now celebrated 'pornographic' novels which, during his lifetime, were consigned to clandestinity.

Largely self-taught, apart from a period of study with the Russian philosopher Leon Chestov, who inspired in him an interest in Nietzsche and Dostoyevsky, Bataille belonged to a turbulent generation and was, as he said himself, 'born to literary life in the tumult of surrealism' (*Literature and Evil*, p. 1). His precise relation with Surrealism remains controversial, but there is no doubting the pivotal role that this encounter played in the development of his sensibility. Like most of the first-generation Surrealists, Bataille was profoundly marked by the trauma of the First World War and the crisis of consciousness to which it gave rise among European intellectuals. In Bataille's case this social and cultural trauma was also associated with personal childhood traumas that arose from his relationship with his blind and syphilitic father who died in 1915, abandoned and alone, in the bombardment of Rheims. The spell of anguish this event cast over Bataille never appears to have left him. Its mark is to be found throughout his work as tormented

appreciation not simply of personal tragedy but also of the tragic fate of humanity itself.

Also of crucial importance to him was the study of gift exchange made by the sociologist Marcel Mauss, whose lectures Bataille attended in the late 1920s. From Mauss's study of gift exchange in such practices as the potlatch ceremony of the peoples of north-western Canada, Bataille was able to derive support for his own theory of the interplay between taboo and transgression, and its centrality to the development of the human sensibility and to social organization. Equally decisive for the establishment of his social theory were the famous lectures of Alexandre Kojève on 'the master and slave dialectic' in Hegel, which provided stimulation for his understanding of the dynamic of human relations.

Bataille's thinking about art was also informed by his location within the ambit of Surrealism, and by his personal relations with practising artists. He had a particularly close relationship with André Masson, especially during the 1930s, and also had close ties with Max Ernst, Hans Bellmer and Jean Fautrier. His writings on art represent a small but not insignificant part of his oeuvre. However, their value lies less in any contribution they might make to art history than in the extent to which they enable us to understand Bataille's more general theories, from which his real relevance for debates in art emerges. For him art had no value in isolation; it assumed importance only as part of a universal history. The art that most interested him was in fact prehistoric cave art, which he was privileged to inspect at

first-hand in the caves of Lascaux during the early 1950s. His study of the Lascaux paintings, which gave rise to a monograph published in 1955 and to a series of essays (recently collected in a volume published in English, *The Cradle of Humanity*), was also at the root of his most important work, *Eroticism*, published in 1957. This in turn would give rise to the exploration of eroticism in art in his final work, *The Tears of Eros*, published in 1961, the year of his death. He also published a book-length study of the work of Manet (1955).

A profoundly anti-humanist thinker, Bataille was nevertheless imbued with an Enlightenment spirit of enquiry. In fact he appears to have been less concerned to oppose Enlightenment than to extract from it its humanism and its idealism, while restoring a dark core to it, one that no amount of 'illumination' would ever be able to penetrate; in this respect his thinking has often been compared with that of Pascal. Certainly Bataille was motivated by a will to dethrone reason from its pedestal as the primary human characteristic. The Cartesian cogito was based upon a deception: thought did not ennoble us; in many ways it degrades. Most especially, it did not differentiate us from other animals and the idea that it did was a primary human falsehood. Bataille did nevertheless believe that humans are fundamentally different from other animals.

This differentiation was to be found not in elevation but in something more brutal and elemental; it was the recognition and consciousness of death, something that was placed in evidence by eroticism, which fundamentally differed from animal sexuality in not being principally directed towards the propagation of the species. In eroticism, humans experience *jouissance*, which is not precisely enjoyment, but rather enjoyment imbued with anguish. In eroticism we experience at once the plenitude of being and the terror of death. It makes us aware of our limited natures, of the fact that in being born we are torn from the continuity of existence.

For Bataille everything follows from this primary recognition. It causes us to try to erect barriers against our vulnerability in order to give ourselves the illusion of permanence. We build to protect ourselves from the elements and to plan for the future. Most especially, we work to establish a sense of security in an unstable world, and work thus provides the basis for culture and the development of social structures. Through our efforts, we strive to give form and meaning to an incomprehensible situation.

Even in our striving, however, we are unsatisfied. We are constantly pulled back to death, so that even as we construct we are consumed with a will to destroy. This must be contained if stability is to be maintained, hence human communities are led to proscribe certain behaviour and actions. Such prohibitions, however, ultimately serve to intensify the feelings they sought to expel, and so they give rise to the desire for transgression, to a will to tear apart the very restrictions we have placed on ourselves.

Bataille saw the foundation of art as lying in this transgressive impulse. It was what he perceived in the art he saw in the Lascaux caves, which he viewed not principally as a form of sympathetic magic by which success in the hunt might be assured, but as responding to what he called 'inner experience': a sense of awe at the magnitude and 'impossibility' of our existence in the world. It is his theory of transgression that has tended to be the main attraction of Bataille's work for contemporary artists. This attraction, however, often turns on a fundamental misunderstanding, because Bataille did not celebrate transgression as a liberation or release from constricting social ties. Quite the contrary, in fact, he considered it to be fundamentally conservative; it did not deny but strengthened and completed the initial taboo, which founds social rules and regulates collective behaviour.

What really mattered for Bataille was not transgression but communication and what he termed 'sovereignty'. It is true that this is more likely to be encountered in transgression than in taboo, since the latter is bound to work and is thus inherently and irrevocably servile. Nevertheless, genuine communication, which is what sovereignty is, lies beyond the opposition between taboo and transgression. It is a sacred element that is fundamentally unknowable and unsayable, and as such it was characterized by Bataille as 'the impossible'. It is that which lacerates our being and momentarily tears us from our restricted existence as sentient individuals, causing us to recognize our insufficiency. For Bataille this sense was experienced most forcibly in the sacrificial rituals of ancient society. In modern society its possibilities were severely diminished. It was most likely to be encountered in eroticism, since there is in the carnality of the sexual act something rending and elemental. If art and poetry also offered intimations of it, it was only to the extent that their expression contained an alertness to the presence of death and decay.

Misunderstandings of the nature of Bataille's work (or perhaps more accurately its transformation into art historical terms alien to Bataille's own way of thinking) were encapsulated by an exhibition at the Centre Georges Pompidou that took place in 1996, curated by ROSALIND KRAUSS and Yves-Alain Bois, entitled *Informe, mode d'emploie* (Formless: a user's guide). Here Bataille's anti-classificatory sorties were turned into a kind of anti-modernist aesthetic comprising artworks that refused the constrictions of form. What seems to have escaped Krauss and Bois is that, for Bataille, arguments for or against modernism were beside the point. As he made clear in his study of Manet, the movement of modern art merely reflects the social/political movement of modern society. The true significance of art must be sought *outside* of the history of art in the direct

relation of the artwork to the heart of the human sensibility.

Bataille also deserves mention for his part in the editing of one of the most remarkable art journals of the twentieth century. We do not know the precise role he had in the production of *Documents*, fifteen issues of which were published during 1929 and 1930 under the patronage of Georges Wildenstein. Bataille was its 'Secretary General', but what precisely this meant is unclear and his actual role is subject to debate. It seems likely that Carl Einstein, Georges-Henri Rivière, Robert Desnos and Michel Leiris also had a significant input into the orientation and direction of the journal. Yet it is difficult not to see Bataille's contribution as central to establishing the organizing principles that characterized the journal, in which art was placed in direct confrontation with ethnography and archaeology in such a way as to bring their preliminary classifications into question. In it, he published his first articles in which his later preoccupations would assume a preliminary form in explorations of 'base matter' which provide the basis upon which he could assert that the origins of the work of art lie not in an aspiration towards elevation but in the dark heart of our sensibility. The centrality of *Documents* to current debates surrounding art was highlighted by an exhibition devoted to it at the Hayward Gallery in London in 2006.

Bataille's oeuvre, provocative and extreme as it often is, reminds us that art is an elemental activity whose expression responds to fundamental needs within human beings. It is not a pastime to be engaged in as a diversion from more pressing concerns and if it is to be genuinely appreciated it must be approached in a full-blooded way. Its expression and its appreciation are not for the faint-hearted.

MICHAEL RICHARDSON

BIBLIOGRAPHY

Primary literature

Bataille G., *Manet*, trans. Austryn Wainhouse and James Emmons, Geneva: Skira/London: Macmillan, 1955.

Bataille, G., *Prehistoric Painting: Lascaux or the Birth of Art*, trans. Austryn Wainhouse, Geneva: Skira/London: Macmillan, 1955.

Bataille, G., *Literature and Evil*, trans. Alastair Hamilton, London: Calder and Boyars, 1973.

Bataille, G., *Eroticism*, trans. Mary Dalwood, London: Calder & Boyars, 1962; San Francisco: City Lights, 1986; London: Marion Boyars, 1987.

Bataille, G., *Visions of Excess: Selected Writings 1927–1939*, trans. Allan Stoekl, Manchester: Manchester University Press, 1985.

Bataille, G., *The Tears of Eros*, trans. John Connor, San Francisco: City Lights, 1989.

Bataille, G., *The Absence of Myth*, trans. Michael Richardson, London: Verso, 1994.

Bataille, G., *The Cradle of Humanity*, trans. Michelle and Stuart Kendall, New York: Zone Books, 2005.

Secondary literature

Ades, D. and Baker, S. (eds), *Undercover Surrealism: Georges Bataille and Documents*, London: Hayward Gallery/Cambridge: MIT Press, 2006.

Botting, F. and Wilson, S., *Bataille*, New York: Palgrave, 2001.

Champagne, R. A., *Georges Bataille*, New York: Twayne, 1998.

Hegarty, P., *Georges Bataille, Cultural Theorist*, London: Sage Publications, 2000.

Krauss, R. and Bois, Y.-A., *Formless: A User's Guide*, New York: Zone Books, 1997.

Richardson, M., *Georges Bataille*, London: Routledge, 1994.

Surya, M., *Georges Bataille, an Intellectual Biography*, trans. Krzysztof Fijalkowski and Michael Richardson, London: Verso, 2002.

JEAN BAUDRILLARD (1929–)

Jean Baudrillard did not have a conventional career as an academic. He embarked on university teaching in the 1960s after some years teaching German in provincial schools and by building a reputation as a major translator of the works of Peter Weiss into French. Joining the circles around ROLAND BARTHES, his prolific output began with structuralist studies of consumer objects and systems. Indeed Baudrillard has privileged art – and literature – as a key domain of analysis, and to illustrate his theoretical sociology and philosophy. Baudrillard's method of analysis was initially highly formal, concerned mainly with semiotic codes and decisively influenced by WALTER BENJAMIN and Marshall McLuhan, subsequently becoming more influenced by the anthropological tradition from Marcel Mauss to GEORGES BATAILLE.

For Baudrillard, Western art from the Renaissance has represented the real world

through a number of 'orders of simulacra'. His central analyses chart the decline of classic bourgeois (or 'modern') art in the age of mechanization and virtualization. The value of authenticity and autonomy continues to haunt these orders of reproduction as they increasingly become driven by the various art markets: when capitalism shifts into industrialism and art no longer remains the preserve of elite groups attached to a transcendental or autonomous conception of the aesthetic, art begins to collude with the design of commodities (e.g. the Bauhaus). Once the commodity itself becomes aestheticized – its exchange value is no longer dependent on function, or use-value – it becomes an object in an 'object system'. The increasing dominance of the Logo (the brand label) means not only the appearance of a new type of capitalism – consumer capitalism – but also the integration of an aesthetic order and the process of commodification. Such a shift has consequences for the mode of consumption of all forms of art.

Baudrillard's terminology changed in the 1990s, from that of orders of simulacra and simulation to that of forms of illusion and disillusion. Primitive cultures are always born of 'seduction' and 'fundamental illusion', a 'vital illusion of appearances', before all representation and interpretation and aesthetics can come into existence. The realm of modern aesthetics involves a new attempt to banish this world of radical illusion by mastery of radical disillusion. The emphasis in modern culture shifts away from absence towards presence, above all to the presence of 'reality'. Ironically, in the long term this collapses the distinction between sign and reality into technical simulation and 'virtual reality'. The real is both produced and also disappears – and with it the doubled-up forms of imaginative simulacra that accompanied the real–illusion couple.

What interests Baudrillard is the way in which the logic of the modern art aesthetic could lead to the exhibition of a framed empty space. What is significant is that this framed 'nothing' would nonetheless have a signature, that of the artist. Primitive art never had a signature. Such art not only played an important role as ritual, it formed part of a symbolic world. It did not represent an external reality, but functioned in a culture of 'symbolic exchange'. The world of the anonymous artist (or group of artists) partakes of a world that already exists, a world that is created by the gods. Since there is no 'authentic' art, there can be no fakes. Everything changes with the emergence of the individual artist and the signature style. At first, the artist remained a craftsman or master craftsman, and the work of art 'represented' an outside reality. With reference to **MICHEL FOUCAULT**'s famous analysis of Velázquez's *Las Meninas* (1656), Baudrillard suggests that with this appearance of the named artist (and the signature) the relation of the painting to the world is altered. He observes that since the Renaissance there have been four different and successive 'orders of simulacra'. Each of these can be analyzed by means of the theory of the sign (signifier/signified/real referent) as opposed to the symbol (there is no element of the real outside the symbol).

In this historical process, art is increasingly rationalized with techniques of capturing real perspective and its double, *trompe l'oeil*. Paintings depicted mythic or religious subjects as established by tradition or sacred texts, so at this stage of semiotic relation there is reference to a referent in the 'symbolic'. Baudrillard conceives this order of representation as the first order of simulacra: the representation separates the real world and the order of representations. From now on the masterwork can be copied; the original craft style of the artist can be faked. This is radical in the sense that the 'real' is given a very specific meaning and significance. The philosophical category of 'the real' makes its appearance at the birth of modernity, and art has a privileged but ambiguous role in this process.

The internal dynamic of modernity – today experienced through the pervasiveness of the mass media – transforms our relationship to the world, a world that can no longer be experienced independently of its representation. 'The real' becomes a problematic term. Baudrillard uses the term 'hyperreal' to analyze this transition. At the same time the boundary between the aesthetic realm and other value realms breaks down in a process Baudrillard calls 'transaestheticization'. Baudrillard analyzes this as a shift from commodity to 'sign-exchange' (the shift from commodity to an object no longer acquired primarily for its use). Consumer society is a society that consumes images, and is saturated with the aestheticized tautologies of advertising and the fashion cycle. This society is no longer based on production, but on representation and seduction. Identity is determined not by function in production, but by style and mode of consumption, and this third order of simulacra is no longer based on a clear distinction between representation and the real world. The world is swallowed by its own image.

Baudrillard has developed a response to this condition which now governs his own work: 'fatal theory'. Originally a Marxist, Baudrillard's works increasingly follow Nietzsche and Baudelaire; and the dominant problems of Western societies are no longer those of economic exploitation and scarcity of resources, but ones characterized by the production of anomalies, viruses, saturation and obesity. Modern autonomous art, no matter how critical, is incapable of forming a coherent response to a world driven by these new exponential logics, fatal strategies, extreme events and spirals, which arise against the background indifference of mass culture. The responses to this condition in art that Baudrillard identifies (and rejects) are two radicalizations, the first towards reality, the second towards replication.

Failing to hold a critical distance, and to work within a reduced number of dimensions, art is drawn closer to a project of reproducing the real, either on the surface or abstractly. As the real becomes progressively a product of promotion, art also becomes promotional. Art renounces its symbolic function altogether and destroys the possibility of illusion (always based on an absence not superabundance of dimensions). Technically, it also becomes fascinated by reproducibility and serial reproduction. Fused together this leads to the art of Andy Warhol, whom Baudrillard regards as an ambivalent figure, both able to push the limits of the modern aesthetic and yet remains trapped in projects that reproduce themselves.

The ambivalence of modern art is centred on the fact that it wants both to maintain a mastery of autonomous aesthetics while at the same time master the symbolic manipulation of modern disillusion with the world. This later operation is contradictory since it involves a rejection of any vital primary illusion in favour of a fundamental assertion of the primacy of reality and realization and its genres and sub-types – surreality, hyperreality, virtual reality, etc. Baudrillard reads early Warhol as marking the moment when a new order of simulacral art eliminated the old unity of representation (real and its image) and became an unconditional simulacrum, producing a new 'transaesthetic illusion'. When later Warhol repeated this theme in 1986 he fell back into an 'inauthentic form' of simulation. Baudrillard seems, then, to have a meta-aesthetic which condemns on aesthetic grounds certain kinds of art. A further example is his clear rejection of New York 'simulationists' (Peter Halley, Haim Steinbach, Meyer Vaisman, Ashley Bickerton, et al.), and art exhibitions of plasticized, vitrified, frozen excrement, or garbage that do not produce an irruptive moment of clarification, but simply a form of aesthetic disillusion. The current situation of art is a state of radical indifference, a 'metalanguage of banality' ('Objects, Images, and the Poss-ibilities of Aesthetic Illusion' [*OIPAI*], p. 10).

Through the 1990s Baudrillard worked at outlining a theory of a fourth order of simulacra, or, more accurately, simulation. Beyond the code and system of reproducibility there is now emerging an order of radical uncertainty in which the relation of context and event is changing. In this order, dominated by extreme events, the event creates its own context. This is Baudrillard's concept of singularity defined as that which cannot be exchanged. There are two kinds of such events. One is anodyne: an extreme painting 'could be characterised as a simplified form of impossible exchange … and the best discourse about such a painting would be a discourse where there is nothing to say, which would be equivalent of a painting where there is nothing to see' (*OIPAI*, p. 9). The other event attains a symbolic power because its force is such that it cannot be absorbed into any cultural system.

One important criticism of Baudrillard's work has been that although his writings on art are voluminous, his actual engagement with specific artists and specific works is limited. Some critics have questioned the adequacy of his knowledge over the range and detail of modern art in particular (*Sans Oublier Baudrillard*, pp. 45–56). Others have questioned the adequacy of his aesthetic theory and categories as being either outmoded or too general to be of use in close analysis (*Critical Vices*, pp. 119–43). Others have seen his ideas as ambiguous, imprecise and shifting, a character which may explain why he himself has complained that he has often been misunderstood.

His reply to these criticisms is to argue that he has attempted to provide a new kind of cultural theory of the major shifts in modern culture (fatal theory) and has illustrated these shifts above all with reference to the key moments of modern art, risking the possibility of being misunderstood. His position has remained tantalizing: he plays on the one hand with a conception of seduction, challenge, symbolic power, only in the end to chart the way in which modern artists by and large have been unable to master them; while on the other hand he argues that in the world of simulacra and virtual reality very few artists have been able to live at the edge of the technological revolutions with an equivalent and appropriate response.

MIKE GANE

BIBLIOGRAPHY

Primary literature

Baudrillard, J., *For A Critique of the Political Economy of the Sign* (*Pour Une Critique de L'Economie du Signe*, 1972), trans. Charles Levin, St Louis: Telos Press, 1981.

Baudrillard, J., *Symbolic Exchange and Death* (*L' Echange Symbolique et la Mort*, 1976), trans. Iain Hamilton Grant, London: Sage, 1993.

Baudrillard, J., *The Transparency of Evil* (*La Transparence du Mal*, 1990), translated by James Benedict, London: Verso, 1993.

Baudrillard, J., 'Objects, Images, and the Possibilities of Aesthetic Illusion', in ed. N. Zurbrugg, *Jean Baudrillard, Art and Artefact*, London: Sage, 1997.

Baudrillard, J., *The Uncollected Baudrillard*, ed. G. Genosko, London: Sage, 2001.

Baudrillard, J., *The Conspiracy of Art*, ed. S. Lotringer, New York: Semiotexte, 2005.

Secondary literature

Gane, M., *Jean Baudrillard: In Radical Uncertainty*, London: Pluto, 2000.

Gane, M. (ed.), *Jean Baudrillard: Masters of Social Theory* (4 vols), London: Sage, 2000.

Kroker, A. and Cook, D. (eds), *The Postmodern Scene*, London: Macmillan, 1988.

Majastre, J.-O. (ed.), *Sans Oublier Baudrillard*, Brussels: La Lettre Volee, 1996.

Stearns, W. and Chaloupka, W. (eds), *Jean Baudrillard: The Disappearance of Art and Politics*, London: Macmillan, 1992.

Zurbrugg, N., *Critical Vices: The Myths of Postmodern Theory*, Amsterdam: G+B Arts International, 2000.

WALTER BENJAMIN (1892–1940)

Walter Benjamin was born to wealthy Jewish parents in Berlin in 1892 and committed suicide on the flight from Nazism on the Spanish–French border in Port Bou in 1940. After his doctoral thesis, *The Concept of Art Criticism in German Romanticism* (1920), Benjamin failed to secure a professorship in philosophy with his book *The Origin of the German Tragic Drama* (1928), a philosophical treatise on the historicity of aesthetic concepts and a critique of Neo-Kantianism. Subsequently, Benjamin became one of the most influential German cultural critics in the 1920s, he translated Proust and Baudelaire and was one of the first to recognize the importance of Kafka. His essay 'The Task of the Translator' (1923) is one of the foundation texts of translation theory, and his essays on 'Goethe's *Elective Affinities*' (1924–25) and on Baudelaire (especially 'On Some Motifs in Baudelaire', 1939), introduced new critical concepts and methods to literary studies.

From the mid-1920s Benjamin underwent a 'Copernican turn', towards Marxism, combining strands from Jewish mysticism with Marx and Freud to forge an idiosyncratic materialist philosophy of history and culture. Through his friendship with **THEODOR ADORNO** he became associated with the Frankfurt School, and his influence on Adorno's thought cannot be underestimated. His association with the playwright Bertolt Brecht also left a deep trace in his later work, especially 'The Work of Art in the Age of its Mechanical Reproducibility' (1935–36), 'The Author as Producer' (1934) and the 'Theses on the Philosophy of History' (1939–40).

In touch with virtually every philosophical, theoretical and aesthetic discourse of his time from Henri Bergson, Georg Simmel, Freud, Carl Schmitt and Martin Heidegger to *L'Art Pour L'Art*, Art Nouveau, Surrealism, Futurism, New Objectivity and the Bauhaus, Benjamin's thought is self-consciously heterogeneous and anti-systematic. Crossing the boundaries between philosophy, theology, sociology, psychology and literature, Benjamin's concepts (aura, artwork, experience, history, etc.) are purposefully unstable and ambiguous, implying a critique of thinking in scientific and systematic philosophical categories. Both Horkheimer's and Adorno's later critique of the totalitarian potential of Enlightenment philosophy and science and their critique of the concept of culture can be traced back to Benjamin.

While the early Benjamin conceives of the artwork as a medium of truth that can be experienced but not conceptualized, under the influence of Georg Lukács' *History and Class Consciousness* (1926) Benjamin locates both the artwork, and the aesthetic concepts through which society describes its experience, in their historical context. Following the example of Siegfried Kracauer, the most influential critic of Weimar Germany, Benjamin turns away from abstract academic thought towards the philosophical understanding of the phenomena of contemporary mass culture and technology, exploring the connection between aesthetic forms, historical development, politics and consciousness. Together with Adorno, Benjamin developed an 'immanent' method of criticism, which, rather than imposing

outside criteria and concepts, begins with the presuppositions of the work itself and extrapolates an entire historical epoch out of its internal contradictions. While vulgar Marxism regards cultural artefacts as external to the principal conflict of Capitalist property relations, Benjamin reads artefacts as the expression of the inherent social, political and intellectual contradictions of their epoch.

Benjamin's most influential essay, 'The Work of Art in the Age of its Mechanical Reproducibility' is an attempt to theorize what happens to art when it becomes mechanically reproducible. Benjamin's central argument is that philosophical concepts as well as subjective experiences are historical, and that their truth changes with the historical situation. For Benjamin, the industrialization of society in the nineteenth century effects a restructuring of human experience: the process of technicization and alienation in modernity progressively erodes the principles on which the bourgeois experience of selfhood is based, i.e. contemplation, inwardness and solitude. For Benjamin, the essential experience of modernity consists in the destruction of bourgeois subjectivity in the continuous shock of urbanized space. Benjamin follows Marx's theory of alienation here, namely that the worker at the machine is turned into a mere thing due to the division of labour and the lack of control he has over the production process. This, Benjamin argues, is paralleled in the situation of the passer-by in accelerated urban spaces. Being subject to constant shocks, the experience of neither can be categorized in terms of autonomous subjectivity in control of its destiny. As a consequence, the aesthetic categories with which the bourgeois subject describes its experience (authenticity, creativity and beauty) become outdated and have to be rethought.

The consequences for art and aesthetics are twofold. First, to the new forms of technological mass production correspond new forms of aesthetic production (photography, film) as well as new forms of apperception and reception. While artworks are traditionally consumed in isolated contemplation, film reception is collective and distracted. The reception adequate for bourgeois artworks is thus at odds with the experience of modernity itself, the decentring of the bourgeois subject. Benjamin conceives of (silent) film with its shock-like montage aesthetics as a training ground for a new form of urban subjectivity, no longer based on the centred subject. Second, Benjamin recognizes that in modernity all experience of reality and thus all subject positions are increasingly mediated by technology. This outdates the descriptive categories of bourgeois aesthetics, which depend on an idea of subjective authenticity, presupposing a subject immediate to itself. Consequently, Benjamin dispenses with categories central to Kantian aesthetics and their reception in Germany such as aesthetic autonomy, 'creativity and genius, eternal value and mystery'.

For Benjamin, the technical reproducibility of artworks undermines the authority of the original. The technically reproduced artwork destroys what Benjamin refers to as the *aura* of the work, its unique presence in time and space. The aura is not only tied to the authenticity of the work but also to the origin of art in myth and cultic fetish. In Benjamin's example, a medieval painting used in religious practice is not primarily a work of art but a cultic object. It only acquires the status of artwork at a later stage in a society that venerates artists, and develops a market for originals. Nonetheless, the cultic aspect of the fetish survives in the artwork in changed form. As in Adorno's aesthetic theory, for Benjamin the history of aesthetics retains aspects of cultic practice. Bourgeois aesthetics is essentially the transformation of religious into aesthetic experience under the cult of beauty.

While technological reproductions of artworks (postcards of paintings, sculptures, cathedrals, etc.) destroy their aura from within through proliferation, works intended for mass reproduction (film, photography) have no aura from the outset. The 'withering of the aura' thus corresponds to the destruction of the depth of subjective experience in modernity. For Benjamin, the mass-produced and mass-reproduced work 'emancipates the work of art from its parasitical dependence on ritual'; and art's cultic value is increasingly replaced by its exhibition value. Mass-produced artworks are works produced for exhibition and mass reception, not private ownership. This precludes the idea of aesthetic autonomy and the concept of the artist as genius-creator that had governed bourgeois aesthetics since Kant's *Critique of Judgement* (1790), and leaves the artist to rethink his or her relationship to society, and its structures of power.

Benjamin dismisses the concept of aesthetic autonomy as an ideological self-deception veiling the relationship between art and power. Relatedly, Benjamin argues that the concepts of culture and tradition are tied to a continuing history of oppression and private property. In Benjamin's view, the process by which cultural goods become part of a tradition is inextricably linked to a history of oppression in which these goods provide a legitimizing narrative for the ruling class. Cultural tradition is thus essentially two-faced, a repository of historical experience and a document of barbarism. Benjamin's most influential literary essays, 'Goethe's *Elective Affinities*' and 'On Some Motifs in Baudelaire' are essentially attempts to wrest the work of these poets away from an inclusion into conservative aesthetics and its personality cult of the artist as heroic creator, prophet and leader. Similarly, for Benjamin, the 1920s debates that seek to establish film as 'art' against a conservative aesthetic elite misrecognize film's potential as a training

ground for new forms of perception which could be harnessed for political ends. The attempt to turn film into 'culture' ultimately results in the domestication of film's revolutionary potential in the cult of star (cf. Adorno on the 'Culture Industry').

The incompatibility of aesthetic categories of the bourgeois age with mass-produced aesthetic products causes him to drop the term 'work of art' altogether. Benjamin's 'Artwork' essay is thus not a defence of popular culture against high culture's attempts to discredit it, but an attempt to reveal the structural properties of film as aesthetic *correspondence* to the technological development of society. Like the essays on Goethe and Baudelaire, the 'Artwork' essay is an example of what Jürgen Habermas calls *redemptive critique*; it attempts to salvage the revolutionary powers of film and its base origin in fairground shows from its increasing elevation into a narrative of 'culture'.

Benjamin's late thought increasingly turns into a critique of forms and modes of representation and their implicit politics, particularly naturalist forms of representation. On the level of production and reception, notions of 'immediacy' and 'authenticity' are aesthetically and politically naive and dangerous, especially since German fascism exploited the personality cult of conservative aesthetics with respect to Hitler as the 'genius-leader'. While Benjamin jettisons the cultic aspect of the artwork, he stresses its property as a medium of knowledge, albeit with a changed function. For Benjamin, the end of bourgeois aesthetic autonomy results in a re-evaluation of aesthetic practice as social and political and a rediscovery of the didactic value of art. His favoured example is Bertolt Brecht. Brecht's dialectic theatre is not only a critique of representation: it self-critically de-auratizes itself as 'art' by exposing its assembled nature. As collaborative work of an increasingly preliminary nature Brecht's

plays subvert the categories of 'work' and 'artist-creator' altogether.

The strongest critique of Benjamin's theses came from Adorno. Adorno applauded both Benjamin's critique of bourgeois aesthetics as grounded in myth and his redemption of the 'kitsch' film against the 'quality' film. However, he criticized Benjamin's rejection of the autonomous work of art in favour of a politicized concept of art along Brechtian terms. Arguing against Benjamin's identification of aura with the autonomous artwork, he pointed out that modernist artists such as Kafka and Schönberg produce autonomous, non-auratic works, as a result of their insight into the historical development of both society and their aesthetic material. In Adorno's view, Benjamin's opposition of autonomous, reactionary vs. political, progressive art was undialectical, and the autonomous work of art was in as much need of dialectic defence as the base cinematic floor show.

Over the last fifty years, Benjamin has emerged as one of the most influential thinkers of the twentieth century. His influence can be traced not only in the disciplines of literary and cultural studies (FREDRIC JAMESON, Terry Eagleton), media theory (Friedrich Kittler, Vilem Flusser), translation theory, philosophy (Giorgio Agamben), historiography (Hayden White), aesthetic and social theory (Theodor W. Adorno) but also in the fields of aesthetic practice: in German, American and Italian literature (W. G. Sebald, Richard Powers, Gianni Celati), photography (Luigi Ghirri) and architecture (Daniel Libeskind).

HELMUT SCHMITZ

BIBLIOGRAPHY

Primary literature

Benjamin, W., *Selected Writings* (vols. 1–4), eds Howard Eiland and Michael Jennings, Cambridge: Belknap Press, 1996–2003.
Benjamin, W., *Understanding Brecht*, trans. Anna Bostock, London: Verso, 1998.
Benjamin, W., *The Arcades Project*, trans. Howard Eiland and Kevin McLaughlin, Cambridge, Mass. and London: Belknap Press, 1999.

Secondary literature

Buck-Morss, S., *The Dialectics of Seeing: Walter Benjamin and the Arcades Project*, Cambridge: MIT Press, 1989.
Ferris, D. S. (ed.), *The Cambridge Companion to Walter Benjamin*, Cambridge: Cambridge University Press, 2004.
Leslie, E., *Overpowering Conformism*, London: Pluto, 2000.
Gilloch, G., *Myth and Metropolis: Walter Benjamin and the City*, Cambridge: Polity, 1996.
Nägele, R., *Theater, Theory, Speculation: Walter Benjamin and the Scenes of Modernity*, Baltimore: Johns Hopkins University Press, 1991.
Osborne, P. (ed.), *Walter Benjamin: Critical Evaluations in Cultural Theory* (3 vols), London: Routledge, 2005.

PIERRE BOURDIEU (1930–2002)

Pierre Bourdieu, one of the most influential twentieth-century social scientists, acquired an intellectual stature that for some matched that of Sartre. He came from the Béarn in south-eastern France and studied philosophy at the École Normale Supérieure in the 1950s. After military service in Algeria he switched from philosophy to the social sciences, first to anthropology and then to sociology (later maintaining the philosophical and ethnographic dimensions of social investigation). Following spells at the University of Paris (where he worked under Raymond Aron) and at Lille University, he obtained a post at l'École Pratique des Hautes Études in 1964. In 1981, he was appointed to the Chair in Sociology at the Collège de France.

By the time of his death he had gained a formidable reputation across a wide spectrum of subjects including anthropology, art history, cultural studies, education, linguistics, literary studies, museum studies, philosophy and sociology. His books include two major contributions to the sociology of art: *Distinction* (first published in 1979) and *The Rules of Art* (first published in 1992). His legacy also includes one of the most sophisticated sociological attempts to transcend the limitations of subjectivism, which he encountered as post-war Sartrean phenomenology, and objectivism, which was exemplified by the structuralism of Lévi-Strauss and Althusser. For Bourdieu, phenomenological sociology reduced society to discrete encounters between individuals, whilst structuralism deleted the human agency that generated 'social structures'.

In *The Logic of Practice* (1980) he argued that these problems could be overcome by means of (i) a dialectical approach, which incorporated the partial insights of both perspectives; (ii) a relational theory, which rescued sociology from futile debates about whether the individual was more or less real than society, and (iii) a reflexive practice, which rendered visible the bias of the situated observer.

Art was intimately associated with Bourdieu's sociological imagination. First, art illuminated the problem of agency and structure at a point where sociology was conventionally thought to reach the limits of its explanatory power. Second, it expressed his intuitive grasp of the symbolic aspects of social change and the historical nature of economic logic. The worlds of bohemian art and the Algerian peasant provided examples of exchange which negate bourgeois economic rationality. They were, Bourdieu argued, rooted in a collective denial which euphemizes power so that, for example, domination is concealed in the alchemy of family giving or in the 'quasi-magical' potency of the artist's signature or in the donations of corporate patronage. Third, his analyses of the gestation of autonomous art worlds were integral to his more general perspective on modernity and the contemporary role of intellectuals.

By the 1970s Bourdieu was internationally known for his work on educational inequality. In a series of books he argued that, contrary to meritocratic rhetoric, privilege was transmitted through the medium of schooling and that (i) school pedagogy was based on a

dominant and arbitrary definition of cultural worth; (ii) scholastic success presupposed cultural assets, or 'cultural capital', whose possession was concentrated in the middle and upper classes; and (iii) working-class aspirations might be explained in part by reference to agency, i.e. to a habitus that was adjusted to a situation of inequality and which reconciled the disadvantaged to their situation.

These ideas about social class and the transmission of cultural assets were also developed in relation to art. Surveys, including museum visitor research conducted with colleagues in the 1960s, formed the basis for books about the consumption of culture. The concept of habitus, which he knew from Mauss, was the theoretical linchpin. Habitus, a mental habit or a set of durable dispositions, acquired through socialization, was (pace Merleau-Ponty) an embodied frame of reference which oriented people towards the priorities of the world in which they were situated. Thus, social structure was incorporated by individuals as their 'second nature'; habitus was a generative principle of improvisation which specified creation as a condition of social reproduction. Informed also by his reading of art historian Erwin Panofsky on scholasticism and medieval cathedral builders, the concept offered a way beyond the received wisdom that society is merely art's 'context'. Sociology's object of enquiry was, therefore, 'the creative project as a meeting point and adjustment between determinism and a determination'; that is, the influence of external social forces on art was exerted through the medium of the determinations of the artistic field and the habitus of the artist ('Intellectual Field and Creative Project', p. 185).

Bourdieu also argued that museums are, like schools and universities, sites of symbolic violence – they impose an arbitrary definition of cultural worth with the complicity of the dominated (*The Rules of Art*, pp. 167–68). In *The Love of Art* (1991) the universal claims of the art museum were found to be interwoven with cultural inequalities which the museum implicitly endorsed. Thus, social classes, which are unequally endowed with the resources necessary to impose their vision of the world, are caught up in relations of mutual misrecognition in which subordinate classes internalize the voices of the powerful. With the publication of *The State Nobility* (1989), it became clear that Bourdieu was extending Norbert Elias's theory of the state and violence by arguing that schools, universities and museums contribute to the state's monopoly over the means of symbolic violence.

In the 1960s Bourdieu argued that photographic meaning was governed by norms of what was photographable for a given social class, and which expressed its sense of its objective situation vis-à-vis other classes (*Photography: A Middle Brow Art*). Later, in *Distinction*, which became a celebrated ethnography of French lifestyles, he drew on the legacies of Marx, Weber and Durkheim to argue that cultural consumption tends 'to fulfil a social function of legitimating differences' (*Distinction*, p. 7). The principles of classification, which inform judgments of taste, are themselves objects of struggle between groups who are enmeshed in struggles for power and privilege, and who seek to impose their vision of the universe and its divisions on each other. Bourdieu maintained that aesthetic distinctions (such as that between high and low art) are not innocent. The pure or disinterested gaze, sanctioned as the legitimate taste of a Kantian aesthetic, presupposes a habitus which is rooted in a refusal of popular culture – a relationship of symbolic power which is misrecognized as innate taste. His model of contemporary society was one in which groups, who occupy determinate positions in relation to necessity and who possess different ratios of cultural and economic

capital, struggle to augment their assets. It also specified that a feature of modernity was the growing weight of cultural capital within the social order. For Bourdieu, modern societies have an irreducibly symbolic dimension: they are, in part, spaces of semiotic struggle in which the winners are those who convert their tastes into cultural capital.

In challenging romantic ideology Bourdieu did not banish the artist to the realm of fiction: '[t]he task of bringing authors and their environments back to life could be that of the sociologist' (*The Rules of Art*, p. xvi). He argued that (i) the belief in the artist-as-creator entails a collective suppression of the commercial labour of exhibiting and trading in art; (ii) the subject of creation is *the field of art*, that is, the configuration of dealers, critics, artists and others which consecrates the artist and from which she derives social honour or symbolic capital; and that (iii) the field of art is a space of struggle for symbolic power.

In the 1990s Bourdieu's ideas about fields and art were developed in *The Field of Cultural Production* (1993) and *The Rules of Art*. He argued that, with modernization, human faculties which had been incarnate in institutions or people were distributed and impersonalized. Societies were transformed into networks of fields or 'games': economics, politics, science, sport, art, etc. were each ordered according to specific rules and forms of capital, so that players tacitly invest their being in the game, while they pursue strategies for winning (which are emergent properties of a practical mastery of the logic of a game that they may lose or win).

Field theory, which owed much to Weber, was a non-teleological perspective that parted company with the theory that modernization conformed to a master logic of social change. Thus the field of art refracts the political and economic forces of what Bourdieu called the field of power; the more autonomous is the former, the more that heteronomous power is mediated by the logic of art. The field of power was an emergent property of social changes that divided the labour of domination and which was in turn shaped by struggles for and over the priority of different assets, for example economic and cultural capital.

The artist exists in and through the medium of a historical field of struggle for the monopoly of the power to define art; it is the field that authorizes her. Field theory made it possible for Bourdieu to think sociologically about the difference that a great artist makes to art. Flaubert, for example, had produced himself as a new kind of writer through the medium of the cultural field: 'we try to discover what he had to do and wanted to do in a world that was not yet transformed by what he in fact did, which is to say, the world to which we refer him by treating him as a "precursor"' (*The Field of Cultural Production*, p. 205).

In his work on Manet, Bourdieu traced the socio-genesis of 'the pure gaze' and its habitus. Modernism had entailed a symbolic revolution, a collective transformation of the categories of perception and of the field of art; it had spawned artists whose habitus was at odds with the logic of bourgeois calculation (i.e. of commercially successful art). Theirs was an inverted world in which commercial 'losers' took the prizes; they were artists whose habitus committed them to new rules and who suspended the immediate gratification of renown, which might impede their struggles for consecrated reputations among their peers.

During the 1990s three things became evident features of Bourdieu's thinking: (i) he tempered the relativism of *Distinction* with new arguments about universal value; (ii) he expressed a growing concern for the autonomy of art and artists in late twentieth-century capitalist society; and (iii) he contributed, as a public intellectual, to debates on politics, poverty, suffering and globalization.

Bourdieu's oeuvre, which has spawned a literature on the subject of cultural capital and value is at the intersection of two twentieth-century disciplinary developments: the cultural turn of sociology and the theoretical turn of the humanities. He has been judged by some scholars, for example Richard Jenkins, to be a sophisticated determinist, and criticized by others, for example Bridget Fowler, for misunderstanding popular art, and for treating working-class culture as an analytical foil to formalism. It has been claimed that his theory and data, being too French and now too dated, lack universal application. This, he countered, was to commit the substantialist error that only those things which are directly apprehended are real. Thus statistics about consumer preferences or educational achievements were visible expressions of hidden 'relationships between groups maintaining different, and even antagonistic relationships to culture' (*Distinction*, p. 12). Such data realized the possibilities secreted by fields and whose hidden principles Bourdieu sought to expose.

GORDON FYFE

BIBLIOGRAPHY

Primary literature

Bourdieu, P., 'Intellectual Field and Creative Project', in ed. Michael F. D. Young, *Knowledge and Control*, London: Collier Macmillan, 1971.

Bourdieu, P., *Distinction: A Social Critique of the Judgement of Taste*, London: Routledge & Kegan Paul, 1984.

Bourdieu, P., *The Logic of Practice*, Cambridge: Polity, 1990.

Bourdieu, P. (with Boltanski, L., Castel, R., Chamboredon. J.-C. and Schnapper, D.), *Photography: A Middle Brow Art*, Cambridge: Polity, 1990.

Bourdieu, P. and Darbel, Alain (with Schnapper, D.), *The Love of Art: European Art Museums and their Public*, Cambridge: Polity, 1991.

Bourdieu, P., *The Field of Cultural Production*, Cambridge: Polity, 1993.

Bourdieu, P., *The Rules of Art*, Cambridge: Polity, 1996.

Secondary literature

Armstrong, I., *The Radical Aesthetic*, Oxford: Blackwell, 2000.

Fowler, B., *Pierre Bourdieu and Cultural Theory*, London: Sage, 1997.

Jenkins, R., *Pierre Bourdieu*, London: Routledge, 1992.

JUDITH BUTLER (1956-)

Judith Butler is an American philosopher, best known as a prominent exponent of what came to be called 'queer theory' in the 1990s. Trained as a philosopher at Yale and Heidelberg, she wrote her dissertation on Hegel's reception in twentieth-century France (published as her first book, *Subjects of Desire*). In her best-known work, *Gender Trouble* (1990), and its follow-up, *Bodies That Matter* (1993), Butler draws upon feminist theory and psychoanalysis as well as the broader traditions of Western philosophy. Her work in the early 1990s had enormous resonance with artists, in particular those working at the intersection of performance and photography to make their own type of gender trouble, whether in ironic, subtle or flamboyantly theatrical ways. (Cindy Sherman, Lyle Ashton Harris, Catherine Opie, Yasumasa Morimura and Deborah Bright are but a few examples.) Most recently, Butler has addressed issues of contemporary relevance in politics and law, including such issues as same-sex marriage, affirmative action, anti-discrimination legislation, internal debates within the left and the new formations of state power and violence of the post-9/11 political landscape in the United States. As of 2005 Butler is Maxine Elliot Professor in the Departments of Rhetoric and Comparative Literature at the University of California, Berkeley, where she has taught since the early 1990s.

Queer theory emerged in the era of AIDS, in the 1980s and 1990s, in tandem with political mobilization. It provided a theoretical language for activists and academics examining the intertwining of sexuality and cultural production. The AIDS crisis revealed cracks in the image of 'normal' heterosexuality, and also brought new attention to divergences between sexual identity and sexual practice, to improvised forms of kinship and networks of care, and to the socio-sexual organization of space. Militant AIDS activists sought radical political change that embraced issues of gender, race and class as well as sexual orientation, and often used innovative interventionist tactics drawn from street theatre and performance art. The term 'queer', originally a term of injury, was (like 'Black' before it) consciously appropriated to represent an anti-identity politics, anti-essentialist, in-your-face rebellion against social norms, often embracing bisexuality, transgender, non-monogamy, drag and SM.

In *Gender Trouble*, Butler challenges feminist theory from within, elaborating her arguments in dialogue with such French feminists as Luce Irigaray, Monique Wittig and JULIA KRISTEVA. Following MICHEL FOUCAULT, she argues that systems of power *produce* the subjects they address. Feminism, she suggests, by making political claims on behalf of subjects it calls 'women', participates in the production of those subjects, projecting a fictional unitary identity to which subjects are understood to conform. Butler's work, along with that of Teresa de Lauretis and others, challenged French feminist thinking informed by psychoanalysis that insisted on the centrality of sexual difference. Butler also contests the separation of sex and gender – common in feminist writing since Simone de Beauvoir – in which sex refers to biological fact and gender to superimposed social convention. For Butler, both sex *and* gender are a matter of social and linguistic performance.

The notion of the performative is partly derived from philosopher J. L.

Austin's speech act theory (and JACQUES DERRIDA's reading thereof). In language, the performative is a statement that brings a state of affairs into being, as in 'I now pronounce you man and wife'. For sex to be performatively produced means that there is no pre-existing essence of male or female that precedes language. Rather, it is reiterated through daily corporeal acts, which Butler calls *stylized*. These consist of such bodily 'inscriptions' as posture and gesture – the imperative to sit, walk or compose one's face in a certain way – along with more obvious forms of gendered adornment. Even the existence of something we call biological sex is the product of discourse, which, in establishing norms, always produces exclusions. (One very concrete example that appears in Butler's work is the forcible sex assignment of intersex infants, babies either chromosomally or physically 'between' sexes.)

At the conclusion of *Gender Trouble*, Butler identifies parody as a direction for subversive action. Drawing on Joan Rivière's 'feminine masquerade' and Luce Irigaray's notion of 'mimicry' (exaggerated performances of gender norms), and on Esther Newton's *Mother Camp* (1972), a study of drag queens, Butler argues that practices of drag and gender impersonation can challenge gender norms. Once *Gender Trouble* became a huge success, however, Butler was forced to clarify her position. Some of the book's popularity derived from a voluntarist misreading of the notion of gender as performative: an idea that one can freely change one's gender by choosing to perform it differently. As Butler put it in her preface to *Bodies That Matter* she did not mean that one can simply wake up one morning and decide to put on (as an outfit) a different gender that day. In *Bodies That Matter*, while she seeks to open possibilities of political resistance, she also emphasizes that the acts by which gender is performed and thereby produced are not simply a matter of free choice. Whether

unremarkable or defiant, acts of gender performance take shape within norms applied by force, and sometimes collide with them violently.

Such violence is apparent in *Bodies That Matter* in the essay 'Gender Is Burning', an analysis of Jennie Livingston's documentary about drag queen culture in Harlem, *Paris is Burning* (1991). The figure of the drag queen, according to Butler, allegorizes gender; s/he is not a bad imitation of an 'original' (i.e. femininity), but rather demonstrates the constructedness of that original, indeed of the concept of an original itself. Thus, 'women' can be said to perform 'femininity' in much the same way as a drag queen does. While in the film drag produces possibilities of subversion (the quality of realness which is at the same time the height of artifice) it can also represent a (dangerous) desire to be merely ordinary: all Venus Xtravaganza wants is to be a 'normal' woman, but for being too 'real' at femininity, she is murdered. The exclusions produced by gender norms, Butler argues, do not simply render sex intelligible, they define certain lives as unlived and unliveable, creating 'zones of abjection' in which certain subjects cannot be recognized as subjects.

The drag queen is also one of several figures through which Butler develops, throughout *Gender Trouble* and *Bodies That Matter*, a theory of gender as *melancholic*. This notion is based on her reading of Freud's essay on 'Mourning and Melancholia' (1917). Melancholia, a prolonged state of sadness or depression, arises from the *incorporation* of a lost person or object through a failure to mourn: incorporation means that the melancholic takes on the qualities of the lost but unmourned person or object. While mourning has a beginning and an end, melancholia, in not acknowledging and instead incorporating the loss, is interminable. The stereotype of the melancholic drag queen, Butler notes, highlights the melancholia of the process

of assuming (taking on) gender: gender itself, she argues, is produced through a refusal or a failure to mourn the loss of the possibility of loving a person of the same gender. Incorporation projects the lost love object onto the body: a woman becomes a woman by incorporating and manifesting, in the style of her own body, an unmourned, unacknowledged (potential) female love object. In the essay 'The Lesbian Phallus and the Morphological Imaginary' (*Bodies That Matter*), Butler reads Freud against the grain to suggest that the phallus as symbol originates (like melancholia) in an experience of physical pain and absence; this runs counter to the psychoanalytic notion of castration as a supervening threat. From this reading Butler derives a notion of the phallus as mobile, phantasmatic and creatively produced – hence alterable and available for appropriation.

Butler's difficult argumentation has produced its discontents. Some apparent objections to Butler's work, it should be said, have not been addressed to the work itself but to the widespread influence of voluntarist (mis)readings of her work in the early 1990s. But objections have also come from those who find Butler's writing style obscurantist and those who argue for a more fact-based, sociological approach to queer (or more specifically gay and lesbian) issues. In her essay 'The Professor of Parody', Martha Nussbaum charged Butler with writing in a difficult and allusive style for an initiated audience and of putting style over substance. Her primary claim was that Butler reduces resistance to a relatively ineffectual 'parody' of gender norms – that Butler praises parodic resistance for its own sake without prescribing ethical norms and without leaving room for legal remedies for harm. To some, like Nussbaum, Butler's Foucauldian approach can be used to undermine any political claims, no matter what their goals, thereby evacuating the possibility of resistant agency. Tim Edwards, in 'Queer

Fears: Against the Cultural Turn' (1998), argued for more empirical and materially based research in gay and lesbian studies to counterbalance Butler and other queer theorists; he suggests the 'cultural turn' is also a visual turn, which he views as a sign of commodification.

Despite Edwards's association of Butler's work with a visual turn, at first blush it might seem more linguistically oriented. Her work has influenced literature, theatre and film studies, but also art history and theory. In *Antigone's Claim* (2000), once again opposing Lacan, who viewed Antigone as a figure of beauty, Butler suggests Antigone poses a perverse challenge to kinship and the state and the enforced relations between the two. Butler thus pursues notions of alternative kinship structures first addressed in 'Gender is Burning', in which her attention to possible alternatives to normative kinship structures brings to light the daily improvisatory creativity required to form and maintain bonds in non-traditional family/social structures. In 'Bracha's Eurydice' (2004), an essay on the *Eurydice* series of artist and psychoanalyst Bracha Lichtenberg Ettinger, she considers the 'scene' of early childhood as one of fragmentation and loss and the transmission of unarticulated trauma and desire (cf. GRISELDA POLLOCK). One might expect that Butler would not accept Ettinger's use of principles like the 'feminine' and the 'matrixial' (matrix=womb), yet she approvingly reads them as a radical challenge to and displacement of the Lacanian phallus (translated into the field of vision as 'the gaze'). Ettinger's drawings, for Butler, suggest vision as loss, not surveillance, dispossession rather than mastery.

An essay in 1984 on Diane Arbus for *Artforum* likewise suggests non-dominant ways of looking: among Arbus's photographs, Butler emphasizes human figures that present a sealed surface to the camera, and others that make themselves available to a kind of playful intimacy. Butler's work has

been theoretically important to recent work on performance art and abject art (as in the exhibition *Abject Art: Repulsion and Desire in American Art* at the Whitney Museum, 1993). Other questions Butler's work raises for the field of art include whether artists do gender differently, whether the making of art might itself be a way of performing gender and/or identity and how images themselves might be said to perform.

REBECCA ZORACH

BIBLIOGRAPHY

Primary literature

Butler, J., *Subjects of Desire: Hegelian Reflections in Twentieth-Century France*, New York: Columbia University Press, 1987.

Butler, J., *Gender Trouble: Feminism and the Subversion of Identity*, New York: Routledge, 1990.

Butler, J., 'The Body You Want', interview with Liz Kotz, *Artforum* (November 1992).

Butler, J., *Bodies That Matter: On the Discursive Limits of 'Sex'*, New York: Routledge, 1993.

Butler, J., *Antigone's Claim: Kinship Between Life and Death*, New York: Columbia University Press, 2000.

Butler, J., 'Bracha's Eurydice', in *Theory, Culture and Society* vol. 21, no. 1 (2004), pp. 95–100.

Butler, J., 'Surface Tensions', *Artforum* (February 2004).

The Judith Butler Reader, ed. Sarah Salih, Oxford: Blackwell, 2004.

Secondary literature

Abject Art: Repulsion and Desire in American Art, New York: Whitney Museum of American Art (exh. cat.), 1993.

Edwards, T., 'Queer Fears: Against the Cultural Turn', *Sexualities* vol. 1, no. 4 (1998), pp. 471–84.

Jones, A., *Body Art/Performing the Subject*, London: Routledge, 1998.

Jones, A. and Stephenson, Andrew (eds), *Performing the Body/Performing the Text*, London: Routledge, 1999..

Meyer, R., *Outlaw Representation: Censorship and Homosexuality in Twentieth Century American Art*, Oxford: Oxford University Press, 2002.

Nussbaum, M., 'The Professor of Parody', *The New Republic* (February 1999).

Ricco, J. P., *The Logic of the Lure*, Chicago: University of Chicago Press, 2002.

Sheriff, M., *The Exceptional Woman: Elisabeth Vigee-Lebrun and the Cultural Politics of Art*, Chicago: University of Chicago Press, 1990.

MICHEL FOUCAULT (1926–1984)

The work of Michel Foucault, which crosses disciplinary boundaries between philosophy, history and cultural theory, is often cited in relation to a number of seemingly loosely connected themes. These include: the 'death of the author', and the subordination of authorial intention to a concept of discursive practice; madness as a cultural construction; practices of surveillance, especially as embodied in architectural or technical interventions in the visual field; the body as a target of institutional practices of discipline; confession and other techniques deployed in pursuit of the truth or 'care' of the self. But there is a common thread that links these themes: Foucault's central concern with the ways in which fields of knowledge are ordered and constituted, both with regard to historically specific relations between objects and subjects of knowledge considered in themselves and (particularly in *Discipline and Punish*, translated into English 1977, and *The History of Sexuality, Volume I: Introduction*, translated into English 1978) as actualizations of relationships of power.

Readers of Foucault have often remarked on his tendency to imagine these problems in spatial or visual terms, as in his discussion of Velázquez's *Las Meninas* (1656) in *The Order of Things* ([*OT*] translated into English 1970). For Foucault, this painting figures the discursive and visual practices that ordered the elements of knowledge in the classical age (what Foucault calls the classical *episteme*), before the modern notion of man, as at once 'sovereign subject' and 'difficult object' of knowledge, became the governing figure

of a new form of knowledge (*OT*, p. 310). In Velázquez's painting, the painter himself appears from behind the canvas, brush in hand, to contemplate his models; but Foucault also discerns a spectator (observing the scene from a doorway) and an image of the models, reflected in a mirror behind the painter. Every element of representation might thus seem to be displayed here: the painter, the means of representation (canvas and brush), a spectator and the figures represented. But despite its apparent exhaustiveness, a crucial dimension would seem, to modern eyes, to be elided from this tableau of representation: we do not see the painter in the act of painting or a spectator looking at the picture; nor are the models seen posing for the artist, but only as a peripheral reflected image.

This points to the paradox of the painting, as summed up by Hubert Dreyfus and Paul Rabinow in *Michel Foucault: Beyond Structuralism and Hermeneutics* ([*MF*] 1982): it disperses all the elements of representation in order to display them, according to the order of classical knowledge, as set on an organized table, but nowhere portrays representation as an activity. It thus dramatizes the '*impossibility*', within the classical *episteme*, of '*representing the act of representing*'. Man, as 'a unified and unifying subject who posits these representations and who makes them objects for himself', has no place on the table of classical knowledge (*MF*, p. 25). It is only with the passage from the classical to the modern *episteme*, Foucault insists, that man will emerge as 'a primary reality with

his own density', as at once the object of the 'human sciences' and the subject of 'all possible knowledge' (*OT*, p. 310). The effect of Foucault's commentary is to make us see the absence of modernity's concept of man from *Las Meninas*, without suggesting that there is anything lacking in Velázquez's portrayal of classical representation. He does this partly in order to make visible the governing order of classical knowledge, which had no need of that concept of man; but it is also to show us that man, the organizing figure of the modern *episteme* and perennial target of Foucault's critiques, is 'a recent invention' (*OT*, p. 386), which itself might soon 'be erased, like a face drawn in sand at the edge of the sea' (*OT*, p. 387).

No figure has been more crucial in the reception of Foucault's work than the Panopticon in *Discipline and Punish* (*DP*), where the emergence of man as an object of knowledge is linked to the development of new forms of power. Foucault argues that Jeremy Bentham's architectural design – an annular building, divided into cells, surrounding a central tower from which each cell is visible, but in which the observer's presence or absence is concealed – provides the 'architectural figure' (*DP*, p. 200) of a form of power which both made possible new strategies for governing the vast populations of industrial modernity and gave rise to new methods for knowing the individual, as the object of the emerging 'human sciences'. By making the occupants of the cells visible and immediately recognizable as discrete individuals, panoptic space enables their distribution according to analytic categories or ranks (as when students are distributed according to their aptitude, or criminals according to their character) and facilitates individualized training or correction. As a site of knowledge, the Panopticon is thus 'a privileged place for experiments on men, and for analysing with complete certainty the transformations that may be obtained from them' (*DP*, p. 204).

But the Panopticon also foregrounds the tendency of modern power to be de-individualized in its exercise, even as it individualizes those it subjects: 'power has its principle not so much in a person as in a certain concerted distribution of bodies, surfaces, lights, gazes; in an arrangement whose internal mechanisms produce the relation in which individuals are caught up' (*DP*, p. 202). In this 'machine for dissociating the see/being-seen dyad', there is no need for the application of external force, or even for continuous surveillance (*DP*, p. 202). It is enough for the occupant of the cell to know that he or she may be observed at any time for the inmate to be obliged to act as if a monitor were present, and consequently to regulate his or her own comportment according to the tasks and behaviours demanded by the institution. The panoptic machine thus induces the inmate to '[assume] responsibility for the constraints of power', as both subject and object of surveillance and correction (*DP*, p. 202). This assures that effects of power can be produced without the need for power to show itself as such and makes it possible for those effects to be extended into the self-regulation of the minutiae of individual existence in a way that purely external threats and prohibitions could not.

The Panopticon combines two aspects of power crucial for Foucault's analysis of modernity – the close relationship of power to knowledge (reinforced by his use of the term 'power-knowledge' in his late works) on the one hand, and, on the other the tendency of power to become invisible and incorporeal, as the subject 'becomes the principle of his own subjection' (*DP*, p. 203). In its dense interweaving of these elements the Panopticon thus appears with stunning 'imaginary intensity' as 'a figure of political technology' (*DP*, p. 205).

It may be that the power of this figure has blinded some readers to the complexity of Foucault's work, leading them to portray

it as offering a dangerously totalizing and undifferentiated vision of power-knowledge, in which all possible resistance or critical thought has been contained in advance. Yet power is not totalizing in Foucault, any more than knowledge is monolithic or undifferentiated. It is not a global plan or set of obligations and prohibitions imposed in a unitary fashion from above by those in power on 'those who "do not have it"': it is instead a contested relation in which power 'invests' the dominated and 'is transmitted by them and through them', but, by that very fact, gives rise to 'innumerable points of confrontation, focuses of instability' as the dominated themselves, 'in their struggle against' power, 'resist the grip it has on them' (DP, p. 27). Indeed, power's solicitation of the dominated to enact their own subjection is inseparable from the risk that the effects of power will be displaced or transformed from below.

If power is omnipresent in Foucault, it also discovers everywhere within and alongside the sites in which it is exercised the possibility of resistance, struggle and inversion. Similarly, while it is through their integration into practices of knowledge that the shifting 'processes and struggles' (DP, p. 28) composing power relations take on form and regularity, as GILLES DELEUZE argues in Foucault (translated into English 1988), knowledge cannot be described as a monolithic representation of dominant truths. This is in part because the same regime of knowledge is composed of heterogeneous practices, as Deleuze underscores in discussing the 'non-relation' of 'statements' and 'visibilities' as forms of knowledge in Foucault (pp. 61–66).

In the prison, for example, the inmate is made visible in panoptic space even as his 'soul' is judged by a legal discourse on delinquency: but the two forms of knowledge have different genealogies, practices and effects. Nor does a form of power-knowledge remain identical as it moves between different sites and populations. In The History of Sexuality, for example, Foucault shows how sexuality, as a field of power-knowledge, assumes different forms as it extends its reach beyond the bourgeoisie to invest the working classes. Finally, even the most unitary and hierarchical discourses exist alongside discontinuous, local or marginal forms of knowledge that 'allow us to rediscover the ruptural effects of conflict and struggle that the order imposed by functionalist or systematising thought is designed to mask' ('Two Lectures', 1976, p. 82). Invoking such 'illegitimate knowledges' (ibid., p. 83) as they appear in the historical archive, as well as in the present, Foucault speaks of 'an insurrection of subjugated knowledges' (ibid., p. 81), in which resistance to the dominant returns within the domain of knowledge itself.

The interrogation of the relationship of power and resistance to forms of knowledge remains central to appropriations of Foucault's work in the theory and practice of visual culture. In the domain of art theory and criticism, such interrogations have sometimes concerned the ways in which specific practices of visibility, whether in art, science or mass culture, become focal points of power and resistance. For example Jonathan Crary's Techniques of the Observer (1990) explores the ways in which the subject of vision becomes visible as such in the practices of science and visual culture in the nineteenth century, and how attempts to impose normative forms of vision upon the observer relate to broader strategies of power in its regulation and normalization of subjects in that period. Another example is Gary Shapiro's Archaeologies of Vision (2003), which, invoking Foucault's aborted work on Manet as a counterweight to Discipline and Punish, argues that Manet explores strategies of viewing antithetical to the ordering of vision in the panoptic universe.

But, in a broader sense, these questions have been taken up by artists in recent years,

as in the 'mock' museum installations of Fred Wilson, and the Critical Art Ensemble's performative interventions in the discourses and practices of biotechnology. Such artists – as they both appropriate and contest the dominant forms in which we are obliged to speak or make visible our truths as subjects and objects of scientific, institutional or popular knowledge – 'induce' (as Foucault said, alluding to his own writing) 'effects of truth' that are no longer those of the dominant powers, but are perhaps those of a politics to come ('The History of Sexuality', 1977 interview, p. 193). The interventions of such artists, who have contributed in a different idiom to the insurrection of subjugated knowledges invoked by Foucault, might find a philosophical counterpart in his project: 'One "fictions" history on the basis of a political reality that makes it true, one "fictions" a politics not yet in existence on the basis of a historical truth' (p. 193).

SCOTT DURHAM

BIBLIOGRAPHY

Primary literature

Foucault, M., *The Order of Things: An Archaeology of the Human Sciences*, New York: Vintage, 1973.

Foucault, M., *Discipline and Punish: The Birth of the Prison*, trans. Alan Sheridan, New York: Pantheon, 1977.

Foucault, M., *The History of Sexuality, Volume I: Introduction*, trans. Robert Hurley, New York: Vintage, 1980.

Citations of Foucault's lectures and interviews refer to: *Power/Knowledge: Selected Interviews and Other Writings 1972–1977*, ed. Colin Gordon, New York: Pantheon, 1980.

Secondary literature

Crary, J., *Techniques of the Observer: On Vision and Modernity in the Nineteenth Century*, Cambridge: MIT Press, 1990.

Deleuze, G., *Foucault*, trans. Sèan Hand, Minneapolis: University of Minnesota Press, 1988.

Dreyfus, H. L. and Rabinow, P., *Michel Foucault: Beyond Structuralism and Hermeneutics* (second edition), Chicago: University of Chicago Press, 1983.

Shapiro, G., *Archaeologies of Vision: Foucault and Nietzsche on Seeing and Saying*, Chicago and London: University of Chicago Press, 2003.

FREDRIC JAMESON (1934–)

Jameson's analysis of the visual arts, including video, film and architecture in *Postmodernism* (1991), contributions to film theory in *The Geopolitical Aesthetic* (1992) and his commentary on architecture in *The Seeds of Time* (1994) must be understood in

the context of his extensive work in cultural theory and literary theory; his first major studies were surveys of Marxist, Russian formalist and structuralist accounts of literature, *Marxism and Form* (1971) and *The Prison-House of Language* (1972). In the former, Jameson reviews the work of Georg Lukács, **THEODOR ADORNO**, **WALTER BENJAMIN** and other Marxist theorists, and asks how the form of a literary work can be related to the history of class conflict. This task calls for a kind of criticism which will avoid the potential reductiveness of sweeping ideology critique as well as the ideological blindness of pure formalism. This would be 'a kind of Marxist philology or systematic investigation of the inner, social forms of art in general' which would extend the established methods of 'local' literary studies 'to the point where, intersecting either with the realities of class or those of commodity production, they find themselves once more regrounded in concrete social history' (*Marxism and Form*, p. 396).

Jameson will repeatedly in his work assert 'the priority of history'; his approach consists of a constant sifting of theoretical models which might produce a theoretically satisfactory literary and cultural criticism. The principal turn which this process will take is to graft onto the Hegelian Marxism of *Marxism and Form* the linguistic methods of formalism and structuralism, surveyed in *The Prison-House of Language* (*PHL*). In this latter work, Jameson presents and analyzes the linguistics of Ferdinand de Saussure, the formalism of Victor Skhkolvsky, the structuralism of Claude Lévi-Strauss, **ROLAND BARTHES** and A. J. Greimas. He identifies inherent problems with formalist/structuralist models, which project a synchronic object (as if language could be frozen in an instant of time for the purposes of formal analysis) while history and consciousness are by their nature diachronic (temporal and mutable). This work closes with a call for a structuralist hermeneutics

that would be 'free from the myth of structure itself', which might reconcile the 'apparently incommensurable demands of synchronic analysis and historical awareness, of structure and self-consciousness, language and history' (*PHL*, p. 216).

Jameson's work achieved additional exposure in England with the publication of *Aesthetics and Politics* ([*AP*] 1977), a collection of letters and articles of the 1930s by Georg Lukács, Theodor Adorno, Walter Benjamin, Bertolt Brecht and Ernst Bloch on the topic of modernism in literature and art. The collection includes an afterword by Jameson which argues that the conflict between realism and modernism extends from the seventeenth-century *querelle des anciens et des modernes* to the present day, and seeks to bracket the debate of 1930s Marxism as one which, although relevant forty years on, should be viewed as belonging to a different period. Jameson claims that 'the fundamental difference between our own situation and that of the thirties is the emergence in full-blown and definitive form of that ultimate transformation of late monopoly capitalism variously known as the *société de consommation* or as post-industrial society' (*AP*, p. 208).

Jameson asserts that the Cold War and the acceleration of consumerism have established new aesthetic demands quite different from the circumstances of the 1930s, so much so that while we might endorse the defence of the politics of modernism made by Adorno and Brecht as being valid for that period, we should acknowledge that, by the 1970s, 'modernism and its accompanying techniques of estrangement have become the dominant style whereby the consumer is reconciled with capitalism' (*AP*, p. 211) and that by now a return to realism is called for. The firm distinction which Jameson asserts to exist between the 1930s and the 1970s both prepares the way for his later work on postmodernism, and is also symptomatic of

his dissatisfaction with the parameters of European Hegelian Marxist debate.

Arguably, the discontinuity between Germany in the 1930s and the United States in the 1970s is more socio-cultural than epochal. Indeed, in much of his work, Jameson addresses his readers as a universal 'we' in a manner which seems to gloss over differences of context. At a British conference, the philosopher and Adorno specialist Gillian Rose argued that Jameson's call for a new, self-renewing aesthetics is misconceived since he ignores Adorno's detailed account of the contradictions of modernism. Marxist theorists outside the United States have frequently criticized the periodization of modernism and postmodernism on which many of Jameson's arguments depend.

Although less noted than other of his works, *Fables of Aggression* ([*FA*] 1979) is of significance as Jameson's most sustained single literary study. The subject of the study is the modernist writer and artist, Wyndham Lewis. Lewis was a key figure in the reception of post-Impressionist and Futurist art and art theory in England, though Jameson concentrates mainly on his fiction, in which Lewis attempted to create a verbal style analogous to that of his painting. Lewis's writing, Jameson claims, has retained its modernism because it has remained relatively unknown and not been assimilated by decades of critical activity. Jameson's approach combines stylistic and narrative analysis, psychoanalysis and ideology critique. The objective is to locate the 'political unconscious' of Lewis's oeuvre. This will involve a 'methodological eclecticism' which 'is unavoidable, since the discontinuities projected by these various disciplines or methods themselves correspond to objective discontinuities in their object' (*FA*, p. 6).

Lewis's work is analyzed in terms of the 'libidinal apparatus' of his work, a form of literary psychoanalysis which identifies

narrative schemata as objective structures invested and reinvested with shifting ideological and libidinal contents. Jameson makes use of A. J. Greimas's 'semiotic rectangle', a diagrammatic presentation of binary value oppositions as invested in characters who become bearers of complex ideological loads. The aim is to create a formal, schematic way of understanding the manner in which objective social conflicts are mediated within the artwork as differences between characters, and as such it reflects Jameson's constant aim of combining structuralism and Marxism. *Fables of Aggression* is an impressive realization of the type of critical *praxis* that Jameson had been calling for, and provides a model for the interpretation of films in *The Geopolitical Aesthetic* (1992) as 'conspiratorial texts', symbolically actualizing objective and ideological conflict.

The Political Unconscious ([*PU*] 1981) continues to explore the possibilities of the literary essay in accounts of Gissing, Balzac and Conrad, and continues to 'argue the priority of the political interpretation of literary texts … as the absolute horizon of all reading and all interpretation' (*PU*, p. 17). The mutual formal mediation of history and language continues as the main theme of the theoretical sections of the text. The 'political unconscious' which criticism aims to identify is the product of social and ideological contradiction and also, in a new emphasis, of the Utopian impulse to transcend the closure of the present. So now, 'a Marxist negative hermeneutic, a Marxist practice of ideological analysis proper, must in the practical work of reading and interpretation be exercised *simultaneously* with a Marxist positive hermeneutic, or a decipherment of the Utopian impulses of these still ideological and cultural texts' (*PU*, p. 296). The notion of 'political unconscious' becomes extended in *The Geopolitical Aesthetic* (*GA*) to the 'geopolitical unconscious', where it is argued that recent cinematic texts can be read as

narratives striving to present the totality of a new world system which has replaced the old national boundaries. Far from being Utopian, the narratives of these films are 'fantasy-solutions' to the ontological anxiety of postmodernity, which 'endlessly process images of the unmappable system' (*GA*, p. 4).

Jameson acquired a new audience with the essay 'Postmodernism: or, The Cultural Logic of Late Capitalism' (*PM*) in *New Left Review* (1984). This essay sweepingly groups post-war developments in art, poetry, film, fiction and architecture under a series of broad theoretical specifications to argue the existence of a postmodern period. Influenced by Ernest Mandel's theory of late capitalism and Daniel Bell's notion of the 'post-industrial society', Jameson advances the concept of a postmodern period dating from 'the end of the 1950s or the early 1960s'. This period signals the end of the 'hundred-year-old modern movement', which included 'abstract expressionism in painting, existentialism in philosophy, the final forms of representation in the novel, the films of the great *auteurs*, or the modernist school of poetry' (*PM*, p. 53).

What succeeds modernism can only be described in terms which are 'empirical, chaotic and heterogeneous' (*PM*, p. 54). Postmodernism is said to collapse the distinction between high and low culture advanced by 'ideologues of the modern' from Leavis to Adorno; even where postmodernism is discernibly continuous with modernism, its meaning is utterly different because of its late capitalist context. Expressive depth is replaced as an ideal by aesthetic superficiality in a phenomenon Jameson terms 'the waning of affect'. This is evidenced by comparing the art of the modernist Edvard Munch to that of postmodernist Andy Warhol. Historical depth is replaced by nostalgia, pastiche replaces parody, and an art of surface and loss is substituted for a history which 'remains forever out of reach' (*PM*, p. 71). This process is entwined with the 'breakdown of the signifying chain', as theoretically evidenced with reference to the presentation of schizophrenia in the work of Jacques Lacan, which is found to have its aesthetic correlative in the L=A=N=G=U=A=G=E poetry of Bob Perelman. Postmodern aesthetics is characterized by a 'hysterical sublime' of technological deferral, in which signs and representations proliferate but 'the real' is permanently unobtainable.

Jameson's postmodernism essay is the culmination of his immersion in Marxist and structuralist theory. It is also the culmination of his critical method which is learned, ruminative, speculative and marked by a tendency to circulate through possible positions in the search for a grand thesis which will bring together the received traditions of theory in a culminating moment of aesthetic, social and philosophical synthesis. His work has been considered flawed in terms of its insistence on period and its tendency to produce universal claims from a cosmopolitan American perspective, although such distortion in Jameson's work may itself be the product of the unpromising climate for Marxist intellectuals in the United States. Jameson's later work has attempted to extend his remit but also has drawn criticism for its grandiose ethnocentrism. His essay on 'Third World Literature in the Era of Multinational Capital' (1986) was criticized by Aijaz Ahmad for its simplistic positioning of First and Third World subjects as mutually 'other'. Reservations about Jameson's treatment of Adorno were to a degree ameliorated by *Late Marxism* (1990). In general, Jameson's theoretical eclecticism and confident postulation of universal cultural and socio-economic narratives has been the source of his influence as well as the source of critical reservations about his work.

DAVID AYERS

BIBLIOGRAPHY

Primary literature

Jameson, F., *Marxism and Form: Twentieth-Century Dialectical Theories of Literature*, Princeton: Princeton University Press, 1971.

Jameson, F., *The Prison-House of Language: A Critical Account of Structuralism and Russian Formalism*, Princeton: Princeton University Press, 1972.

Jameson, F., 'Reflections in Conclusion', in Ernst Bloch et al., *Aesthetics and Politics*, trans. and ed. Ronald Taylor, London: NLB, 1977.

Jameson, F., *Fables of Aggression: Wyndham Lewis, the Modernist as Fascist*, Berkeley, Los Angeles and London: University of California Press, 1979.

Jameson, F., *The Political Unconscious: Narrative as a Socially Symbolic Act*, Ithaca: Cornell University Press, 1981.

Jameson, F., 'Postmodernism: or, The Cultural Logic of Late Capitalism', *New Left Review* 146 (1984), pp. 59–92.

Jameson, F., 'Third World Literature in the Era of Multinational Capital', *Social Text* 15 (1986), pp. 65–88.

Jameson, F., *Late Marxism; Adorno, or, the Persistence of the Dialectic*, London and New York: Verso, 1990.

Jameson, F., *Postmodernism: or, the Cultural Logic of Late Capitalism*, London and New York: Verso, 1991.

Jameson, F., *The Geopolitical Aesthetic: Cinema and Space in the World System*, Bloomington and Indianapolis: Indiana University Press/ London: BFI, 1992.

Jameson, F., *The Seeds of Time*, New York: Columbia University Press, 1994.

Secondary literature

Ahmad, A., *In Theory: Classes, Nations, Literatures*, London: Verso, 1992.

Rose, G., 'On the Presentation of Adorno in *Aesthetics and Politics*', in eds Francis Barker et al.,*1936: The Sociology of Literature. Volume 1: The Politics of Modernism. Proceedings of the Essex Conference on the Sociology of Literature July 1978*, Colchester: University of Essex, 1979.

MELANIE KLEIN (1882–1960)

In the 1920s and 1930s, Melanie Klein pioneered the psychoanalysis of children, translating Freud's talking cure into a new clinical method, the psychoanalytic play technique. In the process, she reoriented psychoanalysis towards the infant and the 'death drive'. Stimulating an enduring controversy in psychoanalysis, Klein maintained that early life is lived, and subjectivity shaped, under the sway of aggression. For Klein, in contrast to Freud, the anxiety of aggression, rather than sexual anxiety, is the pivotal psychic struggle. The focus of Freudian psychoanalysis is on the

neuroses arising from repressed sexuality. Klein concentrates instead on the feelings of fragmentation endured prior to repression, in infancy. Suggesting that early childhood amounts to a brush with psychosis, Klein contends that the distortions of reality experienced by the premature ego persist throughout life. In times of acute distress, the psychotic trend of infancy is revived and the subject instinctively mobilizes extravagant defence mechanisms – projection, splitting and the denial of reality. A self-described follower of Freud, Klein is remembered as a psychoanalytic dissident.

Melanie Klein began her analytic training in 1912 in Budapest with Sándor Ferenczi, a dynamic and freethinking disciple of Freud. In 1921, Klein moved to Berlin and, with the encouragement of her second analyst and mentor, Karl Abraham, began to work with child patients, drawing on Abraham's theories of early infantile experience. Klein was still relatively unknown when, in 1925, she received an invitation to lecture at the Institute of Psychoanalysis in London, where her work was received with intense interest, both for its reliance on observational techniques and for her child-centred theories.

In 1926, after the death of Karl Abraham, Klein settled in Britain. She enjoyed a period of unbroken creativity, publishing her first book, *The Psycho-Analysis of Children*, in 1932, and surrounding herself with a circle of innovative thinkers, many of them women, including Joan Rivière, Susan Isaacs and Paula Heimann. As well as sharing her commitment to 'Object Relations', as Kleinian theory came to be called, these analysts became vital supporters in her rivalry with Anna Freud, the other leading figure in the field of child analysis. When, in 1938, the Freuds fled Nazi-occupied Vienna for London, the stage was set for one of the defining debates in the history of psychoanalysis, a series of encounters between Melanie Klein and Anna Freud and their followers known as the Controversial Discussions.

Though rivals, Melanie Klein and Anna Freud became the dominant voices in a psychoanalytic discourse increasingly shaped by women analysts, and in relation to the experiences of mothers and children. Like Klein, Anna Freud (1895–1982) developed her theories from the study of children's play. In contrast to Klein, who offered frank interpretations of the violent fantasies enacted in children's games, Anna Freud recommended friendly instruction as a means to support the development of the child's fragile ego. The crux of the debate was Klein's insistence on the primary role of the self-destructive 'death drive' and aggressive instincts in the child's psychic life, and Anna Freud's stress on the self-preserving role of the ego.

At stake in the Controversial Discussions between 1943 and 1944 was nothing less than the intellectual legacy of Sigmund Freud and the future of psychoanalysis. For Klein, that future lay at the threshold of subjectivity. According to Jacqueline Rose, 'she saw her task as one of excavation, as the retrieval of something which even Freud, she argued, had barely been able to approach' (*Why War?* [*WW?*], p. 138). The aim of analysis was, she argued, to uncover the child's deepest fears and anxieties by eliciting a 'negative transference' to the analyst, representing, most often, the mother. This clinical objective, which Klein deemed an extension of Freud's method, aroused alarm in some of her critics, notably Jacques Lacan, who accused Klein of forcing interpretations on vulnerable young patients. Klein, in turn, referred her critics to Freud's writings, including both his admonition to deal honestly with the patient, and the trend in his later writings towards the sources of psychic negativity. Lacan acknowledged Klein's effectiveness as a clinician, even if he disputed her techniques, and drew heavily on her theory of infantile subjectivity in mapping the territory of the Imaginary in his own psychic schema.

Constructing her model of subjectivity around the infant, and so in relation to an immediate and fragmented bodily experience, Klein contends that the subject first relates to its environment as a field of objects (called 'part-objects') to be fused or split, possessed or destroyed, in phantasy (spelled with a *ph* to mark the special significance of the term for Klein). Phantasy arises at a pre-linguistic stage of experience, in infancy: it is not only the mind in the act of dreaming but the mouth in the act of sucking that phantasizes. Several writers on twentieth-century art, including Annette Michelson and myself, have highlighted parallels between Klein's theories of the part-object and schizoid phantasies of the body, and the work of artists including Marcel Duchamp, Jasper Johns, Eva Hesse and Louise Bourgeois. Duchamp's *The Bride Stripped Bare by Her Bachelors, Even* (1915–23), for example, incorporating a 'bachelor machine' composed of interconnecting parts, or part-objects, can be interpreted as a monument to autistic self-enclosure and autoerotic sexuality – and as an elaborate defence against Oedipal law.

One of Klein's most significant contributions to psychoanalytic theory was to draw psychosis into the pattern of everyday reality and so to make the schizoid subject more accessible, not only to psychoanalytic treatment, but also to cultural representation. In *Anti-Oedipus: Capitalism and Schizophrenia* (1972), GILLES DELEUZE and Félix Guattari credit Melanie Klein with the discovery of the part-object while insisting that she failed to grasp its significance as a tool of resistance against Oedipal law. For Deleuze and Guattari, reality is fragmentation, and the coherent self a normative fiction used to constrain and control the subject. Klein, despite her interest in the psychotic in all of us, remains committed to the aim of psychic integration.

For Klein, the psyche is structured by two pivotal positions. The first of these is the 'paranoid-schizoid' position, in which the ego produces aggressive phantasies of destruction mobilized against perceived threats, such as the withholding, or 'bad' breast. The second position, arising from the first, and at a later stage of infancy, is the depressive position, in which the ego confronts the damage done to internal objects in phantasy. The psychic burden of the depressive position is guilt. Finding itself the agent of its own internal world's destruction, the ego overcomes the depressive position by repairing its good objects in phantasy. It is this trend towards reparation that defined the aesthetic discourse arising from Kleinian theory in Britain beginning in 1929, when Klein published her first essay on art, 'Infantile Anxiety Situations Reflected in a Work of Art and the Creative Impulse'. For writers including the artist and critic Adrian Stokes, the critic Peter Fuller and the psychoanalyst Hanna Segal, the impetus of artistic creativity in Klein is towards the re-creation of an object world perceived to be lost – destroyed in phantasy by the subject. In *The Culture of Redemption* (1990), Leo Bersani delivered a passionate critique of this 'reparative trend' in Klein, arguing that the emphasis on symbolic restitution fostered a false aesthetic morality, blunting the catastrophes of history by redeeming violent reality in restorative representation. JUDITH BUTLER has argued, conversely, that the Kleinian subject is the victim of its own 'moral sadism', and can survive the self-annihilating self-reproach that is the voice of the depressive position only by mobilizing a 'hatred for its own hatred' ('Moral Sadism and Doubting One's Own Love: Kleinian Reflections on Melancholia', *Reading Melanie Klein*, p. 183). Far from finding consolation in reparative creativity, the Kleinian ego struggles to save its love objects from its own drive to destruction.

The 1990s witnessed a return to Klein. The absorption of psychoanalytic criticism in the language-centred theories of Jacques Lacan through the 1970s and 1980s had

been so complete, Mary Jacobus remarked, that returning to Klein, and to theories of pre-linguistic subjectivity, seemed 'to risk a kind of theoretical regression' ('"Tea Daddy": Poor Mrs Klein and the Pencil Shavings', in *Reading Melanie Klein*, p. 92). What made this return compelling was Klein's attention to the role of psychic negativity. Some writers, notably Jacqueline Rose in *Why War?*, underscored the political import of Klein's theories for probing the origins of violence and aggression, arguing that the neglect of Klein had given rise to the orthodoxy of an 'aestheticized psychoanalysis' in the humanities, and to an excessive investment in cultural fantasies of 'transgressive liberation' (*WW?*, pp. 144/143). 'There is no shortage of text-centred studies of pleasure and desire', observed Kobena Mercer in 1994, 'but where are the analyses of pain and hatred as everyday structures of feeling too?' ('Fear of a Black Penis', p. 122.)

Still, Klein remains a controversial figure, perhaps especially for feminism. Her reorientation of psychoanalysis towards the mother–infant relation has been seen by some as pioneering feminist theory and by others as a reinscription of women in the maternal role. In 'psychoanalytic feminism and the search for the "good enough" mother', Janice Doane and Devon Hodges observe that for Klein the mother is all-important, but exclusively as a phantasy of the child. Klein's construction of the mother as a figure of contingency, they remark, is in contrast to the fixity of patriarchal representations, but because this figure is exclusively a projection of the child's phantasy, Kleinian theory ultimately perpetuates the cultural myth of the mother as the object, never the subject, of aggression and desire. Other writers, notably the psychoanalyst Roszika Parker (cf. GRISELDA POLLOCK), have argued that Klein's work can be read more expansively, by, for example, considering its potential to elaborate maternal ambivalence and aggression. This is also the position adopted by the artist Louise Bourgeois. A student of child psychoanalysis who once considered training in the field, Bourgeois has, since the 1940s, produced a body of work that explores, but also expands, the territory of Kleinian psychoanalysis, by embracing the maternal subject of ambivalence and aggression and by articulating what Parker calls a maternal depressive position in her art.

For Klein, life is a circle, often a vicious one. Yet, as Jacqueline Rose observes, 'the value of Klein's insights resides precisely in their negativity, in their own points of internal resistance to narratives of resolution' (*WW?*, p. 223). For the decentred, fragmented subject of postmodernism, the theories of Melanie Klein have given fresh significance to psychoanalysis in art.

MIGNON NIXON

BIBLIOGRAPHY

Primary literature

Mitchell, J. (ed.), *The Selected Melanie Klein*, New York: The Free Press, 1986.
King, P. and Steiner, R. (eds), *The Freud-Klein Controversies, 1941–45*, London: Tavistock/ Routledge, 1991.
Klein, M., *Envy and Gratitude and Other Works 1946–1963*, (1975) London: Vintage, 1997.
Klein, M., *The Psychoanalysis of Children*, (1932) London: Vintage, 1997.
Klein, M., *Love, Guilt and Reparation and Other Works 1921–1945*, London: Vintage, 1998.
Klein, M., *Narrative of a Child Analysis*, (1961) London: Vintage, 1998.

Secondary literature

Bersani, L., *The Culture of Redemption*, Cambridge: Harvard University Press, 1990.

Doane, J. and Hodges, D., *From Klein to Kristeva: Psychoanalytic Feminism and the Search for the 'Good Enough' Mother*, Ann Arbor: University of Michigan Press, 1992.

Kristeva, J., *Melanie Klein*, trans. Ross Guberman, New York: Columbia University Press, 2001.

Lacan, J., *The Seminar of Jacques Lacan, Book I, Freud's Papers on Technique, 1953–1954*, New York: W. W. Norton, 1975.

Mercer, K., 'Fear of a Black Penis', *Artforum* 32 (April 1994), p. 81.

Michelson, A., '"Where Is My Rupture?" Mass Culture and the *Gesamtkunstwerk*', *October* 56 (Spring 1991), pp. 42–63.

Nixon, M., *Fantastic Reality: Louise Bourgeois and a Story of Modern Art*, Cambridge: MIT Press/ *October* Books, 2005.

Phillips, J. and Stonebridge, L. (eds), *Reading Melanie Klein*, London: Routledge, 1998.

Rose, J., *Why War? Psychoanalysis, Politics, and the Return to Melanie Klein*, Oxford: Blackwell, 1993.

Sanchez-Pardo, E., *Cultures of the Death Drive: Melanie Klein and Modernist Melancholia*, Durham, N.C.: Duke University Press, 2003.

Segal, H., *Dream, Phantasy and Art*, London: Brunner-Routledge, 1991.

JULIA KRISTEVA (1941–)

Julia Kristeva was born in Bulgaria in 1941 and moved to Paris in 1966 to do graduate studies with Lucien Goldmann and ROLAND BARTHES. Her work criticized the study of language merely as a system of signs and their exchange in communication, viewing literature as a signifying practice that returns history, social structure and the living body to the frozen object 'language'. This view brought her in line with the writers of *Tel Quel*, a collaborative journal influential in France in the late 1960s and early 1970s, to which she contributed theoretical pieces. The journal published both contemporary poetry and writings that brought the range of theoretical work of the period – from Marxist analysis to Freudian theory to deconstruction – into relation with literary writing. In 1974 Kristeva published her doctorat d'état, *Revolution in Poetic Language*, which investigates how signifying practices transform meaning and the subject. The view expressed in this work, that psychoanalysis delivers the theory of what literature practices, heralds Kristeva's deepening investigation of Freudian discoveries about language acquisition. She attended Lacan's seminars of the period but the training analysis she completed in 1979 was not in his school. Her 1980s writings develop her own 'return to Freud' supported by knowledge of different traditions, including the British School of Psychoanalysis. This knowledge influences her thought on art.

Kristeva is Professor of Linguistics and Director of the Institute for the Study of Texts and Documents at the University of Paris VII. She is a practising psychoanalyst in France and the author of several novels. She has been a regular visiting professor at Columbia University and given visiting lectures at the New School University. In 2004 Kristeva

became the first Holberg Laureate for her work at the intersection of language, culture and literature.

Kristeva's thought on art is usually offered through fine-grained analyses of specific works rather than an aesthetic theory, since her view is that the significance and value of artworks lies in their being exemplars of meaning, value and freedom. They have significance neither as universals nor as particulars but only in and as specific instances. Kristeva's association of art with the question of freedom recalls the reflection on the aesthetic developed in nineteenth-century German philosophy. Nonetheless, her own thought on art cannot be dissociated from her psychoanalytic work. *Revolution in Poetic Language* proposed that psychoanalysis can theorize the transformations in meaning and the subject that art practices. This view contrasts psychoanalysis as theory to art as practice and is therefore surpassed in her 1980s writings, where both psychoanalysis and art are instantiations of a kind of freedom in so far as they encompass the living body, the experience of memory and the activity of questioning.

The relationship between psychoanalysis and art in Kristeva turns on her categorial distinction between the semiotic and the symbolic. These are two dimensions of meaning and subjectivity that tend, under certain conditions, to fall apart. Artworks achieve their re-engagement or intertwining. Kristeva focuses on the depth, scope and singularity of this achievement in connection with the wider social and symbolic field. Her readings of artworks imply, on the one hand, that the meaning and value of the work cannot simply be divorced from it, making the work just a 'case' of the meaning or value that it has. That is to say the artwork is not a mere particular. On the other hand the work is not a universal either since it does not itself constitute a general standard or measure for meaning and value. It is exemplary. Kristeva's take on the

exemplarity of the artwork is illuminated by her psychoanalytic thought. Psychoanalytic theory develops from what is revealed in psychoanalytic experience. With Kristeva, this experience is a process similar to that given in the experience of art and literature. Her psychoanalytic thought therefore lays out the general significance of the intertwining of the semiotic and symbolic.

On strictly psychoanalytic ground, Kristeva's categorial distinction between the semiotic and symbolic modifies the traditional Freudian centrality of Oedipal destiny, which was preserved in Jacques Lacan's conception of the child's entrance into language or the symbolic order. In Kristeva's report and that of others, contemporary psychoanalysis encounters difficulties over selfhood, meaning and 'others' that indicate the prevalence of narcissistic sufferings rather than an Oedipal struggle with paternal law. Narcissus is a more primitive moment of subjectivity. Kristeva takes the narcissistic structure of subjectivity back to the earliest relationship of mother and infant. The elements of primary narcissism lie in the early life of affects and drives that register and respond to the first beginnings of otherness and separateness. Primary narcissism precedes and lays the ground for language speaking, which is now understood to be a late stage in a long process of symbol *formation*. In brief, there is in child development a pre-verbal, affective and corporeal contribution to symbol formation, which is transposed into a non-verbal dimension of subjectivity and meaning, for example rhythm or tone. This is Kristeva's *semiotic* as distinct from strictly *symbolic* functioning. Artworks instantiate both.

The value of the developmental perspective on the semiotic is that it shows the emergent subject to be, first, the living body in relation to the mother's body. This living body is not some pre-cultural nature but, rather, a corporeal and affective responsiveness within a surrounding symbolic. The latter

impinges on early infantile life, not in its 'proper' form as a linguistic sign, but within the dual relationship of infantile dependence where the mother is a being at the threshold of nature and culture. The early relationship to the mother is therefore a situation of exposure to otherness and separateness together with a corporeal, non-signifying responsiveness to that exposure. 'Semiotic' capacities are a primitive but complex, affective and corporeal mode of separateness and connectedness that is required for and leads into Lacan's 'entrance into language' where symbolic capacities, properly speaking, turn up.

In Kristeva's view, the semiotic – more precisely, the corporeal and affective variations of responsiveness – is at the origin and then *limit* of the subject. Narcissus is a boundary subjectivity that shows up in moments of crisis. This view rests upon the claim that the semiotic must carry forward into symbolic life if that life is not to be intolerably abstract, impersonal or mechanistic, a 'merely' linguistic universe of communicative exchanges without the experience of meaning and value. The semiotic taken up into symbolic form gains in complexity and potential and this opens up possibilities for meaning and value in connection with others. The view Kristeva opposes is that the analysis of the structure of the linguistic sign, alone, will provide us with all we can know of the elements of meaning, culture and intersubjectivity. That view entails the redundancy in the symbolic order of the living body in relation to another – what lies at the heart of individuation and symbol formation according to psychoanalysis. The view she opposes is symptomatic of a wider tendency to affirm a merely linguistic universe, undermining possibilities for separateness and connections with others. This tendency shows up in particular strength in late modern societies. Its subjective counterpart is the abandoned Narcissus or the narcissistic

crisis that psychoanalysis meets in the clinic: Kristeva's 'new maladies of the soul'.

Kristeva's view is that to work with *forms* is the most radical way to seize the moments of crisis. Art and literature, for her, are the adventure of body-and-signs that mediates the fragmented moments of the social and symbolic field, restoring meaning and value in connection with others. It is therefore their capacity to counter the tendency towards a rigidified symbolic that makes artworks exemplars of meaning, value and freedom. In the 1990s Kristeva underlines a kind of 'revolt' that expresses a possibility in life and thought of 'turning back', the turn and return of one's own memory, and questioning. She shows how variations of this revolt appear in literature. This possibility is increasingly presented as a kind of freedom. Her early twenty-first-century trilogy on Arendt, **KLEIN** and Colette follows through the same question, supplementing her writings on art with biographies that explore lives of thinking, healing and writing.

A broad criticism of Kristeva is that she allows the psychoanalytic theory to swamp the art. Her readings of artworks give special attention to the subjectivity of the artist and promote a therapeutic conception of art whose sense comes from psychoanalysis. This limits the meaning of art to what can be known from the psychoanalytic standpoint. To defend Kristeva on this point, psychoanalysis is often viewed not as a fixed theoretical approach but as a dynamic exercise sensitive to a complex and changing experience of subjectivity, language and culture. Second, attention to the artist's subjectivity is only reductive if we stand by narrow conceptions of childhood, the past, the lived body, memory, etc. Kristeva's expansions of this territory enrich the significance of art and literature. Third, Kristeva's thought includes an attempt to restore a relation in Western cultures to the value and complexity of healing. As a result, she attributes more to art than is usually done in those cultures,

even or especially where the therapeutic conception of art dominates her thinking.

Kristeva's growing body of work crosses the boundaries of current disciplines and writing practices to an almost unprecedented extent. Her influence is fluid and wide-ranging. The expansion of the theory of primary narcissism is likely to draw long-standing attention in psychoanalytic circles. She is one of the major figures in a body of thought studied in the anglophone world under the heading of French feminism. Her critical approach to culture – aspects of which are sometimes compared to THEODOR ADORNO on culture industry – has brought her an audience within and beyond academic confines. In recent years Kristeva's thought was also responsible for the interest in 'abjection' in 1990s sculpture, installation and photography. In Kristeva's theoretical writing abjection is the aspect of semiotic functioning closest to the anarchic life of the drives and affects, which turns up prior to and underlies the body 'proper' that is upheld in language. Abjection is a fundamental dimension of the responsiveness to the surrounding social and symbolic world that acts corporeally and affectively rather than within linguistic structures. It appears, especially, in cultural conditions in which moral, political or religious ideas are subject to deformation, which are also those where language is in the process of losing its hold on the body. Abjection is both a symptom of and a response to these conditions. The influence of these ideas was apparent in the fascination with revulsion and bodily ejecta in practices as diverse as Mike Kelley and Paul McCarthy's scatological performances, Cindy Sherman's colour photographs of rotting detritus engulfing fragments of human form, Kiki Smith's flayed figures and Mark Quinn's self-portraits from frozen body fluids. Kristeva's impact on the art world probably continues to be strongest in the interest that individual artists are taking in her ideas.

SARA BEARDSWORTH

BIBLIOGRAPHY

Primary literature

Kristeva, J., *Powers of Horror: An Essay on Abjection*, New York: Columbia University Press, 1982.

Kristeva, J., *Revolution in Poetic Language*, New York: Columbia University Press, 1984.

Kristeva, J., *Tales of Love*, New York: Columbia University Press, 1987.

Kristeva, J., *Black Sun: Depression and Melancholia*, New York: Columbia University Press, 1989.

Kristeva, J., *The Sense and Non-Sense of Revolt: The Powers and Limitations of Psychoanalysis I*, New York: Columbia University Press, 2000.

Kristeva, J., *Intimate Revolt: The Powers and Limits of Psychoanalysis II*, New York: Columbia University Press, 2002.

Kristeva, J., *Colette*, volume 3 of *Female Genius: Life, Madness, Words – Hannah Arendt, Melanie Klein, Colette*, New York: Columbia University Press, 2004.

Secondary literature

Beardsworth, S., *Julia Kristeva: Psychoanalysis and Modernity*, New York: SUNY Press, 2004.

Chanter, T. and Ziarek, E. P. (eds), *Revolt, Affect, Collectivity: The Unstable Boundaries of Kristeva's Polis*, New York: SUNY Press, 2005.

Lechte, J., *Julia Kristeva*, New York: Routledge, 1990.

Oliver, K., *Reading Kristeva: Unraveling the Double-Bind*, Bloomington and Indianapolis: Indiana University Press, 1993.

Smith, A.-M., *Julia Kristeva: Speaking the Unspeakable*, London: Pluto, 1998.

NIKLAS LUHMANN (1927–1998)

In German-speaking scholarship Niklas Luhmann is widely regarded as among the most important and widely read sociologists of the late twentieth century. That this degree of recognition of his theory of social systems was not, by the time of his death in 1998, reflected in anglophone studies in general, and in studies on art in particular, is a situation which is slowly being rectified with the ongoing translation of his vast, diverse and highly sophisticated work. His general theory is outlined in *Social Systems* and numerous other books including studies on the systems of law, economics and science. His main theories on art are outlined in *Art as a Social System* in which he expounds an anti-ontological theory of art. Art is, for Luhmann, constituted by the system of art, itself a sub-system of society.

Luhmann's radical and lasting insight lies in his development of Systems-Theory as a methodological tool for sociology. Society, Luhmann argues, is comprised of a variety of sub-systems. These are operatively closed and functionally distinct from one another. Each system operates according to its own internal and self-defined rules. These systems include economic, political, legal, scientific, religious and educational systems; and like these, the art system functions according to an intrinsic set of processes. However, despite the local differences between these particular systems they nonetheless exhibit what Luhmann calls 'comparable structures'. They are thus receptive to the comparative analysis of systems-theory.

An important concept in Luhmann's analysis is that of *distinction*. Because social systems are operatively closed they are distinct from one another. Thus, the art system operates according to a set of principles that are distinct from those of the economic or legal system. Each system is also distinct from its environment. Systems distinguish themselves from their environments by virtue of being closed to the complexity of their surroundings. The formation of a system involves an ordering, via 'selective relations amongst its elements', of the multiple relations of a complex environment. In short, systems reduce complexity; and they do so according to the structure which is distinct to that system.

To explain how the process of distinction functions Luhmann introduces his radical concept of *observation*. Observation is the process by which distinctions are indicated from a position relative to the system in which it takes place. This is a paradigm shift from a more traditional sociological notion of representation to a concept of social meaning that is contingent not only on particular systems but also upon the process of observation itself. Without observation no differentiation would occur. Thus, the economic system observes and differentiates the world in terms of economic value while the art system differentiates what it observes in terms of artistic and aesthetic value. The corollary to observation is the important concept of second order observation. This is the process by which a system observes its own actions and blind spots. This is

a process of self-reflexivity that recalls deconstruction in that it is a process by which a system observes its own observing. Thus in the process of second order observation, the art system can observe how art itself is constituted by the art system's processes of observation and distinction. And, likewise, systems-theory can observe itself as a discursive system that observes the world from a particular perspective.

Systems are able to systematize their elements in distinction to the complexity of their environments because of their capacity for self-organization or *autopoiesis*. For a system to be autopoietic means that its reproduction and perpetuity is sustained by its own internal operations. The autopoietic system is, in Luhmann's terms, 'self-referential' and defines its own elements, structure, function and limits. The art system thus not only operates according to its own internal functions, but also generates these functions via its own self-referential and self-organizing activities. This means that although the art system might interact with other systems (such as the economic system) it ultimately produces meaning on its own terms.

The self-organization of systems manifests itself in the emergence of two further concepts: *communication* and *meaning*. Communication is the manifold of information, message and understanding. Thus a communication is an occurrence, specific to a particular system, that generates meaning within that system from the unity of a message as well as its communication and reception. Luhmann dismisses a theory of communication as the transmission of information from one agent to another as 'too ontological'. Meaning is not something handed over like a parcel, rather it is something generated in an observer by a self-referential process. Communication facilitates the production of meaning by reducing complexity and contingency. It creates some possibilities while excluding others thus reducing the complexity of the world to terms intelligible to the system while reinscribing the distinction between itself and its environment. Different systems generate communication according to their particular codes of self-reference. For example the science system is ordered by a coding of differences between true/false that produce meaning by simplifying the complexity and contingency of the world to communications on truth and falsehood; the art system facilitates communication about art through the sensuous and aesthetic forms of works of art. For Luhmann, communication (and meaning) is the basic constituent of society, and therefore the basic concept of sociology. There can be no society without communication. The limits of society are the limits of communication. Individuals do not participate in society unless they engage in communication.

Communication provides the opportunity for Luhmann to discuss the uniqueness and importance of the art system. The art system produces a special type of communication, one that mediates between the individual perceptions of consciousness (psychic systems) and the operations of the social system. It does this by being grounded in sensuous engagement with material, perceptual form, while also generating communications which then circulate in the social system.

Perhaps Luhmann's most radical insight into art is his anti-ontological definition. His definition is independent of particular genres such as painting or music. Instead it is a non-media-specific theory of 'the medium of art' that produces a special type of communication. This involves an inversion of a traditionally conceived relationship between medium and form. The traditional conception of *medium constitutes form* is replaced by the notion that *form constitutes medium*. The example Luhmann gives (in 'The Medium of Art', 1990) is music. Music is heard (observed) as music only by those 'who

can also hear the uncoupled space in which the music plays'. In other words 'whereas we normally hear noises as differences to silence and are thereby made attentive, music presupposes this attention and compels it to the observation of a second difference – that between medium and form'. We may 'observe' the medium of music, because we have paid attention to the sensuous form of the music's manifestation. In this sense, then, *form constitutes medium*.

The sources for Luhmann's thought are a reflection of the interdisciplinary nature of systems-thinking in general and his own erudition and breadth of learning. As sociology, his work shares a concern with methodological reflexivity prefigured in Weber, Simmel and Durkheim, though his notion of observation makes his position much more radically self-reflexive. His notion of systems-theory synthesizes the sociology of social systems formulated by Talcott Parsons with the General Systems Theory of the biologist Ludwig von Bertalanffy. His theory of communication draws on the Communication Theory of Claude Shannon and the Cybernetics of Norbert Weiner and Von Foerster. His theory of distinction is based on the obscure calculus of George Spencer Brown, while theories of emergence and autopoiesis come from biologist Gregory Bateson and the neurobiological studies of consciousness pioneered by Maturana and Varela.

Philosophically, Luhmann's Systems-Theory owes a large debt to Husserl whose theory of the transcendental ego is replaced by the notion of the observing system to produce a phenomenology of social as well as psychic systems. Derrida's engagement with Husserl also reappears in Luhmann, and he frequently acknowledges the comparisons between the self-reflexivity of systems-theory, especially that of second order observations, and deconstruction. Second order observations in particular recall both Nietzsche's perspectivism and MICHEL

FOUCAULT's questioning of the relationship between discourse and its object. Luhmann's relationship to modernity is haunted by the spectres of the post-Enlightenment German philosophical project and includes comparisons to Hegel's attempt to complete an all encompassing philosophical system and Habermas's attempts to re-energize the process of enlightenment. His aesthetic theory, being based on the sensuous qualities of art, also reflects the post-Kantian tradition of aesthetics, while his arguments concerning the autonomy of the art system recall THEODOR ADORNO's *Aesthetic Theory* (1970), albeit without any utopian drive for enlightenment.

The most sustained critique of Luhmann's work came from Habermas, who collaborated with Luhmann on a joint seminar at the Max Planck Institut in the early 1970s (published as *Theory of Society or Social Technology – What is Achieved by Systems Theory?*, 1971). Habermas contended that Systems-Theory was too reliant on the misapplied biological model and was thus depoliticized. In places this critique recalls the Habermas/Foucault debate in so far as Luhmann is accused of prioritizing the social system and its communication over the psychic system, implying a radical anti-humanism that denies individual agency in social systems. Other criticisms include those levelled more generally at Luhmann's radical constructivism for denying the existence of any concrete social reality, and the reductionism by which the theory attempts to totalize all social activity under the rubric of 'the system'. Luhmann could not dismiss such objections; nonetheless his theory represents a highly sophisticated attempt to negotiate the relationship between his own system and the phenomena that it observes.

Given the breadth of sources that Luhmann exploits, reading his texts can often be a breathtaking and vertigo-inducing experience. While always easy to read, he

works at a high level of abstraction that can often seem obscure. He rarely talks about specific works of art, preferring instead a style which recalls Adorno's *Aesthetic Theory* to talk about a concept of art without ever clarifying any of its specific empirical qualities. His work is thus not social history of art a là T. J. CLARK, Arnold Hauser or Antal. Likewise readers looking for a sociological explanation of specific art systems in the style of PIERRE BOURDIEU or Becker will be disappointed. In places the anti-ontological aspects recall the Institutional Theory of Art attributed to ARTHUR DANTO, albeit with different philosophical co-ordinates. Luhmann also locates his theory of art in a historical teleology of an exhausted modernism in which the system of art has reached a level of self-reflexive awareness that recalls the end of art theories of Adorno, Belting, Danto, DE DUVE and Kuspit.

Luhmann's lasting interest to art theory lies in his definitions of art and media. They are, he argues, contingent upon the systems of their institutional and discursive situation. This is certainly flexible enough to account for the diverse, self-reflexive practice of art after modernism. This is art that is, as de Duve among others has argued, not well served by aesthetic and art historical theories that are, essentially, modernist. Further, his concept of second order observation provides a model of discursive self-reflexivity that could be adopted by aesthetic and historical discourse to radical and exciting effect.

FRANCIS HALSALL

BIBLIOGRAPHY

Primary literature

Luhmann, N., *Essays on Self-Reference*, New York: Columbia University Press, 1990.
Luhmann, N., 'A Redescription of "Romantic Art"', *Modern Language Notes* vol. III, no. 3 (1996), pp. 506ff.
Luhmann, N., *Art as a Social System*, trans. Knodt, Stanford: Stanford University Press, 2000.
Luhmann, N., *Theories of Distinction*, ed. Rasch, Stanford: Stanford University Press, 2002.

Secondary literature

Habermas, J., 'Excursus on Luhmann's Appropriation of the Philosophy of the Subject through Systems Theory', in *The Philosophical Discourse of Modernity: Twelve Lectures*, Cambridge: MIT Press, 1987, pp. 368–85.
Rasch, W., *Niklas Luhmann's Modernity*, Stanford: Stanford University Press, 2000.
Rasch, W. and Wolfe, C. (eds), *Observing Complexity: Systems Theory and Postmodernity*, Minneapolis: University of Minnesota Press, 2000.
Savänen, E., 'Art as an Auto-poietic Sub-System of Modern Society: A Critical Analysis of the Concepts of Art and Autopoietic Systems in Luhmann's Late Production', in *Theory, Culture and Society* vol. 18, no. 1 (Feb. 2001), pp. 75–103.

GLOSSARY OF KEY TERMS

ABJECTION

Theorized by Julia Kristeva, abjection denotes a state of expulsion or aggressive repulsion, usually involving something that threatens a breakdown in meaning or convention, putting into danger the integrity of the self or the social order. The abject elicits a reaction of repulsion, disgust, aversion or horror; examples could be corpses, human waste, rotten food. A space of abjection has also been conceived as a space of social exclusion of marginalized minorities, where micro- or subcultures emerge in antagonism to the dominant culture and its modes of sensible expression.

ACKNOWLEDGEMENT

For Stanley Cavell, the act of acknowledgement is a mode of understanding that is ethical in character. It does not separate the world of knowledge from the world of people. Scientific rationality (knowledge as facts, logic, statistical quantity) cannot explain what makes the world a world for us. For Cavell, there is no knowledge of the world apart from our claims, agreements and expressions. Acknowledgement is a way of orienting oneself towards others (and thus the world) in a manner that allows them to reveal themselves on their own terms (by acknowledging the conventions they use and criteria they mobilize in their self-presentation).

AESTHETICS

From the Greek 'aesthetika' or perceptible things (things perceived by the senses rather than conceived by using concepts), aesthetics emerged in the eighteenth century as a 'science of perception' and then broadly a branch of philosophy investigating the arts, taste, interpretation, beauty and the sublime, and aesthetic experience (which might be experience of art, but is also the experience of nature). As a sphere of value, aesthetics tends to be distinguished from other spheres of value, such as morals or ethics, but also from theoretical or objective knowledge of the world. Distinct from the 'philosophy of art', aesthetics generally retains its Germanic concern with the nature of non-conceptual experience, whereas Anglo-American 'analytic' philosophy of art is more concerned with the objective sustainability of aesthetic claims, language and concepts about artworks.

ALIENATION

This term can signify a component in mental neurosis (such as loss of identity), a condition of modern consumer society, or a critical-philosophical stance towards the world. In the critical theory tradition from Marx to Adorno this experience had material conditions: by virtue of living and working under unjust labour conditions (capitalism) I am alienated from the products of my labour (they are used for the profit of others), from my own potential, from fellow citizens (divided into classes) and even from my true needs, as they are distorted by desires 'manufactured' by consumer culture.

ALLEGORY

Traditionally, a narrative retelling an earlier narrative. Benjamin's influential use of the term, in relation to baroque (and earlier Renaissance) art, emphasizes the fragmentary and fluid nature of allegorical meaning, where signs are never fixed to their referents, and maintain a material presence that falls outside of the general order of meaning. Craig Owens subsequently conceived 'allegory' as the postmodern aesthetic, where a 'doubling' of texts occurs, a palimpsest of voices emerges, univocal or monolithic meanings are subverted, the authority of the author is dissolved and the boundaries between the work and its context eroded.

APPROPRIATION

Appropriation is the act of using visual imagery from other sources than the artist's own: extracting, reproducing, recontextualization, using 'ready-mades', copying, simulation, quotation, parody, forging. It became prominent in art discourse (particularly that associated with 'postmodernism') on the nature of authorship, the function of the artist's intention, originality and the authority of the artistic statement. With precedents in Pop art, and earlier Cubism and Duchamp (even Manet), growing international IP law and copyright has made the practice perilous.

AURA

Coined by Benjamin, 'aura' signifies a work of art's unique 'presence' in time and space, the way it expresses its history, and its embeddedness in tradition. This gets stripped away in reproduction (such as its photographic reproduction) and, it has subsequently been claimed, is absent altogether from new media (film, video, etc.). Art is not just an object, but part of social ritual, reinforcing hierarchies of value in the economy of culture. In the modern era, art maintained a special value beyond exchange value (price); helping to construct a value-system (of individuality, autonomy, self-expression) that became intrinsic to the construction of bourgeois subjectivity (self-identity) and which in turn facilitated social reproduction (their claims on power). Hence, when aura 'withers' in the age of mechanical reproduction, it signifies the emergence of a different social order.

AUTHORSHIP

Both idealism and romanticism in aesthetics propose that the work of art is a direct expression of a unique mind and sensibility (genius), articulating truths unique to the artist's perception and insight, and only partially recoverable with reference to biographical analysis of the author's 'intentions'. Recently, the concepts of intention and expression have been challenged, and theorists such as Barthes and Foucault have proclaimed the 'death of the author', according to which the author is a function rather than an origin – a function of the systems of meaning that determines who speaks, what is said, how it is said and how it is interpreted.

AUTONOMY

The notion that art is self-legislating, a practice or discourse with its own laws or conventions, historical development, institutions and methods of interpretation, is intrinsic to most modernist theories of art and culture; and 'autonomy' as an idea has appeared in various forms, from 'disinterested' contemplation, through 'art for art's sake', to modernist-formalism. Most uses of the term in critical theory relate to Weber's concept of modernity as the emergence of professional specializations: art became distinct (or excluded) from the other orders of meaning – from knowledge

of the world (science) and the moral order (ethics/law/religious beliefs). This is both independence and exclusion, and art proclaims both.

BEING/BECOMING

These terms denote opposing views on the state of existence (both human nature and material nature) common since ancient times. 'Being' suggests that life emerges from a single unified source and exists in and through a stable and unified substrate. 'Becoming' suggests that life in its totality is in a state of constant flux and conflict; it does not entail a unified source (like a creator being) and indicates that nature itself is continually evolving (or decaying, or both at once). These in turn generate radically different views on human nature.

CANON

The artistic canon is the most revered works of art ('masterpieces'), which function both as linchpins in art historical narrative, and as a standard of quality by which other works are judged. There is no one register of canonical works, but together the register emerges from the mainstream historical surveys, catalogues of great exhibitions, and 'political' machinations of powerful scholars: it is political in as much as it exercises a power of legitimization, marginalizing certain categories, classes of works or most typically female or non-Western artists, and has often involved questionable claims for the universal validity of its own aesthetic values.

CAPITALISM

An economic system based on private property and driven by profit. It is a system of wage-labour and commodity production for sale, exchange and profit, rather than for the needs of the producers or society as a collectivity. Its fundamental motive is profit, and it adheres to economic concepts like

'free enterprise' and the 'free market' ('free' in this context is synonymous with 'private' or dominated by the most powerful actors). Competition is the dynamic force of market growth. Contemporary (or 'late') capitalism, driven by a dual expansion and retraction of globalized markets and consumer demands, now predominantly operates through information and technology.

COMMODITY FORM

A commodity is a material object or a service for sale, and has two functions – to satisfy a desire to use or consume, and to serve as a vehicle of exchange. Money is the measure of a commodity's exchange value; it also indicates its position in any given market (or circuit of commodities). 'Commodity form' signifies that the object or action of the produce has become detached from that of the producer, and its value entirely determined by the market (not by its use-value, or cost or place of origin).

CONVENTION

Modernist art's stripping away traditional rules, protocols, methods and techniques divested art of the authority of the academy, and this entailed a certain deskilling. However, for many modernists this was not a destructive exercise, but a radical advancement of the historical conventions of painting or sculpture in a way that maintained their relevance vis-à-vis contemporary society. For Cavell and Fried there is no essential characteristic to a 'painting' or 'sculpture'; rather the concepts of painting and sculpture are constituted by convention (those specific practices and techniques that make up the practice of painting or sculpture at any given historical moment).

CRITERIA

Criteria determine what it is for something to count as an instance of a given kind

– what it is for something to fall under a given concept, and so constitute one of its instances. The notion of criteria is deployed in Cavell's work, as it developed in dialogue with Wittgenstein, as an outgrowth of the Kantian project of 'transcendental' philosophy in its various forms: defining 'conditions' for the possibility of something. Criteria are the conceptual conditions under which we think any given thing. A criterial investigation seeks to understand what governs the application of concepts, and to assess their intelligibility (what can and cannot be said about their object).

CRITICAL THEORY

Philosophically, a rejection of a value-free knowledge (positivism and rationalism) and an assertion that knowledge is socially constructed. Originally associated with the Frankfurt School, it runs back to Kant's critical philosophy, through Marx and up to Nietzsche and Freud, all of whom exercised a 'hermeneutics of suspicion': all claims to rational thought and truth are taken to mask operations of power and interest. Contemporary critical theory investigates how the meaning and authority of one's communication is an expression of who one is (class status; gender) and where one stands (institutional context; geographic location). More recent postmodern critical theory has largely jettisoned the Marxist heritage and emphasized gender, race and subcultures rather than class structures.

CRITIQUE/CRITICAL

'Critical' means an examination of the function of concepts (how we use words), the legitimacy of the claims we make (the criteria we use; the values we appeal to), and the grounds of our knowledge (our concept of truth). Kant's philosophy, where even reason itself (the way we think) must be subject to criticism, initiated a project of 'critical

philosophy' which aims at self-reflexivity – not only must we think, but we must also know the conditions or criteria by which we think. In our own time, the term critical often refers to all levels of conceptual thinking, and has been given a sociological application by 'critical theory': to what degree do our concepts, their application and meaning, relate to power and interests embedded in our social context?

CULTURE INDUSTRY

Coined by Adorno and Horkheimer in *The Dialectic of Enlightenment* (1944), culture industry signifies the integration of 'culture' and 'industry' (i.e. the integration of economic-instrumental rationality and creative-social activity). Culture does not emerge from the free creative expression of social agents, but is constructed in commodity form by an alliance of the state and private corporations. It signals the complete rationalization of the emancipatory powers of creativity, where creativity is converted into standardized mass-produced products and reduced to basic formulaic patterns of taste. This commercialized culture engenders intellectual passivity and docility, which themselves are the conditions needed for authoritarian politics to reign (cf. kitsch).

DEATH DRIVE

A term that originates with Sigmund Freud, the founder of psychoanalysis, the death drive (or 'thanatos') signifies the darkest instinctive force at the root of human behaviour. It denotes an unconscious, pathological, desire for a bodily return to the state of quiescence which preceded birth (a pre-organic, primordial chaos). As such it is opposed to 'eros', the instinct for self-preservation or life, and appears largely in his later writings like *Beyond the Pleasure Principle* (1920). As a theory the 'death drive' seeks to explain why,

contradicting our natural drive for pleasure, there is a compulsive urge to revisit traumatic events. This is explained in terms of a desire to return to the state of homeostasis, calm or non-existence.

DECONSTRUCTION

Initiated by Jacques Derrida, who denied it was a method, or critique or analysis. It was not an operation performed 'on' a text, but was a means of allowing the text itself to reveal its own 'otherness' and self-undoing. This otherness is what the text is apart from our deeply rooted predisposition to read it as a cipher for the thoughts and imagination of a single author. We impose this way of reading on the text. Deconstruction asserts that our belief in the author's 'presence' in the text is metaphysical, and that this 'metaphysics of presence' predisposes us to understand the text as a unified, coherent and rational statement. Deconstruction, however, reveals internal conflicts in the text and shows the univocal voice to be an ideal construction.

DIALECTIC

In Hegelian-Marxist terms dialectic took the form of thesis (proposition), anti-thesis (counter-proposition) and synthesis (resolution). This also became a useful way to describe the process of history (or social change) itself, where internal social contradictions will finally be resolved in a greater synthesis (for Marx the communist society). Adorno attempted to salvage the dialectic after orthodox Marxism: his 'negative dialectic' was a relentless critical opposition refusing any final synthesis – the very notion of synthesis means an expulsion of that which cannot be assimilated into a coherent whole, and thus the expulsion of the possibility of movement, change, difference, dissent and opposition, for Adorno crucial to radical thought.

DISCOURSE

Discourse for Foucault includes the assembly of categorizations, ideas, typologies and concepts through which communication takes place, and these are produced, reproduced and continually change in various contexts. Foucault's 'archaeology' seeks to investigate the matrices of power through which 'discursive formations' are constructed, and how these formations are institutionalized as 'knowledge'. Knowledge acquisition is neither transparent and uniform, nor linear and progressive, but full of ruptures and subjugations and constructed through regimes and networks of power. All knowledge and social activity is structured according to such discursive fields.

DISENCHANTMENT

Probably derived from Friedrich Schiller's 'de-divinization' of the world, sociologist Max Weber updated it as a theory of modernity. Modernity was the dissolution of traditional values, experiences, customs and protocols in the work of social rationalization (secularization, industrialization, commercialization and professionalization) according to the mathematical logic of utility and efficiency. Unlike the radical appeal to human freedom intrinsic to Enlightenment thinking, modern instrumental rationality is destructive of all non-rational models of activity (such as aesthetic experience). 'Overcoming disenchantment' has been a recurring theme in critical philosophy since the romantics.

EMBODIMENT

In understanding human beings, how they think and act and experience the world, it is important to understand the interrelationship of body and mind. Ideas of embodiment emerged as part of a critique of so-called 'Cartesian dualism' – an understanding of the human subject in terms of a distinct

mind–body separation. For Descartes the mind is immaterial, a realm of thought, whereas the body is material, a realm of natural cause and effect, devoid of cognitive function. Merleau-Ponty, however, (following Heidegger) tried to show how our experience, ideas and understanding of the world take place in and through our physical acting, interaction and location in the world. Our bodies are not merely brute biological or material entities, and 'meaning' in the world is not derived wholly from mental stimuli; body and mind are entwined as we are embedded in the world around us.

EPISTEMOLOGY

A philosophical examination of the grounds, limits and criteria of knowledge and knowledge claims; it also concerns the cognitive processes by which we acquire knowledge (and it can overlap with certain kinds of psychology). Recently, 'anti-foundationalism' has attacked the possibility of any general epistemological principles that apply universally. 'Social epistemology' investigates the way knowledge and our acquisition of it is always socially constructed, through task-driven and institutionalized forms of discourse. Feminist epistemology has asserted that gender determines the acquisition and shape of a subject's knowledge of the world.

EXISTENTIALISM

A broad movement popularized by Sartre (see his 'Letter on Existentialism and Humanism' of 1947). It attempted to create a philosophy of life, in which the reality of death, the value of life, interpersonal relationships, consciousness and moral decisions are the subject of an individual's self-exploration. Human subjectivity itself is defined in terms of irreducible individuality and freedom. The objective was not to find and to live by

some universal ethical code, but in a state of 'authenticity' or truth to oneself, to act on one's self-determined free will (as opposed to 'bad faith', or living according to imposed or received norms).

FORMALISM

Formalism generally asserts that art's primary meaning and value is invested in its 'form' as opposed to its 'content' (whatever representational, ethical, social or ideological values or meanings it may have). How 'form' is defined is the crucial issue. For Greenberg and Fried, form was not just style, technique, composition or pictorial structure, but the way the artwork articulated and transformed the conventions of its medium. These 'conventions' were not identifiable as properties of an object, or triggers for sensory responses to certain combinations of colour and shape; they were visual articulations of the identity of a historical tradition under conditions of contemporary sensibility.

GAZE

The gaze for Lacan suggests that objects determine how we see them, as if they were returning our look: in other words what and how we see is not a function of our voluntaristic will, but of how objects structure our gaze – vision is socialized and constituted through regimes of power beyond our volition. Latterly, 'the gaze' has been used to understand how representation directs our interpretation. The 'male gaze' is where, for example, a female nude 'situates' the viewer in a masculine position of viewing (the viewing process is structured by male desire). The 'objectification' of women (as object of the gaze) is for the purposes of taking (visual) possession, and thus a vehicle of social control and sexual exploitation.

GENEALOGY

Foucault used this term to denote a form of historical method or analysis following his earlier 'archaeological' method. How do ideas or theories emerge and become structural features of our lives, culture or society? Nietzsche's 'Geneology of Morals' (1887) asserted that moral categories such as good and bad do not emerge from actual 'essentially' good and bad actions, but from social and historical processes. Similarly for Foucault, the terms 'good and bad' were not timeless and rooted in universal valid moral norms, but contingent, subject to arbitrary and accidental development, the historical origins of which are often concealed or erased. Genealogy uncovers the development of our knowledge and its ruling concepts, where knowledge is always power.

GENIUS

More than just brilliant human intelligence, the genius maintained an innate ability to perceive and express truth, usually through developing a unique artistic language. Kant's conception was most influential and involved originality (exemplary works of art and technical mastery) and inimitability (genius is unique and cannot be taught). The term has ancient origins and yet endured, along with its spiritual connotations, through the modern era. It is now commonly disparaged as embodying an elitist, male-dominant system of canonization, perpetuating a modern version of the 'old master' patriarchy of art history. However, Merleau-Ponty, Lyotard and Bernstein have shown that Kant's original concept involved a radical vision of human subjectivity, mobilizing thought outside of mainstream regimes of reason. Criticism of genius usually conflates empirical or sociological questions about the use of the term with conceptual questions about its meaning for philosophers such as Kant.

GRAMMATICAL INVESTIGATION

For Wittgenstein, a way of clearing away misunderstandings, vague generalizations, the misuse of words, and what can properly be said or not said (particularly with regard to crucial terms like 'certainty' or 'objectivity'). This investigation is not simply about grammar in the sense of a correct ordering of syntax, but the ordering of language itself (in relation to our actions and intentions). There are no fixed 'regulations' in language, but there are conventions of intelligibility and expression firmly embedded in the life of the speaker – in ordinary language. A grammatical investigation assesses and evaluates the utterances in the context of these conventions. Updated in Cavell's idea of 'recounting criteria'.

HERMENEUTIC

Used as a synonym for 'interpretation', it is a philosophical tradition (recently, Gadamer and Ricoeur) where texts are read not just as authorial statements, but as embodiments and expressions of a cultural, historical and literary 'world'. They emerge from this world, and are themselves acts of interpretation and expressions of it. We must not, therefore, impose an alien interpretative schema onto a text in search of meaning, but allow its own interpretative structures and contents to unfold, as it reveals its emergence from collective practices of meaning construction, law and tradition. This in turn allows us to philosophically contemplate the nature of meaning and truth as they have historically emerged.

HISTORICISM/POST-HISTORICAL

Historicism includes various methods of interpreting historical artefacts, and sometimes identifies the structure of historical development itself. It generally denies that meanings and values can be understood independently of their specific

context in times and places of history, arguing that the meaning of objects cannot be understood apart from the cultural and social economy, and matrices of practices in which they were formed. 'Post-historical' signifies the belief that today we no longer find grand narratives of historical development credible.

HUMANIST/ANTI-HUMANIST/POST-HUMANIST

A conviction in intrinsic human powers and moral integrity: it has both religious and secular forms. Secular humanism holds that humanity (as opposed to a divinity) holds the key to its own redemption; that the truth of human life resides within human reason (not in the supernatural or some realm above humanity); and that human life progresses with the increasing implementation of rational solutions. Anti- and post-humanists deny that there is any essential meaning to the term 'human' other than what we construct in historical, social, ethical and political contexts; there is no linear progress to human history, and reason is deceptive.

IDENTITY POLITICS

Identity in this sense is socially constructed and expressive of particular self-understandings in relation to specific social contexts. Since the 1960s, feminist, gay and lesbian, or various ethnic or subcultural minorities have formed allegiances in search of social recognition and political representation in the cause of their neglected rights and aspirations. Arguably a product of the 1960s counterculture, identity politics flourished with the waning of anti-authorial postmodernism, and new interest in multiculturalism and post-colonial theory in the 1990s. Identity politics also signifies the way marginalized groups have articulated specific cultural means of expression, politicizing culture as a vehicle for legal recognition.

IDEOLOGY

For Marxism, ideology ranges from illusory beliefs or 'false consciousness' (Marx, Lukács) to a regulating framework of ideas, which does not necessarily demand individual assent (Althusser, Gramsci). Apart from Marxism the term is still used to identify beliefs (like the idea of the 'free market') that both legitimize power (e.g. of corporations), and command assent (by suggesting that a given state of affairs is desirable, or just inevitable). The 'end of ideology' thesis concerns the historical collapse of socialism and communism as credible and competing ideological alternatives to capitalism.

IMAGINARY

For Jacques Lacan, the imaginary is a state of necessary illusion or misrecognition. Lacan theorized the psyche as a tripartite structure of 'real', 'imaginary' and 'symbolic'. The real is an unspeakable, unconceptualizable ground or force within the psyche, always present, but always mediated by the imaginary and the symbolic. The imaginary is a state through which the young infant passes whereby an illusory, integrated, conception of the self is created; the symbolic is the realm of rationality, conceptualization and language. Lacan's primary instance of imaginary misrecognition is that of the 'mirror-stage' in which infants encounter an integrated image of themselves, but from outside themselves; this apprehension of self creates an imaginary identification with the mirror image, and this becomes the basis of the cognitive distinction of self and other.

INSTITUTIONAL CRITIQUE

Often taking the form of installation art, conceptual art or direct political activism, institutional critique took as its subject the process of its own production, display, systems of distribution and circulation, commodification and sale. Emerging in late

1960s and early 1970s (with artists such as Buren, Broodthaers and Haacke) institutional critique interrogated the institutions of art, often by intervening in its conventions of viewing and display. It responded to the rise of institutional power of the museum, markets and dealers, and, subsequently, the professionalization of the curator. Its subjects were the institutionalized process of spectatorship, the hierarchical and gendered nature of the art system, and the relation between museums and commerce.

INSTRUMENTALISM

This is the notion that beliefs, values, actions are valuable only to the extent to which they achieve preconceived, separately specifiable and measurable ends; and concepts and theories are only valuable to the extent that they can be proved to be true or false. Logic, empirical accounting and statistical calculation rank highly in the instrumentalist's means of assessing value (usually in terms of 'objectivity' or efficiency). For critical theory, the entire development of Western modernity is inherently instrumentalist, eroding all value (aesthetic, ethical, etc.) outside its imposed norms.

JUDGMENT

Judgment in aesthetics encompasses categorical or descriptive statements such as 'this is a work of art' and evaluative statements such as 'this is beautiful' that assess the quality and value of a work of art. Given its classic modern form by Kant, aesthetic judgment denotes the unique way in which nature and art are judged in the absence of conceptual determination, for the feeling they arouse in a viewer. Kant analyzed the logic of such judgments, but his central claims (concerning the autonomy and the 'disinterested' contemplation that beauty in nature and art demand) have been largely abandoned in favour of assessing all forms

of visual culture in their specific context of signification.

KITSCH

'Kitsch' (from the German) entered modernist art criticism through Greenberg's 1939 essay 'Avant-garde and Kitsch'. Greenberg saw kitsch, much as Adorno saw culture industry, as a threat to genuine art in an age of industrialization. Kitsch, including magazines, popular music, movies and the like, raided authentic art for whatever effects and tropes it could represent in an 'easier' predigested form for mass or popular consumption. The need for kitsch was a product of mass literacy, urbanization and 'leisure time'. The opposition was symptomatic of cultural crisis, and engendered two modes of human cognition – the former reflective and critical, the latter determined by standardized and formulaic responses. Avant-garde art challenged received norms and extended individual powers of perception; kitsch operated on established patterns of consumption, inducing intellectual docility (and a sublimated fear of individuality and difficulty).

LEGITIMIZATION

After Weber, an idea or activity gains legitimacy by way of tradition, or the endorsement of a charismatic individual, or adoption by an institution (protection under the law could be included here). The term is related to 'institutionalization' whereby certain heterodox practices gain acceptance and become orthodoxy, doing so through an identifiable process of introduction, reaction, tolerance, acceptance, adoption and absorption into the functional dimensions of social or organizational life. However, even heterodox practices can be tolerated as part of a legitimation process (e.g. the political radical avant-garde art celebrated by otherwise conservative art museums).

Baudrillard pointed out that such practices can be used as an 'inoculation' against further radicalization.

LIBIDINAL

The libido is a primary psychic force associated with sexuality. As a biological drive, it has to be directed in some way (and it is directed in different ways for the various stages of the psychosexual development of the subject). Libidinal objects are invested with heightened attention and interest (what Freud termed 'cathexis'). Freud regarded all mental energy as libidinal at root, though his conception of libido reached far beyond limited sexual desire for another person. It was used in terms of 'libidinal impulses' or 'libidinal gratification', and introduced by Freud in his book *Three Essays on the Theory of Sexuality* (1905). As a quasi-physics of the body, libido theory remained contentious, but has been taken up and reworked in various ways by later theorists such as Lyotard and Deleuze.

LOGOCENTRISM

The *logos* signified 'the word', or originary intelligence, by which the universe is structured. 'Logocentrism', as used by Derrida, is a continuing need for this originary truth and universal structure, with its appeal to a 'transcendental signifier' by nature unrepresentable (whether God, the Idea, the Self, Reason, etc). In this vertical universe, hierarchy is the norm, and all key terms are organized by this logic, with one privileged over the other (the immediacy, self-presence and transparency of speech, for example, over the distance, detachment and equivocation of writing). Derrida's deconstruction reveals that logocentrism is metaphysics that conceals the way such oppositions are interdependent, and in a constant play of difference.

MEDIATION

The concept of mediation is an epistemological principle, arguably traceable to Kant on the categorical conditions of knowledge, that holds that there is no direct cognitive apprehension of the world: we 'know' or understand the world by using an apparatus of concepts or representations. Meaning is not simply 'given' but actively produced. Later philosophers in the phenomenological tradition tried to circumvent such 'representationalism' by emphasizing the 'task-driven', or engaged, nature of cognition, as it emerges from our intersubjective interaction with the world into which we are already thrown. 'Mediation' in communication, media or cultural studies emphasizes how all our understanding and communication is already embedded in semiotic and symbolic systems, cultural beliefs and hierarchies of values; and that all communication is channelled through organizational apparatuses.

MEDIUM

Medium is often distinguished from material or matter. The artist's materials (oil paint, canvas, brush) were not unique in themselves, only their use, according to the conventions of painting or sculpture as they were configured at a particular historical moment. The artist's medium developed as a complex of evolving materials, technical practice and institutional protocol. The concept of a distinct or 'specific' medium has been attacked from a number of perspectives: as a legacy of academic practice, regulation and protocol; as the remnant of an outmoded aesthetic theory of artistic autonomy; and in light of the rise of new digital technologies 'multimedia' facilities for visual communication.

MEDIUM-SPECIFICITY

Current reference to the term tends to be in the context of modernist theory, particularly that of Clement Greenberg. For Greenberg what made a work *modernist* as opposed to merely modern was that it sought out the 'unique and irreducible' (i.e necessary and sufficient) properties of its medium, and did so in an attempt to establish what the minimal conditions were for something to count as a painting, sculpture, etc. On this view, a work counts as painting, say, in virtue of having a set of specifiable properties that all paintings have, and that only paintings have, thereby distinguishing all paintings from all works of other kinds.

METAPHYSICS

Meta-physics literally means the realm 'above' physics. As such it signifies the branch of philosophy that considers the broadest questions on the nature of reality and existence, and which attempts to speculate rationally on what lies beyond the physical realm we experience (historically related to theology). In modern times, metaphysics has become as problematic as religion, hence the recent idea, linked to philosophers such as Habermas, of 'post-metaphysical' thinking. Modern criticisms of metaphysics go back at least as far as Kant's critique of 'transcendent metaphysics' in which human reason strains to go beyond the bounds of what can be known. Metaphysics has been attacked by much twentieth-century analytic philosophy in particular for attempting to legitimize the inscrutable and invisible as an object of rational analysis.

MODERNIST/MODERNISM

Generally taken as the period *c.* 1860–1960, it is understood in a narrow and a broad sense. Understood narrowly, by modernists such as Greenberg, it signified a self-critical approach to the medium, whereby each art form interrogated itself in an attempt to secure its autonomy and unique mode of address. More broadly, when taken as a historical term, it also encompasses the numerous 'isms' and rapid turnover of individual styles, non-conventional media and techniques, political engagement and transgression of social protocols that characterized the historical avant-garde, particularly in the first half of the twentieth century.

MYTH/MYTHOLOGIZATION

Used in anthropology, psychoanalysis and in cultural analysis to describe the operation and circulation of beliefs, values and communication in society. For Barthes, mythologization is the construction of beliefs that operate as self-evident or collectively endorsed truths; these myths can be simple explanations why the family is structured like it is, what values a nation-state stands for, or how boys and girls typically behave. However, the term is used in distinction to ancient myth, in that it is ideological, masking real social relations, presenting coherency where there is in fact conflict.

NEGATION

Derived from logic, negation is the operation of changing the way a received truth is understood by revealing its internal connection to its opposite. Used in critical theory to describe the way in which critical interpretation can reveal positive knowledge about society, without replicating the patterns of meaning or ideology of that society (and thus acting in an 'affirmative' way that effectively works, shores up or 'legitimates' that society). 'Negative' signals the way that criticism does not simply reproduce the object of critique.

NEO-AVANT-GARDE

Popularized largely by Peter Bürger's *Theory of the Avant Garde* (1984), the term identified

the radical art movements of the 1960s who both revised and extended the strategies of the historical avant-garde (the use of new technologies like film and photography; the subversion of pictorial convention with montage and assemblage; the use of mass-cultural imagery and so on). The relation between the first and second, or historical and 'neo', avant-garde is still a matter of debate. Positions range from the charge of impotence and empty repetition (Bürger) to a redefined resistance to the cultural industry's domination of all spaces of cultural representation and activity (Buchloh, Foster) that retrospectively confers on the historical avant-garde its generative force.

OBJECTHOOD

Michael Fried coined this term as a way of characterizing what he thought aesthetically meretricious and ethically pernicious about minimalist art. Fried argued that minimalism confused the characteristic stress of modernist works on their own materiality for 'objecthood' per se. Unlike genuine art, minimalism consisted of little more than art's phenomenal substrate: there was neither an expressive nor conventional dimension by virtue of which it distinguished itself from an everyday world of things. The results, for Fried, were not properly thought of as art at all, and by being proposed as such, contributed to the further levelling of emphatic experience, the ethical equivalent of confusing persons with mere bodies.

OBJECT RELATIONS

A strand of psychoanalytic theory, particularly important in the development of the British psychoanalytic tradition. Klein is arguably a part of this school of thought, a school that attempted to avoid either a biology-based or purely psychology-based understanding of psychic development. Through the increasing importance of 'transference' in Freud's psychoanalytical practice (i.e. the relationship between analyst and analysand) there developed in the theories of others like Klein a central emphasis on the relation between the 'ego' or subject and 'objects' (a person or some other thing that is perceived to be the vehicle by which the satisfaction of an instinctual desire is to be obtained). It pushed psychoanalysis further into the empirical world.

OEDIPAL

The 'Oedipus complex' (or conflict) was one of Freud's central theories of psychosexual development, tracing the origin of certain neuroses back to childhood experience within the family. Using the Greek myth of Oedipus, who inadvertently kills his father and marries his mother, Freud unfolds a scenario in which the male child develops a rivalry towards the father for the exclusive love of the mother (discharging sexual energy and encountering prohibition). A fear of 'castration' (the consequences of the father's prohibition), Oedipal rivalry is resolved through identification with the father. This theory, though immensely influential, has been widely criticized for making the male child's psychic development the model for the development of subjectivity in general.

ONTOLOGY

If epistemology investigates how we know what there is, ontology investigates what there is. Historically, it is a branch of philosophy that investigates the nature of existence as a whole (or 'being'), what kind of entities exist, their fundamental relationships to one another and their modes of existence. The ontology of art as a formal field of enquiry only properly emerged in the twentieth century, and considers what kind of entities artworks are and their modes of existence. Basic ontological questions in the philosophy of art include how to correctly

specify the relation between unique and multiple arts, whether artworks are mental or physical, real or ideal objects, and whether all and only works of art share any minimal set of features or properties in common.

OPTICALITY

Opticality was a term used by Greenberg to describe what he saw as modernist sculpture's tendency to render matter incorporeal and weightless. It entered widespread critical discourse when Rosalind Krauss used it to show what was wrong with modernist conceptions of sculpture. For Krauss, Greenberg's stress on the 'sheerly visible', that is the belief that works of art may be understood solely in terms of the sense through which we intuit them, was a form of aesthetic 'idealism' because it glossed over our embodied relation to works of art in space and time. Philosophically, it would be more accurate to see this as a form of aesthetic empiricism, however, because it posits the senses as the bedrock of experience and knowledge of the world.

PERSPECTIVALISM

Perspectivalism is a view on cognition or knowledge (associated with Nietzsche) that denies the existence of emphatic objectivity, truth or universal validity. It holds that claims to universal truth or objectivity mask their status as 'perspectives', or that they are meaning systems constructed within particular paradigms or according to particular interests or regimes of power. Perspectivalism, understood in Nietzsche's sense, is opposed to the universalizing claims of Western rationality and associated with Enlightenment thinkers in particular. Perspectivalism is common to various more or less 'deflationary' schools of thought, including historicism, relativism, scepticism, pragmatism, post-structuralism and postmodernism.

PHALLUS

The phallus, while literally related to the male sexual organ, has a much broader symbolic function in psychoanalytic theory since Lacan. Here it functions as the 'privileged signifier' or that around which differences and relative values are structured and assigned. As such it signifies power and authority within a symbolic system. 'Phallocentrism' since Lacan has come to signify, in broad terms, the primacy of the male gender in determining 'human' psychosexual development. For Lacan, however, 'the phallus' signifies something more abstract; a privileged position at the heart of the symbolic order.

PHANTASY/PHANTASMATIC

In Freudian psychoanalysis, 'fantasy' was a substitute form of satisfaction, where instinctual desires that had failed to find satisfaction in reality could find illusory gratification. For Klein, however, 'phantasy' works alongside reality, and despite being a mental phenomenon of somatic instincts and desires that are unfulfilled can act as developmental mechanisms and a defence against instinctual impulses. As they are effectively mental representations of biological drives, phantasies are common to the subject from birth and are instrumental in different ways throughout life. Its significance is that it acts as a means for relating to and interpreting objects outside the self.

PHENOMENOLOGY

A philosophical school of thought that opposes all forms of philosophy and science that advocate a radical division between subject and object (from rationalism and Cartesian dualism, to scientific naturalism and positivism). It understands reality in terms of the structure of experience (or consciousness), which is rooted in a life, context-bound place and a unified

experience of an 'embodied' subject (who experiences no radical division of mind and body). All consciousness for phenomenology is consciousness *of*, there is no bare consciousness, nor is there a world prior to its being a world for me. Hence the embodied subject is constituted through a primordial connection to the world. Like critical theory in this respect, phenomenology holds that scientific modernity has repressed our primordial interconnection with the world and each other, creating chronic alienation.

POLITICIZATION

The term can mean both an investment of an activity with political motives or viewpoints (like 'radicalization') or an act of critique that reveals the structures of power within supposedly non-political phenomena (e.g. the operations of patriarchy, gender and sexual politics within the institution of painting the female nude). The 'political' is defined in broad terms as the exercise of power, which is intrinsic to all human activity. Thus it is possible to reconceptualize all areas of everyday life in terms of immanent operations of power.

POSTMODERNISM

Revision, extension, critique or interrogation of modernism or modernity. In art most commonly an inversion of modernism: if modernism was abstraction, a return to figuration or narrative was postmodern; if modernism held to specific media, multimedia and mixed-media were postmodern; if modernism was stylistic development and technical innovation, then pastiche, quotation and appropriation were postmodern; if modernism was the autonomy of art, the use of art as a form of social or political discourse was postmodern, and so on. 'Postmodernism' used as a historical periodization is defined in broad terms as an ironic view of history; an abandonment of any faith in the progress in history; a denial

of philosophical foundations or one mode of interpretation; the abandonment of 'master narratives'; and a refusal of an emphatic conception of truth.

PRAXIS

A Marxist term now used widely. Praxis is the unity of theory and practice: it could mean the way that conceptual activity can be manifest in political action (political activism as political critique in action) or it could mean that action itself is a form of reflection, and that a theoretically informed action would itself be a reflection on the adequacy and effectiveness of the theory. In both cases theory and practice were dialectically poised; the point was not, as Marx said, to understand the world, but to change it.

PROJECTION

Used by Freud and Klein, projection has both a technical psychoanalytic sense and an everyday folk psychological sense, and the two are related. We say of someone who accuses us of some emotion (say anger) for no apparent reason that they are 'projecting' their own anger upon us. In psychoanalytic theory projection (or 'projective identification') occurs when a subject imagines his or her emotions, fears, anxieties, desires to be the product or characteristic of some agent outside themselves. This often happens when, for whatever reason, they are unable to acknowledge their own desires and emotions as their own.

RATIONALIZATION

Rationalization literally means reorganization according to systematic ideas and operation of human reason – which in modernity is manifest as instrumental and 'formal logic' or a mathematical calculus that expunges acknowledgement of anything that cannot be quantified or identified under general

categories of utility. For Weber modern society was created out of a separation of science, morality and art; this creates advanced specialization but at the cost of a fragmentation of human consciousness, preventing coherent cultural development.

REPRESENTATION

A representation stands (in) 'for' something, and therefore can conceal its referent as well as reveal it. Distinct from 'depiction', the term indicates that identities are 'constructed' and can take many forms: a representation reconstructs the identity of something rather than simply reflecting or expressing that identity. Representation is a social process and has many determining factors, and actively attempts to structure the process of its own reception or interpretation (as in the case of the 'male gaze'). The word has important political connotations as representation places one in relation to the social sphere, hence the 'politics of representation'.

SCHIZOID; PARANOID-SCHIZOID

'Paranoid schizoid' is a technical term, deriving from Melanie Klein, that denotes a stage of psychic development that is said to characterize the pre-linguistic infant during the first six months of life. It is 'paranoid' because it suffers continual fear of persecution from those 'objects' it attacks in phantasy; it is schizoid because the objects it fears are a product of its own 'projective splitting' of complex objects (first and foremost the mother, or parts thereof, hence the use of the term 'part-object' to denote the infant's relation to the breast) into ideally good and bad objects, the former of which is loved and desired, the latter of which is feared and detested. Like all Kleinian psychic structures these are not 'stages' so much as 'states' that can be reactivated under duress or recur later in adult life as personality disorders (e.g. schizophrenia).

SEMIOTICS

Emerging from structuralism, semiotics (or semiosis) extends its principles from language to social activity and cultural communication. We do not live among single objects and activities that have transparent, universal or essential meanings; our lives are ordered by codes and systems of signs which function like a text (or a language). Clothes, behaviour, objects, activities all 'signify' meaning and can be 'interpreted' like a text; meaning is always constructed within signifying systems and the powers of signification operate within systems of symbolic representation (social organization). Barthes identified different orders of signification.

SIMULACRUM

In *Simulacra and Simulations* (1981), Baudrillard uses the term 'simulacrum' (plural: simulacra), from the Latin *simulare*, 'to make like, to put on an appearance of', registering the proliferation of images in advanced capitalist society. According to Baudrillard's historical thesis that reality is mediated by increasingly attenuated 'orders of simulacra', we have moved from a society that uses representations (of something real) to a society that lives within a vast topography or image-world: simulations no longer have no reference to reality, but have evolved into a hyperreal system of their own. Genuine theory or political praxis are all but impossible, as we have lost essential co-ordinates informing us of 'the real'.

SPECTACLE

In *The Society of the Spectacle* (1967) Guy Debord proclaimed that 'real life' had been recast as its own image through the ubiquity of media and consumer imagery. This society is a world created for the consumer, not by them; people do not have their own life or their own experiences, but live life through

the images and identities assigned them in the world of commodities, from fashion to social stereotypes. A spectacle is something visually engaging, but only apprehended from a distance: people effectively become spectators of their own lives.

SPLITTING

Splitting is a psychoanalytic term for the ego's tendency to split its 'objects' into good and bad, rather than acknowledge that it either has conflicting emotions towards one and the same person, or that one and the same person ('object' in psychoanalytic terminology) can exhibit conflicting tendencies towards the subject. Unable to deal with such complexity it attributes these characteristics to different objects. It is the earliest defence the child has against the torment of anxiety (the internal conflict between the instincts) and its own aggressive tendencies.

STRUCTURALISM/POST-STRUCTURALISM

Structuralism was a form of linguistics that conceived of language as a self-regulating system of signs. Signs have no essential meaning in themselves apart from their relation to other signs (their meaning is constituted by their difference from each other, thus language is a dynamic process of sign interactivity). A sign consists of both signifier and signified (word and concept) each being transformed over time. A structuralist analysis could be performed on a synchronic or diachronic register: the former would analyze a sign system as it stood and functioned at a given moment; the latter as it changes historically. Post-structuralism was a critique of structuralism, emphasizing the dynamism and 'differential' quality of signs, and extending its study to all forms of culture (cf. semiotics). It is anti-systematic and interested in the anarchic and creative dimensions of language, its inherent instability and the potential of writing for cultural subversion.

SUBJECTIVITY/INTERSUBJECTIVITY

In the absence of a belief in the transcendent soul or spirit, modern philosophy has been centrally concerned with defining the self or subjectivity: how are human beings constituted as self-conscious thinking subjects, capable of intersubjective interaction? Anti-humanism and materialist critical theory maintains that human subjectivity is not essential or pre-existent (like a soul or spirit) but constructed, and therefore contingent on its environment; second, a conception of the human subject is key in the operation of ideology. Art and critical theory investigate the way art and cultural forms are actively involved in the construction of subjectivity and the way representation perpetuates and legitimizes certain models of subjectivity in the interests of certain groups.

SUBLIME

Unlike Burke, Kant's sublime was not an emotional reaction to an overwhelming physical phenomenon (awe, wonder, horror, fear, etc.). Rather, in virtue of the overwhelming large or overwhelmingly powerful capacity to outstrip our finite powers of intuition, while nonetheless not outstripping our powers of reason, it is an experience of supremacy of human reason over both material and human nature. Though as 'finite rational beings' we cannot experience the infinitely large, we can nonetheless entertain the idea of such expanses (the idea of infinity) in thought. As the source of morality, this supremacy of reason over sensory experience points us in the direction of our moral vocations. Sublimity for Kant was

primarily an experience of nature, not art, but later Lyotard and others made use of Kant's theory of the sublime to understand avant-garde art as an attempt to 'present the unrepresentable' (later paradigmatic for postmodernism).

SUPERSTRUCTURE

Marx and Engels held that society could be understood in terms of two spheres: the base structure of economic systems (or material production of goods), and the superstructure of institutions, ideas and beliefs (including art and morality). The superstructure itself had two spheres: the mechanisms of social organization (including government or the state), and the beliefs, ideas, religion, philosophies and conceptions of life held by people. Ideology results when the latter is organized by the former (government or state) for the purposes of naturalizing of justifying the shape of the base structure. According to classic Marxist analysis the superstructure is essentially passive, in the sense that it can reflect but not alter the base; later critical theorists such as the Frankfurt School sought to give art a much more active role in relation to underlying economic reality.

TECHNOCRACY

A new class of industrial mandarins or a new framework of government and organization. All forms of government have historically been based on an ideology, philosophy or religion, but technocracy is based on the 'objective' principles of science. All decisions on all matters of productivity and the functional aspects of society are made by 'technocrats' with specialized knowledge based on empirical accounting procedures. Efficiency, economy and functionality are their values and productivity their objective.

TRANSCENDENCE

A term with strong metaphysical or spiritual connotations; it typically denotes an ability to rise above or step outside the conditions of experience (the opposite of immanence). It could be an attainment of a spiritual realm of consciousness or experience, or the positing of a realm or world that is not observable or is the source or provider of the underlying laws of something. Kant famously distinguished, at the outset of his own critical project, between making claims about what cannot be known (i.e. *transcendent* metaphysics), which oversteps the bounds of sense and is therefore to be avoided, and seeking to deduce the necessary *conditions of* experience (i.e. a properly transcendental philosophy).

TRANSFERENCE

In a psychoanalytic context transference is what takes place in the relation between analyst and patient or 'analysand', where the latter projects or acts out on the analyst various unresolved impulses, wishes, anxieties and frustrations. This is called 'transference' because such forms of relating to others are taken to underlie the patient's way of relating to all significant figures in their experience, and to derive ultimately from their earliest experience of interacting with their parents. Such habitual patterns are then 'transferred' onto the analyst. This gives the analyst an insight into the patient's psychic life. Transference can be good or bad, 'positive' or 'negative', depending on how the patient interacts with the analyst.

TRANSGRESSION

The 'transgressive' could take the form of denying established truth, offending social pieties, breaking convention or protocol, or erasing instituted boundaries. Its most controversial form is taboo-breaking art, and as taboos largely concern birth, copulation,

bodily waste and death, the body is commonly used as an artistic medium, particularly in performance and other forms of live art. While some transgressive art was deeply politicized (such as feminist art) and so unavoidably appealed to codified ethical norms, taboo-breaking transgression activates a deeper shared sense of horror or existential aversion that we instinctively avoid.

TRAUMA

Psychological trauma is the experience of an event or occurrence that the subject cannot integrate into his or her experience. As a result the subject is overpowered by the experience, which becomes a threat to integrity or mental stability. Historically psychoanalytic interest in trauma gathered moment with Freud's observation of the effects of the Great War. Since Lacan, trauma has typically been associated with an event or irruption of the real, as that which cannot be mentally processed and so threatens to unseat the subject. This can be seen, for example, in Kristeva's notion of abjection as that which threatens the integrity of the subject. More recently, art theorists such as Foster have used the concept in an attempt to theorize the compulsive fascination of certain kinds of subject matter in art (e.g. Warhol's car crashes).

CONTRIBUTORS' BIOGRAPHIES

Darren Ambrose is Lecturer in the Department of Philosophy, University of Warwick. His publications include '30, 000 B.C.: Painting Animality – Deleuze & Prehistoric Painting', *Angelaki* (2006), 'Deleuze and Guattari and Creative Pedagogy', *Angelaki* (2006); 'Deleuze, Philosophy and the Materiality of Painting', *Symposium: Canadian Journal of Continental Philosophy* (2006).

David Ayers is Senior Lecturer in English at the University of Kent. He works on literary modernism and critical theory, and his publications include *Wyndham Lewis and Western Man* (1992), *English Literature of the 1920s* (1999), *Modernism: A Short Introduction* (2004) and a forthcoming book on literary theory.

Sara Beardsworth is Assistant Professor in the Department of Philosophy at Southern Illinois University. She is author of *Julia Kristeva: Psychoanalysis and Modernity* (2004). Her research is in nineteenth- and twentieth-century European philosophy, and she has published articles on psychoanalysis, feminism and Frankfurt School critical theory.

Francesca Berry is Lecturer in History of Art at the University of Birmingham and is author of 'Designing the Reader's Interior: Subjectivity and the Woman's Magazine in Early Twentieth-Century France' in *Journal of Design History* (2005). She is researching a book on sexual difference and the art of the interior.

Claire Bishop is Leverhulme Research Fellow in the Department of Curating Contemporary Art at the Royal College of Art, London. She is a regular contributor to *Artforum* magazine, and is the author of 'Antagonism and Relational Aesthetics', *October* (2004) and *Installation Art: A Critical History* (2005).

Martha Buskirk is Associate Professor of Art History and Criticism at Montserrat College of Art, Beverly, Massachusetts. She is author of *The Contingent Object of Contemporary Art* (2003) and co-editor with Mignon Nixon of *The Duchamp Effect* (1996), and with Clara Weyergraf-Serra of *The Destruction of Tilted Arc: Documents* (1990).

David Carrier is Champney Family Professor, a post divided between Case Western Reserve University and the Cleveland Institute of Art. A former philosopher who writes art criticism, he has published books on Poussin's paintings, Baudelaire's art criticism, the abstract painter Sean Scully and the history of the art museum.

Michael Corris is Head of Art and Photography, at the University of Wales, Newport. His writings on art have appeared in *Art Monthly*, *Artforum*, *Art History*, *art+text* and *Mute*, and recent publications include *Conceptual Art: Theory, Myth and Practice* (2004), *David Diao* (2005) and *Ad Reinhardt* (2006).

Diarmuid Costello lectures in aesthetics in the Department of Philosophy at the University of Warwick. He has published

on various aestheticians and art theorists, including Kant, Greenberg, Fried, de Duve, Danto, Lyotard, Heidegger and Benjamin. He is co-editor of *After Beauty: Exchanges on Art and Culture* (2007), and is completing a monograph, *Aesthetics after Modernism*.

Eric de Bruyn teaches art history at Groningen University and is author of 'Land Art in the Mediascape' in *Ready to Shoot* (2004) and 'The Expanded Field of Cinema, or Exercise on the Perimeter of the Square' in *X-Screen: Film Installations and Actions in the 1960s and 1970s* (2004). He is currently writing a book, *Media Topologies: Filmic Practices in Post-minimalism*.

Robert del Principe is a freelance writer living in New York. He writes about contemporary art and the history of philosophy, and is the former Managing Director of the Adrian Piper Research Archive.

Jonathan Lahey Dronsfield is Reader in Theory and Philosophy of Art, University of Reading. His research includes the deconstruction of social space, the resistance of art both to autonomism and socially engaged aesthetics, and two books in progress: *Art Ethics: The Collapse of Aesthetics into Ethics*, and *Problems of Responsibility in Contemporary Continental Philosophy*.

Scott Durham is Associate Professor of French at Northwestern University. He is the author of *Phantom Communities: The Simulacrum and the Limits of Postmodernism* (1998), and the editor of *Jean Genet: In the Language of the Enemy* (1997).

Gordon Fyfe, Fellow of Keele University, writes on the sociology of art and the sociology of museums. His publications include *Theorizing Museums* (1996), which he co-edited with Sharon Macdonald, and *Art Power and Modernity* (2000). He is a managing editor of the online journal *Museum and Society*.

Mike Gane teaches at Loughborough University and has written extensively on Baudrillard and French thought, including *Jean Baudrillard: In Radical Uncertainty* (2000), and he recently edited *French Social Theory* (2003), and (with Nicholas Gane) the anthologies *Roland Barthes* (3 vols, 2004) and *Umberto Eco* (3 vols, 2005).

Francis Halsall is Lecturer in Art History at Limerick School of Art and Design. He has published on art history, visual culture and systems theory; he is also co-editor of *Re-discovering Aesthetics* (on the intersections between art, art-history and philosophy, forthcoming) and is completing a book on art history and systems-theory.

Espen Hammer is Reader in Philosophy at the University of Essex and Professor of Philosophy at the University of Oslo. Among his publications are *Stanley Cavell* (2002), *Adorno and the Political* (2005). He is currently working on a project on time and modernity.

Gregg M. Horowitz is Associate Professor of Philosophy at Vanderbilt University. His publications include *Sustaining Loss: Art and Mournful Life* (2001) and, with Arthur C. Danto and Tom Huhn, *The Wake of Art* (1998). He is currently at work on a book on psychoanalysis and political authority entitled *The Weak Father*.

Gordon Hughes is Assistant Professor at the University of Maine. He is the editor, with Hal Foster, of *October Files: Richard Serra* (2000). His work has appeared in *October*, *Critical Matrix* and is forthcoming in *The Oxford Art Journal*. He is writing a book on Robert Delaunay, early abstraction and Cubism.

Margaret Iversen is Professor in the Department of Art History and Theory, University of Essex. Her publications include *Alois Riegl: Art History and Theory* (1993); *Mary Kelly* (1997); 'Readymade, Found Object', *Art*

Journal (2004) and many other essays on art and psychoanalysis. A book, *Beyond Pleasure: Freud, Lacan, Barthes*, is forthcoming.

Michael Kelly is Chair of the philosophy department at the University of North Carolina at Charlotte. He is the author of *Iconoclasm in Aesthetics* (2003) and editor of the *Encyclopedia of Aesthetics* (1998). His current work concerns the relationships among art, art history and aesthetics in the 1960s.

Esther Leslie is a Reader in Political Aesthetics in the School of English and Humanities at Birkbeck, University of London. She is the author of *Synthetic Worlds: Nature, Art and the Chemical Industry* (2005), *Hollywood Flatlands: Animation, Critical Theory and the Avant Garde* (2002) and *Walter Benjamin: Overpowering Conformism* (2000).

Riccardo Marchi is Assistant Professor at the University of South Florida in Tampa, where he holds the Stuart S. Golding Endowed Chair in Modern and Contemporary Art. He has published on the history of twentieth-century art history, and is working on a book on Boccioni, Kandinsky and Robert Delaunay in Berlin between 1912 and 1913.

Melanie Mariño is Assistant Professor of Contemporary Art at the University of Wisconsin-Milwaukee. She has contributed to *The Last Picture Show* (2003) and *The Art of Rachel Whiteread* (2004). She is currently a fellow at the Center for 21st Century Studies.

Stewart Martin is Lecturer in Modern European Philosophy at Middlesex University, and a member of the editorial collective of the journal *Radical Philosophy*. He has written numerous essays on philosophy and art, and is currently composing a book on the ontology of post-conceptual art called *Absolute Art*.

Derek Matravers lectures in philosophy at the Open University and is a Fellow Commoner at Jesus College, Cambridge. He is the author of *Art and Emotion* (1988) and numerous articles in aesthetics and in ethics, including 'Pictures, Knowledge and Power: The Case of T. J. Clark' in eds Matthew Kieran and Dominic Lopes, *Knowing Art* (2006).

Christine Mehring is Assistant Professor of Art History at Yale University. She is the author of *Wols Photographs* (2002), of a forthcoming book on the painter Blinky Palermo and of essays published in *History of Photography*, *Artforum*, *Texte zur Kunst* and *Grey Room*.

Stephen Melville is Professor of Art History at Ohio State University. His publications include *Philosophy Beside Itself: On Deconstruction and Modernism* (1986), *Seams: Art as a Philosophical Context* (1996) and (with Philip Armstrong and Laura Lisbon) *As Painting: Division and Displacement* (2000), and he edited *The Lure of the Object* (Clarke Art Institute, 2006) among others.

Stephen Mulhall is Fellow and Tutor in Philosophy at New College, Oxford. His publications include *Stanley Cavell: Philosophy's Recounting of the Ordinary* (1994), *Inheritance and Originality* (2001), *On Film* (2002) and 'Crimes and Deeds of Glory: Michael Fried's Modernism', *British Journal of Aesthetics* (2001).

Mignon Nixon is Senior Lecturer at the Courtauld Institute of Art, University of London, and an editor of *October*. She has written extensively on contemporary art, feminism and psychoanalysis, including *Fantastic Reality: Louise Bourgeois and a Story of Modern Art* (2005).

Alex Potts is Max Loehr Collegiate Professor and Chair of the Department of History of Art at the University of Michigan, Ann

Arbor. His publications include *Flesh and the Ideal: Winckelmann and the Origins of Art History* (1994 and 2000) and *The Sculptural Imagination: Figurative, Modernist, Minimalist* (2000).

Dominic Rahtz is Lecturer in Art Theory at Oxford Brookes University, and works on American art of the 1960s and 1970s. His publications include 'Literality and Absence of Self in the Work of Carl Andre', *Oxford Art Journal* (1994).

Katerina Reed-Tsocha is Research Fellow at Trinity College, Oxford, and teaches at the Department of the History of Art, University of Oxford. She pursues interdisciplinary research in art history and philosophy, and has authored *Art History: Methods, Theories and Practice* (2007).

Michael Richardson is currently Visiting Professor at Waseda University, Tokyo. He is the author of *Georges Bataille* (1994), *The Experience of Culture* (2001) and *Surrealism and Cinema* (2006), and, with Krzysztof Fijalkowski, edited *Surrealism against the Current* (2001).

Helmut Schmitz is Senior Lecturer in German Studies, University of Warwick. His research interests are German Holocaust literature and memory discourses, and twentieth-century German intellectual history. His publications include *On Their Own Terms: German Literature and the Legacy of National Socialism after Unification* (2004).

Nancy Shawcross teaches at the University of Pennsylvania for the English Department and for the Program in Comparative Literature & Literary Theory. Publications include *Roland Barthes on Photography: The Critical Tradition in Perspective* (1997) as well as essays on photography and literature.

Kirstie Skinner is completing her doctoral research on minimalism and installation art at Edinburgh College of Art. She has published 'The Self as a Screen', *Journal for Visual Art Practice* (2004), and 'Camera Perspective', *Norwich Gallery Dispatch* (2005); 'Framing consciousness in the 1960s: The Filmic Qualities of Serial Sculpture', CAA is forthcoming.

Ruth M. Sonderegger is currently Associate Professor at the Philosophy Department of the University of Amsterdam. Her main fields of research are aesthetics and critical theory and she has published, among others, *Für eine Ästhetik des Spiels. Hermeneutik, Dekonstruktion und der Eigensinn der Kunst* (2000).

Cain Samuel Todd is Lecturer in Philosophy at Lancaster University. His research concerns the objectivity of aesthetic judgment, the role of imagination in appreciation, the relationship between cognitive and aesthetic value, various connections between ethical and aesthetic judgment and evaluation, and fiction and the emotions.

Jonathan Vickery is Lecturer and programme director in the Centre for Cultural Policy Studies, University of Warwick. He has published on art theory, public art and aesthetics, and is a founding editor of *Aesthesis: International Journal of Art and Aesthetics in Management and Organisational Life*.

John C. Welchman is Professor of Art History in the Visual Arts Department at UC, San Diego. He is the author of major titles including *Art After Appropriation: Essays on Art in the 1990s* (2001); he co-authored *Mike Kelley* (1999); and he edited Mike Kelley's *Foul Perfection: Essays and Criticism* (2003), *Minor Histories* (2004) and *Interviews* (2005).

James Williams is Reader in Philosophy at the University of Dundee. His writings include *Lyotard and the Political* (2000), *Gilles Deleuze's Difference and Repetition* (2003), *Understanding Poststructuralism* (2005) and *The Lyotard Reader and Guide*, co-edited with Keith Crome (2006). He is currently working on the philosophy of events.

Robert Williams is Professor of the History of Art and Architecture at the University of California, Santa Barbara. He is the author of *Art, Theory, and Culture in Sixteenth-Century Italy: From Techne to Metatechne* (1997) and *Art Theory: An Historical Introduction* (2004).

Dominic Willsdon is Leanne and George Roberts Curator of Education and Public Programs at the San Francisco Museum of Modern Art. He was formerly Curator of Public Events at Tate Modern, London, and a lecturer at the London Consortium and Royal College of Art.

Rebecca Zorach is Assistant Professor of Art History at the University of Chicago and author of *Blood, Milk, Ink, Gold: Abundance and Excess in the French Renaissance* (2005). She co-edited *Embodied Utopias: Gender, Social Change, and the Modern Metropolis* (2002) and has published articles in *Art History*, *Res*, *Wired Magazine* and *rhizome.org*.